'No one who is invested in any kind of art, in questions of what real art does and doesn't have to do with money, spirituality, ego, love, ugliness, sales, politics, morality, marketing, and whatever you call "value", can read *The Gift* and remain unchanged.'

David Foster Wallace, author of *Infinite Jest*

'Quirky and luminous.'

Jay Parini, *Guardian*

'Hyde mounts a provocative argument for the incompatibility of poetic gifts and market valuation.'

Bharat Tandon, *Times Literary Supplement*

'Hyde's book is so true to itself that I get the impression it has long circulated as a gift, rather than being purchased and consumed (as if a book could ever really be consumed) as a commodity.'

Harry Eyres, *Financial Times*

'Persuasive and fascinatingly illustrated . . . It is notoriously difficult to write without bombast or bullshit about the creative process or the duty of the artist, and to pull it off at such length is admirable. Hyde offers a quietly explosive series of arguments for the necessity of our shadow economy of ideas. But perhaps most importantly, his book offers to the lone scribbler in his workshop those most valuable of gifts: inspiration, companionship, understanding and justification.' Tim Martin, *Independent on Sunday*

'*The Gift* has been a source of inspiration and affirmation in my artistic practice for over twenty years. It is the best book I have read on what it means to be an artist in today's economic world.'

Bill Viola, video artist

THE GIFT

HOW THE CREATIVE SPIRIT TRANSFORMS THE WORLD

LEWIS HYDE

CANONGATE

Edinburgh · New York · Melbourne

First published in the United States and Canada in 1983
by Random House

First published in Great Britain in 2006
by Canongate Books Ltd,
14 High Street, Edinburgh, EH1 1TE

This paperback edition first published in 2007 by Canongate Books

Portions of this work were previously published in *The Kenyon Review,*
Corona and *Working Papers.*

7

Copyright © 1979, 1980, 1983, W. Lewis Hyde

British Library Cataloguing-in-Publication Data
A catalogue record for this is available on
request from the British Library

ISBN 978 1 84195 993 1

Typeset by Palimpsest Book Production Limited, Grangemouth, Stirlingshire
Printed and bound by Clays Ltd, St Ives plc

www.meetatthegate.com

FOR MY PARENTS

'What is good is given back.'

CONTENTS

FOREWORD

Book salesmen find it handy to have a ten-second description of each title when they go into a bookstore to pitch the product. Any current list of bestsellers will provide a sample of the genre: 'Extraordinary conclusions about the lineage of Christ.' 'Newspaper columnist learns life lessons from his neurotic dog.' 'How the dead communicate with us.' 'Reporter exposes a ring of vampires out to take over Seattle.' 'Memoir by the bad-boy golf champion.'

The Gift has always been hard to summarize in such pithy prose. In a way, that is its point: I began writing the book because it seemed to me that my own experience with 'the commerce of the creative spirit' was nowhere very well articulated. Some explaining was in order and while perhaps it could have been done in less than 300 pages it surely couldn't be done in a sentence or even a chapter. This meant, however, that when it first came out the book was in fact an embodiment of the problem it addresses. Books that are hard to explain may, one hopes, be more useful in the long run, but they are also the harder to commodify for a ten-second sell.

The original editor for *The Gift* was Jonathan Galassi and I remember when we first sat and talked about the project he asked me the question

all editors must ask, Who is your audience? I didn't know how to respond. I felt like saying 'All thinking humans' but, made shy by my own grandiosity, I settled for 'poets.' That's not what most editors want to hear (many prefer 'dog owners seeking news of the dead'). But it was poetry that had brought me to writing in the first place and it was in the poetry world that I could see most clearly the disconnect between art and the common forms of earning a living.

I was very lucky to have happened upon an editor willing to see if the audience might start with poets and move outward, and I've been luckier still that in fact it has. That may have had as much to do with our historical situation as with the book itself. The commercial ethic that *The Gift* engages has not diminished in recent decades; quite the opposite. As the afterword to this edition explains more fully, I believe that since the 1989 fall of the Soviet Union, the West has undergone a period of remarkable market triumphalism. We've witnessed the steady conversion into private property of the art and ideas that earlier generations thought belonged to their cultural commons, and we've seen the commodification of things that a few years ago would have seemed beyond the reach of any market. The loyalty of school children, indigenous knowledge, drinking water, the human genome – it's all for sale.

Whatever the link to recent history, the happy fact is that *The Gift* has managed to find an audience beyond the community of poets. Not too long after it came out, for example, I was asked to give a keynote address at the national convention of the Glass Arts Society; later I did the same for the Society of North American Goldsmiths. This was a nice surprise; it has turned out that artists in the craft community – not just those working with glass and gold but cabinet-makers, potters, weavers, and other artisans – have found the book useful, perhaps because artists who deal with actual physical objects feel most strongly the tensions *The Gift* describes. There has turned out to be a receptive ear in spiritual communities as well. I have spoken about the book's themes at an Anglican Church in New York, an Episcopal Cathedral in San Francisco, and a Zen Buddhist monastery in the California mountains. More broadly, I've had encouraging responses from historians, museum curators, landscape architects, Jungian analysts, agronomists, environmentalists, and more. Last year saw the first translation into Italian. A Chinese version is in the works.

This Canongate edition now promises finally to give the book a presence

in the United Kingdom. For that I am very grateful, and I'm grateful especially to Margaret Atwood who first brought the book to the attention of Jamie Byng at Canongate.

And if the salesmen want to pitch it as 'Bad-boy critic deploys magic charm against vampire economy,' that's all right with me.

Lewis Hyde
Cambridge, Massachusetts
June 2006

INTRODUCTION

The artist appeals to that part
of our being . . . which is a gift and not
an acquisition — and, therefore, more permanently enduring.
JOSEPH CONRAD

At the corner drugstore my neighbors and I can now buy a line of romantic novels written according to a formula developed through market research. An advertising agency polled a group of women readers. What age should the heroine be? (She should be between nineteen and twenty-seven.) Should the man she meets be married or single? (Recently widowed is best.) The hero and heroine are not allowed in bed together until they are married. Each novel is a hundred and ninety-two pages long. Even the name of the series and the design of the cover have been tailored to the demands of the market. (The name Silhouette was preferred over Belladonna, Surrender, Tiffany, and Magnolia; gold curlicues were chosen to frame the cover.) Six new titles appear each month and two hundred thousand copies of each title are printed.

Why do we suspect that Silhouette Romances will not be enduring works of art? What is it about a work of art, even when it is bought and sold in the market, that makes us distinguish it from such pure commodities as these?

It is the assumption of this book that a work of art is a gift, not a commodity. Or, to state the modern case with more precision, that works of art exist simultaneously in two 'economies,' a market economy and a gift economy. Only one of these is essential, however: a work of art can survive without the market, but where there is no gift there is no art.

There are several distinct senses of 'gift' that lie behind these ideas, but common to each of them is the notion that a gift is a thing we do not get by our own efforts. We cannot buy it; we cannot acquire it through an act of will. It is bestowed upon us. Thus we rightly speak of 'talent' as a 'gift,' for although a talent can be perfected through an effort of the will, no effort in the world can cause its initial appearance. Mozart, composing on the harpsichord at the age of four, had a gift.

We also rightly speak of intuition or inspiration as a gift. As the artist works, some portion of his creation is bestowed upon him. An idea pops into his head, a tune begins to play, a phrase comes to mind, a color falls in place on the canvas. Usually, in fact, the artist does not find himself engaged or exhilarated by the work, nor does it seem authentic, until this gratuitous element has appeared, so that along with any true creation comes the uncanny sense that 'I,' the artist, did not make the work. 'Not I, not I, but the wind that blows through me,' says D. H. Lawrence. Not all artists emphasize the 'gift' phase of their creations to the degree that Lawrence does, but all artists feel it.

These two senses of gift refer only to the creation of the work – what we might call the inner life of art; but it is my assumption that we should extend this way of speaking to its outer life as well, to the work after it has left its maker's hands. That art that matters to us – which moves the heart, or revives the soul, or delights the senses, or offers courage for living, however we choose to describe the experience – that work is received by us as a gift is received. Even if we have paid a fee at the door of the museum or concert hall, when we are touched by a work of art something comes to us which has nothing to do with the price. I went to see a landscape painter's works, and that evening, walking among pine trees near my home, I could see the shapes and colors I had not seen the day before. The spirit of an artist's gifts can wake our own. The work appeals, as Joseph Conrad says, to a part of our being which is itself a gift and not an acquisition. Our sense of harmony can hear the harmonies that Mozart heard. We may not have the power to profess our

gifts as the artist does, and yet we come to recognize, and in a sense to receive, the endowments of our being through the agency of his creation. We feel fortunate, even redeemed. The daily commerce of our lives – 'sugar for sugar and salt for salt,' as the blues singers say – proceeds at its own constant level, but a gift revives the soul. When we are moved by art we are grateful that the artist lived, grateful that he labored in the service of his gifts.

If a work of art is the emanation of its maker's gift and if it is received by its audience as a gift, then is it, too, a gift? I have framed the question to imply an affirmative answer, but I doubt we can be so categorical. Any object, any item of commerce, becomes one kind of property or another depending on how we use it. Even if a work of art contains the spirit of the artist's gift, it does not follow that the work itself is a gift. It is what we make of it.

And yet, that said, it must be added that the way we treat a thing can sometimes change its nature. For example, religions often prohibit the sale of sacred objects, the implication being that their sanctity is lost if they are bought and sold. A work of art seems to be a hardier breed; it can be sold in the market and still emerge a work of art. But if it is true that in the essential commerce of art a gift is carried by the work from the artist to his audience, if I am right to say that where there is no gift there is no art, then it may be possible to destroy a work of art by converting it into a pure commodity. Such, at any rate, is my position. I do not maintain that art cannot be bought and sold; I do maintain that the gift portion of the work places a constraint upon our merchandising.

The particular form that my elaboration of these ideas has taken may best be introduced through a description of how I came to my topic in the first place. For some years now I myself have tried to make my way as a poet, a translator, and a sort of 'scholar without institution.' Inevitably the money question comes up; labors such as mine are notoriously nonremunerative, and the landlord is not interested in your book of translations the day the rent falls due. A necessary corollary seems to follow the proposition that a work of art is a gift: there is nothing in the labor of art itself that will automatically make it pay. Quite the opposite, in fact. I develop this point at some length in the chapters that follow, so I shall not elaborate upon it here except to say that every modern artist who has chosen

to labor with a gift must sooner or later wonder how he or she is to survive in a society dominated by market exchange. And if the fruits of a gift are gifts themselves, how is the artist to nourish himself, spiritually as well as materially, in an age whose values are market values and whose commerce consists almost exclusively in the purchase and sale of commodities?

Every culture offers its citizens an image of what it is to be a man or woman of substance. There have been times and places in which a person came into his or her social being through the dispersal of his gifts, the 'big man' or 'big woman' being that one through whom the most gifts flowed. The mythology of a market society reverses the picture: getting rather than giving is the mark of a substantial person, and the hero is 'self-possessed,' 'self-made.' So long as these assumptions rule, a disquieting sense of triviality, of worthlessness even, will nag the man or woman who labors in the service of a gift and whose products are not adequately described as commodities. Where we reckon our substance by our acquisitions, the gifts of the gifted man are powerless to make him substantial.

Moreover, as I shall argue in my opening chapters, a gift that cannot be given away ceases to be a gift. The spirit of a gift is kept alive by its constant donation. If this is the case, then the gifts of the inner world must be accepted as gifts in the outer world if they are to retain their vitality. Where gifts have no public currency, therefore, where the gift as a form of property is neither recognized nor honored, our inner gifts will find themselves excluded from the very commerce which is their nourishment. Or, to say the same thing from a different angle, where commerce is exclusively a traffic in merchandise, the gifted cannot enter into the give-and-take that ensures the livelihood of their spirit.

These two lines of thought – the idea of art as a gift and the problem of the market – did not converge for me until I began to read through the work that has been done in anthropology on gifts as a kind of property and gift exchange as a kind of commerce. Many tribal groups circulate a large portion of their material wealth as gifts. Tribesmen are typically enjoined from buying and selling food, for example; even though there may be a strong sense of 'mine and thine,' food is always given as a gift and the transaction is governed by the ethics of gift exchange, not those of barter or cash purchase. Not surprisingly, people live differently who treat a portion of their wealth as a gift. To begin with, unlike the sale of a commodity, the giving of a gift tends to establish a relationship between

the parties involved.* Furthermore, when gifts circulate within a group, their commerce leaves a series of interconnected relationships in its wake, and a kind of decentralized cohesiveness emerges. There are, as we shall see, five or six related observations of this kind that can be made about a commerce of gifts, and in reading through the anthropological literature I began to realize that a description of gift exchange might offer me the language, the way of speaking, through which I could address the situation of creative artists. And since anthropology tends not to concern itself so much with inner gifts, I soon widened my reading to include all the folk tales I could find involving gifts. Folk wisdom does not differ markedly from tribal wisdom in its sense of what a gift is and does, but folk tales are told in a more interior language: the gifts in fairy tales may, at one level, refer to real property, but at another they are images in the psyche and their story describes for us a spiritual or psychological commerce. In fact, although I offer many accounts of gift exchange in the real world, my hope is that these accounts, too, can be read at several levels, that the real commerce they tell about stands witness to the invisible commerce through which the gifted come to profess their gifts, and we to receive them.

The classic work on gift exchange is Marcel Mauss's 'Essai sur le don,' published in France in 1924. The nephew of Émile Durkheim, a Sanskrit scholar, a gifted linguist, and a historian of religions, Mauss belongs to that group of early sociologists whose work is firmly rooted in philosophy and history. His essay begins with the field reports of turn-of-the-century ethnographers (Franz Boas, Bronislaw Malinowski, and Elsdon Best, in particular), but goes on to cover the Roman laws of real estate, a Hindu epic, Germanic dowry customs, and much more. The essay has proved to hold several enduring insights. Mauss noticed, for one thing, that gift economies tend to be marked by three related obligations: the obligation to give, the obligation to accept, and the obligation to reciprocate. He also pointed out that we should understand gift exchange to be a 'total social phenomenon' – one whose transactions are at once economic, juridical, moral, aesthetic, religious, and mythological, and whose meaning cannot, therefore, be adequately described from the point of view of any single discipline.

* It is this element of relationship which leads me to speak of gift exchange as an 'erotic' commerce, opposing *eros* (the principle of attraction, union, involvement which binds together) to *logos* (reason and logic in general, the principle of differentiation in particular). A market economy is an emanation of *logos*.

Almost every anthropologist who has addressed himself to questions of exchange in the last half century has taken Mauss's essay as his point of departure. Many names come to mind, including Raymond Firth and Claude Lévi-Strauss, but in my estimation the most interesting recent work has been done by Marshall Sahlins, an economic anthropologist at the University of Chicago. Sahlins's 1972 *Stone Age Economics*, in particular, contains an excellent chapter on 'The Spirit of the Gift,' which applies a rigorous *explication de texte* to part of the source material upon which Mauss based his essay, and goes on to place Mauss's ideas in the history of political philosophy. It was through Sahlins's writings that I first began to see the possibility of my own work, and I am much indebted to him.

The primary work on gift exchange has been done in anthropology not, it seems to me, because gifts are a primitive or aboriginal form of property – they aren't – but because gift exchange tends to be an economy of small groups, of extended families, small villages, close-knit communities, brotherhoods and, of course, of tribes. During the last decade a second discipline has turned to the study of gifts, and for a second reason. Medical sociologists have been drawn to questions of gift exchange because they have come to understand that the ethics of gift giving make it a form of commerce appropriate to the transfer of what we might call 'sacred properties,' in this case parts of the human body. The earliest work in this field was done by Richard Titmuss, a British professor of social administration, who, in 1971, published *The Gift Relationship*, a study of how we handle the human blood that is to be used for transfusions. Titmuss compares the British system, which classifies all blood as a gift, with the American, a mixed economy in which some blood is donated and some is bought and sold. Since Titmuss's work appeared, our increasing ability to transplant actual body organs, kidneys in particular, has led to several books on the ethics and complexities of 'the gift of life.'

Even such a brief précis of the work that has been done on gift exchange should make it clear that we still lack a comprehensive theory of gifts. Mauss's work remains our only general statement, and even that, as its title tells us, is an essay, a collection of initial observations with proposals for further study. Most of the work since Mauss has concerned itself with specific topics – in anthropology, law, ethics, medicine, public policy, and so forth. My own work is no exception. The first half of this book is a theory of gift exchange and the second is an attempt to apply the language of that theory to the life of the artist. Clearly, the concerns of the second half were

the guide to my reading and theorizing in the first. I touch on many issues, but I pass over many others in silence. With two or three brief exceptions I do not, for example, take up the negative side of gift exchange – gifts that leave an oppressive sense of obligation, gifts that manipulate or humiliate, gifts that establish and maintain hierarchies, and so forth and so on.* This is partly a matter of priority (it has seemed to me that a description of the value and power of gifts must precede an explication of their misuse), but it is mostly a matter of my subject. I have hoped to write an economy of the creative spirit: to speak of the inner gift that we accept as the object of our labor, and the outer gift that has become a vehicle of culture. I am not concerned with gifts given in spite or fear, nor those gifts we accept out of servility or obligation; my concern is the gift we long for, the gift that, when it comes, speaks commandingly to the soul and irresistibly moves us.

* There are two authors whose work I would recommend as tonic to the optimistic cast that this omission sometimes lends my work: Millard Schumaker, who has written an excellent series of essays on the problem of gifts and obligation, and Garrett Hardin, whose 1968 essay in *Science*, 'The Tragedy of the Commons,' has been followed in recent years by a thoughtful discussion of the limits of altruism. The works of both of these men are listed in the bibliography.

O wonderful! O wonderful! O wonderful!
I am food! I am food! I am food!
I eat food! I eat food! I eat food!
My name never dies, never dies, never dies!
I was born first in the first of the worlds,
* earlier than the gods, in the belly of what has no death!*
Whoever gives me away has helped me the most!
I, who am food, eat the eater of food!
I have overcome this world!

He who knows this shines like the sun.
Such are the laws of the mystery!

TAITTIRĪYA UPANISHAD

You received gifts from me; they were accepted.
But you don't understand how to think about the dead.
The smell of winter apples, of hoarfrost, and of linen.
There are nothing but gifts on this poor, poor Earth.

CZESLAW MILOSZ

PART I

A THEORY OF GIFTS

CHAPTER ONE

SOME FOOD WE COULD NOT EAT

1 • *The Motion*

When the Puritans first landed in Massachusetts, they discovered a thing so curious about the Indians' feelings for property that they felt called upon to give it a name. In 1764, when Thomas Hutchinson wrote his history of the colony, the term was already an old saying: 'An Indian gift,' he told his readers, 'is a proverbial expression signifying a present for which an equivalent return is expected.' We still use this, of course, and in an even broader sense, calling that friend an Indian giver who is so uncivilized as to ask us to return a gift he has given.

Imagine a scene. An Englishman comes into an Indian lodge, and his hosts, wishing to make their guest feel welcome, ask him to share a pipe of tobacco. Carved from a soft red stone, the pipe itself is a peace offering that has traditionally circulated among the local tribes, staying in each lodge for a time but always given away again sooner or later. And so the Indians, as is only polite among their people, give the pipe to their guest when he leaves. The Englishman is tickled pink. What a nice thing to send back to the British Museum! He takes it home and sets it on the mantelpiece. A time passes and the leaders of a neighboring tribe come

to visit the colonist's home. To his surprise he finds his guests have some expectation in regard to his pipe, and his translator finally explains to him that if he wishes to show his goodwill he should offer them a smoke and give them the pipe. In consternation the Englishman invents a phrase to describe these people with such a limited sense of private property. The opposite of 'Indian giver' would be something like 'white man keeper' (or maybe 'capitalist'), that is, a person whose instinct is to remove property from circulation, to put it in a warehouse or museum (or, more to the point for capitalism, to lay it aside to be used for production).

The Indian giver (or the original one, at any rate) understood a cardinal property of the gift: whatever we have been given is supposed to be given away again, not kept. Or, if it is kept, something of similar value should move on in its stead, the way a billiard ball may stop when it sends another scurrying across the felt, its momentum transferred. You may keep your Christmas present, but it ceases to be a gift in the true sense unless you have given something else away. As it is passed along, the gift may be given back to the original donor, but this is not essential. In fact, it is better if the gift is not returned but is given instead to some new, third party. The only essential is this: *the gift must always move.* There are other forms of property that stand still, that mark a boundary or resist momentum, but the gift keeps going.

Tribal peoples usually distinguish between gifts and capital. Commonly they have a law that repeats the sensibility implicit in the idea of an Indian gift. 'One man's gift,' they say, 'must not be another man's capital.' Wendy James, a British social anthropologist, tells us that among the Uduk in northeast Africa, 'any wealth transferred from one subclan to another, whether animals, grain or money, is in the nature of a gift, and should be consumed, and not invested for growth. If such transferred wealth is added to the subclan's capital [cattle in this case] and kept for growth and investment, the subclan is regarded as being in an immoral relation of debt to the donors of the original gift.' If a pair of goats received as a gift from another subclan is kept to breed or to buy cattle, 'there will be general complaint that the so-and-so's are getting rich at someone else's expense, behaving immorally by hoarding and investing gifts, and therefore being in a state of severe debt. It will be expected that they will soon suffer storm damage . . .'

The goats in this example move from one clan to another just as the

stone pipe moved from person to person in my imaginary scene. And what happens then? If the object is a gift, it keeps moving, which in this case means that the man who received the goats throws a big party and everyone gets fed. The goats needn't be given back, but they surely can't be set aside to produce milk or more goats. And a new note has been added: the feeling that if a gift is not treated as such, if one form of property is converted into another, something horrible will happen. In folk tales the person who tries to hold on to a gift usually dies; in this anecdote the risk is 'storm damage.' (What happens in fact to most tribal groups is worse than storm damage. Where someone manages to commercialize a tribe's gift relationships the social fabric of the group is invariably destroyed.)

If we turn now to a folk tale, we will be able to see all of this from a different angle. Folk tales are like collective dreams; they are told in the kind of voice we hear at the edge of sleep, mingling the facts of our lives with their images in the psyche. The first tale I have chosen was collected from a Scottish woman in the middle of the nineteenth century.

The Girl and the Dead Man

Once upon a time there was an old woman and she had a leash of daughters. One day the eldest daughter said to her mother, 'It is time for me to go out into the world and seek my fortune.' 'I shall bake a loaf of bread for you to carry with you,' said the mother. When the bread came from the oven the mother asked her daughter, 'Would you rather have a small piece and my blessing or a large piece and my curse?' 'I would rather have the large piece and your curse,' replied the daughter.

Off she went down the road and when the night came wreathing around her she sat at the foot of a wall to eat her bread. A ground quail and her twelve puppies gathered near, and the little birds of the air. 'Wilt thou give us a part of thy bread,' they asked. 'I won't, you ugly brutes,' she replied. 'I haven't enough for myself.' 'My curse on thee,' said the quail, 'and the curse of my twelve birds, and thy mother's curse which is the worst of all.' The girl arose and went on her way, and the piece of bread had not been half enough.

She had not travelled far before she saw a little house, and though it seemed a long way off she soon found herself before its door. She knocked and heard a voice cry out, 'Who is there?' 'A good maid seeking a master.' 'We need that,' said the voice, and the door swung open.

The girl's task was to stay awake every night and watch over a dead man, the brother of the housewife, whose corpse was restless. As her reward she was to receive a peck of gold and a peck of silver. And while she stayed she was to have as many nuts as she broke, as many needles as she lost, as many thimbles as she pierced, as much thread as she used, as many candles as she burned, a bed of green silk over her and a bed of green silk under her, sleeping by day and watching by night.

On the very first night, however, she fell asleep in her chair. The housewife came in, struck her with a magic club, killed her dead, and threw her out back on the pile of kitchen garbage.

Soon thereafter the middle daughter said to her mother, 'It is time for me to follow my sister and seek my fortune.' Her mother baked her a loaf of bread and she too chose the larger piece and her mother's curse. And what had happened to her sister happened to her.

Soon thereafter the youngest daughter said to her mother, 'It is time for me to follow my sisters and seek my fortune.' 'I had better bake you a loaf of bread,' said her mother, 'and which would you rather have, a small piece and my blessing or a large piece and my curse?' 'I would rather,' said the daughter, 'have the smaller piece and your blessing.'

And so she set off down the road and when the night came wreathing around her she sat at the foot of a wall to eat her bread. The ground quail and her twelve puppies and the little birds of the air gathered about. 'Wilt thou give us some of that?' they asked. 'I will, you pretty creatures, if you will keep me company.' She shared her bread, all of them ate their fill, and the birds clapped their wings about her 'til she was snug with the warmth.

The next morning she saw a house a long way off . . . [here the task and the wages are repeated].

She sat up at night to watch the corpse, sewing to pass the time. About midnight the dead man sat up and screwed up a grin. 'If you

do not lie down properly I will give you one good leathering with a stick,' she cried. He lay down. After a while he rose up on one elbow and screwed up a grin; and a third time he sat and screwed up a grin.

When he rose the third time she walloped him with the stick. The stick stuck to the dead man and her hand stuck to the stick and off they went! He dragged her through the woods, and when it was high for him it was low for her, and when it was low for him it was high for her. The nuts were knocking at their eyes and the wild plums beat at their ears until they both got through the wood. Then they returned home.

The girl was given the peck of gold, the peck of silver, and a vessel of cordial. She found her two sisters and rubbed them with the cordial and brought them back to life. And they left me sitting here, and if they were well, 'tis well; if they were not, let them be.

There are at least four gifts in this story. The first, of course, is the bread, which the mother gives to her daughters as a going-away present. This becomes the second gift when the youngest daughter shares her bread with the birds. She keeps the gift in motion – the moral point of the tale. Several benefits, in addition to her survival, come to her as a result of treating the gift correctly. These are the fruits of the gift. First, she and the birds are relieved of their hunger; second, the birds befriend her; and third, she's able to stay awake all night and accomplish her task. (As we shall see, these results are not accidental, they are typical fruits of the gift.)

In the morning the third gift, the vessel of cordial, appears. 'Cordial' used to mean a liqueur taken to stimulate the heart. In the original Gaelic of this tale the phrase is *ballen íocshlaint*, which translates more literally as 'teat of ichor' or 'teat of health' ('ichor' being the fluid that flows instead of blood in the veins of the gods). So what the girl is given is a vial of healing liquid, not unlike the 'water of life,' which appears in folk tales from all over the world. It has power: with it she is able to revive her sisters.

This liquid is thrown in as a reward for the successful completion of her task. It's a gift, mentioned nowhere in the wonderful litany of wages offered to each daughter. We will leave for later the question of where it comes from; for now, we are looking at what happens to the gift after it is given, and again we find that this girl is no dummy – she moves it right along,

giving it to her sisters to bring them back to life. That is the fourth and final gift in the tale.*

This story also gives us a chance to see what happens if the gift is not allowed to move on. A gift that cannot move loses its gift properties. Traditional belief in Wales holds that when the fairies give bread to the poor, the loaves must be eaten on the day they are given or they will turn to toadstools. If we think of the gift as a constantly flowing river, we may say that the girl in the tale who treats it correctly does so by allowing herself to become a channel for its current. When someone tries to dam up the river, one of two things will happen: either it will stagnate or it will fill the person up until he bursts. In this folk tale it is not just the mother's curse that gets the first two girls. The night birds give them a second chance, and one imagines the mother bird would not have repeated the curse had she met with generosity. But instead the girls try to dam the flow, thinking that what counts is ownership and size. The effect is clear: by keeping the gift they get no more. They are no longer channels for the stream and they no longer enjoy its fruits, one of which seems to be their own lives. Their mother's bread has turned to toadstools inside them.

Another way to describe the motion of the gift is to say that a gift must always be used up, consumed, eaten. *The gift is property that perishes.* It is no accident that the gifts in two of our stories so far have been food. Food

* This story illustrates almost all the main characteristics of a gift, so I shall be referring back to it. As an aside, therefore, I want to take a stab at its meaning. It says, I think, that if a girl without a father is going to get along in the world, she'd better have a good connection to her mother. The birds are the mother's spirit, what we'd now call the girls' psychological mother. The girl who gives the gift back to the spirit-mother has, as a result, her mother-wits about her for the rest of the tale.

Nothing in the tale links the dead man with the girls' father, but the mother seems to be a widow, or at any rate the absence of a father at the start of the story is a hint that the problem may have to do with men. It's not clear, but when the first man she meets is not only dead but difficult, we are permitted to raise our eyebrows.

The man is dead, but not dead enough. When she hits him with the stick, we see that she is in fact attached to him. So here's the issue: when a fatherless woman leaves home, she'll have to deal with the fact that she's stuck on a dead man. It's a risky situation – the two elder daughters end up dead.

Not much happens in the wild run through the forest, except that both parties get bruised. The girl manages to stay awake the whole time, however. This is a power she probably got from the birds, for they are night birds. The connection to the mother cannot spare her the ordeal, but it allows her to survive. When it's all over she's unstuck, and we may assume that the problem won't arise again.

Though the dilemma of the story is not related to gift, all the psychological work is accomplished through gift exchange.

is one of the most common images for the gift because it is so obviously consumed. Even when the gift is not food, when it is something we would think of as a durable good, it is often referred to as a thing to be eaten. Shell necklaces and armbands are the ritual gifts in the Trobriand Islands, and when they are passed from one group to the next, protocol demands that the man who gives them away toss them on the ground and say, 'Here, some food we could not eat.' Or, again, a man in another tribe that Wendy James has studied says, in speaking of the money he was given at the marriage of his daughter, that he will pass it on rather than spend it on himself. Only, he puts it this way: 'If I receive money for the children God has given me, I cannot eat it. I must give it to others.'

Many of the most famous of the gift systems we know about center on food and treat durable goods as if they were food. The potlatch of the American Indians along the North Pacific coast was originally a 'big feed.' At its simplest a potlatch was a feast lasting several days given by a member of a tribe who wanted his rank in the group to be publicly recognized. Marcel Mauss translates the verb 'potlatch' as 'to nourish' or 'to consume.' Used as a noun, a 'potlatch' is a 'feeder' or 'place to be satiated.' Potlatches included durable goods, but the point of the festival was to have these perish as if they were food. Houses were burned; ceremonial objects were broken and thrown into the sea. One of the potlatch tribes, the Haida, called their feasting 'killing wealth.'

To say that the gift is used up, consumed and eaten sometimes means that it is truly destroyed as in these last examples, but more simply and accurately it means that the gift perishes *for the person who gives it away*. In gift exchange the transaction itself consumes the object. Now, it is true that something often comes back when a gift is given, but if this were made an explicit condition of the exchange, it wouldn't be a gift. If the girl in our story had offered to sell the bread to the birds, the whole tone would have been different. But instead she sacrifices it: her mother's gift is dead and gone when it leaves her hand. She no longer controls it, nor has she any contract about repayment. For her, the gift has perished. This, then, is how I use 'consume' to speak of a gift – a gift is consumed when it moves from one hand to another with no assurance of anything in return. There is little difference, therefore, between its consumption and its movement. A market exchange has an equilibrium or stasis: you pay to balance the scale. But when you give a gift there is momentum, and the weight shifts from body to body.

I must add one more word on what it is to consume, because the Western industrial world is famous for its 'consumer goods' and they are not at all what I mean. Again, the difference is in the form of the exchange, a thing we can feel most concretely in the form of the goods themselves. I remember the time I went to my first rare-book fair and saw how the first editions of Thoreau and Whitman and Crane had been carefully packaged in heat-shrunk plastic with the price tags on the inside. Somehow the simple addition of air-tight plastic bags had transformed the books from vehicles of liveliness into commodities, like bread made with chemicals to keep it from perishing. In commodity exchange it's as if the buyer and the seller were both in plastic bags; there's none of the contact of a gift exchange. There is neither motion nor emotion because the whole point is to keep the balance, to make sure the exchange itself doesn't consume anything or involve one person with another. Consumer goods are consumed by their owners, not by their exchange.

The desire to consume is a kind of lust. We long to have the world flow through us like air or food. We are thirsty and hungry for something that can only be carried inside bodies. But consumer goods merely bait this lust, they do not satisfy it. The consumer of commodities is invited to a meal without passion, a consumption that leads to neither satiation nor fire. He is a stranger seduced into feeding on the drippings of someone else's capital without benefit of its inner nourishment, and he is hungry at the end of the meal, depressed and weary as we all feel when lust has dragged us from the house and led us to nothing.

Gift exchange has many fruits, as we shall see, and to the degree that the fruits of the gift can satisfy our needs there will always be pressure for property to be treated as a gift. This pressure, in a sense, is what keeps the gift in motion. When the Uduk warn that a storm will ruin the crops if someone tries to stop the gift from moving, it is really their desire for the gift that will bring the storm. A restless hunger springs up when the gift is not being eaten. The brothers Grimm found a folk tale they called 'The Ungrateful Son':

> Once a man and his wife were sitting outside the front door with a roast chicken before them which they were going to eat between them. Then the man saw his old father coming along and quickly took the chicken and hid it, for he begrudged him any of it. The old man came, had a drink, and went away.
>
> Now the son was about to put the roast chicken back on the table,

but when he reached for it, it had turned into a big toad that jumped in his face and stayed there and didn't go away again.

And if anybody tried to take it away, it would give them a poisonous look, as if about to jump in their faces, so that no one dared touch it. And the ungrateful son had to feed the toad every day, otherwise it would eat part of his face. And thus he went ceaselessly hither and yon about in the world.

This toad is the hunger that appears when the gift stops moving, whenever one man's gift becomes another man's capital. To the degree that we desire the fruits of the gift, teeth appear when it is hidden away. When property is hoarded, thieves and beggars begin to be born to rich men's wives. A story like this says that there is a force seeking to keep the gift in motion. Some property must perish – its preservation is beyond us. We have no choice. Or rather, our choice is whether to keep the gift moving or to be eaten with it. We choose between the toad's dumb-lust and that other, more graceful perishing in which our hunger disappears as our gifts are consumed.

II • *The Circle*

The gift is to the giver, and comes back most to him – it cannot fail . . .
WALT WHITMAN

A bit of a mystery remains in the Scottish tale 'The Girl and the Dead Man': Where does the vessel of cordial come from? My guess is that it comes from the mother or, at least, from her spirit. The gift not only moves, it moves in a circle. The mother gives the bread and the girl gives it in turn to the birds whom I place in the realm of the mother, not only because it is a mother bird who addresses her, but also because of a verbal link (the mother has a 'leash of daughters,' the mother bird has her 'puppies'). The vessel of cordial is in the realm of the mother as well, for, remember, the phrase in Gaelic means 'teat of ichor' or 'teat of health.' The level changes, to be sure – it is a different sort of mother whose breasts hold the blood of the gods – but it is still in the maternal sphere. Structurally, then, the gift moves from mother to daughter to mother to daughter. In circling twice in this way the gift itself increases from bread to the water of life, from carnal food to spiritual food. At which point

the circle expands as the girl gives the gift to her sisters to bring them back to life.

The figure of the circle in which the gift moves can be seen more clearly in an example from ethnography. Gift institutions are universal among tribal peoples; the few we know the most about are those which Western ethnographers studied around the turn of the century. One of these is the Kula, the ceremonial exchange of the Massim peoples who occupy the South Sea islands near the eastern tip of New Guinea. Bronislaw Malinowski spent several years living on these islands during the First World War, staying primarily in the Trobriands, the northwesternmost group. In his subsequent book, *Argonauts of the Western Pacific*, Malinowski describes how, after he had returned to England, a visit to Edinburgh Castle to see the Scottish crown jewels reminded him of the Kula:

> The keeper told many stories of how [the jewels] were worn by this or that king or queen on such and such an occasion, of how some of them had been taken over to London, to the great and just indignation of the whole Scottish nation, how they were restored, and how now everyone can be pleased, since they are safe under lock and key, and no one can touch them. As I was looking at them and thinking how ugly, useless, ungainly, even tawdry they were, I had the feeling that something similar had been told to me of late, and that I had seen many other objects of this sort, which made a similar impression on me.
>
> And then there arose before me the vision of a native village on coral soil, and a small, rickety platform temporarily erected under a pandanus thatch, surrounded by a number of brown, naked men, and one of them showing me long, thin red strings, and big, white, worn-out objects, clumsy to sight and greasy to touch. With reverence he also would name them, and tell their history, and by whom and when they were worn, and how they changed hands, and how their temporary possession was a great sign of the importance and glory of the village.

Two ceremonial gifts lie at the heart of the Kula exchange: armshells and necklaces. 'Armshells are obtained by breaking off the top and the narrow end of a big, cone-shaped shell, and then polishing up the remaining ring,' writes Malinowski. Necklaces are made with small flat disks of a red

shell strung into long chains. Both armshells and necklaces circulate throughout the islands, passing from household to household. The presence of one of these gifts in a man's house enables him 'to draw a great deal of renown, to exhibit the article, to tell how he obtained it, and to plan to whom he is going to give it. And all this forms one of the favorite subjects of tribal conversation and gossip . . .'

Malinowski calls the Kula articles 'ceremonial gifts' because their social use far exceeds their practical use. A friend of mine tells me that his group of friends in college continually passed around a deflated basketball. The joke was to get it mysteriously deposited in someone else's room. The clear uselessness of such objects seems to make it easier for them to become vehicles for the spirit of a group. Another man tells me that when he was young his parents and their best friends passed back and forth, again as a joke, a huge open-ended wrench that had apparently been custom-cast to repair a steam shovel. The two families had found it one day on a picnic, and for years thereafter it showed up first in one house, then in the other, under the Christmas tree or in the umbrella stand. If you have not yourself been a part of such an exchange, you will easily turn up a story like these by asking around, for such spontaneous exchanges of 'useless' gifts are fairly common, though hardly ever developed to the depth and elegance that Malinowski found among the Massim.

The Kula gifts, the armshells and necklaces, move continually around a wide ring of islands in the Massim archipelago. Each travels in a circle; the red shell necklaces (considered to be 'male' and worn by women) move clockwise and the armshells ('female' and worn by men) move counterclockwise. A person who participates in the Kula has gift partners in neighboring tribes. If we imagine him facing the center of the circle with partners on his left and right, he will always be receiving armshells from his partner to the left and giving them to the man on his right. The necklaces flow the other way. Of course, these objects are not actually passed hand to hand; they are carried by canoe from island to island in journeys that require great preparation and cover hundreds of miles.

The two Kula gifts are exchanged for each other. If a man brings me a necklace, I will give him in return some armshells of equivalent value. I may do this right away, or I may wait as long as a year (though if I wait that long I will give him a few smaller gifts in the interim to show my good faith). As a rule it takes between two and ten years for each article in the Kula to make a full round of the islands.

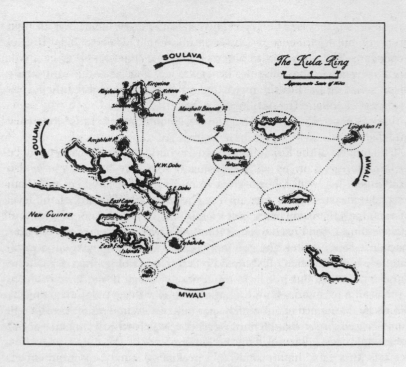

THE KULA RING

*'Soulava' are necklaces and
'Mwali' are armshells.*

Because these gifts are exchanged for each other, the Kula seems to
break the rule against equilibrium that I set out in the first section. But
let us look more closely. We should first note that the Kula articles are
kept in motion. Each gift stays with a man for a while, but if he keeps it
too long he will begin to have a reputation for being 'slow' and 'hard' in
the Kula. The gifts 'never stop,' writes Malinowski. 'It seems almost in-
credible at first . . . , but it is the fact, nevertheless, that no one ever keeps
any of the Kula valuables for any length of time . . . "Ownership," there-
fore, in Kula, is quite a special economic relation. A man who is in the
Kula never keeps any article for longer than, say, a year or two.' When
Malinowski expands on this point, he finds he must abandon his analogy

to the crown jewels. The Trobriand Islanders know what it is to own property, but their sense of possession is wholly different from that of Europeans. The 'social code . . . lays down that to possess is to be great, and that wealth is the indispensable appanage of social rank and attribute of personal virtue. But the important point is that with them *to possess is to give* – and here the natives differ from us notably. A man who owns a thing is naturally expected to share it, to distribute it, to be its trustee and dispenser.'

The motion of the Kula gifts does not in itself ensure that there will be no equilibrium, for, as we have seen, they move but they are also exchanged. Two ethics, however, govern this exchange and both of them ensure that, while there may be a macroscopic equilibrium, at the level of each man there will be the sense of imbalance, of shifting weight, that always marks a gift exchange. The first of these ethics prohibits discussion: 'the Kula,' writes Malinowski, 'consists in the bestowing of a ceremonial gift, which has to be repaid by an equivalent counter-gift after a lapse of time . . . But [and this is the point] it can never be exchanged from hand to hand, with the equivalence between the two objects discussed, bargained about and computed.' A man may wonder what will come in return for his gift, but he is not supposed to bring it up. Gift exchange is not a form of barter. 'The decorum of the Kula transaction is strictly kept, and highly valued. The natives distinguish it from barter, which they practice extensively [and] of which they have a clear idea . . . Often, when criticising an incorrect, too hasty, or indecorous procedure of Kula, they will say: "He conducts his Kula as if it were [barter]."' Partners in barter talk and talk until they strike a balance, but the gift is given in silence.

A second important ethic, Malinowski tells us, 'is that the equivalence of the counter-gift is left to the giver, and it cannot be enforced by any kind of coercion.' If a man gives a second-rate necklace in return for a fine set of armshells, people may talk, but there is nothing anyone can do about it. When we barter we make deals, and if someone defaults we go after him, but the gift must be a gift. It is as if you give a part of your substance to your gift partner and then wait in silence until he gives you a part of his. You put your self in his hands. These rules – and they are typical of gift institutions – preserve the sense of motion despite the exchange involved. There is trade, but the objects traded are not commodities.

We commonly think of gifts as being exchanged between two people and of gratitude as being directed back to the actual donor. 'Reciprocity,' the standard social science term for returning a gift, has this sense of going to and fro between people (the roots are *re* and *pro*, back and forth, like a reciprocating engine). The gift in the Scottish tale is given reciprocally, going back and forth between the mother and her daughter (until the very end).

Reciprocal giving is a form of gift exchange, but it is the simplest. The gift moves in a circle, and two people do not make much of a circle. Two points establish a line, but a circle lies in a plane and needs at least three points. This is why, as we shall see, most of the stories of gift exchange have a minimum of three people. I have introduced the Kula circuit here because it is such a fine example. For the Kula gifts to move, each man must have at least two gift partners. In this case the circle is larger than that, of course, but three is its lower limit.

Circular giving differs from reciprocal giving in several ways. First, when the gift moves in a circle no one ever receives it from the same person he gives it to. I continually give armshells to my partner to the west, but unlike a two-person give-and-take, he never gives me armshells in return. The whole mood is different. The circle is the structural equivalent of the prohibition on discussion. When I give to someone from whom I do not receive (and yet I do receive elsewhere), it is as if the gift goes around a corner before it comes back. I have to give blindly. And I will feel a sort of blind gratitude as well. The smaller the circle is – and particularly if it involves just two people – the more a man can keep his eye on things and the more likely it is that he will start to think like a salesman. But so long as the gift passes out of sight it cannot be manipulated by one man or one pair of gift partners. When the gift moves in a circle its motion is beyond the control of the personal ego, and so each bearer must be a part of the group and each donation is an act of social faith.

What size is the circle? In addressing this question, I have come to think of the circle, the container in which the gift moves, as its 'body' or 'ego.' Psychologists sometimes speak of the ego as a complex like any other: the Mother, the Father, the Me – all of these are important places in the field of the psyche where images and energy cluster as we grow, like stars in a constellation. The ego complex takes on shape and size as the Me – that part of the psyche which takes everything personally – retains our private

history, that is, how others have treated us, how we look and feel, and so on.

I find it useful to think of the ego complex as a thing that keeps expanding, not as something to be overcome or done away with. An ego has formed and hardened by the time most of us reach adolescence, but it is small, an ego-of-one. Then, if we fall in love, for example, the constellation of identity expands and the ego-of-one becomes an ego-of-two. The young lover, often to his own amazement, finds himself saying 'we' instead of 'me.' Each of us identifies with a wider and wider community as we mature, coming eventually to think and act with a group-ego (or, in most of these gift stories, a tribal ego), which speaks with the 'we' of kings and wise old people. Of course the larger it becomes, the less it feels like what we usually mean by ego. Not entirely, though: whether an adolescent is thinking of himself or a nation of itself, it still feels like egotism to anyone who is not included. There is still a boundary.

If the ego widens still further, however, it really does change its nature and become something we would no longer call ego. There is a consciousness in which we act as part of things larger even than the race. When I picture this, I always think of the end of 'Song of Myself' where Whitman dissolves into the air:

> I effuse my flesh in eddies, and drift it in lacy jags.

> I bequeath myself to the dirt to grow from the grass I love,
> If you want me again look for me under your boot-soles.

Now the part that says 'me' is scattered. There is no boundary to be outside of, unless the universe itself is bounded.

In all of this we could substitute 'body' for 'ego.' Aborigines commonly refer to their own clan as 'my body,' just as our marriage ceremony speaks of becoming 'one flesh.' Again, the body can be enlarged beyond the private skin, and in its final expansion there is no body at all. When we are in the spirit of the gift we love to feel the body open outward. The ego's firmness has its virtues, but at some point we seek the slow dilation, to use another term of Whitman's, in which the ego enjoys a widening give-and-take with the world and is finally abandoned in ripeness.

The gift can circulate at every level of the ego. In the ego-of-one we speak of self-gratification, and whether it's forced or chosen, a virtue or

a vice, the mark of self-gratification is its isolation. Reciprocal giving, the ego-of-two, is a little more social. We think mostly of lovers. Each of these circles is exhilarating as it expands, and the little gifts that pass between lovers touch us because each is stepping into a larger circuit. But again, if the exchange goes on and on to the exclusion of others, it soon goes stale. D. H. Lawrence spoke of the *égoisme à deux* of so many married couples, people who get just so far in the expansion of the self and then close down for a lifetime, opening up for neither children, nor the group, nor the gods. A folk tale from Kashmir tells of two Brahmin women who tried to dispense with their almsgiving duties by simply giving alms back and forth to each other. They didn't quite have the spirit of the thing. When they died, they returned to earth as two wells so poisoned that no one could take water from them. No one else can drink from the ego-of-two. It has its moment in our maturation, but it is an infant form of the gift circle.

In the Kula we have already seen a fine example of the larger circle. The Maori, the native tribes of New Zealand, provide another, which is similar in some ways to the Kula but offers new detail and a hint of how gift exchange will feel if the circle expands beyond the body of the tribe. The Maori have a word, *hau*, which translates as 'spirit,' particularly the spirit of the gift and the spirit of the forest which gives food. In these tribes, when hunters return from the forest with birds they have killed, they give a portion of the kill to the priests, who, in turn, cook the birds at a sacred fire. The priests eat a few of them and then prepare a sort of talisman, the *mauri*, which is the physical embodiment of the forest *hau*. This *mauri* is a gift the priests give back to the forest, where, as a Maori sage once explained to an Englishman, it 'causes the birds to be abundant . . . , that they may be slain and taken by man.'

There are three gifts in this hunting ritual; the forest gives to the hunters, the hunters to the priests, and the priests to the forest. At the end, the gift moves from the third party back to the first. The ceremony that the priests perform is called *whangai hau*, which means 'nourishing *hau*,' feeding the spirit. To give such a name to the priests' activity says that the addition of the third party keeps the spirit of the gift alive. Put conversely, without the priests there is a danger that the motion of the gift will be lost. It seems to be too much to ask of the hunters to both kill the game and return a gift to the forest. As we said in speaking of the Kula, gift exchange is more likely to turn into barter when it falls into the ego-of-two. With a simple

give-and-take, the hunters may begin to think of the forest as a place to turn a profit. But with the priests involved, the gift must leave the hunters' sight before it returns to the woods. The priests take on or incarnate the position of the third thing to avoid the binary relation of the hunters and forest which by itself would not be abundant. The priests, by their presence alone, feed the spirit.

Every gift calls for a return gift, and so, by placing the gift back in the forest, the priests treat the birds as a gift of nature. We now understand this to be ecological. Ecology as a science began at the end of the nineteenth century, an offshoot of the rising interest in evolution. Originally the study of how animals survive in their environments, one of ecology's first lessons was that, beneath all the change in nature, there are steady states characterized by cycles. Every participant in the cycle literally lives off the others with only the ultimate energy source, the sun, being transcendent. Widening the study of ecology to include man means to look at ourselves as a part of nature again, not its lord. When we see that we are actors in natural cycles, we understand that what nature gives to us is influenced by what we give to nature. So the circle is a sign of an ecological insight as much as of gift exchange. We come to feel ourselves as one part of a large self-regulating system. The return gift, the 'nourishing *hau*,' is literally feedback, as they say in cybernetics. Without it, that is to say, with the exercise of any greed or arrogance of will, the cycle is broken. We all know that it isn't 'really' the *mauri* placed in the forest that 'causes' the birds to be abundant, and yet now we see that on a different level it is: the circle of gifts enters the cycles of nature and, in so doing, manages not to interrupt them and not to put man on the outside. The forest's abundance is in fact a consequence of man's treating its wealth as a gift.

The Maori hunting ritual enlarges the circle within which the gift moves in two ways. First, it includes nature. Second and more important, it includes the gods. The priests act out a gift relationship with the deities, giving thanks and sacrificing gifts to them in return for what they give the tribe. A story from the Old Testament will show us the same thing in a tradition with which we are more familiar. The structure is identical.

In the Pentateuch the first fruits always belong to the Lord. In Exodus the Lord tells Moses: 'Consecrate to me all the first-born; whatever is the first to open the womb among the people of Israel, both of man and of beast, is mine.' The Lord gives the tribe its wealth, and the germ of that

wealth is then given back to the Lord. Fertility is a gift from God, and in order for it to continue, its first fruits are returned to him as a return gift. In pagan times this had apparently included sacrificing the firstborn son, but the Israelites had early been allowed to substitute an animal for the child, as in the story of Abraham and Isaac. Likewise a lamb was substituted for the firstborn of any unclean animal. The Lord says to Moses:

> All that opens the womb is mine, all your male cattle, the firstlings of cow and sheep. The firstling of an ass you shall redeem with a lamb, or if you will not redeem it you shall break its neck. All the firstborn of your sons you shall redeem.

Elsewhere the Lord explains to Aaron what is to be done with the first-born. Aaron and his sons are responsible for the priesthood, and they minister at the altar. The lambs, calves, and kids are to be sacrificed: 'You shall sprinkle their blood upon the altar, and shall burn their fat as an offering by fire, a pleasing odor to the Lord; but their flesh shall be yours . . .' As in the Maori story, the priests eat a portion of the gift. But its essence is burned and returned to the Lord in smoke.

This gift cycle has three stations and more – the flocks, the tribe, the priests and the Lord. The inclusion of the Lord in the circle – and this is the point I began to make above – changes the ego in which the gift moves in a way unlike any other addition. It is enlarged beyond the tribal ego and beyond nature. Now, as I said when I first introduced the image, we would no longer call it an ego at all. The gift leaves all boundary and circles into mystery.

The passage into mystery always refreshes. If, when we work, we can look once a day upon the face of mystery, then our labor satisfies. We are lightened when our gifts rise from pools we cannot fathom. Then we know they are not a solitary egotism and they are inexhaustible. Anything contained within a boundary must contain as well its own exhaustion. The most perfectly balanced gyroscope slowly winds down. But when the gift passes out of sight and then returns, we are enlivened. Material goods pull us down into their bones unless their fat is singed occasionally. It is when the world flames a bit in our peripheral vision that it brings us jubil-ation and not depression. We stand before a bonfire or even a burning house and feel the odd release it brings, as if the trees could give the sun

return for what enters them through the leaf. when no property can move, then even Moses' Pharaoh is plagued with hungry toads. A sword appears to seek the firstborn son of that man who cannot be moved to move the gift. But Pharaoh himself was dead long before his firstborn was taken, for we are only alive to the degree that we can let ourselves be moved. And when the gift circles into mystery the liveliness stays, for it is 'a pleasing odor to the Lord' when the first fruits are effused in eddies and drifted in lacy jags above the flame.

I described the motion of the gift earlier in this chapter by saying that gifts are always used, consumed, or eaten. Now that we have seen the figure of the circle we can understand what seems at first to be a paradox of gift exchange: when the gift is used, it is not used up. Quite the opposite, in fact: the gift that is not used will be lost, while the one that is passed along remains abundant. In the Scottish tale the girls who hoard their bread are fed only while they eat. The meal finishes in hunger though they took the larger piece. The girl who shares her bread is satisfied. What is given away feeds again and again, while what is kept feeds only once and leaves us hungry.

The tale is a parable, but in the Kula ring we saw the same constancy as a social fact. The necklaces and armshells are not diminished by their use, but satisfy faithfully. Only when a foreigner steps in to buy some for his collection are they 'used up' by a transaction. And the Maori hunting tale showed us that not just food in parables but food in nature remains abundant when it is treated as gift, when we participate in the moving circle and do not stand aside as hunter or exploiter. Gifts are a class of property whose value lies only in their use and which literally cease to exist as gifts if they are not constantly consumed. When gifts are sold, they change their nature as much as water changes when it freezes, and no rationalist telling of the constant elemental structure can replace the feeling that is lost.

In E. M. Forster's novel *A Passage to India*, Dr Aziz, the Moslem, and Fielding, the Englishman, have a brief dialogue, a typical debate between gift and commodity. Fielding says:

'Your emotions never seem in proportion to their objects, Aziz.'
'Is emotion a sack of potatoes, so much to the pound, to be measured out? Am I a machine? I shall be told I can use up my emotions by using them, next.'

'I should have thought you would. It sounds common sense. You can't eat your cake and have it, even in the world of the spirit.'

'If you are right, there is no point in any friendship . . . , and we had better all leap over this parapet and kill ourselves.'

In the world of gift, as in the Scottish tale, you not only can have your cake and eat it too, you can't have your cake *unless* you eat it. Gift exchange and erotic life are connected in this regard. The gift is an emanation of Eros, and therefore to speak of gifts that survive their use is to describe a natural fact: libido is not lost when it is given away. Eros never wastes his lovers. When we give ourselves in the spirit of that god, he does not leave off his attentions; it is only when we fall to calculation that he remains hidden and no body will satisfy. Satisfaction derives not merely from being filled but from being filled with a current that will not cease. With the gift, as in love, our satisfaction sets us at ease because we know that somehow its use at once assures its plenty.

Scarcity and abundance have as much to do with the form of exchange as with how much material wealth is at hand. Scarcity appears when wealth cannot flow. Elsewhere in *A Passage to India*, Dr Aziz says, 'If money goes, money comes. If money stays, death comes. Did you ever hear that useful Urdu proverb?' and Fielding replies, 'My proverbs are: A penny saved is a penny earned; A stitch in time saves nine; Look before you leap; and the British Empire rests on them.' He's right. An empire needs its clerks with their ledgers and their clocks saving pennies in time. The problem is that wealth ceases to move freely when all things are counted and priced. It may accumulate in great heaps, but fewer and fewer people can afford to enjoy it. After the war in Bangladesh, thousands of tons of donated rice rotted in warehouses because the market was the only known mode of distribution, and the poor, naturally, couldn't afford to buy. Marshall Sahlins begins a comment on modern scarcity with the paradoxical contention that hunters and gatherers 'have affluent economies, their absolute poverty notwithstanding.' He writes:

> Modern capitalist societies, however richly endowed, dedicate them-
> selves to the proposition of scarcity. [Both Paul Samuelson and Milton
> Friedman begin their economies with 'The Law of Scarcity'; it's all over
> by the end of Chapter One.] Inadequacy of economic means is the first
> principle of the world's wealthiest peoples. The apparent material status

of the economy seems to be no clue to its accomplishments; something has to be said for the mode of economic organization.

The market-industrial system institutes scarcity, in a manner completely unparalleled and to a degree nowhere else approximated. Where production and distribution are arranged through the behavior of prices, and all livelihoods depend on getting and spending, insufficiency of material means becomes the explicit, calculable starting point of all economic activity.

Given material abundance, scarcity must be a function of boundaries. If there is plenty of air in the world but something blocks its passage to the lungs, the lungs do well to complain of scarcity. The assumptions of market exchange may not necessarily lead to the emergence of boundaries, but they do in practice. When trade is 'clean' and leaves people unconnected, when the merchant is free to sell when and where he will, when the market moves mostly for profit and the dominant myth is not 'to possess is to give' but 'the fittest survive,' then wealth will lose its motion and gather in isolated pools. Under the assumptions of exchange trade, property is plagued by entropy and wealth can become scarce even as it increases.

A commodity is truly 'used up' when it is sold because nothing about the exchange assures its return. The visiting sea captain may pay handsomely for a Kula necklace, but because the sale removes it from the circle, it wastes it, no matter the price. Gifts that remain gifts can support an affluence of satisfaction, even without numerical abundance. The mythology of the rich in the overproducing nations that the poor are in on some secret about satisfaction – black 'soul,' gypsy *duende*, the noble savage, the simple farmer, the virile game keeper – obscures the harshness of modern capitalist poverty, but it does have a basis, for people who live in voluntary poverty or who are not capital-intensive do have more ready access to erotic forms of exchange that are neither exhausting nor exhaustible and whose use assures their plenty.

If the commodity moves to turn a profit, where does the gift move? The gift moves toward the empty place. As it turns in its circle it turns toward him who has been empty-handed the longest, and if someone appears elsewhere whose need is greater it leaves its old channel and moves toward him. Our generosity may leave us empty, but our emptiness then pulls gently at the whole until the thing in motion returns to replenish us. Social nature abhors a vacuum. Counsels Meister Eckhart, the mystic: 'Let us

borrow empty vessels.' The gift finds that man attractive who stands with an empty bowl he does not own.*

The begging bowl of the Buddha, Thomas Merton has said, 'represents the ultimate theological root of the belief, not just in a right to beg, but in openness to the gifts of all beings as an expression of the interdependence of all beings . . . The whole idea of compassion, which is central to Mahayana Buddhism, is based on an awareness of the interdependence of all living beings . . . Thus when the monk begs from the layman and receives a gift from the layman, it is not as a selfish person getting something from somebody else. He is simply opening himself to this interdependence . . .' The wandering mendicant takes it as his task to carry what is empty from door to door. There is no profit; he merely stays alive if the gift moves toward him. He makes its spirit visible to us. His well-being, then, is a sign of its well-being, as his starvation would be a sign of its withdrawal. Our English word 'beggar' comes from the Beghards, a brotherhood of mendicant friars that grew up in the thirteenth century in Flanders. There are still some places in the East where wandering mendicants live from the begging bowl; in Europe they died out at the close of the Middle Ages.

As the bearer of the empty place, the religious mendicant has an active duty beyond his supplication. He is the vehicle of that fluidity which is abundance. The wealth of the group touches his bowl at all sides, as if it were the center of a wheel where the spokes meet. The gift gathers there, and the mendicant gives it away again when he meets someone who is empty. In European folk tales the beggar often turns out to be Wotan, the true 'owner' of the land, who asks for charity though it is his own wealth he moves within, and who then responds to neediness by filling it with gifts. He is godfather to the poor.

Folk tales commonly open with a beggar motif. In a tale from Bengal, a king has two queens, both of whom are childless. A faquir, a wandering mendicant, comes to the palace gate to ask for alms. One of the queens walks down to give him a handful of rice. When he finds that she is childless, however, he says that he cannot accept the rice but has a gift for her instead, a potion that will remove her barrenness. If she drinks his nostrum with the juice of the pomegranate flower, he tells her, in due time she will

* Folk tales are the only proof I shall be able to offer for these assertions. The point is more spiritual than social: in the spiritual world, new life comes to those who give up.

bear a son whom she should then call the Pomegranate Boy. All this comes to pass and the tale proceeds.

Such stories declare that the gift does move from plenty to emptiness. It seeks the barren, the arid, the stuck, and the poor. The Lord says, 'All that opens the womb is mine,' for it is He who filled the empty womb, having earlier stood as a beggar by the sacrificial fire or at the gates of the palace.

THE BONES OF
THE DEAD

The gift in the folk tale from Bengal which closes the last chapter – the gift that the beggar gives to the queen – brings the queen her fertility and she bears a child. Fertility and growth are common fruits of gift exchange, at least in these stories. In all we have seen so far – the Gaelic tale, the Kula ring, the rites of the first fruit, feeding the forest *hau*, and so on – fertility is often a concern, and invariably either the bearers of the gift or the gift itself grows as a result of its circulation.

Living things that we classify as gifts really grow, of course, but even inert gifts, such as the Kula articles, are *felt* to increase – in worth or in live-liness – as they move from hand to hand. The distinction – alive/inert – is not always useful, in fact, because even when a gift is not alive it is treated as if it were, and whatever we treat as living begins to take on life. Moreover, gifts that have taken on life can bestow it in return. The final gift in the Gaelic tale revives the dead sisters. Even if such miracles are rare, it is still true that lifelessness leaves the soul when a gift comes toward us, for gift property serves an upward force, the goodwill or *virtù* of nature, the soul, and the collective. (This is one of the senses in which I mean to say that a work of art is a gift. The gifted artist contains the vitality of his gift within the work, and thereby makes it available to others. Furthermore, works we

come to treasure are those which transmit that vitality and revive the soul. Such works circulate among us as reservoirs of available life, what Whitman calls 'the tasteless water of souls.')

Later in this chapter I shall describe a purely cultural artifact which is felt to increase in worth as it circulates, but to begin an analysis of the increase of gifts I want to turn to a gift institution which, like the story of the beggar and the queen, has as its setting a situation in which natural fertility and growth are at issue.

The American Indian tribes that have become famous for the potlatch – the Kwakiutl, Tlingit, Haida, and others – once occupied the Pacific coast of North America from Cape Mendocino in California to Prince William Sound in Alaska. All of these tribes depended upon the ocean to provide their primary sustenance – herring, eulachon (candlefish), whales, and, above all, the salmon that annually enter the coastal rivers to swim inland and spawn. Like the Maori or the Jews of the Old Testament, the North Pacific tribes developed a relationship to the natural abundance of their environment based upon a cycle of gifts. It was the Indian belief that all animals lived as they themselves lived – in tribes – and that the salmon, in particular, dwelt in a huge lodge beneath the sea. According to this mythology, the salmon go about in human form while they are at home in their lodge, but once a year they change their bodies into fish bodies, dress themselves in robes of salmon skin, swim to the mouths of the rivers, and voluntarily sacrifice themselves that their land brothers may have food for the winter.

The first salmon to appear in the rivers was always given an elaborate welcome. A priest or his assistant would catch the fish, parade it to an altar, and lay it out before the group (its head pointing inland to encourage the rest of the salmon to continue swimming upstream). The first fish was treated as if it were a high-ranking chief making a visit from a neighboring tribe. The priest sprinkled its body with eagle down or red ochre and made a formal speech of welcome, mentioning, as far as politeness permitted, how much the tribe hoped the run would continue and be bountiful. The celebrants then sang the songs that welcome an honored guest. After the ceremony the priest gave everyone present a piece of the fish to eat. Finally – and this is what makes it clearly a gift cycle – the bones of the first salmon were returned to the sea. The belief was that salmon bones placed back into the water would reassemble once they had washed out to sea; the fish would then revive, return to its home, and revert to its

human form. The skeleton of the first salmon had to be returned to the water intact; later fish could be cut apart, but all their bones were still put back into the water. If they were not, the salmon would be offended and might not return the following year with their gift of winter food.

The main elements of this ceremony are the same as those of the other first-fruits rites we have seen – part of the gift is eaten and part is returned – and once again the myth declares that the objects of the ritual will remain plentiful *because* they are treated as gifts. It would be difficult, I suppose, to make the case that to abandon the gift ceremony, to treat the salmon as a commodity, would truly 'offend' the fish and diminish their abundance. The point is perhaps best put in its positive form: the first salmon ceremony establishes a gift relationship with nature, a formal give-and-take that acknowledges our participation in, and dependence upon, natural increase. And where we have established such a relationship we tend to respond to nature as a part of ourselves, not as a stranger or alien available for exploitation. Gift exchange brings with it, therefore, a built-in check upon the destruction of its objects; with it we will not destroy nature's renewable wealth except where we also consciously destroy ourselves. Where we wish to preserve natural increase, therefore, gift exchange is the commerce of choice, for it is a commerce that harmonizes with, or participates in, the process of that increase. And this is the first explanation I offer for the association our tales have made between gift exchange and increased worth, fertility, liveliness: where true, organic increase is at issue, gift exchange preserves that increase; the gift grows because living things grow.*

* In the fall of 1980 a group of Australian aborigines asked the United Nations Human Rights Commission in Geneva to help them protect their lands from commercial exploitation. According to a wire service report, 'one of the group's major concerns is the violation of the sacred home of the aboriginal lizard god, Great Goanna, by Amax, an American petroleum company that is under contract to the state government of Western Australia to drill there. The Yungnara tribe on the Noonkanbah pastoral station believes that if Goanna is disturbed he will order the six-foot monitor lizards, which are a source of food for the aborigines, to stop mating and thus eventually cause a food shortage.'

There may be no necessary link between scarcity and exploitation, but the connection is not unknown, either. In the North Pacific, salmon stocks actually did decline as soon as European settlers began to treat the fish as a commodity to be sold for a profit. By the end of the nineteenth century a salmon cannery sat at the mouth of every major river on the Alaskan coast; many overfished the runs and drove themselves out of business. On the East Coast the salmon essentially disappeared, although they were once so plentiful as to have been the dietary staple of the textile workers in the mill towns along the Merrimac River. (In the summer of 1974 a salmon was found in the Connecticut River; it was dead, but it was the first to appear in those waters in a hundred and fifty years.)

Now let us see how far we may go toward widening the point to include the growth of gifts that are not in fact alive. Let us turn to a gift at the level of culture – something clearly inorganic and inedible – and try to explain its increase without recourse to any natural analogy.

The same North Pacific tribes that welcomed the first salmon circulated among themselves large decorated copper plaques as ceremonial gifts. As the illustration shows, the upper half of a copper plaque was typically engraved with a highly geometric portrait of an animal or spirit, while the lower portion was left unadorned except for two ridges in the shape of a T. Each copper bore a name, sometimes referring to the animal or spirit, sometimes to the great power of the gift (e.g., 'Drawing All Property from the House').

Coppers were always associated with the property given away at a potlatch. Marcel Mauss, as I indicated in the last chapter, translates 'potlatch' in terms of nourishment and satiation; more commonly the word is taken to mean 'gift,' 'giving,' or, when used as a verb, 'to give.' Potlatches were held to mark important events, such as a marriage or, most often, the assumption of rank by a member of a tribe. The oldest and most universal occasion for a potlatch was the death of a chief and the subsequent elevation of his successor to the vacant rank and title. Potlatches were almost always given by one tribe for another, the order and value of the gifts bestowed establishing the rank of each participant, guest and host alike. Status and generosity were always associated: no man could become a man of position without giving away property.

When American ethnographers first studied the potlatch at the end of the nineteenth century, over a hundred years of trading with the whites had changed it to its roots. We must therefore look upon the literature we have about the potlatch with a wary eye – what is truly aboriginal and what is an accommodation to the new economy? Before the Europeans appeared, for example, a chief was likely to give only one formal potlatch during his lifetime, the one at which he assumed his chieftainship. The tribe would labor a year or more to prepare the ceremony, if only to collect the treasure to be given away, not just coppers, but sea otter and marmot pelts, eulachon oil, tusk shells, skins of albino deer, and nobility blankets woven of mountain-goat wool and cords of yellow cedar bark. When Franz Boas, the first ethnographer to study the potlatch, stayed with the Kwakiutl in the 1890s, however, the gifts were trade items, easy to manufacture and cheap to acquire, and potlatches were held all the time.

Kwakiutl copper

It is worth going into the story of this change a little, for the subtleties of gift exchange always become more apparent when set alongside a market in commodities. The North Pacific coast of America was first opened to white traders by Captain Cook around the time of the American Revolution. Trade in animal pelts increased steadily in the following century. The Hudson's Bay Company established its first outposts in the area in the 1830s. Unlike the later missionaries, the company wanted furs, not souls, and left the Indians alone. But their passive presence had its effect, nonetheless, for with them came firearms, sails, and alcohol. The Indians began to winter near the company stores, crowding the land and depending more and more upon a market they did not control. The Hudson's Bay blanket, machine-made and selling for about a dollar, replaced the traditional nobility robe as an item of commerce. Where formerly a few carefully woven robes would grace a potlatch or feast, now literally thousands of trade blankets might be stacked along a beach to be given in return for a copper.

Toward the end of the century, whites began to commercialize the salmon fishing. No nation at that time recognized the Indians as full citizens and they were therefore unable to file land claims. But any white man could have 160 acres for the asking, and the entrepreneur who wanted a cannery would simply stake off 80 acres on either side of a river mouth, build his shop, and set to work. When he had more salmon than he needed, he might let the Indians come in and fish, or he might not. It's an old story: purchased foodstuffs became necessary to supplement the Indian diet, and to buy food they needed cash, and to acquire cash they had to work for wages in the factory. Indians were paid by the day to fish, bought food on credit at the store, became civilized debtors and returned to work another season.

As if these changes weren't enough, during the nineteenth century the Indian population was thinned out by war and disease, the system of land tenure was widely altered, and large tribal federations emerged in response to European hegemony, all of which led to endless complications in sorting out the hierarchy of each tribe, one of the original functions of the potlatch. Two of the better-known characteristics of potlatch in the popular literature – the usurious nature of loans and the rivalry or 'fighting with property' – while based on traceable aboriginal motifs, are actually post-European elaborations. It really wasn't possible for Boas to see this when he did his early work; he had the misfortune, in a sense, to work in the area near Fort Rupert (one of the first Hudson's Bay Company outposts) where the bitterness and antagonism of the 'rivalry potlatch' had reached its peak. When Mauss read through Boas's published field notes, he declared potlatch 'the monster child of the gift system.' So it was. As first studied, the potlatch was the progeny of a European capitalism mated to an aboriginal gift economy, and with freakish results: sewing machines thrown into the sea, people embarrassed into sitting in houses set afire with fish oil, Indians dancing with pink silk parasols or stooped under layer after layer of cheap wool blankets, and as the sun set the Canadian Royal Mounted Police riding off with coppers and other ritual property to suppress the potlatch, which their government had declared illegally wasteful.

With these words of warning, let us turn to one of Franz Boas's accounts of the ceremonial exchange of a copper, hoping to see in it the smudged image of earlier gift exchange. In Boas's report, one tribe of the Kwakiutl has a copper whose name is Maxtsolem, 'All Other

Coppers Are Ashamed to Look at It.' The tribe invites a second tribe to a feast and offers them the gift. The second tribe accepts, putting themselves under the obligation to make a return gift. The exchange takes place the next day on a beach. The first tribe brings the copper, and the leader of the second tribe lays down a thousand trade blankets as a return gift.

This is only the beginning, however, and in a sense the true gift has not yet appeared. The chiefs who are giving the copper away seem to feel that the return gift is not adequate, for instead of accepting it they slowly retell the entire history of this copper's previous passages, first one man recalling a time when two hundred more blankets had been given for it, then another man saying that an additional eight hundred would seem appropriate – and all the while the recipient of the copper responds to them, saying, 'Yes, it pleases my heart,' or else begging for mercy as he brings out more and more blankets. Five times the chiefs ask for more blankets and five times they are brought out until thirty-seven hundred are stacked in a row along the beach. At each stage the blankets are counted and both sides make elaborate speeches about their traditions and powers, their fathers, grandfathers and ancestors from the beginning of the world.

When the history has been told, the talk stops. Now the true return gift appears, these formalities having merely raised the exchange into the general area of this copper's worth. Now the receiving chief, on his own, announces he would like to 'adorn' his guests. He brings out two hundred more blankets and gives them individually to the visitors. Then he adds still another two hundred, saying, 'You must think poorly of me,' and telling of his forefathers.

These four hundred blankets are given without any of the dialogue that marked the first part of the ceremony. It is here that the recipient of the copper shows his generosity, and it is here that the copper increases in worth. The next time it is given away, people will remember how it grew by four hundred blankets in its last passage.

Before I comment on this exchange, I must describe a second situation in which coppers were felt to increase in value. Several occasions called for the actual destruction of a ceremonial copper. The Tsimshian tribes, for example, would break a copper when they held a potlatch to honor a dead chief and recognize his heir. During this 'feast for the dead,' a masked dancer would come forward with a copper and instruct the new chief to

break it into pieces and then give these pieces to his guests. The chief would take a chisel and cut the copper apart. Among the Kwakiutl when Boas studied them, a man would sometimes break a copper and give the pieces to a rival, who would then try to find a copper of equivalent value, break it, and give back the pieces of both. The man who had initiated the exchange was then obliged to hold a potlatch, distributing food and valuables at least equal to the new (and broken) copper he had received. Sometimes the initial recipient of a broken copper would find a second one, break it, and then throw them both into the sea, an action that brought him great prestige. Most coppers did not end up in the water, however; even when broken, the pieces were saved and continued to circulate. And if someone succeeded in gathering up the parts of a dismembered copper, Boas reports, they were 'riveted together, and the copper . . . attained an increased value.'

It is clear in the literature that coppers increased in worth as they were broken, but I'm not sure it is clear why. To suggest an explanation, I want to introduce an image of dismemberment and increase from a very different culture. There are several ancient gods whose stories involve being broken and then brought back to life – Osiris in Egypt, Dionysos in Crete and Greece, and Bacchus in Rome, to name a few. I shall take Dionysos as my example here.

Carl Kerényi, the Romanian historian of religion, introduces his book on Dionysos by saying that his first insight into the god of wine came to him in a vineyard – he was looking at the grapevine itself and what he saw was 'the image of indestructible life.' The temples are abandoned, but the vine still grows over the fallen walls. To explain the image, Kerényi distinguishes between two terms for 'life' in Greek, *bios* and *zoë*. *Bios* is limited life, characterized life, life that dies. *Zoë* is the life that endures; it is the thread that runs through *bios*-life and is not broken when the particular perishes. (In this century we call it 'the gene pool.') Dionysos is a god of *zoë*-life.

In his earliest Minoan forms, Dionysos is associated with honey and with honey beer or mead. Both honey and grape juice became images of this god because they ferment: 'A natural phenomenon inspired a myth of *zoë*,' writes Kerényi, 'a statement concerning life which shows its indestructibility . . . even in decay.' When honey ferments, what has rotted not only comes back to life – bubbles up – but its 'spirit' survives. Moreover, when the fermented liquid is drunk, the spirit comes to life

in a new body. Drinking the mead is the sacrament of reconstituting the god.

The association of Dionysos with honey came very early; wine soon replaced mead as the spirit drink, but the essentials of the image remained the same. In later centuries Greek celebrants of Dionysos would sing of the dismemberment of their god as they crushed the grapes through the winepresses.

Dionysos is a god who is broken into a higher life. He returns from his dismemberment as strong or stronger than before, the wine being the essence of the grapes and more powerful. The Tsimshian tribes called the fragments of a copper given away at a mortuary potlatch 'the bones of the dead.' They stand for what does not decay even though the body decays. To dismember the copper after the death of the chief and then to declare the pieces, or the reassembled copper, to be of increased value, is to declare that human life participates in *zoë*-life and that the spirit grows even though, or perhaps because, the body dies.* In terms of the gift: the spirit of the gift increases because the body of the gift is consumed. When a copper is exchanged for blankets, the increase comes as a sort of investment, but when coppers are broken, it comes simply through consumption. People feel the gift is worth more just because it has been used up. Boas, when he discusses the potlatch, lumps feasting and the breaking of coppers together in the same paragraph; both are 'eating the gift' as much as the destruction of property.

But I should stop here, for I have already strayed back toward explaining the increase of gifts by way of natural metaphors. Not that it is incorrect to speak in this manner; inorganic gifts do become the vehicles of *zoë*-life when we choose to invest it in them.† But there is a

*To say that coppers are images of zoë-life would explain why their exchange is accompanied by recitations of history and genealogy. Like the Kula articles, the passage of these gifts keeps history alive so that individuals may witness and affirm their participation in non-individual life.

Note as well the mortuary potlatch's connection to my opening story, the first salmon rite, which also has the bones of the dead, their imagined reassembly, and a sense of increase.
† A confusion between organic liveliness and cultural or spiritual liveliness is inherent in a discussion of gift exchange. As Mauss first pointed out, in an exchange of gifts, 'things . . . are to some extent parts of persons, and persons . . . behave in some measure as if they were things.' In the case of the mortuary potlatch, a material thing symbolizes a biological fact, the survival of the group despite the death of the individual. But it may be that the group would not survive as a group (and individual life would not survive, then, either) if these 'biological' facts could not be expressed symbolically. We are social and spiritual beings; at some level biological, social, and spiritual life cannot be differentiated.

different sort of investment – one that can be described without invoking the gods of vegetable life – in the exchange of a copper as Boas has recorded it for us. To begin with, each time the copper passes from one group to another, more blankets are heaped into it, so to speak. The increase is not mysterious or metaphorical: each man really adds to the copper's worth as it comes toward him. But it is important to remember that the investment is itself a gift, so the increase is both concrete (blankets) and social or emotional (the spirit of generosity). At each transaction the concrete increase (the 'adornment') is a witness to the increase in feeling. In this way, though people may remember it in terms of blankets, the copper becomes enriched with social feeling, with generosity, liberality, goodwill.

Coppers make a good example here because there is concrete increase to manifest the feeling, but that is not necessary. The mere passage of the gift, the act of donation, contains the feeling, and therefore the passage alone is the investment. In folk tales the gift is often something seemingly worthless – ashes or coals or leaves or straw – but when the puzzled recipient carries it to his doorstep, he finds it has turned to gold. Such tales declare that the motion of the gift from the world of the donor to the doorsill of the recipient is sufficient to transmute it from dross to gold.* Typically the increase inheres in the gift only so long as it is treated as such – as soon as the happy mortal starts to count it or grabs his wheelbarrow and heads back for more, the gold reverts to straw. The growth is in the sentiment; it can't be put on the scale.

One early commentator on North Pacific culture, H. G. Barnett, in struggling to understand the potlatch, concluded that the property given away was not economic in our usual sense (the investment is not capital investment), it wasn't pay for labor (though guests sometimes labor), and it wasn't a loan. In a description reminiscent of Malinowski, he concludes that it can only be described as a gift, 'in complete harmony with the emphasis upon liberality and generosity (or their simulation) in evidence throughout

* In a typical example from a book of Russian folk tales, a woman walking in the woods found a baby wood-demon 'lying naked on the ground and crying bitterly. So she covered it up with her cloak, and after a time came her mother, a female wood-demon, and rewarded the woman with a potful of burning coals, which afterwards turned into bright golden ducats.'

The woman covers the baby because she's moved to do so, a gratuitous, social act. Then the gift comes to her. It increases solely by its passage from the realm of wood-demons to her cottage.

the area. Virtue rests in publicly disposing of wealth, not in its mere acquisition and accumulation. Accumulation in any quantity by borrowing or otherwise, in fact, is unthinkable unless it be for the purpose of an immediate redistribution.'*

The potlatch can rightly be spoken of as a goodwill ceremony. One of the men giving the feast in the potlatch Boas witnessed, says as the meal begins: 'This food is the good will of our forefathers. It is all given away.' The act of donation is an affirmation of goodwill. When someone in one of these tribes was mistakenly insulted, his response, rather than turning to a libel lawyer, was to give a gift to the man who had insulted him; if indeed the insult was mistaken, the man would make a return gift, adding a little extra to demonstrate his goodwill, a sequence that has the same structure (back and forth with increase) as the potlatch itself. When a gift passes from hand to hand in this spirit, it becomes the binder of many wills. What gathers in it is not only the sentiment of generosity but the affirmation of individual goodwill, making of those separate parts a *spiritus mundi*, a unanimous heart, a band whose wills are focused through the lens of the gift. Thus the gift becomes an agent of social cohesion, and this again leads to the feeling that its passage increases its worth, for in social life, at least, the whole really is greater than the sum of its parts. If it brings the group together, the gift increases in worth immediately upon its first circulation, and then, like a faithful lover, continues to grow through constancy.

I do not mean to imply by these explanations that the increase of coppers is simply metaphorical, or that the group projects its life onto them. For that would imply that the liveliness of the group can be separated from the gift, and it cannot. If the copper disappears, so does the life. When a song moves us, we don't say we've projected our feelings onto the melody, nor do we say our lover is a metaphor for the other sex. Likewise, the gift and the group are two separate things; neither stands for the other. We could say, however, that a copper is an image

* Barnett's language, the language of gift exchange, has procreation at its root. Generosity comes from *genere* (Old Latin: beget, produce), and the generations are its consequence, as are the gens, the clans. At its source in both Greek and Sanskrit, liberality is desire; libido is its modern cousin. Virtue's root is a sex (*vir*, the man), and virility is its action. Virtue, like the gift, moves *through* a person, and has a procreative or healing power (as in the Bible story about the woman who touched the hem of Jesus' garment in the faith that it would heal her: 'And Jesus, immediately knowing in himself that virtue had gone out of him, turned about in the press and said, "Who touched my clothes?"').

for the life of the group, for a true image has a life of its own. Every mystery needs its image. It needs these two, the ear and the song, the he and the she, the soul and the word. The tribe and its gift are separate, but they are also the same – there is a little gap between them so they may breathe into each other, and yet there is no gap at all, for they share one breath, one meal for the two of them. People with a sense of the gift not only speak of it as food to eat but also feed it (the Maori ceremony 'feeds' the forest *hau*). The nourishment flows both ways. When we have fed the gift with our labor and generosity, it grows and feeds us in return. The gift and its bearers share a spirit which is kept alive by its motion among them, and which in turn keeps them both alive. When Black Elk, an Oglala Sioux holy man, told the history of the Sioux 'sacred pipe' to Joseph Epes Brown, he explained that at the time the pipe had first been given to him, his elders had told him that its history must always be passed down, 'for as long as it is known, and for as long as the pipe is used, [the] people will live; but as soon as it has been forgotten, the people will be without a center and they will perish.'

The increase is the core of the gift, the kernel. In this book I speak of both the object and its increase as the gift, but at times it seems more accurate to say that the increase alone is the gift and to treat the object involved more modestly as its vehicle or vessel. A Kwakiutl copper is a gift, but the feeling involved – the goodwill of each transaction – is more clearly embodied in the excess, the extra blankets thrown in at the end by each new recipient. And certainly it makes sense to say that the increase is the real gift in those cases in which the gift-object is sacrificed, for the increase continues despite (even because of) that loss; it is the constant in the cycle, because it is not consumed in use. The Maori elder who told of the forest *hau* distinguished in this way between object and increase, the *mauri* set in the forest and its *hau* which causes the game to abound. In that cycle the *hau* is nourished and passed along, while the gift-objects (birds, *mauri*) disappear.

Marshall Sahlins, when he commented on the Maori gift stories, asked that we 'observe just where the term *hau* enters into the discussion. Not with the initial transfer from the first to the second party, as well it could if [the *hau*] were the spirit in the gift, but upon the exchange between the second and third parties, as logically it would if it were the yield on the gift. The term "profit" is economically and historically inappropriate to

the Maori, but it would have been a better translation than "spirit" for
the *hau* in question.'

Sahlins's gloss highlights something that has been implicit in our discus-
sion, though not yet stated directly – the increase comes to a gift as it
moves from second to third party, not in the simpler passage from first to
second. This increase begins when the gift has passed *through* someone,
when the circle appears. But, as Sahlins senses, 'profit' is not the right
word. Capital earns profit and the sale of a commodity turns a profit, but
gifts that remain gifts do not *earn* profit, they *give* increase. The distinc-
tion lies in what we might call the vector of the increase: in gift exchange
it, the increase, stays in motion and follows the object, while in commodity
exchange it stays behind as profit. (These two alternatives are also known
as positive and negative reciprocity.)

With this in mind, we may return to a dictum laid out in Chapter I –
one man's gift must not be another man's capital – and develop from it
a corollary, saying: the increase that comes of gift exchange must remain
a gift and not be kept as if it were the return on private capital. Saint
Ambrose of Milan states it directly in a commentary on Deuteronomy:
'God has excluded in general all increase of capital.' Such is the ethic of
a gift society.*

I have explained the increase of gifts in three ways in this chapter: as a
natural fact (when gifts are actually alive); as a natural-spiritual fact (when
gifts are the agents of a spirit that survives the consumption of its indi-
vidual embodiments); and as a social fact (when a circulation of gifts creates
community out of individual expressions of goodwill). In each of these
cases the increase pertains to an ego or body larger than that of any indi-
vidual participant. Thus to speak of the increase of gifts is to speak of some-
thing simultaneously material, social, and spiritual. Material wealth may
be produced in the course of a commerce of gifts (in the cases at hand, for
example, food is gathered and preserved for the winter, canoes are
constructed, lodges are built, blankets are woven, banquets prepared, and
so forth and so on). And yet no material good becomes an item of commerce

* Capitalism is the ideology that asks that we remove surplus wealth from circulation and
lay it aside to produce more wealth. To move away from capitalism is not to change the form
of ownership from the few to the many, but to cease turning so much surplus into capital,
that is, to treat most increase as a gift. It is quite possible to have the state own everything
and still convert all gifts to capital, as Stalin demonstrated. When he decided in favor of the
'production mode' – an intensive investment in capital goods – he acted as a capitalist, the
locus of ownership having nothing to do with it.

without simultaneously nourishing the spirit (of the salmon, of the tribe, of the race). To reverse the vector of the increase may not destroy its material portion (it may even augment it), but the social and spiritual portions drop away. Negative reciprocity does not feed the *hau*. To say, then, that the increase of a gift must itself be a gift is to ask that we not abandon the increase-of-the-whole in favor of a more individual and more plainly material growth.

To restate this choice in slightly different terms, a circulation of gifts nourishes those parts of our spirit that are not entirely personal, parts that derive from nature, the group, the race, or the gods. Furthermore, although these wider spirits are a part of us, they are not 'ours'; they are endowments bestowed upon us. To feed them by giving away the increase they have brought us is to accept that our participation in them brings with it an obligation to preserve their vitality. When, on the other hand, we reverse the direction of the increase – when we profit on exchange or convert 'one man's gift to another man's capital' – we nourish that part of our being (or our group) which is distinct and separate from others. Negative reciprocity strengthens the spirits – constructive or destructive – of individualism and clannishness.

In the present century the opposition between negative and positive reciprocity has taken the form of a debate between 'capitalist' and 'communist,' 'individualist' and 'socialist'; but the conflict is much older than that, because it is an essential polarity between the part and the whole, the one and the many. Every age must find its balance between the two, and in every age the domination of either one will bring with it the call for its opposite. For where, on the one hand, there is no way to assert identity against the mass, and no opportunity for private gain, we lose the well-advertised benefits of a market society – its particular freedoms, its particular kind of innovation, its individual and material variety, and so on. But where, on the other hand, the market alone rules, and particularly where its benefits derive from the conversion of gift property to commodities, the fruits of gift exchange are lost. At that point commerce becomes correctly associated with the fragmentation of community and the suppression of liveliness, fertility, and social feeling. For where we maintain no institutions of positive reciprocity, we find ourselves unable to participate in those 'wider spirits' I just spoke of – unable to enter gracefully into nature, unable to draw community out of the mass, and, finally, unable to receive, contribute toward, and pass along the collective treasures we refer to as

culture and tradition. Only when the increase of gifts moves with the gift may the accumulated wealth of our spirit continue to grow among us, so that each of us may enter, and be revived by, a vitality beyond his or her solitary powers.

CHAPTER THREE

THE LABOR OF GRATITUDE

My vocation [his sense, as a child, that he would be a writer] changed everything: the sword-strokes fly off, the writing remains; I discovered in belles-lettres that the Giver can be transformed into his own Gift, that is, into a pure object. Chance had made me a man, generosity would make me a book.

JEAN-PAUL SARTRE

The old engraving reproduced here shows gifts being given out at a funeral, a custom common in Wales a century or more ago. The coffin was placed on a bier outside the house near the door. One of the deceased's relatives would then distribute bread and cheese to the poor, taking care to hand the gifts *over* the coffin. Sometimes the bread or cheese had a piece of money inside it. In expectation of the gift, the poor would have earlier gathered flowers and herbs to grace the coffin.

Funeral gifts belong to a general class I call 'threshold gifts,' gifts that mark the passage from one place or state into another. The gifts passed over the coffin in this instance reflect a particular image of what it is to die. Bodily death is not a final death, they say, but a change, a passage that benefits from the protection of gift exchange. The Welsh believed that the dead who were not properly laid to rest would be left to walk ceaselessly

on earth. They would become the restless dead, never bound up in the
spirit of their race. Similar myths are found all over the world. The Haida
believed the dead live in spirit villages to which they must travel after death,
and a corpse was buried with gifts intended to help the soul on its journey.
The image is kin as well to the Roman Catholic belief that a soul's stay in
purgatory can be relieved through the charity of the living and the sacri-
fice of the mass. In each case, death begins a passage that ends with the
soul's incorporation into the spiritual world, or the spiritual body of the
tribe ('the bosom of Abraham' for the Jews).

Threshold gifts belong to a wider group we might call 'gifts of passage.'
I have adapted these terms from Arnold Van Gennep's classic work, *The
Rites of Passage*. Van Gennep divides rites of passage into three groups:
rites of separation, rites of transition, and rites of incorporation. He
also calls these 'preliminal,' 'liminal,' and 'postliminal rites' – that is,
before the doorway, on the threshold and in the house. Rites of separa-
tion are not so commonly marked by gifts, but even a quick survey of
Van Gennep's work will show that rites in his other two categories are.*
Threshold gifts may be the most common form of gift we have, so well
known as to need little elaboration here. They attend times of passage
or moments of great change. They are with us at every station of life,
from the shower for the coming baby to the birthday parties of youth,
from graduation gifts (and the social puberty rites of earlier times) to
marriage gifts, from the food offered newcomers and the sick to the
flowers placed upon the coffin. Once in my reading I came across an
obscure society that even gave gifts to celebrate the arrival of a child's
second teeth – only to realize later that of course the writer meant the
tooth fairy!

Threshold gifts mark the time of, or act as the actual agents of, indi-
vidual transformation. In a recent book on the Trobriand Islands, Annette
Weiner presents an interesting idea about these gifts that mark the various
stages of the life cycle. Weiner tells us that in the Trobriands at least, 'at
each important phase in the cycle (i.e., conception, birth, marriage,
death, and rebirth), a transformation of a person occurs as artifacts are

* Separation often involves a 'cutting' ceremony rather than a gift (see Van Gennep's remarks
on divorce, for example). Going-away presents are given at the time of separation, but as
the Scottish tale well illustrated, such farewells attempt to overcome the physical departure,
rather than facilitate it. 'My spirit goes with you,' they say. Going-away presents are gifts of
spiritual incorporation.

Giving food over the coffin.

detached from others and invested in ego.' She means that there are two sides to each exchange and to each transformation: on the one hand, the person approaching a new station in life is invested with gifts that carry the new identity; on the other hand, some older person – the donor who is leaving that stage of life – dis-invests himself of an old identity by bestowing these same gifts upon the young. Weiner's main contribution to the ethnography of the Trobriand Islands has been to describe a sexual division of labor within this series of transformations. Men's gifts organize the social and political identities of middle life, while women's gifts are more concerned with birth, death, and rebirth. Women especially are in charge of collecting and disbursing the gifts given away at a mortuary ceremony during the course of which it is understood that the deceased is released not from any particular station in life but from his or her entire social being. 'Symbolically,' Weiner writes, 'women untie the dead person from all reciprocal claims, thus securing a [soul] that is pure ancestral essence.'

I have taken death gifts as my example of threshold gifts not as an exceptional case but as the type, for I would like to speak of all transformations as involving death.* Spiritually, at least, the old life must leave before the new may enter. Initiation ceremonies make a good illustration because they commonly include a symbolic death. A man who was to be initiated into the priesthood among the Sabians (a Gnostic sect) would confine himself to a reed hut for a full week. During this time he was not allowed to sleep. Each day he would change his clothes and give alms to the poor. After seven days a funeral would be held for him, as he would then be considered dead. After the funeral he would be taken to a river and baptized. For the next two months he would bathe three times a day, eat only certain foods and give alms.

The novitiate's gifts are intended to encourage the death of the secular self and the birth of the spiritual. The alms are the evidence that the

* Those who write on gift exchange usually mention at this point that the German word *Gift* means 'poison.' The connection is more accidental than significant, however. The French etymologist Benveniste writes: 'There is a . . . medical usage in which [the Greek word] *dósis* denotes the act of giving, whence develops the sense of the amount of medicine given, a "dose" . . . This sense passed by loan translation into German, where *Gift*, like Gr.-Lat. *dósis*, was used as a substitute for *venēnum*, "poison." . . .'

would-be priest is giving up the old life. All old gifts are handed over the coffin. It might be said that the gifts we give at times of transformation are meant to make visible the giving up we do invisibly. And of course we hope that there will be an exchange, that something will come toward us if we abandon our old lives. So we might also say that the tokens we receive at times of change are meant to make visible life's reciprocation. They are not mere compensation for what is lost, but the promise of what lies ahead. They guide us toward new life, assuring our passage away from what is dying.

The guidance is of use because there are those who do not survive change. It is as if human beings were like that subclass of insect, the Metabola, which must undergo complete metamorphosis from egg, through larva and pupa, to imago. In some way the fluidity of gift exchange assures the successful metamorphosis. Woody Allen used to tell a joke at the end of his stand-up routine: he would take a watch from his pocket, check the time, and then say, 'It's an old family heirloom. [Pause] My grandfather sold it to me on his deathbed.' The joke works because market exchange will always seem inappropriate on the threshold. There is a discrete range of conditions that will assure the emergence of the imago. A man who would buy and sell at a moment of change is one who cannot or will not give up, and if the passage is inevitable, he will be torn apart. He will become one of the done-for dead who truly die. Threshold gifts protect us from such death.

There is a story in the *Babylonian Talmud* of a man whose astrologers told him that his daughter would not survive her marriage. She would, they prophesied, be bitten by a snake and die on her wedding day. As the story goes, on the night before her wedding the girl happened to hang her brooch up by sticking its pin into a hole in the wall where it pierced the eye of a serpent. When she took the brooch down in the morning, the snake came trailing after it. Her father asked if any act of hers could account for her having so luckily avoided her fate. 'A poor man came to our door yesterday evening,' she replied. 'Everybody was busy at the banquet, and there was none to attend to him. So I took the portion that was given to me and gave it to him.' 'You have done a good deed,' her father said, and he went about thereafter lecturing that 'charity delivereth from death.' And, the *Talmud* adds, 'not merely from an unnatural death, but from death itself.'

The astrologers had predicted that the daughter would not survive the

passage from maiden to wife, but she does survive through an act of spontaneous generosity; she has the right spirit on the day of her wedding. The tale offers the same image as the Welsh funeral rite or the Sabian initiation: a moment of change is guarded by the giving of gifts. It's not that there is no death, nor that there is no change – the novitiate and the bride suffer a 'death,' but they are able to pass through it into new life under the aegis of the gift. We should really differentiate two sorts of death here: one that opens forward into a greater life and another – a dead-end death – that leaves a restless soul, unable to reach its home. This is the death we rightly fear. And just as gifts are linked to the death that moves toward new life, so, for those who believe in transformation (either in this life or in another), ideologies of market exchange have become associated with the death that goes nowhere. George Romero, the man who made the movie *The Dawn of the Dead*, set his film in a shopping mall near Pittsburgh; the parking lots and aisles of discount stores may be where the restless dead of a commodity civilization will tread out their numberless days.

These stories present gift exchange as a companion to transformation, a sort of guardian or marker or catalyst. It is also the case that a gift may be the actual agent of change, the bearer of new life. In the simplest examples, gifts carry an identity with them, and to accept the gift amounts to incorporating the new identity. It is as if such a gift passes through the body and leaves us altered. The gift is not merely the witness or guardian to new life, but the creator. I want to speak of 'teachings' as my primary example here. I do not mean schoolbook lessons, I mean those infrequent lessons in living that alter, or even save, our lives. I once worked for several years as a counselor to alcoholics in the detoxification ward of a city hospital. During those years I naturally became acquainted with Alcoholics Anonymous. AA provides a 'program of recovery' for alcoholics that makes a good example of the sort of teaching gift I have in mind.

AA is an unusual organization in terms of the way money is handled. Nothing is bought or sold. Local groups are autonomous and meet their minimal expenses – coffee, literature – through members' contributions. The program itself is free. AA probably wouldn't be as effective, in fact, if the program was delivered through the machinery of the market, not because its lessons would have to change, but because the spirit behind

them would be different (the voluntary aspect of getting sober would be obscured, there would be more opportunity for manipulation, and – as I shall argue presently – the charging of fees for service tends to cut off the motivating force of gratitude, a source of AA's energy).*

So AA's teachings are free, a literal gift. Someone who comes to the group will hear it said, 'If you do such and such, you will stay sober for a day.' His pain is heavy or his desire strong, so he tries it. Suppose it works. Now he's in an odd state. He has received the teaching and he's seen that it has some power, but, as is always the case, it takes some time before the message really sinks in. An insight may come quickly, but the gut transformation is slow. After a day, even a month, of sobriety the newcomer isn't a drunk, technically, but he's not a recovered alcoholic, either. The teachings are 'in passage' in the body of their recipient between the time they are received and the time when they have sunk in so deeply that they may be passed along. The process can take years.

AA has 'twelve steps to recovery,' which more or less summarize the program. The twelfth step is an act of gratitude: recovered alcoholics help other alcoholics when called upon to do so. It is a step in which the gift is passed along, so it is right that it should be the final one. In AA they speak of people who are 'two-steppers' – that is, people who take Step One (accepting they are an alcoholic) and then jump directly to Step Twelve (helping others) without the in-between steps where the labor lies. They try to pass along something they themselves have not yet received.

There are many other examples of teachings as transformative gifts. Spiritual conversions have the same structure as the AA experience: the Word is received, the soul suffers a change (or is released, or born again), and the convert feels moved to testify, to give the Word away again. Those whose lives have been touched by a true mentor will have known a similar history. I once met a man who ran a research lab for a large petrochemical firm. He had started to work for the company just out of high school,

* Few modern therapies present their teachings as gifts the way AA does. You can pay almost any amount for spiritual advice, psychotherapy, or 'self-help' lessons. Despite my obvious bias, I don't maintain that fees for such services are inappropriate. Therapists, meditation instructors, and so forth work at what they do, and they deserve to earn their keep. A lot depends on the spirit of the exchange, too; gifts will sometimes circulate above the cash.

The AA example indicates, however, that the fee is not always a *necessary* part of the transaction as it is often made out to be. Further, the size of the fee is sometimes the clearest indication that the proffered teaching may not in fact lead to transformation, as when the minimum initial 'donation' to the Church of Scientology is $2,700 for a 12½-hour 'intensive.'

literally pushing a broom. An older man, a Ph.D., had then asked him
to be the handyman in his research lab. The two of them worked together
for years, the older man training the younger. When I met him in his
late forties, the former handyman had earned a master's degree in chem-
istry and was working in the same situation his mentor had filled when
they first met. When I asked this man what he planned to do in the
coming years, he said that he wanted to teach, 'to pass it on to the younger
men.'

We could speak of artists' lives and artists' creations in a similar fashion.
Most artists are brought to their vocation when their own nascent gifts
are awakened by the work of a master. That is to say, most artists are
converted to art by art itself. The future artist finds himself or herself moved
by a work of art, and, through that experience, comes to labor in the service
of art until he can profess his own gifts. Those of us who do not become
artists nonetheless attend to art in a similar spirit. We come to painting,
to poetry, to the stage, hoping to revive the soul. And any artist whose
work touches us earns our gratitude. The connection between art and gift
is the subject of a later part of this book, but it deserves mention here, for
it is when art acts as an agent of transformation that we may correctly
speak of it as a gift. A lively culture will have transformative gifts as a
general feature – it will have groups like AA which address specific prob-
lems, it will have methods of passing knowledge from old to young, it will
have spiritual teachings available at all levels of maturation and for the
birth of the spiritual self. And it will have artists whose creations are gifts
for the transformation of the race.

In each example I have offered of a transformative gift, if the teaching
begins to 'take,' the recipient feels gratitude. I would like to speak of grat-
itude as a labor undertaken by the soul to effect the transformation after
a gift has been received. Between the time a gift comes to us and the time
we pass it along, we suffer gratitude. Moreover, with gifts that are agents
of change, it is only when the gift has worked in us, only when we have
come up to its level, as it were, that we can give it away again. Passing the
gift along is the act of gratitude that finishes the labor. The transforma-
tion is not accomplished until we have the power to give the gift on our
own terms. Therefore, the end of the labor of gratitude is similarity with
the gift or with its donor. Once this similarity has been achieved we may
feel a lingering and generalized gratitude, but we won't feel it with the
urgency of true indebtedness.

There is a group of folk tales that are models of the labor of gratitude. In each of them a spirit comes to help a mortal and stays, sometimes in actual bondage, until released by the mortal's expression of gratitude.

In a tale with which we are all familiar, 'The Shoemaker and the Elves,' a shoemaker is down on his luck and has only enough leather to sew a single pair of shoes. He cuts the leather out and goes to bed, planning to sew the shoes in the morning. During the night, two naked elves come and make the shoes. The shoemaker is speechless with astonishment when he finds them. Not a stitch is out of place! The shoes are such a masterpiece that the first customer to appear in the morning pays handsomely for them, and the cobbler has enough money to buy leather for two pairs of shoes. That night he cuts the leather out and goes to bed. Again in the morning the shoes are made, and again they sell for such a price as to afford the leather for four pairs of shoes. In this way the shoemaker soon prospers.

One evening ('not long before Christmas,' the tale says), the cobbler suggests to his wife that they stay up and see who has been helping them. They leave a candle burning, hide behind some coats, and, at midnight, see the elves come in and set to work. In the morning the wife says to the shoemaker, 'The little men have made us rich and we should show our gratitude for this. They're running about with nothing on and might freeze! I'm going to make them each a shirt, coat, jacket, trousers and a pair of stockings. Why don't you make them each a pair of little shoes.' The cobbler willingly agrees, and one night when the clothes are finished he lays them out on the bench in place of the leather. He and his wife hide behind the coats to watch.

The elves are surprised and pleased to find the clothes. They put them on and sing—

> 'We're sleek, we're fine, we're out the door,
> We shan't be cobblers any more!'

And they dance around the room and away. They never return, but everything continues to go well with the shoemaker and he prospers at whatever he takes in hand.

The tale is a parable of a gifted person. It describes the time between the initial stirrings of a gift (when it is *potentially* ours) and the releasing

of a gift (when it is *actually* ours). In this case the gift is the man's talent, carried by the elves. The shoemaker is poor, to begin with. His own worth is not available to him for some reason that is never explained. But then, while he is asleep, it begins to come. The process is always a bit mysterious. You work at a task, you work and work and still it won't come right. Then, when you're not even thinking about it, while spading the garden or stepping into the bus, the whole thing pops into your head, the missing grace is bestowed. That's the elves, the 'magic touch' by which our tasks take on life. The process does not end there, however, for the elves have need of us, as well. It is a curious detail in the story that these manikins so skilled with the needle and thread are unable to make themselves some clothes, but that seems to be the case. Their outfits and, above all, their freedom depend on the shoemaker's recognition and gratitude.*

My general point here is that a transformative gift cannot be fully received when it is first offered because the person does not yet have the power either to accept the gift or to pass it along. But I should qualify this. Some part of the self is able to apprehend the gift. We can feel the proffered future. I am reminded of the odd phenomenon of the 'instant cure' in psychotherapy: sometimes in a very early session a patient will experience a total lifting of his or her neurosis. For a brief period, say a week, he will experience a longed-for freedom. Then normalcy will descend, and then the years of labor to acquire that freedom as a true possession. The gift is not ours yet but the fullness of the gift is felt, and we respond with gratitude and with desire. The shoemaker in this tale is completely asleep when the first gift arrives, so we can't say he's really acquired his talent. But he does feel something being roused in him and he gets to work.

Once a gift has stirred within us it is up to us to develop it. There is a reciprocal labor in the maturation of a talent. The gift will continue to discharge its energy so long as we attend to it in return. The geometrical progression of exchange between shoemaker and elves reaches a sort of critical mass when the man finally decides to stay awake and watch the shop. Of course it's amusing that it takes the shoemaker so long to get around to seeing who's been helping out. We husband our gifts when we

*That the helpers are in a sort of bondage is clearer in other tales with the same motif. Several examples are cited in the notes at the end of the book.

cannot do without them, or when they are not fully formed. But once his poverty has been relieved, the cobbler wonders where his riches have come from, and he and his wife stay up to see the elves; at this point we might say he wakes up to his gift.

What can we make of the initial nudity of the elves, the clothes they are given, and the result of that gift? To put clothes on a thing is a kind of acknowledgment, like giving it a name. By this act we begin to differentiate what was undifferentiated. Sometimes we are unable to escape from a bad mood, for example, until we have correctly articulated the feeling. Articulation allows a slight gap to open between the feeling and the self, and that gap permits the freedom of both. In this story the clothes realize the gift (that is, they make it real, make it a thing). Note that the shoemaker makes his first pair of shoes (within the tale) in order to dress the elves. It's the last act in his labor of gratitude. Now he's a changed man. Now he has worth that can be communicated. The shoes he makes are a return gift which simultaneously accomplishes his own transformation and frees the elves. This is why I say that the end of the labor of gratitude is similarity with the gift or its donor. Now the man is a real shoemaker, as were the elves on the first night. (A gift isn't fully realized until it is given away, then. Those who will not acknowledge gratitude or who refuse to labor in its service neither free their gifts nor really come to possess them.)

In speaking of gratitude as a 'labor' I mean to distinguish it from 'work,' and I must digress briefly here to elaborate my distinction. Work is what we do by the hour. It begins and ends at a specific time and, if possible, we do it for money. Welding car bodies on an assembly line is work; washing dishes, computing taxes, walking the rounds in a psychiatric ward, picking asparagus – these are work. Labor, on the other hand, sets its own pace. We may get paid for it, but it's harder to quantify. 'Getting the program' in AA is a labor. It is likewise apt to speak of 'mourning labor': when a loved one dies, the soul undergoes a period of travail, a change that draws energy. Writing a poem, raising a child, developing a new calculus, resolving a neurosis, invention in all forms – these are labors.

Work is an intended activity that is accomplished through the will. A labor can be intended but only to the extent of doing the groundwork, or of *not* doing things that would clearly prevent the labor. Beyond that, labor has its own schedule. Things get done, but we often have the

odd sense that we didn't do them. Paul Goodman wrote in a journal once, 'I have recently written a few good poems. But I have no feeling that *I* wrote them.' That is the declaration of a laborer. Like the shoemaker, we wake up to discover the fruits of labor. And labor, because it sets its own pace, is usually accompanied by idleness, leisure, even sleep. In ancient days a seventh part of a person's time (both Sunday and the sabbatical, the seventh year) were set aside for non-work. Nowadays when a worker or teacher gets a sabbatical, he or she may try to finish six years of unfinished chores. But first he should put his feet up and see what happens. In numerology the '7' is the number for ripening; '8' is the number for perfection, but during the seventh period what has been accomplished by the will is left alone. It either ripens or it doesn't. It's out of our hands. One of the first problems the modern world faced with the rise of industrialism was the exclusion of labor by the expansion of work. Machines don't need a Sunday. Early mill hands found themselves working a seven-day week, and had to fight for years to get back the Sabbath.*

When I speak of a labor, then, I intend to refer to something dictated by the course of life rather than by society, something that is often urgent but that nevertheless has its own interior rhythm, something more bound up with feeling, more interior, than work. The labor of gratitude is the middle term in the passage of a gift. It is wholly different from the 'obligation' we feel when we accept something we don't really want. (An obligation may be discharged by an act of will.) A gift that has the power to change us awakens a part of the soul. But we cannot receive the gift until we can meet it as an equal. We therefore submit ourselves to the labor of becoming like the gift. Giving a return gift is the final act in the labor of gratitude, and it is also, therefore, the true acceptance of the original gift. The shoemaker finally gives away some shoes. The twelfth step in AA gives away what was received; the man who wanted to teach so as to 'pass it on to the younger men' gives away what he received. In each case there is an interim period during which

* As those who must worry about the livelihood of artists are fond of saying, 'You cannot play "The Minute Waltz" in less than a minute.' Worse (or perhaps better) you cannot *write* 'The Minute Waltz' in less than . . . what? A day, a week, a year? – however long it takes. There is no technology, no time-saving device that can alter the rhythms of creative labor. When the worth of labor is expressed in terms of exchange value, therefore, creativity is automatically devalued every time there is an advance in the technology of work.

the person labors to become sufficiently empowered to hold and to give the gift.

(It may be clearer now why I said above that a fee for service tends to cut off the force of gratitude. The point is that a conversion, in the general sense, cannot be settled upon ahead of time. We can't predict the fruits of our labor; we can't even know if we'll really go through with it. Gratitude requires an *unpaid* debt, and we will be motivated to proceed only so long as the debt is *felt*. If we stop feeling indebted we quit, and rightly so. To sell a transformative gift therefore falsifies the relationship; it implies that the return gift has been made when in fact it can't be made until the transformation is finished. A prepaid fee suspends the weight of the gift and de-potentiates it as an agent of change. Therapies and spiritual systems delivered through the market will therefore tend to draw the energy required for conversion from an aversion to pain rather than from an attraction to a higher state. There's no way to pay for a higher state unless you're in it! The labor must precede. In the hospital where I worked we would ask people if they wanted to get sober, but that was only after someone had asked them if they could afford a week in the hospital. AA only asks if you want to get sober.)

As a parable of a gifted person, 'The Shoemaker and the Elves' is also a parable for artists. Most artists early on find themselves in the position of the shoemaker on the first night – a talent has appeared, but it's naked, immature. Ahead lie the years of reciprocal labor which precede the release of an accomplished gift. To take a literary example, George Bernard Shaw underwent a typical period of retreat and maturation before he emerged as a writer. The young Shaw started a career in business and felt the threat not of failure but of success. 'I made good in spite of myself, and found, to my dismay, that Business, instead of expelling me as the worthless imposter I was, was fastening upon me with no intention of letting go.' He was twenty. 'In March, 1876, I broke loose,' he says. He left family, friends, business and Ireland. He spent about eight years *in absentia*, writing constantly (five novels, published only toward the end of his life – and then with a note by Shaw asking the buyer not to read them). Erik Erikson has commented:

> Potentially creative men like Shaw build the personal fundament
> of their work during a self-decreed moratorium, during which they

often starve themselves, socially, erotically, and, last but not least, nutritionally, in order to let the grosser weeds die out, and make way for the growth of their inner garden. Often, when the weeds are dead, so is the garden. At the decisive moment, however, some make contact with a nutriment specific for their gifts. For Shaw, of course, this gift was literature.

For the slow labor of realizing a potential gift the artist must retreat to those Bohemias, halfway between the slums and the library, where life is not counted by the clock and where the talented may be sure they will be ignored until that time, if it ever comes, when their gifts are viable enough to be set free and survive in the world.

The task of setting free one's gifts was a recognized labor in the ancient world. The Romans called a person's tutelar spirit his *genius*. In Greece it was called a *daemon*. Ancient authors tell us that Socrates, for example, had a *daemon* who would speak up when he was about to do something that did not accord with his true nature. It was believed that each man had his *idios daemon*, his personal spirit which could be cultivated and developed. Apuleius, the Roman author of *The Golden Ass*, wrote a treatise on the *daemon/genius*, and one of the things he says is that in Rome it was the custom on one's birthday to offer a sacrifice to one's own *genius*. A man didn't just receive gifts on his birthday, he would also give something to his guiding spirit. Respected in this way the *genius* made one 'genial' – sexually potent, artistically creative and spiritually fertile.

According to Apuleius, if a man cultivated his *genius* through such sacrifice, it would become a *lar*, a protective household god, when he died. But if a man ignored his *genius*, it became a *larva* or a *lemur* when he died, a troublesome, restless spook that preys on the living. The *genius* or *daemon* comes to us at birth. It carries with it the fullness of our undeveloped powers. These it offers to us as we grow, and we choose whether or not to accept, which means we choose whether or not to labor in its service. For, again, the *genius* has need of us. As with the elves, the spirit that brings us our gifts finds its eventual freedom only through our sacrifice, and those who do not reciprocate the gifts of their *genius* will leave it in bondage when they die.

An abiding sense of gratitude moves a person to labor in the service of his *daemon*. The opposite is properly called narcissism. The narcissist feels

his gifts come from himself. He works to display himself, not to suffer change. An age in which no one sacrifices to his *genius* or *daemon* is an age of narcissism. The 'cult of genius' which we have seen in this century has nothing to do with the ancient cult. The public adoration of *genius* turns men and women into celebrities and cuts off all commerce with the guardian spirits. We should not speak of another's *genius*; this is a private affair. The celebrity trades on his gifts, he does not sacrifice to them. And without that sacrifice, without the return gift, the spirit cannot be set free. In an age of narcissism the centers of culture are populated with *larvae* and *lemures*, the spooks of unfulfilled *genii*.

I want to offer a final example of transformation and gratitude, this one at quite a different level. Meister Eckhart, the fourteenth-century Christian mystic, presents a high spiritual statement of the commerce I have tried to outline between man and spirit. The specifics are quite different, of course, but the form of the exchange is the same as with the shoemaker and the elves or with the Roman and his *genius*, an escalating exchange energized, on the human side, by gratitude and culminating in the realization (and freedom) of the gift. For Eckhart, all things owe their being to God. God's initial gift to man is life itself, and those who feel gratitude for this gift reciprocate by abandoning attachment to worldly things, that is, by directing their lives back toward God. A second gift comes to any soul that has thus emptied itself of the world – a Child is born (or the Word is spoken) in the soul emptied of 'foreign images.' This gift, too, can be reciprocated, the final stage of the transformation being the soul's entrance into the Godhead.

Eckhart says: 'That man should receive God in himself is good, and by this reception he is a virgin. But that God should become fruitful in him is better; for the fruitfulness of a gift is the only gratitude for the gift.' Eckhart is speaking his own particular language here. To understand what he means we need to know, first, that according to his theology, 'God's endeavor is to give himself to us entirely.' The Lord pours himself into the world, not on a whim or even by choice, but by nature: 'I will praise him,' says this mystic, 'for being of such a nature and of such an essence that he must give.'

When Eckhart says that it is best if God becomes fruitful in man, he is commenting on a verse from the Bible which he translates as: 'Our Lord

Jesus Christ went up into a little castle and was received by a virgin who was a wife.' He interprets the verse symbolically: to be a 'virgin' has nothing to do with carnal life but refers to 'a human being who is devoid of all foreign images, and who is as void as he was when he was not yet.' A virgin is detached, someone who no longer regards the things of this life for themselves or for their usefulness. Detachment is the first station in Eckhart's spiritual itinerary. When God finds the soul detached he enters it: 'Know then, that God is bound to act, to pour himself out into thee as soon as ever he shall find thee ready . . . It were a very grave defect in God if, finding thee so empty and so bare, he wrought no excellent work in thee nor primed thee with glorious gifts.' When God pours himself into the soul, the Child is born, and this birth is the fruit of the gratitude for the gift.

If a human were to remain a virgin forever, he would never bear fruit. If he is to become fruitful, he must necessarily be a wife. 'Wife,' here, is the noblest name that can be given to the soul, and it is indeed more noble than 'virgin.' That man should receive God in himself is good, and by this reception he is a virgin. But that God should become fruitful in him is better; for the fruitfulness of a gift is the only gratitude for the gift. The spirit is wife when in gratitude it gives birth in return and bears Jesus back into God's fatherly heart.

For Eckhart we are not really alive until we have borne the gift back into the Godhead. Whatever has proceeded from God comes to life, or receives its being, only at that moment when it 'gazes back' toward Him. The circuit must be completed. 'Man ought to be flowing out into whatever can receive him.' As in the other stories we have read, we come alive when we give away what has been received. In Eckhart the passage is purely spiritual. He tells us not to pray to God for things, because things are nothing; we should simply pray to be closer to the Godhead. The final fruit of gratitude toward God is to be drowned in Him.

In the abstract Godhead there is no activity: the soul is not perfectly beatified until she casts herself into the desolate Deity where neither act nor form exists and there, merged in the void, loses herself: as self she perishes, and has no more to do with things than she had when she was not. Now, dead to self, she is alive in God . . .

The labor of gratitude accomplishes the transformation that a gift promises. And the end of gratitude is similarity with the gift or with its donor. The gifted become one with their gifts. For Eckhart, the child born in the soul is itself a god: whoever gratefully returns all that God has bestowed will, by that act of donation, enter the Godhead.

CHAPTER FOUR

THE BOND

It is the cardinal difference between gift and commodity exchange that a gift establishes a feeling-bond between two people, while the sale of a commodity leaves no necessary connection. I go into a hardware store, pay the man for a hacksaw blade and walk out. I may never see him again. The disconnectedness is, in fact, a virtue of the commodity mode. We don't want to be bothered. If the clerk always wants to chat about the family, I'll shop elsewhere. I just want a hacksaw blade.

But a gift makes a connection. To take the simplest of examples, the French anthropologist Claude Lévi-Strauss tells of a seemingly trivial ceremony he has often seen accompany a meal in cheap restaurants in the South of France. The patrons sit at a long, communal table, and each finds before his plate a modest bottle of wine. Before the meal begins, a man will pour his wine *not* into his own glass but into his neighbor's. And his neighbor will return the gesture, filling the first man's empty glass. In an economic sense nothing has happened. No one has any more wine than he did to begin with. But society has appeared where there was none before. The French customarily tend to ignore people whom they do not know, but in these little restaurants, strangers find themselves placed in close relationship for an hour or more. 'A conflict exists,' says Lévi-Strauss, 'not very keen to be sure, but real enough and sufficient to create a state of tension between the norm of privacy and the

fact of community . . . This is the fleeting but difficult situation resolved by the exchange of wine. It is an assertion of good grace which does away with the mutual uncertainty.' Spacial proximity becomes social life through an exchange of gifts. Further, the pouring of the wine sanctions another exchange – conversation – and a whole series of trivial social ties unfolds.

There are many such simple examples, the candy or cigarette offered to a stranger who shares a seat on the plane, the few words that indicate goodwill between passengers on the late-night bus. These tokens establish the simplest bonds of social life, but the model they offer may be extended to the most complicated of unions. As I took gifts at the time of death as the best examples of threshold gifts, so I would take gifts as peace overtures and gifts given in marriage as the types for the class of gifts that bring people together and make one body out of several (gifts of incorporation). The ceremonies are no different from the wine pouring. To take just one of the innumerable examples of marriage gifts, in New Caledonia when boys reach puberty they seek out girls from the clan complementary to their own and exchange tokens whose value and nature are set by custom. A boy's first question to a girl whose favor he seeks is, 'Will you take my gifts or not?' The answer is sometimes 'I will take them,' and sometimes 'I have taken the gifts of another man. I don't want to exchange with you.' To accept a boy's gifts initiates a series of oscillating reciprocations which leads finally to the formal gifts of nuptial union. Courtship in New Caledonia, it seems, is no different from courtship throughout the world.

Gifts of peace have the same synthetic character. Gifts have always constituted peace overtures among tribal groups and they still signify the close of war in the modern world, as when the United States helped Japan to rebuild after the Second World War. A gift is often the first step toward normalized relations. (To take a negative example, the United States did *not* offer aid to Vietnam after the war. The American Friends and the National Council of Churches both gave gifts to the Vietnamese – medical supplies and wheat – but Congress refused all reconstruction aid and the State Department went out of its way to frustrate the churches' attempts to ship food. For the government, it seems, the war was not over.)

The bonds that gifts establish are not simply social, they may be spiritual and psychological as well. There are interior economies and invisible economies. Gift exchanges may join figures and forces within the drama

of our inner lives. Were we to take the characters in a dream as separated powers of the soul, for example, then a gift given in a dream might serve the soul's integration. To read the Scottish tale 'The Girl and the Dead Man' in a similar fashion, the daughter who gives food to the night birds is joined to the spirit of her mother from whom she has parted in fact (while her sisters are estranged from the mother in fact and then in spirit). Gift exchange is the preferred interior commerce at those times when the psyche is in need of integration.

Our gifts may connect us to the gods as well. Sacrifice turns the face of the god toward man. We have already discussed the rites of the first fruit, a return gift that seeks to maintain relationship with the spiritual world. On the other side, the side of the gods, there are compassionate deities who approach us with gifts. The special case I want to consider here are the gods who become incarnate and then offer their own bodies as the gift that establishes the bond between man and the spiritual state to which the god pretends. In some of these cases the gift makes amends for an earlier separation. 'Christ gave his body to atone for our sins, so that we might be made one with God.' 'Sin' here is a falling away, a splitting apart: a man who sins acts so as to divide himself, internally or from his fellows or from God. 'To atone' is to reunite, to make 'at one.' There was a time when a criminal was allowed – and expected – to atone for his crime with a gift, the synthetic power of which would reestablish the broken bond and reincorporate him into the body of the group. Spiritual systems call for atonement when a particular person or mankind as a whole is seen as having fallen away from an original unity with the gods. The Christian story is well known. In the Crucifixion or in the 'Take, eat: this is my body,' Christ's body becomes the gift, the vehicle of atonement, which establishes a new covenant between man and God.*

In other spiritual systems an incarnate spirit makes a gift of the body, though not in atonement, for no fall has preceded. There are higher states to which the race might aspire, and the spirit that has attained to them gives its body to open a path and establish a connection for others who would follow. Such a gift potentially revalues or redeems mankind. Again, this aspect of the Christian story is well known. Among the stories that

* To atone and to forgive are complementary acts. In forgiving a sin, he who has been sinned against initiates the exchange that reestablishes the bond. We forgive once we give up attachment to our wounds.

are told about the Buddha there is another such tale of giving up the body. Tradition holds that the giving of alms is the first of the ten perfections required of a future Buddha. The *Jātaka*, the Pali collection of accounts of the Buddha's former lives, tells us that there was no limit to the number of existences in which Gautama Buddha became perfect in alms giving, but the height of his perfection was reached during a lifetime in which he was a rabbit, the Wise Hare. Being a Future Buddha, this hare was naturally a rather special animal, one who not only gave alms but kept the precepts and observed the fast days.

The story goes like this. On one particular fast day the Wise Hare lay in his thicket, thinking to himself that he would go out and eat some dabba-grass when the time came to break his fast. Now, as the giving of alms while fasting brings great reward, and as any beggar who came before him might not want to eat grass, the hare thought to himself, If any supplicant comes, I will give him my own flesh. Such fiery spiritual zeal heated up the marble throne of Sakka, the ruler of the heaven of sensual pleasure. Peering down toward the earth, he spied the cause of this heat, and resolved to test the hare. He disguised himself as a Brahman and appeared before the Future Buddha.

'Brahman, why are you standing there?' asked the hare.

'Pandit, if I could only get something to eat, I would keep the fast-day vows and perform the duties of a monk.'

The Future Buddha was delighted. 'Brahman,' he said, 'you have done well in coming to me for food. Today I will give alms such as I never gave before; and you will not have broken the precepts by destroying life. Go, my friend, and gather wood, and when you have made a bed of coals, come and tell me. I will sacrifice my life by jumping into the bed of live coals. And as soon as my body is cooked, eat my flesh and perform the duties of a monk.'

When Sakka heard this speech, he made a heap of live coals by using his superhuman power, and came and told the Future Buddha, who then rose from his couch of dabba-grass and went to the spot. He shook himself three times, saying, 'If there are any insects in my fur, I must not let them die.' Then 'throwing his whole body into the jaws of his generosity' (as the Sutra puts it), he jumped into the bed of coals, as delighted in mind as a royal flamingo when it alights in a cluster of lotus blossoms.

The fire, however, was unable to burn even a hair-pore of the Future

Buddha's body. 'Brahman,' said the hare, 'the fire you have made is exceed-
ingly cold. What does it mean?'

'Pandit, I am no Brahman. I am Sakka, come to try you.'

'Sakka, your efforts are useless, for if all the beings who dwell in the
world were to try me in respect to my generosity, they would not find in
me any unwillingness to give.'

'Wise Hare,' said Sakka, 'let your virtue be proclaimed to the end of this
world-cycle.' And taking a mountain in his hand, he squeezed it and,
with the juice, drew the outline of a hare on the disk of the moon.

The *Jātaka* records five hundred and fifty stories of the Buddha's ante-
rior lives; the point of these stories is to record the helical development
of Gautama Buddha through the cycles of birth and rebirth. Almsgiving
is always a part of the preparation for incorporation into a higher level,
and the story of the Wise Hare is, says the *Jātaka*, 'the acme of alms-
giving.' It is a Buddhist version of 'Take, eat: this is my body,' the highest
gift of the incarnate spirit. It is not a tale of atonement because the gift
follows no previous alienation from the spirit world. But the gift connects
the Buddha – and any who would follow his spirit – to a higher state.
We must all give up the body, but saints and incarnate deities intend
that gift, and, through it, establish bonds between man and the spiri-
tual world.

The synthetic or erotic nature of the giving of a gift may be seen more
clearly if we contrast it to the selling of commodities. I would begin the
analysis by saying that a commodity has value and a gift does not. A gift
has worth. I'm obviously using these terms in a particular sense. I mean
'worth' to refer to those things we prize and yet say 'you can't put a price
on it.' We derive value, on the other hand, from the comparison of one
thing with another. 'I cannot express the value of linen in terms of linen,'
says Marx in the classic analysis of commodities which opens his *Capital*.
Value needs a difference for its expression; when there is no difference we
are left with tautology ('a yard of linen is a yard of linen'). The phrases
'exchange value' and 'market value' carry the sense of 'value' I mean to
mark here: a thing has no market value in itself except when it is in the
marketplace, and what cannot be exchanged has no exchange value.*

* I use 'value' and 'worth' when I want to mark this distinction. I was therefore delighted

It is characteristic of market exchange that commodities move between two independent spheres. We might best picture the difference between gifts and commodities in this regard by imagining two territories separated by a boundary. A gift, when it moves across the boundary, either stops being a gift or else abolishes the boundary. A commodity can cross the line without any change in its nature; moreover, its exchange will often establish a boundary where none previously existed (as, for example, in the sale of a necessity to a friend). *Logos*-trade draws the boundary, *eros*-trade erases it.

In his analysis of commodities, Marx gives many examples of useful objects which are the product of human labor but which are not commodities. A man who makes his own tools does not make commodities. Likewise, 'in the primitive communities of India . . . the products of . . . production do not become commodities.' The materials that circulate *inside* a factory are not commodities. Marx intends by all of these examples to underline his point that a commodity becomes such when it moves between two separate spheres (without, we would add, abolishing their separation). 'The only products which confront one another as commodities are those produced by reciprocally independent enterprises.'

This being the case, commodity exchange will either be missing or frowned upon to the degree that a group thinks of itself as one body, as 'of a piece.' Tribal groups or Marx's 'primitive communities of India' or close-knit families would all be examples. There is a famous law in the Old Testament – which I shall expand upon in a later chapter so as to present a history of gift exchange – a double law which prohibits the charging of interest on loans to members of the tribe while allowing that it may be charged to strangers. In terms of the present analysis, such a law asks that gift exchange predominate within the group (particularly in the case of needy members), while allowing that strangers may deal in commodities (money let out at interest being commodity-money or stranger-money). The boundary of the group is the key to which of the two forms of exchange is proper. Such a double law is not at all peculiar to the Jews; any close-knit group will express their sense of 'brothers and others' in a double economy. In an earlier chapter I referred to an ethic

to find the following footnote in Marx: 'In the seventeenth century, many English authors continued to write "worth" for "use-value" and "value" for "exchange-value", this being accordant with the genius of a language which prefers an Anglo-Saxon word for an actual thing, and a Romance word for its reflexion.'

among the Uduk: 'any wealth transferred from one subclan to another, whether animals, grain or money, is in the nature of a *gift*, and should be consumed, not invested for growth.' No such prohibition applies to dealings with strangers, but the subclans of the Uduk intermarry; they are meant to be 'of a piece,' and the preferred economy is therefore gift exchange, not market exchange.

If a thing is to have a market value, it must be detachable or alienable so that it can be put on the scale and compared. I mean this in a particular sense: we who do the valuation must be able to stand apart from the thing we are pricing. We have to be able to conceive of separating ourselves from it. I may be fond of my wristwatch but I can put a value on it because I can imagine parting with it. But my heart has no market value (at least not to me!), for to detach it is inconceivable. (I address below the interesting question of value in relation to body organs used for transplant.) We feel it inappropriate, even rude, to be asked to evaluate in certain situations. Consider the old ethics-class dilemma in which you are in a lifeboat with your spouse and child and grandmother and you must choose who is to be thrown overboard to keep the craft afloat – it's a dilemma because you are forced to evaluate in a context, the family, which we are normally unwilling to stand apart from and reckon as we would reckon commodities. We are sometimes forced into such judgments, to be sure, but they are stressful precisely because we tend not to assign comparative values to those things to which we are emotionally connected.

Let us take one example each of the form of deliberation appropriate to marketing a commodity and to giving a gift. I intend these examples to illustrate the nature of the gift bond, to show that a bond precedes or is created by donation and that it is absent, suspended, or severed in commodity exchange. I have chosen rather striking cases here – how the Ford Motor Company marketed its Pinto automobile and how people who are called upon to do so decide whether or not to give one of their kidneys to a dying relative – yet each case is typical of the contrast between gift and commodity in that it is the presence or absence of an emotional connection which determines the mode of evaluation.

One classic way of evaluating the production, sale, or purchase of a commodity is cost-benefit analysis, in which a balance sheet is drawn up for some undertaking, weighing its expenses against its rewards. Cost-benefit analyses have met with justifiable scorn in recent years because they often involve a hidden confusion or deliberate obfuscation of the differ-

ence between worth and value. We feel some things to be gifts by nature, and these cannot be entered into a cost-benefit analysis because they cannot be priced. What is or isn't a gift, however, is a matter of belief or custom, so it is not necessarily obvious when quantitative evaluation is improper.

In a classic example both of cost-benefit analysis and of the confusion between worth and value, the Ford Motor Company had to decide if it should add an inexpensive safety device to its Pinto cars and trucks. The Pinto's gas tank was situated in such a way that it would rupture during a low-speed rear-end collision, spilling gasoline and risking a fire. Before putting the car on the market, Ford tested three different devices that would tend to prevent the rupturing of the tank. One would have cost $1, another around $5, and the third, $11. In the end, however, Ford decided that benefits did not justify costs, and no safety feature was added to the vehicle. According to Mark Dowie, between 1971, when the Pinto was introduced, and 1977, when the magazine *Mother Jones* printed Dowie's analysis of the case, at least five hundred people burned to death in Pinto crashes.

In order to apply a cost-benefit analysis to a situation in which the core equation is 'cost of safety parts vs cost of lives lost,' one must first put a price on life. Ford was spared the embarrassment of doing this themselves because the National Highway Traffic Safety Administration had already done it and Ford merely cribbed the figures. Here, as it appeared in a 1971 NHTSA study, is the itemized price of a traffic fatality, including a precise figure for 'pain and suffering':

ITEM	COST
Future Productivity Losses	
Direct	$132,000.
Indirect	41,300.
Medical Costs	
Hospital	700.
Other	425.
Property Damage	1,500.
Insurance Administration	4,700.
Legal and Court	3,000.
Employer Loses	1,000.

Victim's Pain & Suffering	10,000.
Funeral	900.
Assets (Lost Consumption)	5,000.
Misc. Accident Cost	200.
TOTAL per fatality:	$200,725.

A Ford Motor Company internal memorandum estimated that if the
Pinto was sold without the $11 safety feature, 2,100 cars would burn every
year, 180 people would be hurt but survive, and another 180 would burn
to death. Rounding off the government's figure, Ford put the price of a life
at $200,000. They estimated a survivor's medical bills at $67,000 and the
cost of a lost vehicle at $700. Given the market – 11 million cars and 1.5
million light trucks every year – the company then drew up the following
balance sheet:

BENEFIT *money saved by a safer car*	COSTS *money spent on safety device*
180 deaths X $200,000 + 180 injuries X $67,000 + 2,100 vehicles X $700	11 million cars X $11 per part +1.5 million trucks X $11
= $49.5 million	= $137.5 million

As the costs so clearly exceed the benefits, the decision was made not to
spend money on the safety feature.

If we accept for a moment that human life may be counted as a commodity,
the story of the Pinto offers a picture of decision-making in the market-
place. The classic model of market deliberation assumes an 'economic man'
whose desire is to increase his rewards and cut his costs. *Homo oeconomicus*
identifies the elements of a problem and all of its possible solutions, treating
no element as so much a part of himself that his emotions would be unduly
stirred by its alienation. He lines up his choices, assigns prices to them,
weighs one against another, chooses his course and acts. Few of our deci-
sions benefit from such complete analysis, of course, but nonetheless it is
our goal in the marketplace to deliberate in this quantitative and compar-
ative manner. How, then, do we make choices that involve gifts?

Some of the most interesting recent work on this question has come from studies of people who have been asked to give one of their kidneys to a mortally ill relative. The human body is able to function with a single kidney, though nature has given us two. It is now the case that another person's kidney can be transplanted into the body of someone whose own kidneys have failed. The greatest problem with such transplants has been that the recipient's immunological system, reacting as if the body had been invaded by a disease or by a foreign protein, attacks and destroys the new kidney. The closer the match between the blood type and tissue of the donor and those of the recipient, the less likely it is that the kidney will be identified as 'foreign' and rejected. Kidney transplants are therefore more successful when the donor is a close relative. An identical twin is ideal, followed by siblings and then by parents or offspring. In 90 percent of the cases, transplants from a twin are still viable after two years. With other related donors, the success rate is around 70 percent. Kidneys from non-relatives (usually from cadavers) are accepted about half the time.

How does a person go about deciding to give someone a kidney? The decision is not a trivial one. There is some risk (about 1 in 1,500 donors dies as a result of his or her gift). The operation is major. It calls for several days of hospitalization and a month or more of convalescence; it involves considerable pain and leaves a scar that runs halfway around the abdomen. Not surprisingly, then, some individuals, when they become aware that a relative might need one of their kidneys, think it over in the classical 'economic' fashion. They seek information about the operation – its risks and benefits; they talk to and compare themselves with other potential donors; they discuss the prognosis with the family doctor, and so on.

What is surprising, however, is that such deliberation is not at all usual. The majority of kidney donors volunteer to give as soon as they hear of the need. The choice is instantaneous; there is no time delay, no period of deliberation. Moreover, the donors themselves do not regard their choice as a decision at all! When asked how she had made up her mind, a mother who had given a kidney to her child replied, 'I never thought about it . . . I automatically thought I'd be the one. There was no decision to make or sides to weigh.' A woman who gave a kidney to her sister said, 'I don't think it was a decision. I really didn't consider much. I kept thinking "What was the decision?" . . . As far as I was concerned . . . , I would donate a kidney.' These quotations come from a study done at the University of Minnesota; for most donors, the study concluded, 'the term *decision* appears

to be a misnomer. Insofar as decision-making implies a period of deliberation and conscious choice of one alternative, most individuals do not feel as if they have made a decision. Although the gift of a kidney is a major sacrifice, the majority of donors appear to have known instantaneously that they would give the gift, and they report no conscious period of deliberation.'

I have been focusing this contrast between commodity and gift on the issue of relationship, the emotional ties between the parties in the exchange. We do not deal in commodities when we wish to initiate or preserve ties of affection. One hardly needs a study (though the studies have been done) to know that people who give one of their kidneys give it to someone they feel close to (and the gift brings them even closer). The instantaneous decision of these organ donors should not be such a surprise, after all. Situations calling for gifts are exactly those in which we find inappropriate the detachment of analytic deliberation. Sometimes it won't even occur to us. As the woman said, there are 'no sides to weigh.' Instantaneous decision is a mark of emotional and moral life. As an expression of social emotion, gifts make one body of many – almost literally in this case – and when a person comes before us who is in need and to whom we feel an unquestioning emotional connection, we respond as reflexively as we would were our own body in need.

Emotional connection tends to preclude quantitative evaluation. To return briefly to the Pinto story, when a decision involves something that clearly cannot be priced, we refrain from submitting our actions to the calculus of a cost-benefit analysis. The executives at Ford seem so sleazy because we find it hard to suspend our sense that life is not a commodity. To some degree, what constitutes a gift is a matter of opinion, of course. For example, wherever there has been slavery, some life has carried a price and some not. Arable land is treated as a commodity nowadays, but there have been times and places when it was improper for it to be bought and sold. Similarly with food. 'The Yakut refused to believe,' writes an anthropologist, 'that somewhere in the world people could die of hunger, when it was so easy to go and share a neighbor's meal.' We do not put a price on food if it is an inalienable part of the community. It would still be hard to find a family where food is sold at the dinner table, but beyond that there are few who feel it indecent to announce the price of a meal. Executives at Ford might have hesitated to buy Pintos for their own children, but no sense of their oneness with the rest of human life inhibited them from

assigning it a price for their analysis. The great materialists, like these auto-mobile executives, are those who have extended the commodity form of value into the human body, while the great spiritual figures, like the Buddha, are those who have used their own bodies to extend the worth of gifts just as far.

Because of the bonding power of gifts and the detached nature of commodity exchange, gifts have become associated with community and with being obliged to others, while commodities are associated with alien-ation and freedom. The bonds established by a gift can maintain old iden-tity and limit our freedom of motion. To take a simple example, as soon as an adolescent truly wants to leave his parents, he does well to stop accepting their gifts, for they only maintain the parent-child bond. If you want out, you pay your own way. I had a friend in college who once decided to stop participating in the family celebration of Christmas. He explained himself in several ways – the great distance to travel, the waste of money, the commercialization of the holiday – but whatever the reason, his absence removed him from a gift ceremony that would have reaffirmed his connection to family at exactly the time when he wanted to leave it. (The same friend re-joined the family Christmas in later years, the group spirit of a gift holiday being less threatening once he had established his own identity.)

It seems no misnomer that we have called those nations known for their commodities 'the free world.' The phrase doesn't seem to refer to political freedoms; it indicates that the dominant form of exchange in these lands does not bind the individual in any way – to his family, to his community, or to the state. And though the modern state is too large a group to take its structure from bonds of affection, still, the ideology of the socialist nations begins with the call for community. 'Labor should not be sold like merchandise but offered as a gift to the community,' Che Guevara used to say. The young writers in Cuba refuse royalties for their books. 'In a socialist society literary property cannot be private,' they say. The revolution belongs to everyone and everyone belongs to the revolu-tion, they say.

In states that profess to be such a 'big family' we can well expect an equivalent to my friend's refusal to participate in Christmas. The jails in the free world are full of people who have committed 'crimes against prop-

erty,' but in the East, it seems, they lock men up for crimes 'in favor of property.' There will always be times when we want to act upon our *discon*nection from the group. Herein must lie the fascination of Communist youth for Western commodities. Teenagers in Prague will risk their futures to acquire a pair of genuine Levis. In Russia there are secret societies of owners of Beatles records. A young man approaches a Western newsman in Peking to ask if he will buy him a Sony tape deck next time he's in Hong Kong. He knows all the model numbers.

The excitement of commodities is the excitement of possibility, of floating away from the particular to taste the range of available life. There are times when we *want* to be aliens and strangers, to feel how the shape of our lives is not the only shape, to drift before a catalog of possible lives, staring at the glass arcades of shoes that are sensible and shoes for taking a chance, buses leaving town and the gray steam railway depot where men and women hurry by with their bags.

It is not simply luxury the teenagers of Peking and Prague want. All youth wants, once, to be alienated from the bonds that nurture, to be the prodigal son. Sometimes we go to the market to taste estrangement, if only to fantasize what our next attachment might be. This experience is so available in the West, of course, that we are well aware of its short-comings. The freedom of the free world tends toward the perfect freedom of strangers. When Vietnamese refugees settled in Southern California they found its culture toxic to something they had always taken for granted, their family life. It's a free country, you can do what you want: get married, get divorced, settle down, leave town, ski, farm, talk on the radio, buy the radio; the problem is to find someone to do it with. In this old lovers' quarrel between liberty and community, Westerners are those who defend freedom and long for attachment. The tone of Country and Western music must be the American complement to blue-jeans mania in the East. In the typical Country song, a man is driving his Studebaker away from a bad marriage, toward the lights of town; or else he's working in the car factory in Detroit, all alone and pining for his home in the mountains. The truck drivers who figure so largely in these songs are a perfect image of commodity incarnate: free as a bird and lonesome. Given the choice, we choose the road. Those particularly American movie heroes, the cowboy and the private eye, act out for us the drama of survival in a land where man has no attachments. The cowboy and the detective survive despite lives of complete rootlessness, and they do it by

fighting the lawlessness that is the necessary companion to the perfect freedom of strangers.

The conflict between freedom and the bonds that gifts establish is not absolute, of course. To begin with, gifts do not bring us attachment unless they move us. Manners or social pressure may oblige us to those for whom we feel no true affection, but neither obligation nor civility leads to lasting unions. It is when someone's gifts stir us that we are brought close, and what moves us, beyond the gift itself, is the promise (or the fact) of transformation, friendship, and love.

The issue of bondage and freedom has been well addressed in the literature on organ donors. Early writers on the psychology of organ donation confessed considerable trepidation because they saw that the exchange was inherently unequal, a case of a gift so valuable it could not possibly be reciprocated. 'The gift not yet repaid debases the man who accepts it,' Marcel Mauss had written. Might not problems of indebtedness create an inexorable tension? What if the recipient avoided the donor, resenting his subordinate position? What if the donor took advantage of the debt and attempted to exert his will over the recipient? One man who pondered these risks went so far as to suggest a sort of incest taboo prohibiting live organ transplants between close relatives.

Problems between donors and recipients have in fact occurred, but they are rare. Gifts bespeak relationship. As long as the emotional tie is recognized as the point of the gift, both the donor and the recipient will be careful to structure the exchange so that it does not jeopardize their mutual affection. The University of Minnesota study found that kidney donors typically seek to define their gift so as to minimize the recipient's sense of debt. A young man who gave a kidney to his mother insisted on referring to it as a return gift for her having borne him in the first place. A man who donated to his brother said, 'I don't make him feel he should pay me back because he doesn't owe me anything . . . I don't want him to feel grateful . . . He doesn't owe me a thing.' The point is simply that donors who care about the relationship seek to assure that their gift is *not* perceived in terms of power and debt. They may in fact expect gratitude and be hurt if it is not forthcoming, but nonetheless, those donors who prize their closeness to the recipient are careful to make it clear that the gift is not conditional.

Recipients are likewise aware of their relationship to the donor as it exists over and above this particular gift, and their gratitude is not a response to

the gift so much as to the affection it carries. When the affection is missing, so is the gratitude. In one rather striking case in the Minnesota study, a woman who was to receive a kidney from her daughter found the girl saying that she would donate *if* her mother would buy her an expensive coat! Here is the mother's description of the daughter a year after the transplant:

> She's a very selfish girl and not very mature in many ways . . . She's not used to doing things for people. She didn't think her life should be constricted in any way . . . She wanted a fur coat. It really shook me up. It was unnerving . . . She was reluctant and un-enthusiastic . . . She's very calculating.

Asked if the gift had made her uncomfortable, the mother replied, 'I'm not uncomfortable. I've put up with so much . . . then she turns around and kicks us in the teeth.' The daughter even saw fit to complain to her mother about postoperative pain. 'I said to her, "I didn't tell you about my labor pains." And that shut her up.'

The story is hardly a model of familial affection, but the reader will note that despite its magnitude, the gift did not render the mother subservient to the daughter. And for a good reason: it wasn't a gift. As soon as the daughter shifted the category of the exchange and tried to barter, all of her authority drained away. When either the donor or the recipient begins to treat a gift in terms of obligation, it ceases to be a gift, and though many in such a situation will be hurt by the revealed lack of affection, the emotional bond, along with its power, evaporates immediately.

We cannot really become bound to those who give us false gifts. And true gifts constrain us only if we do not pass them along – only, I mean, if we fail to respond with an act or an expression of gratitude. We might here remember the stories of *genius* and of the shoemaker's elves, for they make it clear that there is a kind of servitude associated with gifts of transformation. We are indentured to our gifts until they come to term. But this is a willing bondage, and the bond is loosened with the maturation of the gift. Our servitude is ended by the act of gratitude which accomplishes the transformation. The elves and the shoemaker are quit of each other then, just as *genius* becomes free spirit. Bondage to our gifts (and to the teachers who wake them) diminishes as we become empowered to pass them along. It is true that when a gift enhances our life, or even saves it, gratitude will bind us to the donor. Until it is expressed, that is. Gratitude, acted upon or

simply spoken, releases the gift and lightens the obligations of affection between lovers, family, and comrades. Is it really proper, then, to speak of the ties of affection as a bondage? These are attachments to be desired. When gift exchange achieves a convivial communion of spirits, there is no call for liberty; it is only when our attachments become moribund that we long to break them. Interesting as the subject may be, it is not for a theory of gift exchange to explain why we so often enter and maintain relationships that have in them no life to offer.

Because gifts do have the power to join people together, there are many gifts that must be refused. On the simplest level, we are wary of gifts in any situation that calls for reckoning and discrimination. If I am to negotiate a contract, I do well to pause when the man who wants my signature offers a three-course meal with wine. For, if I am a man of goodwill, I may subsequently feel my generosity rise as the time comes to put my name on the line. A gift, no matter how well intentioned, deflects objective judgment. Persons whose position in society demands that they maintain their objectivity – I am thinking now of policemen, politicians, judges – are expected, even required, to refrain from gift exchange. A judge should embody the law's impartiality. We want to feel he can separate himself from the particulars of his class, race, and religion; we certainly want to feel he has no tie to either the prosecution or the defense. Similarly, we would be suspicious of a congressman who accepted secret contributions from the liquor industry, or a doctor who took gifts from pharmaceutical companies. We want the doctor to be concerned about our health, and not feel a convivial communion with some proprietary drug.*

Despite my earlier caveat about fees for service, there are times when it would be inappropriate for a psychotherapeutic relationship to be a gift relationship. All healers risk contamination from their patients. In psychotherapy the doctor and the patient may both feel the need for a kind of distance between them. There are patients who can't begin to work until

*The prohibition on gifts to public servants has always been a problem because our expectations are conflicting: we want such people to become a part of their community, but we do not want them to be beholden to one particular element. Is a policeman who accepts an apple from the greengrocer an extortionist? Is he a lackey of the grocery trade, or is he merely accepting and expressing his connection to the group he serves?

they sense that their illness won't destroy the person to whom it is revealed. They are not seeking an erotic attachment. In the Catholic Church the risk of contamination from confession is addressed by the architecture of the confessional itself: a grille or cloth stands between penitent and priest. Though it has other functions, the anonymity of the confessional shields the priest so that he may speak of sin without being drawn into it. The fee in psychotherapy may be a modern equivalent to the screen in the confessional, making it clear that the therapist is distinct from the client (as we now say). The fee states clearly that the therapist is not a friend or lover or parent. Freudian analysts maintain further that the fee is an aide in the resolution of the transference. The patient's unconscious emotions are expected to be transferred to the analyst in the beginning, but in the end they are to be withdrawn, and it will help if the relationship is a market relationship in which therapist and client are, as Marx says of commodities, 'reciprocally independent enterprises.'*

Gift exchange must also be refused when there is a real threat in the connections that it offers. In ancient tales the hero who must pass through hell is warned that charity is dangerous in the underworld; if he wishes to return to the land of the living, he should lend a hand to no one, nor accept the food offered by the dead.

An Irish fairy tale offers a similar warning. In return for an act of charity the Queen of the Fairies invites a midwife to festivities at Fairy Knoll. The man who comes to lead the midwife to the fairies says that he himself is not a fairy, but a human who lies under their spell. He gives her instructions so that she may avoid his fate and return to her home. 'I will come for you when your time is out,' he concludes, 'and then the fairies will gather about you, and each one of them will offer you something to take with you as a gift. You may take anything they will give you, except gold or silver.'

Some days later the man returns to guide the midwife home. As he foretold, the fairies gather around with gifts. She takes everything but the gold and silver. Then, as she rides off with her guide, he tells her to throw one

* Alcoholics who get sober in AA tend to become very attached to the group, at least to begin with. Their involvement seems, in part, a consequence of the fact that AA's program is a gift. In the case of alcoholism, the attachment may be a necessary part of the healing process. Alcoholism is an affliction whose relief seems to require that the sufferer be bound up in something larger than the ego-of-one (in a 'higher power,' be it only the power of the group). Healings that call for differentiation, on the other hand, may be more aptly delivered through the market.

of the fairy gifts away. As soon as it strikes the ground it explodes like a bomb, burning the bushes around it. The midwife throws each gift away, and each one burns as it hits. 'Now,' says the guide, 'had you kept those things until you went home, they would have set the house on fire and burnt all that was in it, including yourself.'

The tale says there are powers in the fairy world which cannot be contained in the human. In speaking of increase in the last chapter I mentioned tales in which a spirit gift grows in worth when the mortal arrives at his doorstep. Here the increase seems too huge. The tale smells like a warning about psychosis.* Had the midwife tried to bring the gifts into the house, she would have been like a young person who gets involved with psychedelic drugs before the ego is strong enough to contain the experience. There are powers so great that if we were to try to live with them they would consume our dwelling place. The fairy gifts must be abandoned.

Gifts from evil people must also be refused lest we be bound to evil. In folk tales the hero is well advised to refuse the food and drink offered him by a witch. Folk wisdom similarly advises silence before evil. Conversation is a commerce, and when we give speech we become a part of what we speak with. A bewitched princess in one of the Grimms' tales says to the man who wants to save her, 'Tonight twelve black men, draped with chains, will be coming; they'll ask you what you're doing here. Keep silent, however, and don't answer them.' She says they will beat him and torture him and finally kill him, but if he does not utter 'a single solitary word,' she will be freed and will revive him with the Water of Life. Were he to speak with the black men, he would enter their bewitchment, just as the midwife would have fallen under the spell of the fairies if she had accepted their gold and silver.

It is because gift exchange *is* an erotic form that so many gifts must be refused. The issue commonly arises in public life. Should a university accept an endowment from a notorious dictator? Should a writer or a scientist accept a grant from a government waging an immoral war? We often refuse relationship, either from the simple desire to remain unentangled, or because we sense that the proffered connection is tainted, dangerous, or frankly evil. And when we refuse relationship, we must refuse gift exchange as well.

* Schizophrenia occurs at about the same rate throughout the world with two exceptions: it is more common in one area of northern Sweden and in all of Ireland. This tale is Gaelic. The strained relations between fairies and mortals in Gaelic tales seem appropriate to a land where commerce with the spirits is unusually risky.

CHAPTER FIVE

THE GIFT COMMUNITY

In the early 1950s Lorna Marshall and her husband lived with a band of Bushmen in South Africa. When they left they gave each woman in the band enough cowrie shells for a short necklace, one large brown shell and twenty smaller gray ones (the shells came from a New York dealer, Marshall remarks, 'perhaps to the confusion of future archaeologists.') There had been no cowrie shells among the Bushmen before the Marshalls gave their going-away present. When they returned a year later, they were surprised to find hardly a single one left in the band where they had been given. 'They appeared, not as whole necklaces, but in ones and twos in people's ornaments to the edges of the region.'

This image of the seashells spreading out in a group like water in a pool takes us from the simple, atomic connections between individuals to the more complicated organization of communities. If we take the synthetic power of gifts, which establish and maintain the bonds of affection between friends, lovers, and comrades, and if we add to these a circulation wider than a binary give-and-take, we shall soon derive society, or at least those societies – family, guild, fraternity, sorority, band, community – that cohere through faithfulness and gratitude. While gifts are marked by motion and momentum at the level of the individual, gift exchange at the level of the

group offers equilibrium and coherence, a kind of anarchist stability. We can also say, to put the point conversely, that in a group that derives its cohesion from a circulation of gifts the conversion of gifts to commodities will have the effect of fragmenting the group, or even destroying it.

To take a modern illustration rather than another tribal tale, Carol Stack, in her book *All Our Kin*, presents an instructive description of the commerce of goods in the Flats, an urban ghetto south of Chicago. The Flats is a black neighborhood characterized by networks of cooperating kin. 'Kin' in this context are not just blood relations, they are 'those you count on,' related or not. Each kinship network in the Flats is composed of as many as a hundred individuals, all of whom belong in one way or another to one of several interlocking households.

Stack tells a sad but instructive story about an influx of capital into one of the families she knew. One day Calvin and Magnolia Waters inherited some money. One of Magnolia's uncles in Mississippi had died and left them $1,500. It was the first time they'd ever had a cash reserve, and their immediate hope was to use the money as a down payment on a house.

Here's what happened to it.

Within a few days the news of their good fortune had spread throughout the kin network. One of Magnolia's nieces soon came to ask if she could borrow $25 to pay a bill so the phone would not be turned off. Magnolia gave her the money. The welfare office heard about the inheritance and cut off medical coverage and food stamps for Magnolia's children, telling her that she would get no more until the money was gone. Then Magnolia's uncle in the South became seriously ill, and she and her older sister Augusta were called to sit by his side. Magnolia bought round-trip train tickets for herself, her sister, and three of her children. After they had returned, the uncle died, and she and her sister had to go south again. Soon thereafter Augusta's first 'old man' died, leaving no one to pay for his burial. Augusta asked Magnolia if she would help pay for the digging of the grave, and she did. Another sister's rent was two months overdue; the woman was ill and had no source of income. Magnolia paid the rent. It was winter and the children and grandchildren (fifteen in all) were staying home from school because they had neither winter coats nor adequate shoes. Magnolia and Calvin bought all of them coats, hats and shoes. Magnolia bought herself a winter coat and Calvin bought a pair of work shoes.

The money was gone in six weeks.

The only way this couple could have capitalized on their good fortune

would have been to cut themselves off from the group.* To make a down payment on a house, they would have had to cease participating in the sharing and mutual aid of their kin. One of Magnolia's sisters, Lydia, had done just that at one time. She and the man she married both had steady jobs. They bought a house and furniture. Then, for ten years, they cut themselves off from the network of kin cooperation, effectively preventing their friends and relations from draining their resources. In our modern symbology, they 'moved to the suburbs.' Then the marriage began to break up. Lydia started giving clothes to her sisters and nieces. She gave a couch to her brother and a TV to a niece. By the time her marriage had fallen apart, she had reincorporated herself into the network.

It isn't easy to say which is the 'better' sister, the hard-hearted one ('far-hearted,' the Bushmen say) who separates herself from a community that would pull her down or the soft-hearted one who dreams of getting ahead but in fact distributes her wealth and stays in the group. There's no simple moral because there's no simple way to resolve the conflict between community and individual advancement, a conflict that accounts for so much of our political and ethical life. But the story nonetheless illustrates our general point, that a group may form, cohere, and endure when property circulates as gift, and that it will begin to fragment when the gift exchange is interrupted or when gifts are converted to commodities.† Both this story and the one about the Bushmen treat people who are so poor that one hesitates to praise the virtues of 'community,' lest it seem to romanticize oppression and privation. These are groups who adopt a necessary mutual aid, not a voluntary poverty. And the rewards of community lose some of their luster when they are not a matter of choice. I want to turn from the ghetto and the desert, therefore, to see how this vision of 'gift community' might be filled out using a less thorny, more subtle case, that of the community of science.

In order to proceed within the terms of our wider argument, we will

* A third alternative, besides sharing and separation, is deceit. In Mexican peasant communities, which are marked by similar networks of mutual aid, one finds the opposite of 'conspicuous consumption': a family that has become rich will maintain the shabbiest of adobe walls around the house so that their wealth will not be apparent. Magnolia and Calvin could have squirreled away the money, leaving the rent unpaid, the dead unburied, and the children unclothed.
† Magnolia could have turned her inheritance into commodity-money by loaning it out at interest. In the long run she would have needed loan collectors, police and so forth to pull it off, however – the conflicts with the spirit of a kin network should be obvious.

need to ask not just how scientific community emerges and endures, but specifically what happens to it when scientific knowledge circulates as a gift, and what happens when knowledge is treated as a commodity, for sale at a profit. The man who has done the most work on the organization of science in the United States is a sociologist from the University of Michigan, Warren Hagstrom. Hagstrom's point of departure is similar to mine. He begins his discussion of the commerce of ideas in science by pointing out that 'manuscripts submitted to scientific periodicals are often called "contributions," and they are, in fact, gifts.' It is unusual for the periodicals that print the work of scientists to pay their contributors; indeed, the authors' institutions are often called upon to help defray the cost of publication. 'On the other hand,' Hagstrom says, 'manuscripts for which the scientific authors do receive financial payments, such as textbooks and popularizations, are, if not despised, certainly held in much lower esteem than articles containing original research results.' (The same is true in the literary community. It is the exception, not the rule, to be paid for writing of literary merit, and the fees are rarely in accord with the amount of labor. There is cash in 'popular' work – gothic novels, thrillers, and so forth, but their authors do not become bona fide members of the literary community.)

Scientists who give their ideas to the community receive recognition and status in return (a topic to which I shall return below). But there is little recognition to be earned from writing a textbook for money. As one of the scientists in Hagstrom's study puts it, if someone 'has written nothing at all but texts, they will have a null value or even a negative value.' Because such work brings no *group* reward, it makes sense that it would earn a different sort of remuneration, cash. 'Unlike recognition, cash can be used outside the community of pure science,' Hagstrom points out. Cash is a medium of foreign exchange, as it were, because unlike a gift (and unlike status) it does not lose its value when it moves beyond the boundary of the community. By the same token, as Hagstrom comments elsewhere, 'one reason why the publication of texts tends to be a despised form of scientific communication [is that] the textbook author appropriates community property for his personal profit.' As with the Cubans who say, 'literary property cannot be private,' when and if we are able to feel the presence of a community, royalties (like usury) seem extractive.

Scientists claim and receive credit for the ideas they have contributed to

science, but to the degree that they are members of the scientific commu-
nity, such credit does not get expressed through fees. To put it conversely,
anyone who is not a part of the group does 'work for hire'; he is paid a 'fee
for service,' a cash reward that compensates him for his time while simul-
taneously alienating him from his contribution. A researcher paid by the
hour is a technician, a servant, not a member of the scientific community.
Similarly, an academic scientist who ventures outside of the community to
consult for industry expects to be paid a fee. If the recipients of his ideas
are not going to treat them as gifts, he will not give them as gifts. The inverse
might be the old institution of 'professional courtesy' in which professionals
discount their services to each other (an optical physicist visiting an ophthal-
mologist may find $15 knocked off his bill when he leaves, for example).
The custom is the opposite of a 'fee for service' in that it changes what
would normally be a market transaction into a gift transaction (removing
the profit) as a recognition of the fact that the 'buyer and seller' are members
of the same community and it is therefore inappropriate to profit from each
other's knowledge. We are seeing here the same sort of double economy
that characterized tribal groups, from the Old Testament to the Uduk. Any
exchange, be if of ideas or of goats, will tend toward gift if it is intended to
recognize, establish, and maintain community.

In communities drawn together by gift exchange, 'status,' 'prestige,' or
'esteem' take the place of cash renumeration. No one will deny that one
reason scientists contribute the results of their research to journals is to
earn recognition and status. Sooner or later the question arises: Wouldn't
we do better to speak of these contributions in terms of ambition and
egotism? Might not a theory of competition better account for scientific
publication? To begin with, we should notice that the kind of status we are
speaking of is achieved through donation, not through acquisition. The
distinction is important. The Indians of the Northwest American coast also
give gifts in order 'to make a name' for themselves, to earn prestige. But
notice: a Kwakiutl name is 'raised' by giving property and 'flattened' by
receiving it. The man who has emptied himself with giving has the highest
name. When we say that someone made a name for himself, we think of
Onassis or J. P. Morgan or H. L. Hunt, men who got rich. But Kwakiutl
names, first of all, are not the names of individuals; they are conferred
upon individuals, yes, but they are names on the order of 'Prince of Wales,'
meant to indicate social position. And here are some of them:

- Whose Property is Eaten in Feasts
- Satiating
- Always Giving Blankets While Walking
- For Whom Property Flows
- The Dance of Throwing Away Property

Some names, it is true, are agonistic (Creating Trouble All Around), but the majority refer to the outflow of property. A man makes a name for himself by letting wealth slip through his fingers. He may control the goods, but it is their dispersal he controls. Just as the anthropologist may say of the Indians, 'virtue rests in publicly disposing of wealth, not in its mere acquisition . . . ,' so Hagstrom writes that 'in science, the acceptance by scientific journals of contributed manuscripts establishes the donor's status as a scientist – indeed, status as a scientist can be achieved *only* by such gift-giving – and it assures him of prestige within the scientific community.' A scientist *does* contribute his ideas in order to earn status, but if the name he makes for himself is He Whose Ideas Are Eaten in Conferences, we need not call his contributions meretricious. This status is not the status of the egotist.*

It is true that many people in science will scoff if you try to tell them about a scientific community in which ideas are treated as gifts. This has not been their experience at all. They will tell you a story about a stolen idea. So-and-so invented the famous such and such, but the man down the hall hurried out and got the patent. Or so-and-so used to discuss his research with his lab partner but then the sneaky fellow went and published the ideas without giving proper credit. He did it because he's competitive, they say, because he needed to secure his degree, because he had to publish to get tenure – and all of this is to be expected of departmentalized science in capitalist universities dominated by contractual research for industry and the military.

But these stories do not contradict the general point. I am not saying

*A gift economy allows its own form of individualism: to be able to say 'I gave that.' After he had lived with the Sioux Indians for a while, Erik Erikson commented about their treatment of children: 'A parent . . . would not touch a child's possessions, because the value of possessions lay in the owner's right to let go of them when *he* was moved to do so – i.e., when it added prestige to himself and to the person in whose name he might decide to give it away.' Individualism in a gift economy inheres in the right to decide when and how to give the gift. The individual controls the flow of property away from him (rather than toward him, a different individualism).

science *is* a community that treats ideas as contributions; I am saying it becomes one *to the degree* that ideas move as gifts. Each of these stories demonstrates the general point, though by way of exception. In each case the personal aggrandizement – the theft of an idea, the profiteering – breaks up the group. No one will talk over nascent ideas with a fellow known to have a hot line to his patent attorney. The man whose ideas were stolen stops talking to his lab partner. Where status is bestowed according to the contribution of original ideas, a thief may survive for a while, but in the long run someone smells a rat, notoriety replaces prestige, ill repute replaces esteem, and the crook is out in the cold.

We should now face the question of exactly why ideas might be treated as gifts in science. To answer it we shall be obliged to speak first of the function of the scientific community. Let us say briefly that the task of science is to describe and explain the physical world, or more generally, to develop an integrated body of theory that can account for the facts, and predict them. Even such a brief prospectus points toward several reasons why ideas might be treated as gifts, the first being that the task of assembling a mass of disparate facts into a coherent whole clearly lies beyond the powers of a single mind or even a single generation. All such broad intellectual undertakings call for a community of scholars, one in which each individual thinker can be awash in the ideas of his comrades so that a sort of 'group mind' develops, one that is capable of cognitive tasks beyond the powers of any single person. The commerce of ideas – donated, accepted (or rejected), integrated – constitutes the thinking of such a mind. A Polish theoretical physicist who had once been isolated from science by anti-Semitism testifies to the need to be in the stream of ideas: 'Like the Jewish Torah, which was taught from mouth to mouth for generations before being written down, ideas in physics are discussed, presented at meetings, tried out and known to the inner circle of physicists working in the great centers long before they are published in papers and books . . .' A scientist may conduct his research in solitude, but he cannot do it in isolation. The ends of science require coordination. Each individual's work must 'fit,' and the synthetic nature of gift exchange makes it an appropriate medium for this integration; it is not just people that must be brought together but the ideas themselves.

These remarks on the scientific community are intended finally to illustrate the general point that a circulation of gifts can produce and

maintain a coherent community, or, inversely, that the conversion of gifts to commodities can fragment or destroy such a group. To convert an idea into a commodity means, broadly speaking, to establish a boundary of some sort so that the idea cannot move from person to person without a toll or fee. Its benefit or usefulness must then be reckoned and paid for before it is allowed to cross the boundary. Guilds of artisans, such as stone masons or leather tanners, used to keep their know-how a secret and charge the public for their services. Their knowledge would circulate as a 'common' within the guild, but strangers paid a fee. Seen from the outside, trade secrets (commodity ideas) inhibit the advancement and integration of knowledge. Each trade may be its own community, but there will be no 'community of science'; there may be pockets of expertise, but there will be no mechanism whereby a group mind might emerge, nor a body of theory be drawn together. A modern industry that patents the discoveries of its research scientists also sets a fee barrier around ideas.* *Within* an industrial research facility there may be a microcosm of gift exchange, but at the company gate it is profit that governs the flow of ideas. An industrial scientist often cannot contribute his ideas to the scientific community because he has to wait, sometimes years, while the company secures the patent. Even then, the discovery emerges not as a contribution but as a proprietary idea whose users must pay a fee, a usury, for its use. (There will always be exceptions, but as a rule, scientists who treat ideas as gifts thereby enjoy higher repute in the community, they are more apt to be engaged in theoretical ('pure,' 'basic') research, and they are less well remunerated. Those who hire out to proprietary concerns are more anonymous and less a part of the community, they tend to be working in applied science, and they are better paid.)†

* A patent differs from a trade secret in a significant way. Historically a guild or trade could keep its secret for as long as it was able to. Some were kept for centuries. But patents are granted for a limited term (seventeen years in the United States), and as such they are a mechanism for rewarding private invention while slowly moving it into the public domain. Patents belong to a group of property rights, including copyright and usufruct, which grant the right to limited exclusive exploitation. Property rights of this kind are a wise middle-ground between gift and commodity; they manage to honor the desire for individual enrichment and at the same time recognize the needs of the community.
† An exception that seems to prove the rule is the case of the 'academic' scientist installed in an industrial research facility. 'Industrial research organizations whose goals are only in the area of applied research,' Hagstrom notes, 'often appoint distinguished men to do basic research, give a small amount of time to other scientists for this purpose, and publicize their research results, solely to make themselves attractive to superior scientists. If they do not permit pure research, their applied research and development efforts suffer.'

The remarkable commercial potential of recombinant DNA tech-
nology has recently prompted a debate within the scientific community
over precisely the issues of gifts, commodities, and the goals of science.
Not only have many academic biochemists been drawn into the market-
place and ceased to treat their ideas as gifts, but several academic insti-
tutions have considered following suit. In the fall of 1980, for example,
Harvard University announced a proposal to found a university-related
corporation to exploit the gene-splicing technology developed by its
faculty. The idea was opposed (and eventually rejected) on several
grounds, a primary one being the conflict between the need for secrecy
in commercial ventures and the free exchange of ideas to which the
academy is dedicated. As a geneticist at MIT, Dr Jonathan Kind,
remarked: 'In the past one of the strengths of American bio-medical
science was the free exchange of materials, strains of organisms and
information . . . But now, if you sanction and institutionalize private
gain and patenting of micro-organisms, then you don't send out your
strains because you don't want them in the public sector. That's already
happening now. People are no longer sharing their strains of bacteria
and their results as freely as they did in the past.'

Here we may revise my remarks on the connection between freedom
and the marketplace. Free-market ideology addresses itself to the freedom
of individuals, and from the point of view of the individual there often *is*
a connection between freedom and commodities. But the story changes
when approached from the point of view of the group. A gift community
puts certain constraints on its members, yes, but these constraints assure
the freedom of the gift. 'Academic freedom,' as the term is used in the debate
over commercial science, refers to the freedom of ideas, not to the freedom
of individuals. Or perhaps we should say that it refers to the freedom of
individuals to have their ideas treated as gifts contributed to the group
mind and therefore the freedom to participate in that mind. The issue arises
because when all ideas carry a price, then all discussion, the cognition of
the group mind, must be conducted through the mechanisms of the market
which – in this case, at least – is a very inefficient way to hold a discus-
sion. Ideas do not circulate freely when they are treated as commodities.
The magazine *Science* reported on a case in California in which one DNA
research group sought to patent a technique that other local researchers
had treated as common property, as 'under discussion.' An academic scien-
tist who felt his contribution had been exploited commented, 'There used

to be a good, healthy exchange of ideas and information among [local] researchers . . . Now we are locking our doors.' In a free market the people are free, the ideas are locked up.

There are forms of organization other than the one that follows a circulation of gifts. The military is highly organized. So is General Motors. One could develop a 'contractual' theory of the organization of science which would assert that scientists are motivated by the desire for power and money, that they do research and publish in order to attract these rewards from whoever it is – the company, the consumer, the government – that hands out the jobs and the cash. Such a reward system leads to its own sort of group. But in science, at least, as Hagstrom points out, it is precisely when people work with no goal other than that of attracting a better job, or getting tenure or higher rank, that one finds specious and trivial research, not contributions to knowledge. When there is a marked competition for jobs and money, when such supposedly secondary goals become primary, more and more scientists will be pulled into the race to hurry 'original' work into print, no matter how extraneous to the wider goals of the community. (In the literary community, at least in the last few decades, the need to secure a job has certainly accounted for a fair amount of the useless material that's been published, both as literature and as criticism.) A contractual theory of the organization of science, Hagstrom concludes, 'accounts not so much for its *organization* as for its *disorganization*.'

I have not tried here to cover all the ways in which one might speak of science as a community. There is competition in science, of course, as well as gift exchange, and there is individualism as well as teamwork. But I think it right to begin, as Hagstrom does, with the emergence of community through the circulation of knowledge as gift. *After* community has appeared, we may speak of dissent, segmentation, differentiation, dispute, and all the other nuances of intellectual life. But it would be difficult to work in the other direction – to begin with ideas exchanged in a way that stressed particularity, individuality, and personal profit – and then move toward a coordination of effort and a harmony of theory. A contractual theory may well account for effective organization in business, even in businesses that hire scientists. But as long as the goals of science require an intellectual community congenial to discourse and capable of integrating a coherent body of theory, gift exchange will be a part of its commerce.

Science makes for a somewhat anomalous example of community

emerging through a circulation of gifts because ideas exchanged between intellectuals are 'cool' gifts. Not that there aren't passionate scientists, but ideas printed in journals can never really have the emotional immediacy of most gifts. Moreover, the fragmentation that results from the conversion of ideas to commodities doesn't seem as marked as that which follows in less abstract and specialized groups, such as a family or kin network. To take one of innumerable examples, the gifts given in marriage on one Polynesian island are shown in the chart reproduced below. There is no need at this point to go into the exchanges in detail; the sheer complexity of the chart is what I want to present. There are nine major transfers of goods between the kin of the groom and those of the bride, with more than that number of subsidiary transfers. After a marriage like this, everyone is connected to everyone else in one way or another. Imagine what it must be like after half a dozen marriages and as many initiation ceremonies and funerals (whose exchanges are even more complicated than those of marriage). There will be an ongoing and generalized indebtedness, gratitude, expectation, memory, sentiment – in short, lively social feeling. As with the simple exchange of wine in the restaurant, constant and long-term exchanges between many people may have no ultimate 'economic' benefit, but through them society emerges where there was none before. And now imagine what would happen were all the gifts in this chart to be converted to cash purchase. There would be no wedding, of course, but more than that, as with the Bushmen, the residents of the Flats, or scientists doing research, if every exchange were to separate or free the participants from one another there would also be no community.

To close this discussion of community, I want to add a brief suggestion as to what might be the political form of a gift economy. Gifts are best described, I think, as anarchist property. The connections, the 'contracts,' established by their circulation differ in kind from the ties that bind in groups organized through centralized power and top-down authority. Marcel Mauss's original 'Essay on the Gift' was in part a speculation on the origins of modern contract and will serve, therefore, as a useful entry to the point I have in mind. Is gift exchange, Mauss wondered, a primitive form of ensuring those unions that are today made secure by legal, written agreement? He gives two replies. On the one hand, it seems correct to see the felt bond of gift exchange – 'the obligation to return' – as an archaic form of the legal *nexum*. But in tracing

Marriage gifts among the Tikopia. From Primitive Polynesian Economy *by Raymond Firth (London, 1939).*

the shift from primitive to modern, Mauss underscores a loss as well. As I mentioned in the introduction, his essay focuses on gift exchange as a 'total social phenomenon,' one in which religious, legal, moral, economic, and aesthetic institutions appear simultaneously. And it is only as these several threads are differentiated that legal contract develops as a discrete institution.

To take one of Mauss's own examples, a time of such differentiation was marked by the development of the distinction between 'real' and 'personal' law – between, that is, a law of things and a law of persons. In a gift economy, as we have amply seen, such a distinction is blurred, for things are treated in some degree as persons and vice versa. Person and thing, the quick and the dead, are distinguished spiritually, not rationally. Such was the case, Mauss surmises, in ancient Italy. In the very oldest Roman and Italic law, he contends, 'things had a personality and a virtue of their own. Things are not the inert objects which the laws of Justinian and ourselves imply. They are a part of the family . . .' In antiquity the Roman *familia* was not simply people but the entire 'household,' including the objects in the home down to the food and the means of livelihood. Later Roman law, however, increasingly distinguished economic and ritual interest; it divided the *familia* into *res* and *personae*, into things and persons, and in so doing, 'passed beyond that antiquated and dangerous gift economy, encumbered by personal considerations, incompatible with the development of the market, trade and productivity – which was, in a word, uneconomic.' The distinction between thing and person is as much a feature of the modern world as it was of later Roman law, of course. As Mauss comments elsewhere, 'This distinction is fundamental; it is the very condition of part of our system of property, alienation and exchange. Yet it is foreign to the customs we have been studying.'

Legal contract bears a vestige of the gift 'contract,' but gift exchange must be placed in a separate sphere because, while contract sanctioned by law may formalize the union of gift exchange, it does so by disengaging it from the other components of a 'total social phenomenon.' It sheds the emotional and spiritual content. Indebtedness and obligation become simply economic and legal relationships. Contract in law is a rationalization of the gift bond, just as usury (or interest), as I shall argue later, is a rationalization of the increase of gift exchange. Both contract and usury imitate the structure of a gift economy, but both drop the feeling, the 'uneconomic' feeling.

If we are to speak of gift exchange politically, we must derive the politics from the nature of the gift contract. I have opened with Mauss's story of Roman law because it sets the terms for a group of political tales with a similar theme. We may begin, as historians of anarchism commonly do, with the story of the Anabaptists' brief tenure over the Westphalian city of Münster in the early sixteenth century. The various religious movements that emerged in Europe during the Reformation were a reaction not only against the papacy but against a new (and Roman) concept of property that allowed, for example, local princes, through the invisible magic of statutory law, to turn the 'commons' – common fields, woods, and streams – into private preserves.

Of the many movements that rose in opposition to such 'Roman' ideas, the Anabaptists are usually taken as antecedents to the political revolutionaries of later centuries. There were many Anabaptist factions, but all agreed in denying power to civil authority. Since the baptized were in direct contact with the Lord, any intermediary (state *or* church) was not only unnecessary but frankly faithless. Nothing should stand between a person and the inner light which informs his actions.

The town of Münster had suffered a series of tribulations (the plague, an economic recession, heavy state taxes), and a good portion of its citizens converted to the new Anabaptist creed and took control of the town. They expelled both Catholics and Lutherans. The bishop of Westphalia, the town's nominal ruler, laid siege to it with an army of mercenaries. The citizens held the bishop off for almost a year, surviving on communal stores of food and clothing. To the faithful it seemed clear that Münster would soon become the new Jerusalem. As an initial ceremonial act, marking their control of the town and the start of the new age, the Anabaptists burned all written records of contracts and debts.

In 1842, more than three hundred years later, the German anarchist Wilhelm Weitling took the Anabaptist leaders as his inspiration in writing a proclamation: 'A time will come when . . . we shall light a vast fire with banknotes, bills of exchange, wills, tax registers, rent contracts and IOUs, and everyone will throw his purse into the fire . . .'* Thirty years later we find the Italian anarchist Enrico Malatesta acting on Weitling's idea. In

*Weitling adds the abolition of money to the older abolition of contract and debt instruments. The idea became a standard part of the program of European anarchists, who usually, like Weitling, called for cash exchange to be replaced by barter (not gift).

1877 he and a band of compatriots took to the woods near Naples and
began to move from town to town, abolishing the state as best they could.
As the historian James Joll describes it,

> At the village of Lentino the column arrived on a Sunday morning,
> declared King Victor Emanuel deposed and carried out the anarchist
> ritual of burning the archives which contained the record of property
> holdings, debts and taxes.

We do not know if they also threw their purses into the fire.

These are all stories of a struggle between legal contract and what might
be called 'contracts of the heart.' Anarchists, like the Anabaptists before
them, have always sought to declare null and void those unions that
do not carry with them a felt cohesiveness and therefore tend toward co-
ercion. It is a rare society that can be sustained by bonds of affection alone;
most, and particularly mass societies, must have as well those unions which
are sanctioned and enforced by law that is detached from feeling. But just
as the Roman saw the *familia* divided into *res* and *personae*, the modern
world has seen the extension of law further and further into what was
earlier the exclusive realm of the heart. Law has sought to strengthen those
bonds that in former times were secured through faithfulness and grati-
tude, however indeterminate these may have been. But the law is limited
in its ability to bring people together and secure order. Not only does law
tend to shed the emotional and spiritual content of a total social phenom-
enon, but the process of law requires a particular kind of society – it
requires, to begin with, adversaries and reckoning, both of which are
excluded by the spirit of gift exchange. Because the spirit of the gift shuns
exactness and because gifts do not necessarily move reciprocally (and there-
fore do not produce the adversary roles of creditor and debtor), courts of
law would be rightly perplexed as to how to adjudicate a case of ingrati-
tude. Contracts of the heart lie outside the law, and the circle of gift is
narrowed, therefore, whenever such contracts are converted to legal rela-
tionships.

These stories, at any rate, from Anabaptist to anarchist, reflect a felt and
acted-upon belief that life is somehow diminished by the codification of
contract and debt. The opposition has been not only to those codified debts
that secure the position of class, but to any codification that encourages
the separation of thing and spirit by abandoning total social phenomena

to a supposedly primitive past and thereby enervating felt contract. The burning of written debt instruments is a move to preserve the ambiguity and inexactness that make gift exchange social. Seen in this way, their destruction is not an antisocial act. It is a move to free gratitude as a spiritual feeling and social binder. If gratitude is, as Georg Simmel once put it, 'the moral memory of mankind,' then it is a move to refreshen that memory which grows dull whenever our debts are transformed into obligations and servitudes, whenever the palpable and embodied unions of the heart – entered into out of desire, preserved in gratitude and quit at will – are replaced by an invisible government of merely statutory connections.

I should now state directly a limitation that has been implicit for some time, that is, that gift exchange is an economy of small groups. When emotional ties are the glue that holds a community together, its size has an upper limit. The kinship network Carol Stack describes in the Flats numbered about a hundred people. A group formed on ties of affection could, perhaps, be as large as a thousand people, but one thousand must begin to approach the limit. Our feelings close down when the numbers get too big. Strangers passing on the street in big cities avoid each other's eyes not to show disdain but to keep from being overwhelmed by excessive human contact. When we speak of communities developed and maintained through an emotional commerce like that of gifts, we are therefore speaking of something of limited size.* It remains an unsolved dilemma of the modern world, one to which anarchists have repeatedly addressed themselves, as to how we are to preserve true community in a mass society, one whose dominant value is exchange value and whose morality has been codified into law.

By the time that anarchism emerged as a political philosophy, the idea of contract had been significantly enlarged. In the seventeenth and eighteenth centuries, theorists of 'social contract' had extrapolated from the atomic unit of individual bond to that urcontract in which individuals join together to form the state. In Thomas Hobbes's version – to take the most striking example and the strongest opposite pole to anarchist theory – before there was 'society' there was a 'state of nature' in which separate persons knocked about like flies in a hot room – only worse, as they tended to kill

*The exceptions to this rule are those communities which, like the community of science, are organized around quite specific concerns. The group that does not pretend to support the wider social life of its members – feeding them, healing them, getting them married, and so forth – can be connected through gift exchange and still be quite large.

one another. In Hobbes's natural history, man was driven by egocentric desires (chiefly, ambition, avarice, pride, and the fear of death – any apparent altruism being quickly traced back to self-interest). Luckily, these disparate individuals found a shared value in their fear of death, and reason led them away from the state of nature toward the securities of social life. Unluckily, reason was not as strong as human passion, and because the passions were antisocial, the social life that reason suggested had to include an absolute authority with sufficient power to keep men 'in awe.' Hobbes set his state on these four legs: selfishness and the fear of death, reason and the awe inspired by authority.

A recurrent feature of social contract theory was an imagined gap between the primitive and the civilized man. Hobbes's primitive isn't someone you'd want to live with. Dominated by brutish aggression and the 'perpetual and restless desire of Power after power,' he lives in a condition of constant war, knowing no orderly social life and neither shared nor private property, only theft. He is different in *kind* from the civilized man, and that difference leaves a mark on Hobbes's politics because it simultaneously requires contract to join men together and dictates the form of that contract. Hobbes begins his politics with a fantasy about history in which a chaotic aboriginal past is replaced by civilization, the shift being marked by an imaginary moment in which men agree to give up their right to exercise private force in favor of instituting public power. Through this essential clause, social contract brings man out of nature and into civilization. But note that the contract is required precisely because man cannot be trusted to behave without it. So there is always, at least in Hobbes, this mixture of distrust and law which leads, as Marshall Sahlins has pointed out, to a paradoxical politics in which 'the laws of nature cannot succeed outside the frame of contrived organization . . . Natural law is established only by artificial Power, and Reason enfranchised only by Authority.'

The anarchist begins his politics on a different note and comes to a different resolution. Anarchism did not become articulated as a political philosophy until the modern state had become a political reality in the nineteenth century. Even then anarchism was not a politics per se but more of an application of ethics to political thought. Anarchist theory is like an aqua regia applied to the state and its machinery to see how much might be stripped away before people begin to suffer more than they do under law and authority. The anarchist begins with the assumption of man's good nature, contending that law itself is a 'cause' of crime. He feels a

kinship, not a gap, between the modern man and his predecessor 'in nature.' The Russian Peter Kropotkin makes a good example here because he had actually visited tribal groups. Born into a noble family and educated at military schools, Kropotkin was a confirmed rationalist and serious scientist, recognized as a geographer in scientific circles. In his early twenties he had participated in an expedition to Central Asia. James Joll's remarks on the trip touch the same points we are addressing here:

> The primitive tribes he observed seemed to have customs and instincts which regulated their social life without the need of government or laws. For Kropotkin, primitive society, so far from providing an example of Hobbesian conflict and of the war of all against all, showed rather that cooperation and 'mutual aid' were the natural state of man if left uncorrupted by government and by laws which result from the 'desire of the ruling class to give permanence to customs imposed by themselves for their own advantage,' whereas all that is necessary for harmonious living are 'those customs useful for society . . . which have no need of law to insure respect.'

We need not decide whether it is Hobbes or Kropotkin who sees the real primitive. Kropotkin is arguably closer, if only because he'd actually been in the field (while Hobbes never got farther than France), but his reports do give off a slightly romantic air. A fully shaded view of tribal life had to wait for the emergence of ethnography as an empirical science.* These

* Marcel Mauss's essay is one of the first syntheses of true ethnography. It follows the established tradition of seeking the roots of the modern in the archaic, and its conclusions are a mixture of Hobbes and Kropotkin. On the one hand, Mauss's explication of the spirit of the gift (the *hau*) makes it clear that gift contract requires the spirit, and that the spirit of the gift is not well reproduced in law or derived from reason. On the other hand, like Hobbes, Mauss is not at ease with emotion as a social force, and in a pinch, he will submit it to reason. Thus he can write that 'by opposing reason to emotion . . . peoples succeed in substituting alliance, gift and commerce for war, isolation and stagnation.' Or he will speak of 'total presentation' – by which he means constant, large-scale gift exchanges – saying, 'although [they] take place under a voluntary guise they are in essence strictly obligatory, and their sanction is private or open warfare.'

As with his phrase 'the obligation to return,' the emphasis falls on 'oblige' and the motive is fear, not desire. Pure Hobbes. Obviously many gift exchanges in practice are a mixture of fear (or guilt) and desire, but we should at least note that it is just as logical to invert Mauss's premises and say, 'It is by opposing *eros* to reason . . . that peoples succeed in substituting gift for war,' or that 'wars are undertaken in seemingly voluntary guise . . . but really out of fear of private or open friendship.' Otherwise the ground emotions are fear and self-interest, the *hau* is lost, and we are back with reason suggesting law and authority.

early pictures of primitives are better described as expressions of tempera-
ment rather than political science or ethnology. One temperament feels
kinship with the aborigine while the other feels distance; one temperament
assumes generosity while the other assumes a lust for power; for one our
passions are social, for the other they are selfish (by the nineteenth century
the Hobbesian temperament was reading Darwin for his accounts of
conflict, while what Kropotkin remembered out of Darwin was the story
of the blind pelican whose comrades kept him supplied with fish). One
temperament assumes that goodwill underlies social life, while the other
assumes egotism (and so must add reason and authority to derive society).

The two temperaments diverge at their base over the roles of passion
and reason. Hobbes knew no *social* passions. He speaks of his declaration
that life in nature is 'solitary, poor, nasty, brutish and short' as an 'infer-
ence from the passions' against which 'reason suggests convenient articles
of peace . . . called the laws of nature.' For this temperament, reason derives
law as a check to passion, and social life emerges only as each man is
somehow convinced to inhibit a part of himself. So Hobbes is led to base
social life on restraint, to separate the governed from their governors, and
to rely on law (with all of its functionaries, the police, the courts, the jails)
to ensure order.

It is this double conceit – first, that passion will undo social life and,
second, that coercion will preserve it – that anarchist theory and the tradi-
tions of gift exchange call into question. The former imagines and the latter
stand witness to a social life motivated by feeling and nonetheless marked
by structure, durability, and cohesion. There are many connections between
anarchist theory and gift exchange as an economy – both assume that
man is generous, or at least cooperative, 'in nature'; both shun centralized
power; both are best fitted to small groups and loose federations; both rely
on contracts of the heart over codified contract, and so on. But, above all,
it seems correct to speak of the gift as anarchist property because both
anarchism and gift exchange share the assumption that it is not when a
part of the self is inhibited and restrained, but when a part of the self is
given away, that community appears.

CHAPTER SIX

A FEMALE PROPERTY

I • *The Woman Given in Marriage*

As they used to say in our grammar-school workbooks, one of these things is not like the others: 'And at the great festival they gave away canoes, whale oil, stone ax blades, women, blankets, and food.' Margaret Mead records an Arapesh aphorism with the same disconcerting note: 'Your own mother, your own sister, your own pigs, your own yams that you have piled up, you may not eat. Other people's mothers, other people's sisters, other people's pigs, other people's yams that they have piled up, you may eat.' And in the Old Testament we read how one tribe hopes to make peace with another: 'Let us take their daughters to us for wives and let us give them our daughters.'

Of all of the cases in which women are treated as gifts, this last, the woman given in marriage, is primary. We still preserve the custom in the Protestant wedding ceremony, the minister asking the gathered families, 'Who giveth this woman to be married?' and the father of the bride replying, 'I do.' The ceremony is a vestige of the more ancient institution in which marriage is an exchange between tribes or clans, the one giving the bride and the other giving wealth (or service, or a different bride) in return.

Typically the initial wedding gifts – the 'bridewealth' – are not the end of the matter. The marriage marks only the first of a long series of exchanges that have, as usual, no apparent 'economic' function but from which emerges an active and coherent network of cooperating kin.

We have seen enough of gift exchange to know that it would be too simple to say that the woman given in marriage is treated as property. Or, rather, she is a kind of property, but the 'property rights' involved are not those to which the phrase usually refers. She is not a chattel, she is not a commodity; her father may be able to give her away, but he may not sell her.

This distinction hardly quiets our modern sense of justice, however. If a person can be transferred from one man to another, why is being a gift any better than being a commodity? How did the father get the right to give his daughter away, in the first place? Can a mother give her son away? Is the mother consulted in the matter at all? If a marriage must be a gift exchange, why could the couple not give themselves away?

To answer we shall have to begin at the beginning, not with the day of the daughter's wedding, but with the day of her birth. And we shall have to clarify our terms a little.

'Property,' by one old definition, is a 'right of action.' To possess, to enjoy, to use, to destroy, to sell, to rent, to give or bequeath, to improve, to pollute – all of these are actions, and a thing (or a person) becomes a 'property' whenever someone has 'in it' the right of any such action. There is no property without an actor, then, and in this sense property is an expression of the human will in things (and in other people).

The definition is a broad one, but it allows us to make the distinctions necessary to a discussion of cases in which human beings become property of one kind or another. A rather odd problem that arose with the advent of organ transplants will illustrate the particular distinction we need at the moment. It used to be the case that when a person died the law recognized no property rights in the body. Growing out of a religious sense of the sacredness of the body, this legal formula was intended to make it clear that the executors of an estate could not make the body of the deceased into an item of commerce to be bought, sold, or used to pay debts. It even used to be the case that a man could not direct the manner of his own burial and expect the courts to back him up, because his body, not being property, was not a part of his estate. As soon as it became possible to transplant an organ from the dead to the living, however, it

became clear that the sense of 'property rights' being used here was too vague. The law justly restrained the right to sell, but what of the right to bestow?

In response to just this question, every state in the Union has recently adopted what is known as the Uniform Anatomical Gift Act, a law that recognizes the right of an adult to bequeath all or part of his body in the event of his death. It vests that right primarily in the person himself, of course, but in special cases it extends the right of bestowal to other people. In the case of minor children the right of bestowal lies with the parents who may now legally donate the body of a child who has died or been killed.

Our ability to transplant body organs raises ethical questions – and has therefore required legal clarification – because with it comes the understanding that while the body from which an organ is removed may be dead, the organ itself is not. Transactions that involve life itself seem to constitute the primary case in which we feel called upon to distinguish the right of bestowal from the right of sale. The rules of gift exchange are such that what is treated as a gift retains or even increases its liveliness, and most cultures, when forced to decide, therefore classify human life as a gift (which explains why the most significant work on gift exchange outside of anthropology has focused on matters of medical policy and ethics). If human life itself must become an item of commerce, transferred from person to person or house to house, then it must be gift property and the 'rights of action' must be those that appertain to gifts, not to commodities.

With this distinction in mind we may return to the problem of the woman given in marriage, beginning, as I say, at the beginning. Not only do most cultures classify human life as a gift, but they take in particular the life of a newborn child to be a gift that has been bestowed upon its parents. (Bestowed by whom? By the gods, by the earth, by the spirits of the recently dead, by the tree near the water hole which is known to make women pregnant – however the local story has it.) The recipients of this gift are its custodians so long as the child is dependent upon them, and they may, under special circumstances, exercise their right of bestowal. The child whose body organs are given away when it dies is one instance, albeit an unusual one; the young woman whose father gives her in marriage is a second. A third example again distinguishes the right of sale from the right of bestowal: our laws prohibit parents from selling their children, but they

grant them the right to give a child up for adoption. There are special restrictions and guidelines under which a child is given away, of course, but they only serve to emphasize once again our feeling that if a child's life must be transferred from one family to another, it must be a gift.* There are many cultures in which all children are given away in the normal course of events, being raised by the family of a paternal aunt, for example, and not by their biological parents. In these cases a child is just one of many gifts that pass among kin.

At this point, if we are to make our way back to the woman given in marriage, we shall have to distinguish male life from female life, for even though both are taken to be a bestowal at birth, their paths invariably diverge, particularly in groups that figure descent through only one sex. In Africa they say, 'Bridewealth is childwealth,' an aphorism that we may take as another response to the question, If the life of a child is a gift, who is the donor? – the answer in this case being that the mother's clan has given the child to the father's clan. In other words, the gifts given in marriage are not a return gift for the bride so much as for her eventual children. In patrilineal groups in particular (the primary case in Africa), a woman's clan, when she marries, must give up its interest in her offspring and so receives the 'childwealth' in return. The children then belong to their father's clan (as, in a sense, they do in our own society, where they carry the father's name). Looked at structurally, in a patrilineal group, males do not become gifts when they grow up because they do not circulate: a young man stays in his group when he marries, and so does his virility, his potential offspring. But a young woman moves when she marries, and the gifts given for her stand witness to the fact that both she and the rights of her fertility (rights *in gentricem*) have passed to her husband's clan.

Again, if we look only at the structure of things, we could say that in a matrilineal group a husband (and his virility) is bestowed upon his wife's lineage. Her family group receives his contribution to the creation of the children. No gift institution has arisen to recognize this, however (although matrilineal groups do treat bridewealth differently, a point to

* In 1980 a New Jersey couple tried to exchange their baby for a secondhand Corvette worth $8,800. The used-car dealer (who had been tempted into the deal after the loss of his own family in a fire) later told the newspapers why he changed his mind: 'My first impression was to swap the car for the kid. I knew moments later that it would be wrong – not so much wrong for me or the expense of it, but what would this baby do when he's not a baby anymore? How could this boy cope with life knowing he was traded for a car?'

which I shall return). As far as I know, there are no groups in which the men are given in marriage.* As the anthropologist Jack Goody puts it, 'The mirror opposite of bridewealth would be groomwealth; and of bride-service, groom-service. But there is little to put in these two boxes by way of actual cases, except perhaps the payments of "borrowed man" of the Menangkabau of Sumatra.' But if a borrowed man is all we have, and only one at that, we may as well say that men are not given in marriage.

What does happen to male children, then? If the life of a child is a gift, does the right of bestowal in that gift pass automatically to a boy as he becomes a man? Can he just take the car keys and go as soon as he gets his license?†

There is one general situation in which male children are given as gifts, or used to be. Our earlier discussion of the 'rites of the first fruits' indicated that in the Old Testament all natural increase – the harvest, the calves, the lambs, and so forth – is treated as a gift from God, and its first fruits are consequently sacrificed as a return gift. *Exodus* records Yahweh's clear statement as to the gender of these fruits: 'All that opens the womb is mine, all your male cattle, the firstlings of cow and sheep.' The males are the gift from the Lord to the people, and the people pass the first one back.

The exchange was not always confined to animals, apparently. There is some indication that in antiquity the first male *child* was also sacrificed to the Lord. The Old Testament implies the rite by making the exception: 'All the first-born of your sons you shall redeem.' Thus it was permitted to substitute certain ritually pure animals for the male child. The story of Abraham and Isaac is a drama of such a substitution. The New Testament repeats the motif: the Lord gives His son and the life of that firstborn is

* I assume this historical asymmetry derives from the fact that while both parents contribute to conception, the mother must carry the child, give it birth, and suckle it. Even in a matriarchy her contribution is greater.
† In the modern world the rights that adults have in their children – male or female – normally pass slowly from parent to child during adolescence and become fully vested in the child when he or she is ready to leave home.

If our lives are gifts to begin with, however, in some sense they are not 'ours' even when we become adults. Or perhaps they are, but only until such time as we find a way to bestow them. The belief that life is a gift carries with it the corollary feeling that the gift should not be hoarded. As we mature, and particularly as we come into the isolation of being 'on our own,' we begin to feel the desire to give ourselves away – in love, in marriage, to our work, to the gods, to politics, to our children. And adolescence is marked by that restless, erotic, disturbing inquisition: Is this person, this nation, this work, worthy of the life I have to give?

sacrificed as a gift to reconnect man and God (the story being told in the Old Testament terms: 'the blood of the lamb.')*

In Polynesian mythology we find men, gifts, and sacrifice brought together in a manner similar to that of the Old Testament. Polynesian tribal chiefs were equated with gods, and as such they received two gifts from their people: women in marriage and men as sacrifices. The people of Fiji saw the two as equivalent gifts, the woman who is 'brought raw' to be married and the 'cooked man' who is sacrificed to the god-king. In the mythology at least, 'cooked men' were literally eaten. A Hawaiian myth in which a man manages to redeem his life with a substitute gift indicates that had he not done so he would have been killed and baked in an earth oven. Male life is an edible good to the gods, and among the polite greetings that a Fijian commoner can offer to his ruling chief is 'Eat me'! In Polynesia the continued fertility of the land was taken to be a consequence of the women and men given to the god-king. Like the God of Abraham, the Polynesian gods remained the faithful genitors of the land so long as the gift of their increase was recognized by return gifts.

In aboriginal times, therefore – including those aborigines we take to be our own ancestors – male life was sometimes treated as a gift, and parents, kings, and gods were recognized as having the right of bestowal in that gift. The modern parallel may be what Wilfred Owen called 'the old lie: *Dulce et decorum est pro patria mori*' – it is sweet and proper to die for one's country. For when the state replaces the god-king, male life is no longer baked in earth ovens, it is sent to the trenches. And while no gift ceremony accompanies enlistment (no sergeant says, 'Who giveth this man?'), in our popular mythology it is the mother (or the wife if the man is married) who gives a man to the army. When a man actually dies fighting for the state, the newspapers all say the mother 'gave her son,' and she is the one who receives the flag of her country handed across the coffin.

In each of these cases the boy or man who is given as a gift assumes standard functions of the gift: in the aboriginal examples, male life bestowed upon the Lord or god-king renewed the bond between that deity and the group, and ensured the continued fertility of flock and field. And although

*The examples of male life given as a gift are usually stories of sacrifice. It may be that so long as no gift institution recognizes the male contribution to conception – and as the male body cannot in fact give birth – when male life is treated as a gift, the tendency is to give the body itself. In the chapter on the gift bond I spoke of compassionate deities who give their bodies to join man to a higher spiritual plane. These deities are generally male.

the modern state began to lose its appeal as an object of sacrifice after the First World War, we still recognize that the power of a collectively held belief can be increased by the man who gives his life in its name.

The woman who is given in marriage similarly takes on typical functions of the gift. She, too, establishes a bond (between clans or families), and as part of an ongoing system of kinship, she, like any gift, becomes an agent of the community's cohesion and stability. In fact, the institution of the woman given in marriage makes for a rather striking example of what I earlier called 'the old lovers' quarrel between liberty and community.' For the fact is that marriages established through massive gift exchanges are more stable and enduring than those that are not; but by the same token, the partners (both men and women, but women in particular when they are the gifts) have significantly less freedom. Where there is no gift exchange, on the other hand, marriages are less durable, the partners more independent. So the choice: where the desideratum is community we find some people trapped in bad marriages; where it is individual choice we find some people growing old in isolation.

The Uduk, the tribal group I introduced in Chapter 1, make a fine example of the side of this dichotomy in which marriage is not a constraining institution.* The Uduk are matrilineal; neither in structure nor in ceremony is an Uduk bride (or her fertility) given in marriage. In fact, there are essentially no marriage gifts, and according to Wendy James, the anthropologist who has done the most work with the Uduk, marriage itself 'is only meaningful as a sexual relationship, publicly acknowledged and accompanied by a few well-defined but short-term obligations.'

Uduk women are very independent; they readily quit an unsatisfying union. Marriages typically last only three or four years. Not being the property of the men, not even gift property, Uduk women are self-possessed, literally and figuratively. 'In myth, anecdote and popular expectation,' James tells us, 'women often take the initiative in sex and marriage . . . They may often "dominate" their husbands . . .' In the course of her research, James discovered some manuscript notes on the Uduk which contained a telling comment: 'Wife beating is far less common than it is among the [other local tribes] . . . Only among the Uduk is husband beating by the wife no cause for astonishment.' If an Uduk woman suspects that her husband has a lover,

she 'will take her special fighting stick (a six foot bamboo pole) and challenge the other woman to a duel.'

The Uduk are citizens of Ethiopia, and in 1963 the Ethiopian government added an interesting twist to this story. No social scientist pining for the controls of the physics laboratory could have asked for a better case study. Noting that Uduk marriages were unstable, the government decided to introduce a system of bride-wealth payments. Bridewealth stabilizes marriages, they reasoned; why not simply graft it onto the Uduk kinship system? In consultation with tribal elders, the government decided upon a cash sum to be given by a man to his wife's kin at the time of their marriage.

Problems sprang up immediately. As we saw when I first introduced the Uduk, any property transferred from one clan to another among these people must be treated as a gift. All transactions between clans are therefore accompanied by the need to clarify their nature and to make sure that the received wealth is consumed as a gift, not converted into capital. But bridewealth confounded the Uduk, and for the obvious reason: their brides are not in fact given. Therefore, the conundrum: if the bridewealth was a gift, then it was one that had not been reciprocated – and yet the name itself implied that it *had*. And if it was *not* a gift, then the bride had apparently been purchased, an even more onerous interpretation.

Some of the Uduk treated the bridewealth as a gift, inventing new-fangled gift institutions to deal with the moral complexities that it raised. But most settled on the other side, deciding that bridewealth was really cash purchase, and refusing to pay it. They spoke of it in the language of the marketplace, says James, using 'the ordinary word for buying and selling, an action which has no moral content and which only takes place between unrelated people.' Bridewealth payments did nothing to change the underlying structure of Uduk kinship and by that structure women are not gifts.* When asked why they refused to pay bridewealth, the standard cry became 'Are we to sell our girl as if she were a goat or something?'

If we take property to be a right of action and therefore an expression of the human will, then whenever a woman is treated as property, even if she is a gift, we know that she is not strictly her own person: her will is

* It would have been interesting to see the results had the government instituted groomwealth or childwealth, for it is really the Uduk husband who gives children to the wife's kin.

somewhere subject to someone else's. I suspect we may make a general
point here: in societies that confer some degree of power upon women –
matrilineal groups like the Uduk being a primary, but not exclusive,
example – women will tend not to be given in marriage or, if they are, the
return gifts will tend to be tokens and not substantial wealth. The amount
of self-will recognized for women is inversely proportional to the size of
the return gift. Furthermore, in societies that confer property rights on
women – where women may inherit and bequeath, where they may buy
and sell, where they carry a dowry into marriage which is theirs alone to
dispose of – any wealth exchanged for a woman at marriage will tend
to be seen as an immoral purchase, not as a gift. The Uduk interpretation
of bridewealth is one example; another may be found in India, where
women have always had property rights (not equivalent to those of men,
perhaps, but certainly those I have just outlined, the dowry in particular).
In India the ancient Code of Manu says what the Uduk say: 'No father . . .
may take even the smallest gratuity for his daughter; for a man who,
through avarice, takes a gratuity, is a seller of his offspring.'

Even in those societies where a child's life is considered to be a gift
bestowed upon its parents, it does not follow that the parents retain the
right of bestowal in that life after the child matures. In societies that confer
power upon women as well as men, the right of bestowal passes automat-
ically to a woman as she becomes an adult, whereupon she, like her
brothers, is free to bestow her own life where she chooses.* She may even
carry a six-foot bamboo fighting stick if she wants. If, on the other hand,
a woman does not receive the right of bestowal in herself, then she can

* Abandoning the bestowal of the bride in favor of her autonomy is one way to rearrange
the pattern of this institution. Because the woman given in marriage *does* assume the
functions of the gift, the group loses something even as the woman gains. When someone
other than the couple being married is allowed to stand up at a wedding and say 'I do,'
then marriage is understood to be a social event; the ceremony recognizes that we some-
times have rights in the lives of our friends and relations, and that the union occurs within
an 'ego' wider than the couple's 'ego-of-two.' For the feminist wary of the father's right
to bestow his daughter, but wary as well of what I earlier called the perfect freedom of
strangers – that pure individualism which is corrosive to social life – we might, rather than
drop all sense of persons as gifts, extend a 'female' submersion in the group to the groom,
instead of a 'male' individualism to the bride. We could, in other words, add the bestowal
of the man to the ceremony and – a necessary corollary – recognize that mothers share in
the donation of their offspring. In fact, if Freud is right that the most difficult attachment
to resolve is the one we have to the parent of the opposite sex, it might be useful for the
mother of the groom to stand and declare that she, too, is willing to allow her interest in
the life of her son to pass to another woman; that she, like the father of the bride, is letting
go of a gift.

never become an actor in her own right, and never an autonomous individual. This last is what is onerous to us in the idea that a woman may be given in marriage – not, I think, that people are sometimes treated as gifts, not even that there is such a thing as 'the right of bestowal in persons,' but that that right passes to the son when he comes of age, but not to the daughter. For where men alone may give and receive, and where women alone are the gifts, men will be active and women passive, men self-possessed and women dependent, men worldly and women domestic, and so on, through all the clichés of gender in a patriarchy.

II • *Big Men and Little Women*

In a recent edition of Emily Post's *Etiquette*, which I shall be treating as a sort of textbook of domestic ethnography, we find that in a modern, capitalist nation the father still gives away the bride. Before he does so, if he knows his etiquette, he will have played out that famous man-to-man scene in which the groom asks him for, and he agrees to deliver, his daughter's 'hand.' No parallel customs exist for the bride: no one gives the groom to her; she receives no hand from her future mother-in-law.

In the society that Miss Post describes, not only is the bride given in marriage, but she is also the recipient of the marriage gifts. Miss Post is quite clear: 'You seldom send a present to the bridegroom. Even if you are an old friend of his and have never met the bride, your present is sent to her . . . Rather often friends of the bridegroom do pick out things suitable for him, such as a decanter or a rather masculine-looking desk set, which are *sent to her* but are obviously intended for his use.' Finally, the bride not only receives the gifts but it is she, not her husband, who writes the thankyou notes.

The curious asymmetry of this institution suggests that while a man and a woman may be marrying each other, the woman alone is marrying a network of kin. If she receives the gifts and expresses the gratitude, then she is the one who is woven into the social fabric established by the commerce of marriage gifts. In a final note of advice, Miss Post tells her readers that once the wedding is over, the bride 'must try to understand and accept the attitude of her future family (whatever it may be), and she must *not* stand inflexibly upon what she unwittingly considers to be her own family's rights. The objective that she should keep in mind is the

happiness of the relationship between her future in-laws and herself.'
Again, no such suggestion appears for the groom.

A woman given in marriage in a modern, capitalist nation is not only
a gift, then, she is actually expected to think and act in the spirit of the
gift, to become the incarnation and voice of the *hau*. By attending to rela-
tionship and muting her individualism, she is supposed to become the active
link that will unify the two families. The groom is asked to do none of this
labor. In this particular ceremony, at least, to deal with gifts – to receive
them, to express the gratitude, to intuit and act upon their spirit – is a
mark of the female gender.

By 'gender' I mean to indicate the cultural distinctions between male
and female – not the physical signs of sex but that whole complex of activ-
ities, postures, speech patterns, attitudes, affects, acquisitions, and styles
by virtue of which a woman becomes feminine (a man 'effeminate') and
a man masculine (a woman 'mannish'). Any system of gender will be
connected to actual sexuality, of course, but that is only one of its possible
connections. It may also support and affirm the local creation myth, perpet-
uate the exploitation of one sex by another, organize aggression and
warfare, ensure the distribution of food from clan to clan – it may, in other
words, serve any number of ends unrelated to actual sexuality.

Many writers have addressed themselves to divisions of labor based upon
gender; I want to speak here of a similar 'division of commerce,' one in
which a 'man' trades in one manner and a 'woman' in another. I have
opened with a description of the Protestant wedding not to raise again the
issue of the woman given in marriage, but to show that – at least in the
world that Emily Post describes for us – gift exchange is a 'female' commerce
and gifts a 'female' property. There is no actual prohibition on the groom's
involving himself with the wedding gifts, of course; he may write thank-
you notes if he wants to. But that activity will not make him masculine.
Only the bride is able to affirm her gender, her social sexuality, by concerning
herself with gift exchange.*

In recent years as women have justly demanded an opportunity to
become actors on a par with their brothers in the marketplace, a new genre

* Gift exchange is not aboriginally, nor yet universally, a 'female' commerce. There have
always been times and there are still places where both men and women are sensitive to the
functions of gift exchange, and where a man in particular may acquire his masculinity, or
affirm it, through the bestowal of gifts. For a fascinating discussion of gender and exchange
in a tribal group, see Annette Weiner's recent book on the Trobriand Islands, *Women of
Value, Men of Renown.*

of newspaper article has appeared on the women's pages to articulate the silent assumptions of 'male' commerce, assumptions that women will need to know about if they are to survive in a world where the spirit of the gift may be missing. As gifts are agents of relationship, so brides become relations, literally, by the form of commerce assigned to them; but in the market, in a male commerce, relationship is a secondary concern. Thus a woman executive offers a typical word of advice to the women who read the 'style' pages of the *New York Times*: 'Women on the way up should avoid associating with "unsuccessful turkeys," even if they happen to be friends. Leaving your friends behind isn't disloyalty. You are going to be judged by the company you keep. Seek out the people who can help you. Men have known this for years, and we are playing in their arena.'

And playing by their rules, too, we gather. To succeed in the marketplace one must, it seems, be willing to sacrifice attachment to advancement, affection to calculation. This ability to act without regard to relationship has traditionally been a mark of the male gender. The man who wants to make money does not spend a lot of emotional time abandoning his – how did Miss Post put it? – unwitting attitudes in favor of those of his in-laws. He is self-possessed, not self-effacing. He is willing to shun the 'turkeys' who were his pals in college, willing to evict deadbeats from his apartment buildings (and wary, therefore, of renting to friends and relations), willing to put people out of work if one of his ventures isn't paying its way, willing to close the operation down completely if some other property needs a shot of capital, and so forth and so on.

In fine, when anyone, male or female, sets out to make money in the marketplace, he reckons his actions by the calculus of comparative value and allows that value, rather than the home life of his clients and friends, to guide him. I say 'male or female,' but of course this ability is still considered to be a mark of the masculine, a decade of advice columns notwithstanding. The men's pages of the newspapers need no articles earnestly asserting that dumping your friends is not disloyalty. 'Men have known this for years.' In a modern, industrial nation, the ability to act without relationship is still a mark of the masculine gender; boys can still become men, and men become more manly, by entering the marketplace and dealing in commodities. A woman can do the same thing if she wants to, of course, but it will not make her feminine.

These divisions of commerce by gender are most easily seen in those 'boundary' situations in which a man or a woman is caught between two

spheres – where, as in this last example, women would enter the market (and feel they must be 'men' to do so), or where, in the examples that follow, men are denied access to the market and feel as a result that they are not manly. The great blues singer Big Bill Broonzy once wrote a song about the Jim Crow fact that white people call black men 'boys,' regardless of their age ('I wonder when I'll get to be called a man, / D'I have to wait'll I be ninety-three?' goes the refrain). In a society in which black men cannot enter the market as equals with white men, and in which being an actor in the market is associated with masculinity, a black man is always a 'boy' (unless he's a thief: theft will make him a 'bad man,' but a man nonetheless). Think back for a moment to Carol Stack's story of the kinship network in the Flats, the black ghetto near Chicago. Magnolia Waters and her husband, Calvin, disburse an inheritance among their kin. But as anyone who reads the story cannot help noticing, Magnolia is the main actor. Why? Because she is able to respond to need and strengthen the ties of kinship through gifts without any challenge to her gender. So long as gift exchange is a 'female' commerce, her activity actually affirms her gender; through it she becomes a Big Woman in her community.

Calvin has no such luxury. In tribal situations, in an extended family, even in the community of science, a man may become a Big Man through the bestowal of his gifts. But where exchange trade is the only male commerce, generosity makes no one manly. I recently heard a story about an American Indian living on a reservation in North Dakota who, in the late 1960s, received $10,000 from the government, a lot of money in a place where many people lived on $2,000 a year. What did the man do with his windfall? He threw a party for the whole tribe, a party that lasted for days. Now, the interesting thing is that on the reservation there are two distinct versions of this event: the 'Indian version,' in which the party-giver appears as a hero, a true Indian; and the 'white version,' which takes the 'wasted' money as proof of the inherently infantile nature of the Indians, thus justifying the continued management of Indian wealth by the white-dominated Bureau of Indian Affairs. (The story is the same as the one about the Flats – the fate of an influex of capital into a gift community. So long as gifts carry female worth in the white culture, for a black man to emerge from the ghetto or for an Indian to leave the reservation involves a crisis of gender: to make the transition he must adopt what is at home an unmanly individualism.)

To close this discussion of gender and commerce, I want to return one

last time to Emily Post. In the section of her *Etiquette* devoted to 'showers,' a woman's gift-giving institution if there ever was one, Miss Post lists three different persons for whom these 'friendly gatherings' are given: a bride-to-be, an expectant mother, and the new clergyman. What is this solitary gentleman doing among nubile and pregnant ladies?

Miss Post suggests that the women of the town bring food to fill the cleric's empty larder. It seems a sensible enough suggestion, but still, the ladies are not urged to give food to the new vice-president for marketing at the local manufacturing plant. The clergyman is grouped with the pregnant and the betrothed as the object of a gift ceremony because he performs a 'female' role in the community. I earlier distinguished between 'labor' and 'work,' saying that there are gift labors that cannot, by their nature, be undertaken in the willed, time-conscious, quantitative style of the market. A clergyman does such labors. Not only is he charged with the cure of souls, that interior task which cannot be accomplished in any market, but nowadays he must also be a social worker, visiting nurse, marriage counselor, and psychotherapist. And by our current notions of gender all these duties place him closer to Magnolia Waters than to any salesman.

To make the wider point here, what we take to be the female professions – child care, social work, nursing, the creation and care of culture, the ministry, teaching (these last, when done by men, being done by effete men, as Vice-President Spiro Agnew told us) – all contain a greater admixture of gift labor than male professions – banking, law, management, sales, and so on. Furthermore, the female professions do not pay as well as the male professions. The disparity is partly a consequence of a stratified gender system: women are still not paid on a par with men *for equal work*, a discrimination therefore clearly unrelated to the content of that work.

But if we could factor out the exploitation, something else would still remain: there are labors that do not pay because they, or the ends to which they are directed, require built-in constraints on profiteering, exploitation, and – more subtly – the application of comparative value with which the market is by nature at ease. There are two points here, one having to do with the nature of the work, the other with the commitment of the worker. 'Female' tasks – social work and soul work – cannot be undertaken on a pure cost-benefit basis because their products are not commodities, not things we easily price or willingly alienate. Furthermore, those who assume these labors automatically inhibit their ability to 'sell themselves' at the

moment they answer their calling. Gift labor requires the kind of emotional or spiritual commitment that precludes its own marketing. Businessmen rightly point out that a man who cannot threaten to quit his job has no leverage when demanding a higher salary. But some tasks cannot be undertaken in such an adversarial spirit. Few jobs are pure gift labors, of course – although a nurse is committed to healing, she is also an actor in the marketplace – but any portion of gift labor in a job will tend to pull it out of the market and make it a less lucrative – and a 'female' – profession.

But, you ask, if we really valued these gift labors, couldn't we pay them well? Couldn't we pay social workers as we pay doctors, pay poets as we do bankers, pay the cellist in the orchestra as we pay the advertising executive in the box seat? Yes, we could. We could – we should – reward gift labors where we value them. My point here is simply that where we do so we shall have to recognize that the pay they receive has not been 'made' the way fortunes are made in the market, that it is a gift bestowed by the group. The costs and benefits of tasks whose procedures are adversarial and whose ends are easily quantified can be expressed through a market system. The costs and rewards of gift labors cannot. The cleric's larder will always be filled with gifts; artists will never 'make' money.

We must therefore distinguish the necessary feminist demand for 'equal pay for equal work' from the equally important need to keep some parts of our social, cultural, and spiritual life out of the marketplace. We must not convert all gift labors into market work lest we wake one day to see that universal market in which all our actions earn a wage and all our goods and services bear a price. There is a place for volunteer labor, for mutual aid, for inhouse work, for healings that require sympathetic contact or a cohesive support group, for strengthening the bonds of kinship, for intellectual community, for creative idleness, for the slow maturation of talent, for the creation and preservation and dissemination of culture, and so on. To quit the confines of our current system of gender means not to introduce market value into these labors but to recognize that they are not 'female' but human tasks. And to break the system that oppresses women, we need not convert all gift labor to cash work; we need, rather, to admit women to the 'male,' moneymaking jobs while at the same time including supposedly 'female' tasks and forms of exchange in our sense of possible masculinity.

Let me close on a historical note. Ann Douglas has written an interesting book on the feminization of American culture during the nineteenth century.

In 1838, she tells us, an American Unitarian minister, Charles Follen, had a vision in which he saw a band of singing Sunday School children enter his church and displace a group of stern Pilgrim Fathers. In the course of the nineteenth century, Douglas contends, an old association between masculinity and spiritual power was broken; spiritual life became the province of women, children, and an 'unmanly' clergy, who, like the mothers of families, had essentially no social force beyond 'influence.'

The stern Pilgrim Fathers of Follen's vision founded the nation. Serious religious dissenters from Europe, these men felt no necessary disjunction between their sex and attention to spiritual life. An early diarist like Samuel Sewell worried daily about his relationship to God, never about his manliness. But the nineteenth century saw a decline in faith coincide with the remarkable success of a secular, mercantile, and entrepreneurial spirit. The story has been told many times. By the end of the century, to be 'self-made' in the market, or to have successfully exploited the natural gifts of the New World, were the marks of a Big Man, while attention to inner life and the community (and to their subtle fluids – religion, art, and culture) was consigned to the female sphere. This division of commerce by gender still holds. As a character in Saul Bellow's novel *Humboldt's Gift* remarks in regard to creative artists, 'To be a poet is a school thing, a skirt thing, a church thing.' In a modern, capitalist nation, to labor with gifts (and to treat them as gifts, rather than exploit them) remains a mark of the female gender.

CHAPTER SEVEN

USURY:
A HISTORY OF
GIFT EXCHANGE

Unto thy brother thou shalt not lend upon usury, that the Lord thy god may bless thee in
all that thou settest thine hand to.

DEUTERONOMY 23:20

What ye put out at usury to increase it with the substance of others, shall have no
increase from God.

THE KORAN, SÛRA 30:38

I • The Law of The Gate

In an earlier chapter, speaking of gifts that must be refused, I suggested
that a young person leaving home might well be wary of that parental
largess which tends to reinforce the bond between parent and child. A
look at the same situation in terms of money loans will illustrate what
I take to be the ancient meaning of usury, as well as the connection
between gift exchange and the old debate over the morality of charging
interest on a loan. Wherever there is the potential for wealth to increase

over time, an interest-free loan amounts to the gift of the increase. Imagine, then, a young woman recently out of college who approaches her parents for a loan. And imagine these different responses: (1) the family immediately gives her $1,000, nobody says a thing about it, if she ever needs more she should just ask, and so on; (2) they loan her the money and they insist (or she does) on her signing a note promising to repay the loan at such and such a date, along with an interest payment at the prime rate.

The first response makes the woman part of the family, which may be good for her or it may be bad. (Maybe it's a large family where she will be able to give and get support all her life; or maybe if she takes the gift she'll have to go on being a child and never establish herself in the world. It depends.) Either way, the gift creates a psychic bond to the family and its specific structure, while the interest-bearing loan says to all concerned that though she may be on good terms, she is psychologically separated from the family. Usury and interest are sisters to commodity; they allow or encourage a separation.

Several senses of 'usury' precede the modern one. The term took on its current meaning (an excessive or illegal rate of interest) during the Reformation. Before that it simply meant *any* interest charged on a loan, and its opposite was a form of gift, the gratuitous loan. A phrase of Marcel Mauss's first brought me to the connection between 'ancient usury,' as I shall call it, and gift exchange. Mauss speaks of how Maori tribesmen insist that the *hau* of a gift 'constrains a series of users' to make a return gift, 'some property or merchandise or labor, by means of feasts, entertainments or gifts of equivalent or superior value.' The superior value that the 'users' of a gift return or pass along is the 'use-ance' or 'use-ury' of the gift. In this sense, ancient usury is synonymous with the increase that comes to the gift when it is used up, eaten, and consumed, and by the ethics of a gift society this usance is neither reckoned nor charged, it is passed along as a gift.

The primitive connection between gift-increase and usury may also be seen in Roman law, where *usura* originally meant a charge for the loan of a fungible (i.e., any perishable and nonspecific good whose use consists of its consumption). The examples given of fungibles are almost always organic goods, such as grain, which, like gifts, increase through use: if a man borrows a bushel of seed grain, his use of the loan consumes the loan, but if he is prudent, his use will also increase it –

the grain he harvests will be more than the grain he plants. And when he returns the bushel he borrowed, he includes with it the *usura*, the fruit of its use. If both sides of the exchange are gifts, the *usura* is the expression of gratitude.

But I must stop here. This connection between usury and gifts is a fable I have invented to speak of ancient history. Perhaps I am right – the earliest senses of 'usury' may well derive from the increase attendant upon gift exchange; but as we all know, the term does not in fact refer to that increase. When it first appears, 'usury' is already distinct from gift-increase, for in pure gift exchange there is no need to speak of the increase in this intentional manner. The man who gives a gift drops the shells on the ground, saying, 'Take this food I cannot eat,' and keeping silent as to the matter of any return. He certainly does not say, 'The *usura* will be ten percent per annum.' To ask for interest on loaned wealth is to reckon, articulate, and charge its increase. The idea of usury therefore appears when spiritual, moral, and economic life begin to be separated from one another, probably at the time when foreign trade, exchange with strangers, begins.* As we saw in an earlier chapter, wherever property circulates as a gift, the increase that accompanies that circulation is simultaneously material, social, and spiritual; where wealth moves as a gift, any increase in material wealth is automatically accompanied by the increased conviviality of the group and the strengthening of the *hau*, the spirit of the gift. But when foreign trade begins, the tendency is to differentiate the material increase from the social and spiritual increase, and a commercial language appears to articulate the difference. When exchange no longer connects one person to another, when the spirit of the gift is absent, then increase does not appear between gift partners, usury appears between debtors and creditors.

Islamic laws concerning usury support the intuition that the idea of usury originally appeared in order to mark the distinction between gift

* Philip Drucker provides an example from the tribes of the North Pacific coast. Loans were not uncommon there, but most were in the nature of a gift, returned with voluntary increase to indicate gratitude. 'However,' Drucker tells us, 'loans at interest were strictly commercial transactions, the rate being agreed upon at the time of the loan. The ruinous 100 percent rate was usual for a long-term loan, that is, for several years . . . There are no exact data on the origin of the custom, but there is reason to suspect that it may not be aboriginal in origin . . . It is probably significant that loans at interest consisted of trade blankets or money, not of aboriginal value items.' Here, as I surmise must be the general case, the appearance of interest on loans coincides with the introduction of market exchange with foreigners.

giving and the market. I spoke earlier of increase as having a vector or direction: in a gift society, the increase follows the gift and is itself given away, while in a market society the increase (profit, rent, interest) returns to its 'owner.' The material quantity of the increase could be the same in both cases, but the social and spiritual increase cannot, for the feeling-bond – and all that is attendant upon it – does not appear when the increase does not circulate as a gift. The Koran distinguishes in essentially these terms between lawful increase, which comes of gift giving (gifts to the poor, in particular) and unlawful increase, usury (*riba*). 'God shall blot out usury, but almsgiving shall bring increase,' reads a verse in the second Sûra. 'What ye put out at usury to increase it with the substance of others, shall have no increase from God,' says a later verse. The Koran permits a man who has given a gift to receive a return gift of greater worth. But they must both be gifts: to loan a thing under condition that it be returned with increase is usury. Increase borne of a gift (from a friend or from the Lord) is lawful and sacred; increase that comes of capital loaned 'at usury' is profane.

Aristotle is always mentioned in discussions of usury for having made a similar distinction, though the best-known part of his argument strikes me as a bit of a red herring. By the time Aristotle wrote his *Politics* (about 322 B.C.) people were charging usury on money loans. Money had been classified as a fungible like grain, for it was considered to be 'consumed' when it was exchanged for goods. Aristotle objected.

There are two sorts of wealth-getting . . . , one is a part of household management, the other is retail trade; the former necessary and honourable, while that which consists in exchange is justly censured; for it is unnatural, and a mode by which men gain from one another. The most hated sort, and with the greatest reason, is usury, which makes a gain out of money itself, and not from the natural object of it. For money was intended to be used in exchange, but not to increase at interest. And this term interest [*tokos*, 'offspring'], which means the birth of money from money, is applied to the breeding of money because the offspring resembles the parent. Wherefore of all modes of getting wealth this is the most unnatural.

Aristotle distinguishes here between a gift situation (the Greek household) and a commodity one (retail trade). To say that one is natural and the other not so is the red herring; the distinction between these forms of commerce holds up without recourse to organic analogies.* Natural or unnatural, in retail trade 'men gain from one another' and not from their union. Usury and trade have their own sort of growth, but they bring neither the personal transformations nor the social and spiritual cohesion of gift exchange. As the industrialized nations have shown us, a people may grow richer and richer in commodities while becoming more and more isolated from one another. Cash exchange does not engender worth. If you care more about the unity and liveliness of the group than you do about material growth, therefore, usury becomes 'the most hated' sort of gain.

The laws in the Old Testament which deal with usury have been a focal point for the usury debate over the centuries. The most important are two verses in the 23rd chapter of Deuteronomy:

19: Thou shalt not lend upon usury to thy brother; usury of money, usury of victuals, usury of anything that is lent upon usury:
20: Unto a stranger thou mayest lend upon usury: but unto thy brother thou shalt not lend upon usury, that the Lord thy God may bless thee in all that thou settest thine hand to in the land whither thou goest to possess it.

* I am not fond of arguments that depend upon declaring something 'natural' or 'unnatural'; they tend not only to cut off debate but to assume a division between man and nature. Usury may be justly hated, but since men invented it, we must either accept it as a part of nature or say that men are not.
To give Aristotle his due, however, we might change the terms to 'organic' and 'inorganic.' Organic wealth was the original context for most of our economic language. In *The Origins of European Thought* Richard Onians makes an interesting observation in regard to the word 'capital.' For both the Greeks and the Romans, the human head was regarded not as the seat of consciousness but as the container of procreative powers, the seeds of life. A Roman metaphor for kissing was 'to diminish the head,' according to Onians; sexual intercourse also 'diminished the head,' the point being that erotic or generative activity draws the life-stuff out of its container. In this way it was understood that *caput* (head, but also capital) produced offspring. Onians tells of a Roman cult, the Templars, who worshiped a divine head 'as the source of wealth, as making trees bloom and earth to germinate.' Aboriginally 'capital' was a strictly organic wealth that quite literally bore *tokos*, and in this context Aristotle is right: it is unnatural, it is not true to nature, to speak and act as if inorganic capital could possibly do the same.

This double law, both a prohibition and a permission, seeks to organize the double situation of being a brotherhood wandering among strangers. The Hebrews had gift exchange among themselves, but they also had contact with peoples who were not part of the gift cycle.*

In a gift cycle the gift is given without contract or agreement about return. And yet it does return; a circulation is set up and can be counted upon. Within this circle, things must be kept moving, and that is the intent of the first law: no one may ask usury on a loan to a brother, for this converts generosity into a market exchange. The prohibition means not that there should be no increase or usance, but that it must come to the tribe as a whole, not to individuals.

Thus also the law against usury requires that the self be sub-merged in the tribe. This is the 'poverty' of the gift, in which each man, by his generosity, becomes 'poor' so that the group may be wealthy. A needy person is not seen as having a separate and personal problem. His neediness is felt throughout the group, and its wealth flows toward the need and fills it without reflection or debate, just as water flows immediately to fill the lowest place. The law asks that no member of the tribe be either more or less in touch with the necessities of life.

Put another way, the law says there shall be no business in the tribe. Property circulates, but not through buying and selling. Among the Hebrews the contracting of debts and the alienation of movable goods was very difficult. Business, as the saying goes, was done with foreigners (Thomas Jefferson had a phrase: 'The merchant has no homeland'). The law makes it almost a matter of definition: trade is what you do with strangers. When this law is observed, when wealth is not turned into private capital inside the tribe, then they say, 'The Lord thy God may bless thee in all that thou settest thine hand to . . .'

To speak of brotherhood as the first law does is to affirm a trust in the circulation of the gift. The second law deals with situations of doubt. Suppose a strange Egyptian comes by and asks for a few bushels of grain.

* Such a double economy is hardly unique to the Jews; it occurs wherever there is a strong sense of an in-group. In fact, if ancient usury was not the exorbitant rate to which the term now refers but something closer to 'rent' or 'interest,' then the Jewish law is comparatively mild. An ethnologist writes as follows of a Solomon Island society: 'Native moralists assert that neighbors should be friendly and mutually trustful, whereas people from far-off are dangerous and unworthy of morally just consideration. For example, natives lay great stress on honesty involving neighbors while holding that trade with strangers may be guided by *caveat emptor*.'

You can't tell if you'll ever see the man again or if he understands how one bushel in the spring is several in the fall. He has a different god; he hasn't read the local Book. Grain, even what can be spared, is a wealth of the tribe; if it does not come back, the group will lose some of its vitality. Within the body of the tribe there is faith that the gift will return as blood comes back to the heart, but beyond the body there is risk. So, when the Egyptian comes by, you try to articulate what does not need to be said to a brother. Not only do you remind him that the gifts of nature grow with use and that he should return the usance, but you tell him you'd like it all on paper and could he leave his goats as collateral.

The God who permits usury is one who allows gift exchange to have a boundary. Though the weight of my attention in this book falls elsewhere, there is no need to pretend that such a boundary has nothing in its favor. It protects the interior of the circle and assures that the fluid property within will not be lost or spread too thin. The two Mosaic laws describe a community that is like a single-celled being. It was recently understood that some organic cells have a special kind of molecule forming their outer wall. These molecules repel water on one end and attract it on the other, a sort of double law for molecules. When such molecules are put into water, they will eventually group themselves in a circle with the water-repellent ends pointing away from the water, and toward the body of the cell. The cell becomes an organized and living structure by having molecules with two sets of laws, one for the outer edge and the other for the center.

Another image for a group of people governed by such laws is a walled city with a gate at the wall and an altar in the center. Then we may say, as the ancients did, that there is a law of the altar and a law of the gate. A person is treated differently depending on where he or she is. At the edge the law is harsher; at the altar there is more compassion.

To take a metaphor from the last chapter, we could say that the two laws in Deuteronomy are male and female with two kinds of judging for the two kinds of property. The first law says that female property must predominate within the group, while the second allows male exchange at the edge. The breakdown of these laws and the incautious mixing of the forms of property lead to the dissolution of the group. If there is no wall, then wealth flows out, like a manic person who discharges his energy with no means of getting it back. Conversely, if male property gets into the middle, then the group begins to fragment, as does any community whose gifts are placed in the market.

To summarize the Mosaic laws, one ensures the circulation of gift while

the other rationalizes the structure of gift exchange in order to deal with strangers. The permission to charge usury allows some trade across the boundary, but while such trade may set up a flow between admitted aliens, it also carefully maintains them in their alien status. Foreign trade and the charging of rent on loans do not bring people together except materially. There is no felt bond, no group is formed. The rationalization of the gift abandons the spirit of the gift.

The double law worked well for a long time. It became a problem, however, in the centuries after Jesus, for his injunction that all men are brothers seemed to cancel the permission to practice usury. What form should economic life take if the tribe has no boundary at all? This question starts the real debate over usury which has run from the early Church Fathers into the present century. If we say that the double law of Moses describes a circle, with gift circulation inside and market exchange at the edge, then we may say that the history of the usury debate is the history of our attempts to fix the radius of the circle. The Christians extended the radius infinitely under the call for a universal brotherhood. For fifteen centuries people tried to work within that assumption. The Reformation reversed it and began to shorten the radius again, bringing it, by the time of Calvin, into the heart of each private soul.

II • A Scarcity of Grace

The property consciousness of the New Testament is like that of Saint Gertrude, who said, 'The commoner property is, the holier it is.' When someone asks, 'Who is my neighbor?' Jesus tells the story of the good Samaritan. Compassion, not blood, makes one a brother. This spirit changes the boundary of the tribe. The house of Israel has no wall (except faith) after Jesus travels to Tyre and Sidon and is himself moved by the faith of the Canaanite woman.

Jesus continually separates the marketplace from the Kingdom. We all know the stories. He teaches that a person should 'lend expecting nothing in return'; his prayer asks the Lord to 'forgive us our debts as we also have forgiven our debtors.' He drove out all 'who sold and bought in the temple and he overturned the tables of the money-changers and the seats of those who sold pigeons.' When Jesus is preparing himself for crucifixion and burial, a woman anoints his head with fine oil. This is the occasion

upon which he says, 'Ye have the poor always with you,' in reply to a suggestion by the disciples that they take the ceremonial oil and sell it to get some money to give to the poor. As usual, they have been a little slow to catch on. They are thinking of the price of oil as they sit before a man preparing to treat his body as a gift of atonement. We might take Jesus' reply to mean that poverty (or scarcity) is alive and well inside their question, that rich and poor will be with them so long as they cannot feel the spirit when it is alive among them.

The Christians in the early Church lived in a kind of primitive communism, sharing their property. The problem of usury did not receive much attention until after the Church and the Empire had joined. Benjamin Nelson, in his book *The Idea of Usury*,* cites Saint Ambrose of Milan as one of the first of the Church Fathers to try to apply a Christian conscience to the Old Testament law. Ambrose addresses usury in his fourth-century *De Tobia*; he retains Moses' double standard but he changes the terms. The 'brother' is now anyone in the Church. 'For every people which, first, is in the faith, then under Roman law, is your brother.' He is a brother who is 'your sharer in nature and your co-heir in grace.'

Saint Ambrose also has a feeling for the effect of the original permission to charge usury to a foreigner, however, and he allows that Christians may collect usury from enemies of the Church:

> Upon him whom you rightly desire to harm, against whom weapons are lawfully carried, upon him usury is legally imposed. On him whom you cannot easily conquer in war, you can quickly take vengeance with the hundredth. From him exact usury whom it would not be a crime to kill. He fights without a weapon who demands usury; without a sword he revenges himself upon an enemy, who is an interest collector from his foe. Therefore where there is the right of war, there is also the right of usury.

The charging of interest is an aggressive act whenever it goes beyond marking the boundary between peoples, and though in Deuteronomy this may not have been the intent of the permission to practice usury, it

* This remarkable piece of scholarship first appeared in 1949 and has now been reprinted, with addenda, by the University of Chicago Press. Nelson was a historian of religion who, touched by Max Weber's similar work, fixed on the usury debate as a way to trace moral and economic conscience through the history of the Church. I am indebted to his guidance.

can clearly be the effect. Curiously enough, it does not seem to have
occurred to Saint Ambrose that the stranger could be someone who is
not in the group and yet also not an enemy. ('Who then was the stranger,'
he writes, 'except Amalech, except the Amorite, except the enemy?') As
soon as all men *ought* to be brothers, all aliens become enemies. Such
aggressive faith leaves a blind spot in the spirit of universal brotherhood.
A covert boundary lies in the shadow that falls behind an unbounded
compassion, and much that unfolds during the Middle Ages, from a recur-
rent anti-Semitism to the Church's spiritual imperialism, seems to grow
in that darkness.

If we make a list of the ways in which medieval churchmen sought to
reconcile the Gospel with the old permission to usure, we will find that
most resolve the apparent conflict by finding fault with the Jew; nowhere
does there appear the idea of a wandering tribe protecting itself. To para-
phrase a few examples:

- Peter Comestor, twelfth century: The Lord knew the Jews were a
 tricky people who might do worse if they were not permitted to
 charge usury.
- Thomas Aquinas, thirteenth century: The Jews needed an outlet
 for their avarice or they would have stolen from one another.
- William of Auxerre, thirteenth century: As the Lord could not
 bring the Jews to perfection all at once, he permitted them to sin
 in moderation.

Another explanation given for the permission to usure, one that runs from
Saint Ambrose to Martin Luther, is that the Lord allowed usury against non-
Jews in the Holy Land in order to punish them. Usury is a tool of war, and
the Lord, by allowing the Jews to practice usury, authorized a holy war against
His enemies. When medieval savants take up this line of analysis, it becomes
difficult to distinguish the spirit of universal brotherhood from the hegemony
of the Church. In the fifteenth century, for example, Bernardino of Siena
could defend Christian usury as a species of brotherly love:

Temporal goods are given to men for the worship of the true God and
the Lord of the Universe. Where, therefore, the worship of God does
not exist, as in the case of God's enemies, usury is lawfully exacted,
because this is not done for the sake of the gain, but for the sake of

the Faith; and the motive is brotherly love, namely that God's enemies may be weakened, and so return to him . . .

The Crusades were organized under this shadow side of the spirit of brotherhood. And as Saint Ambrose's interpretation of the law would permit usury against the Moslem enemy in the Holy Land, the Church tolerated usury – clerical and secular, Christian and Jewish – for a time. But in fact the occasion to loan money to a declared enemy rarely arises; in financing the Crusades, the Church Fathers soon realized that Jewish moneylenders in Europe imposed more of a burden on the Church than Christian money-lenders could possibly impose on the Moslems. It is usury *at home* that breaks up the brotherhood and loses the war. The Church finally prohibited all usury in order to close its own ranks. A bull issued in 1145 by Pope Eugenius III clearly links a renewed prohibition on usury to the problem of funding the Crusades. As in Moses' time, interior unity demanded such an economic policy.

Clearly, then, usury was not unknown in the Middle Ages. But it must nonetheless be emphasized that despite divergent conclusions the common and unquestioned assumption of all Christians during this period was that usury and brotherhood were wholly antithetical. By the twelfth or thirteenth century the word 'brother' is always used as a universal, and when the question is raised, the double standard of Moses (or of Saint Ambrose) is always resolved on the side of brotherhood. Here, for example, is Raymond of Pennaforte in the thirteenth century: 'From him demand usury, O you, whoever you may be, whom you rightly desire to harm: but you ought rightly to harm no one; therefore, you ought to demand usury from no one.' This is a typical medieval resolution. Here is another from Thomas Aquinas in the same century: 'The Jews were forbidden to take usury from their brethren, i.e., from other Jews. By this we are given to understand that to take usury from any man is simply evil, because we ought to treat every man as our neighbor and brother, especially in the state of the Gospel, whereto all are called . . .' Even in justifying the Crusades, medieval Christians never let go of the basic assumption that usury and brotherhood could not mix. That assumption is the pattern to which the different clothes were cut. Much may have happened in the shadow of universal brotherhood, but the universality itself was never questioned. It is always the ideal: one does not take usury from a brother and all men should be brothers.

The Reformation changed this.

The central figure was Martin Luther. It is difficult to sum up Luther's views on usury, for he was constantly torn by the question. It is not difficult, however, to summarize the effect of his views. Luther and other leaders of the Reformation organized a division of moral and economic life. Faced with managing the break from Rome, the reformers turned to the alternative power with the most stability: the new merchant princes. There were some priests during the Reformation who called for a new Jerusalem and the abolition of private property, but they did not survive. Those who did survive supported the princes and even advised them on matters of monetary policy. To do this, they ceded power to the state by distinguishing between God's law and civil law. They said in effect that while it might be hoped that a prince would rule in the spirit of the Gospels, the world was such an evil place that a strong temporal order based on the sword, not on compassion, was necessary. Therefore Protestant churchmen did not in the end oppose civil usury nor any of the other changes in property rights that marked the sixteenth century (such as the charging of rents for what were formerly common lands). The leaders of the Reformation still spoke of brotherhood, but they had become convinced that brotherhood could not be the basis of civil society.

Luther's views on usury changed greatly during his lifetime. In the young Luther, one finds a traditional medieval condemnation of usury embellished with some attacks on Rome as the usurer. But in 1525 Luther came to a turning point. The Peasants' War broke out in Germany that year, an uprising whose story has been retold many times, for in it are all the elements of the struggle between spirit and property that marks the Reformation. Germany had seen over a hundred years of unrest among peasant farmers as feudalism faded and princes began to consolidate their power by territory. Roland Bainton, a historian of the Church, writes:

> The law was being unified by displacing the diverse local codes in favor of Roman law, whereby the peasant . . . suffered, since the Roman law knew only private property and therefore imperiled the commons – the woods, streams, and meadows shared by the community in old Germanic tradition. The Roman law knew also only free men, freedmen, and slaves; and did not have a category which quite

fitted the medieval serf. Another change . . . was the substitution of exchange in coin for exchange in kind.

The Peasants' War was the same war that the American Indians had to fight with the Europeans, a war against the marketing of formerly inalienable properties. Whereas before a man could fish in any stream and hunt in any forest, now he found there were individuals who claimed to be the owners of these commons. The basis of land tenure had shifted. The medieval serf had been almost the opposite of a property owner: the land had owned *him*. He could not move freely from place to place, and yet he had inalienable rights to the piece of land to which he was attached. Now men claimed to own the land and offered to rent it out at a fee. While a serf could not be removed from his land, a tenant could be evicted not only through failure to pay the rent but merely at the whim of the landlord.

Some of the radical priests identified with the Reformation supported the peasants' opposition to these changes, and Luther was therefore pressed to clarify his position. In 1523–24, Luther preached on Deuteronomy (the sermons later being published as *Deuteronomy with Annotations*). In this book he refers to the Mosaic law that releases debtors from their debts every seventh year, calling it 'a most beautiful and fair law.'

> But [he says] what will you say to Christ who . . . forbids to demand repayment of a loan and commands to lend without the hope of receiving equal value in return? I answer: Christ is speaking to Christians, who are above every law and do more than the laws ordain; but Moses provides laws for people in civil society, who are subject to the government and the sword, so that evildoers are curbed and the public peace is preserved. Here, therefore, the law is to be so administered that he who has received a loan pays it back, although a Christian would bear it with equanimity if such a law did not come to his aid and a loan were not repaid . . . The Christian endures it if he is harmed . . . although he does not forbid the strictness of the avenging sword.

Law and faith are already separated here. A second example from the same years will flesh out the tone of this division. In 1523 James Strauss, one of

the more radical priests, suggested not only that no one should charge interest, but that debtors should resist their creditors or themselves share in the sin of usury. The peasants were delighted, but the local clergy and landowners complained to the electoral government, which in turn asked Luther for his opinion. Luther opened his reply by saying that it would be 'a noble, Christian accomplishment' if all usury was abolished. Then he gets practical. Strauss, he says, does not 'sufficiently deal with the risk' that a businessman takes when he loans capital. Further, 'by using high-sounding words, he makes bold the common man . . . Perhaps he thinks the whole world is full of Christians . . .' The reply is typical of Luther's approach: he opposes usury on moral grounds but distinguishes between civil authority and Christian ethics, and in the end cedes to the princes the right to decide economic questions.*

In these fights, Luther stands personally torn in the conflict that tore the Middle Ages apart, the fight between *sacerdotium* and *imperium*, between church and state. He resolves the opposition by authorizing it. For whatever reasons, by the sixteenth century power had come into the hands of the holders of private property. Those religious leaders who survived were the ecclesiastical statesmen willing to recognize the civil authority of princes, and even to serve them. Some in fact became the economists who helped the princes develop the details of a cash economy. The German theologian Philipp Melanchthon, for example, stepped into a dispute in Denmark in 1553 and helped King Christian III organize the structure of interest rates.

Those reformers and movements (such as the Anabaptists) that did not recognize the new sense of property did not survive. Thomas Müntzer, another radical priest, actively supported the peasants in Saxony and stood in clear opposition to Luther and his advice to statesmen:

> Luther says that the poor people have enough in their faith. Doesn't he see that usury and taxes impede the reception of the faith? He claims that the Word of God is sufficient. Doesn't he realize that men whose every moment is consumed in the making of a living have no time to learn to read the Word of God? The princes bleed the people

* 'The law was our custodian until Christ came, that we might be justified by faith. But now that faith has come, we are no longer under a custodian.' – Gal. 3:24–25. Luther reinstates the law in civil affairs where faith may not be assumed, but risk may. His is an Old Testament spirit.

with usury and count as their own the fish in the stream, the bird in
the air, the grass of the field, and Dr Liar says, 'Amen!' What courage
has he, Dr Pussyfoot, the new pope of Wittenberg, Dr Easychair, the
basking sycophant?

What a clear voice! The authorities caught up with this man, tortured him
and cut off his head.

By the end of the Reformation the power to judge the morality of prop-
erty rights rested in the hands of secular rulers. There is a story about a
group of ministers in Regensburg who, in 1587, questioned the validity of
the 5 percent contract. They were dismissed from their posts and exiled
from the town by the Protestant magistrates. Luther generally opposes
usury on moral grounds, but at crucial moments he supports civil power,
and as civil power in turn supported usury, the effect of his separation of
church and state was to narrow the circle of gift.

The dissociation of civil and moral law brought with it the popularity
of the distinction between 'interest' and 'usury' which we still have today.
The two terms became widespread in the sixteenth century, though in fact
they had been in use for some time. In Latin the verb *interesse* means 'to
make a difference, to concern, to matter, to be of importance.' We still use
it in this sense, as when we say a thing 'interests' us or when we have an
'interest' in a business. In medieval Latin the verbal noun *interesse* came
to mean a compensatory payment for a loss: if someone loses something
of mine, something I have an 'interest' in, then he pays me my *interesse* to
make good the loss (and he pays me nothing if I have no interest). The
word then came to refer to what could be lost when capital was loaned,
and a debtor who defaulted on a loan was obliged to pay the *interesse*, a
fixed amount described in his contract. This payment supposedly differed
from *usura*, a direct charge for the use of money, but the difference was
not that great: creditors came to say that if they lost profits because they
couldn't reinvest their money, this was also *interesse*, and rather than
describe it as a fixed amount in the contract they came to charge a
percentage reckoned periodically.

Even in the Middle Ages, then, *interesse* was, in practice, one of the
shades of usury. By way of illustration we may take a dispute in the Church
shortly before the Reformation that was resolved by distinguishing between
usury and *interesse*. At issue had been Christian pawnshops, known in Italy
then as now as *monti di pietà*, mounts of mercy. Here a Christian burdened

with debt could come and borrow a little cash to begin another season. Benjamin Nelson describes their founding:

> The Brotherhood of Man was the banner under which antisemitic friars . . . cloaked their demagogic appeals to expel the Jewish pawn-brokers, who had swarmed from Rome and Germany into the Italian towns in response to municipal invitations to set up shops, with licenses to take from 20 to 50 per cent on petty loans . . . [They] regurgitated the oft-discredited charges of ritual murder, incited mobs to attacks on Jewish life and property, and harangued the people and their magistrates to destroy the Jews, and establish Christian pawn-shops, the *monti di pietà*. By 1509, eighty-seven such banks had been set up in Italy with papal approval . . .

The priests who defended the *monti* insisted that the money taken above the principal on a loan was not usury at all: it was a contribution to defray the cost of operating the pawnshops, including the salaries of the officials.

This, of course, is precisely why usury had been prohibited in the first place: the spirit of the gift demands that no one make a living off another man's need. A group of people comes to be called a brotherhood not only when the circulation of gifts assures that no one has lost touch with the sources of wealth, but also when no individuals in the group can make a private living by standing in the stream where surplus wealth flows toward need. If there are always enough needy people around to feed a group of pawnbrokers, then something is seriously wrong with the brotherhood.

Nonetheless, the *monti* were set up and Pope Leo X officially approved them in 1515. In a decree at the Fifth Lateran Council he ruled that they could charge interest. The money taken was not to be called *usura*, but compensation for *damna et interesse* (damages and losses). It was a fee to cover the risk involved in making a loan, the loss of what the money might have earned if it had not been loaned, and the salaries of the pawnbrokers. Even before the Reformation, 'interest' was the term accepted to express the right of stranger-money to earn a moderate return.

Luther and other reformers, particularly Philipp Melanchthon, borrowed this page from their enemies. Around 1555 Melanchthon distinguished

between two kinds of loan, one *officiosa* and the other *damnosa*. When a man loans his neighbor an amount he can easily spare for a short time, the loan is *officiosa* and should be free. A *damnosa* loan, on the other hand, is any forced loan, any loan with no fixed time for repayment, or 'sums freely invested with merchants in the form of a partnership.' As the creditor risks a loss in all such contracts, Melanchton wrote, 'the rule of equality demands that he receive a compensation, which is called *interesse*, amounting to no more than five percent.' Luther himself made similar discriminations, condemning usuries of 60 percent, for example, but allowing an 8 percent return on annuities. By the end of the Reformation a new double language had been firmly established for the new double standard. In the eyes of the Lord, usury is still a sin and rightly condemned. But in the everyday world, interest is both necessary and just. Interest is civil usury; now we have capitalism.

There is a way in which these distinctions – between interest and usury, between moral and civil law – revive the dichotomy the Middle Ages had tried to lay aside. Moses, Saint Ambrose, and Luther all recognize two laws. However, though it is related to its predecessors, the distinction that Luther makes is radically different.

In the first place, it is a different thing that is divided in two. In the Old Testament, mankind as a whole is seen as either Brother or Other, and an Israelite conducts himself differently depending on whom he is with. Now each man is divided. The church and the state may be separate but each man partakes of both. When each man has a civil and a moral part, the brother and the stranger live side by side in his heart. Now when I meet someone on the street he is either alien or kin, depending on his business. As each man may participate in a universal brotherhood, so he may partake in an unlimited foreignness. He may be an alien anytime he chooses and without leaving home. He may justify the calculations of his heart as a necessary check to the calculations of others, just as Luther justifies the sword.

Luther's dichotomy differs from that of Moses in yet another way. When the stranger and the brother live side by side, it is not only each man's heart that is divided, but the local population as well. Rather than a new tribalism we find the seeds of social class in Luther's formula. Here is a passage from *Deuteronomy with Annotations* in which the stranger of old ends up as the poor man of today:

Why is it that [Moses] permits repayment of a loan to be demanded from a stranger . . . but not from a brother . . . ? The answer is that this . . . is according to a just principle of public order, that by some privilege citizens are honored beyond outsiders and strangers, lest everything be uniform and equal . . . The world has need of these forms, even if they appear to have a show of inequality, like the status of servants and maids or workmen and laborers. For not all can be kings, princes, senators, rich men, and freemen in the same manner . . . While before God there is no respect of persons, but all are equal, yet in the world respect of persons and inequality are necessary.

Luther is not just speaking of the ancient world here. When social policy is called into question, he does not feel it should be decided by 'the common herd, which is insolent anyhow,' but prefers to place his trust in the princes. To my knowledge, he does not develop the idea directly, but his tone certainly leads one to feel that Christians, though rare, are probably more numerous among the landowners and that the new aliens may well be the lower classes.

One could almost argue that the new formulations of the Reformation are an attempt to reclaim space for the spirit of the gift. Luther tried to free the Church of its empire. Even in his ceding of power to civil rulers there can be seen a desire to reclaim the proper sphere of the spirit in a neo-Mosaic fashion. But when we listen closely to Luther's tone, we do not hear the call for a new brotherhood. Other reformers exhort this, but not Luther. He goes out of his way to insist that the Christian spirit cannot be set loose in the world:

I have already said that Christians are rare in the world; therefore the world needs a strict, hard temporal government that will compel and constrain the wicked not to steal and rob and to return what they borrow, even though a Christian ought not to demand it [the principal], or even hope to get it back. This is necessary in order that the world may not become a desert, peace may not perish, and trade and society may not be utterly destroyed: all which would happen if we were to rule the world according to the Gospel and not drive and compel the wicked, by laws and the use of force, to do and suffer what is right. We must, therefore, keep the roads open, preserve peace

in towns, and enforce law in the land, and let the sword hew briskly
and boldly against the transgressors . . . Let no one think that the
world can be ruled without blood; the sword of the ruler must be red
and bloody; for the world will and must be evil, and the sword is God's
rod and vengeance upon it.

Luther is hardly speaking up for brotherhood here, nor does he sanction
civil law in order to affirm gift and grace. Moreover, his language is the
one that has always been connected to the alienation of property, the
language of separation and war. (Luther was the first since Saint Ambrose
to feel aggression in the Old Testament permission: 'The Jews do well obedi-
ently to yield themselves to God as instruments and to fulfill His wrath on
the Gentiles through interest and usury.')

But more important than the bellicose tone, what Luther does here and
elsewhere is to affirm a scarcity of grace and gift. We shall feel this more
clearly if we pause and contrast the sense of scarcity in Luther with an
earlier sense of bounty. Recall these lines from the fourteenth-century
monk, Meister Eckhart:

> Know then that God is bound to act, to pour himself out into thee
> as soon as ever he shall find thee ready . . . Finding thee ready he is
> obliged to act, to overflow into thee; just as the sun must needs burst
> forth when the air is bright and clear, and is unable to contain itself.
> Forsooth, it were a very grave defect in God if, finding thee so empty
> and so bare, he wrought no excellent work in thee nor primed thee
> with glorious gifts.

> Thou needest not seek him here or there, he is no further off than
> at the door of thy heart; there he stands lingering, awaiting whoever
> is ready to open and let him in . . . He longs for thee a thousandfold
> more urgently than thou for him: one point the opening and the
> entering.

Such intense feeling of an attainable grace and the overwhelming
confidence in its bounty seem to disappear sometime during the fifteenth
century. Certainly they are not present in Luther. What Luther feels on
all sides are dis-grace and scarcity. The spirit is no longer lingering by
the door of the heart but set apart like the Protestant pulpit raised above

the heads of the congregation. The laws of Moses are 'most beautiful and fair' but hardly practical anymore, and the Gospels are utopian and not much good for ruling the world. Power has left the common assumption of generosity and lies with the legions of trade.

In postulating the scarcity of goodwill and in dissociating the Gospels from the everyday world, Luther sets both the Lord and the possibility of gift farther and farther away, a spiritual form of the scarcity economics that always accompanies private property. Now Christians are rare, grace is unusual, and moral conscience is private and without worldly weight.

In one sense the reemergence of ancient usury bespeaks a decline in faith. Gift exchange is connected to faith because both are disinterested. Faith does not look out. No one by himself controls the cycle of gifts he participates in; each, instead, surrenders to the spirit of the gift in order for it to move. Therefore, the person who gives is a person willing to abandon control. If this were not so, if the donor calculated his return, the gift would be pulled out of the whole and into the personal ego, where it loses its power. We say that a man gives faithfully when he participates disinterestedly in a circulation he does not control but which nonetheless supports his life.

Bad faith is the opposite. It is the confidence that there is corruption, not just that the covenants of men may be severed, but that all things may be decomposed and broken into fragments (the old sense of 'corruption'). Out of bad faith comes a longing for control, for the law and the police. Bad faith suspects that the gift will not come back, that things won't work out, that there is a scarcity so great in the world that it will devour whatever gifts appear. In bad faith the circle is broken.

Edmund Wilson once offered a felicitous phrase to describe the sense of faith in the Old Testament. It seems that no tense of the Hebrew verb conforms precisely to our active present. Instead there are two time senses, both of them eternal: things are either completed (the past perfect) or they are part of prophecies unfolding, a tense that Wilson calls the '"prophetic perfect," that phase of the Hebrew verb which indicates that something is as good as accomplished.' A people who live in a perpetual prophetic perfect feel neither risk nor the vicissitudes of time as we feel them. There is no emphasis on present and active risk among neighbors.

But the stranger, as I said at the outset, was a risk for the Hebrew. He was not of the same God. To charge him usury was a way of negotiating risk at the border of prophecy. In fact, risk is only an issue at the boundary

of faith. Usury, written documents, notes signed and notarized, collateral, the law and the courts are all ways of stabilizing peoples who have no common God, who do not trust each other, who are all strangers and who live with an attenuated sense of time and risk. Gift increases inside the circle; capital bears interest at the boundary. These are all one and the same: faithlessness, usury, and the alienation of both property and persons.

Here is a comment of Luther's that cuts both ways on this. In the Middle Ages as now, a 'surety' was a person who made himself liable for another's debts, and friends would 'stand surety' for each other. Luther condemns this as a usurpation of God's role: only the Lord assures things. In the sense of 'faith' that I am using, Luther is right: surety of any kind, including contracts and collateral, shows a lack of confidence that what is given will return. But here are Luther's words:

> He has bidden us, in the Lord's Prayer, to pray for nothing more than
> our daily bread today, so that we may live and act in fear and know
> that at no hour are we sure of either life or property, but may await
> and receive everything from His hands. This is what true faith does.

Yes. And yet the word that leaps out of this passage is not 'faith' but 'fear.' The Hebrew may have felt risk at the edge of the tribe, but when the radius of the circle of gift is pulled back from the brotherhood into the heart of each man, then each of us feels the risk. When all property is privatized, faith is privatized and all men feel fear at the boundary of the self. Thomas Müntzer, quoted above, was right to insist on the connection: 'Luther says that the poor people have enough in their faith. Doesn't he see that usury and taxes impede the reception of the faith?'

Müntzer is addressing a faithlessness in the Reformation, and rightly so. But it would be wrong for us to leave that observation unqualified, nor is there any point in putting the weight of these changes on Luther's shoulders alone. In a sense he worked as a diligent and responsive reporter of the spiritual state of Europe in the sixteenth century. His new dictum does not bring the alien into each heart; it recognized that he is already there. It was a world of rising commerce and the privatization of property, a world where secular and spiritual were already divided and where the commons were no longer common. When Luther gave his first mass as a monk, his father, who had wanted him to become a lawyer because there was money in it, stood behind him in the church. The young priest was unable to feel

the presence of the deity and almost fled the altar. He suffered profound depressions throughout his life. He was a man who sought to articulate a faith that would address his own experience.

Another way of describing what happened during this period, therefore, is to say that Luther brought the war home: he located the enemies of faith near at hand rather than seeing them in the alien Moslem or Jew. He reminded us of the dark side of the Lord, his wrath. It seems as if the attempt to universalize the feeling of charity had only allowed mercenaries to grow up in the back room. In this odd way there is a connection between a universal brotherhood and universal alienation. Many people, when they try to love all mankind, feel a rising contempt for their neighbors. Toward the end of his book on usury, Benjamin Nelson has this pessimistic remark: 'It is a tragedy of moral history that the expansion of the area of the moral community has ordinarily been gained through the sacrifice of the intensity of the moral bond.' Luther tried to speak to this – to the looseness of that bond and the scarcity of grace that he felt all around him. He reported the situation, and, moreover, he tried to imagine the shape that faith must now take to survive. It was still his belief that brothers do not take usury from one another, but he found few brothers left for whom this was a concern.

III • *Relative Strangers*

The final portion of our story narrows the circle of gift even further, for the dualities of Luther, who opposed usury in conscience though not in effect, were soon to be superseded by a universalization of usury (in both conscience and effect) worked out by churchmen such as John Calvin and philosophers such as Jeremy Bentham.

In 1545 a friend of John Calvin's asked him for his views on usury and Calvin replied in a letter. After briefly wishing 'that all usury and even the name, were banished from the earth,' Calvin gets down to brass tacks, saying that 'since this is impossible, it is necessary to concede to the common good.' This 'common good' requires that interest not be taken from the poor, but beyond that Calvin can see no sense in restraining usury. In fact, 'if all usury is condemned, tighter fetters are imposed on the conscience than the Lord himself would wish.'

The first part of Calvin's letter applies common sense to the Scriptural prohibitions on usury and lays them all aside. When Christ says that one

should lend hoping for nothing in return, for example, he is obviously refer-
ring to loans to the poor; 'he does not mean at the same time to forbid
loans being made to the rich with interest.'

Calvin's analysis of the law of Moses is central to the letter. The law 'was
political,' he says, and since the politics have changed, so have the rules:

> It is said that today . . . usury should be forbidden on the same
> grounds as among the Jews, since there is a bond of brotherhood
> among us. To this I reply, that in the civil state there is some differ-
> ence; for the situation in which the Lord had placed the Jews . . .
> made it easy for them to engage in business among themselves without
> usury. Our relationship is not at all the same. Therefore I do not
> consider that usury is wholly forbidden among us, except in so far as
> it is opposed to equity or charity.

Calvin concludes 'that usury must be judged, not by any particular passage
of Scripture, but simply by the rules of equity.'

The idea of equity is crucial to Calvin's approach, as one additional passage
will show. In his commentaries on the laws of Moses, Calvin again main-
tains that the political situation has changed since ancient times; therefore

> usury is not now unlawful, except in so far as it contravenes equity
> and brotherly union. Let each one, then, place himself before God's
> judgment seat, and not do to his neighbor what he would not have
> done to himself, from whence a sure and infallible decision may be
> come to . . . In what cases, and how far it may be lawful to receive
> usury upon loans, the law of equity will better prescribe than any
> lengthened discussions.

Moral law is atomized in this passage. Note the focus: 'Let *each* one . . .
place him*self* . . . ,' and so on. This style or moral calculus brings new
popularity to the old saws 'Do unto others as you would do unto your-
self' and 'God helps those who help themselves,' always sung to a tune
whose accents fall on 'self.' With the moral community of old reduced to
the heart of the landlord, both conscience and guilt are feelings that only
individuals have. Ethical dilemmas are resolved either by comparing self
to self or by having each self sit alone and imagine itself 'before God's
judgment seat.'

If we assume the private ownership of property and then add to it this mode of judging moral questions, we will indeed find little reason to restrain usury. Little reason *among equals*, that is. Equity will still demand that the rich treat the poor differently, but when two businessmen meet, each will agree (even before the Lord) that capital should bear interest. And though Calvin himself does not pursue this line, equity itself may just as easily demand that the rich not deal with the poor at all, for though the Golden Rule may begin with a simple postulate, it can end with as many conclusions as there are selves (e.g., 'If I were poor, I wouldn't want a handout.')

We are now in the modern age. There are three ways to treat the double law of Moses, and with Calvin we come to the last. It can be kept as a double law (the Old Testament brother/stranger, Luther's church/state); it can be universalized on the side of charity (the Middle Ages); or, finally, it can be universalized on the side of usury. After the sixteenth century a brother is someone who will loan you money at the prime rate. Calvin concludes that usury is allowed so long as it is practiced among friends. Indeed a man would be parsimonious not to loan his capital, and interest is the new sign of brotherhood. This spiritual argument will emerge later in the economics of the 'unseen hand' that molds the common good if each man will just determine and seek his own self-interest.*

* It may be time to add a note on the Islamic parallel to this story. As we noted at the outset, the Koran clearly forbids charging interest on a loan. The history of that prohibition is essentially the same as that of the Mosiac law, but without the back-and-forth dialectic, as Muhammad makes no distinction between brothers and others, faithful and infidel.

During and after the Middle Ages, Moslems accepted a practical modification of the Koranic prohibition by allowing a return on capital provided the creditor had taken a risk. A man was still forbidden to take interest in the sense of a guaranteed percentage return, but he could share in a profit if he had taken a risk. Nowadays some Moslems, like some Orthodox Jews, still refuse to charge interest on a loan, but most allow a reasonable rate of return.

The debate between these two factions was one of the minor dramas to be played out in Iran after the fall of the Shah in 1979. The stated intent of the followers of Ayatollah Ruhallah Khomeini was to organize an 'Islamic republic' rooted in the precepts of the Koran. Even a man not closely aligned with the clergy, former President Abolhassen Bani-Sadr, reportedly maintained an elaborate microfilm library with Koranic codes cross-referenced to economic issues.

But, as Calvin told us, a modern state cannot operate on the ethics of an ancient tribe. Soon after the fall of the Shah, the new head of the state-owned oil company – a devout Moslem, a radical lawyer, an enemy of the Shah – declared himself perplexed as to how to proceed, finding it 'neither possible nor beneficial . . . to put all political, economic and judicial problems into an Islamic mold.' A state whose wealth derives from selling fossil fuel to foreigners cannot operate without interest on capital. When this drama is resolved, I imagine that, as was the case in Europe, the merchant princes will emerge with the power. And the clergy will have to produce a Luther or a Calvin if they wish to share that power.

But let us pause here for a moment and consider the pro-usury arguments, like those of Calvin, that sprang up after the Reformation. For a funny thing happens as you read through them – after the sixteenth century one begins to feel that the spirit of charity itself demands that capital be let out at interest.

Let us look first at the problem of how a society keeps its commerce lively, how it keeps the wealth in motion. As Calvin points out, men no longer live in tribes. Those who argue for usury insist that in a nontribal economy wealth will not increase unless capital circulates and it will not circulate unless it bears interest. Calvin dismisses Aristotle: 'Certainly if money is shut up in a strong-box, it will be barren – a child can see that. But whoever asks a loan of me does not intend to keep this money idle and gain nothing. The profit is not in the money itself, but in the return that comes from its use.'

A spokesman for the repeal of usury laws makes a similar point in the British Parliament in 1571: 'Better may it be borne to permit a little [usury], than utterly to take away and prohibit traffick, which hardly may be maintained generally without this.' Now the wealth of the group will not move, get used, nurture, and enliven unless it is allowed to bear interest. Usury among the Hebrews would hamper the circulation of wealth, but now the opposite seems to be true: a probhibition on usury would leave wealth static and barren.

And who suffers? Those who argue in favor of usury maintain that its restraint would hurt the poor as much as the rich. Locke argued that to lower interest rates by law would not only destroy trade but ruin 'widows and orphans.' In the past the widows and those who had once labored but could no longer do so were supported by their kin. How, they ask, does this differ in substance from living in old age on the fruits of invested capital? Surely charity demands that such persons not be cut off to a greater misery or forced to throw themselves on the mercy of the state.

The pro-usury argument goes even further. In 1867 Richard Henry Dana, Jr., the man who wrote *Two Years Before the Mast*, gave a speech in the Massachusetts House arguing against all laws restraining usury. He maintained that such laws do not help the poor. First of all, when interest rates are fixed by law, the poor cannot attract capital because they are forbidden to offer the higher interest that their weaker security would warrant.

Take the case of the poor, honest debtor. Sickness or misfortune has left him in debt, and a hard creditor . . . is pressing him to an execution. If he could borrow a thousand dollars . . . he could pay the debt and have a little with which to begin again. But with his poor security, and the high state of the market, he cannot get the money at six percent. You prohibit him from giving seven, even he must sell the land under his feet, the house over the head of his wife and children . . . , and sell it all at a ruinous loss, as is always the case in forced sales, – a loss of at least twenty-five percent! The debtor might have saved this by a loan . . . at the market value of his security. What shall we say of such legislation? . . . Is it not a shame upon our intelligence, and public spirit, and humanity?

And who, he asks, are the debtors of the modern world? 'It is mostly enterprise that borrows, and capital borrowing more capital.' Who are the creditors? Ever since 'a benign Providence put it into the heart and head of some person early in this century' to establish savings banks, it is the poor themselves who lend money, 'the day-laborers, the seamstresses and household servants, the news-boys in the streets, have become capitalists and lend to the rich and great.' If savings banks are inhibited from lending at the highest rate the market will bear, then it is these 'poorer classes' who suffer.

Having laid aside the question of the poor, Dana sketches further reasons for lifting all restraint on usury. 'The market of the world,' he writes, 'moves with the irresistible power of ocean tides . . .' Moralists cannot fix the value of capital, and to pretend they can only cheapens moral discourse. Legislated interest rates violate the 'immutable laws of trade.' When the market rate falls below the legal rate, usury laws have no effect at all, and when it rises above that rate they dry up trade and drive the poor to loan sharks or make criminals out of honest creditors.

Finally, in the modern world, it seems that interest charged for the use of money no longer sets up a boundary between people. Even in tribal life, usury was a way of having some intercourse with strangers. Now the entrepreneur and the man with ready cash seek each other out. Interest is the sign of a lively community. 'A live country calls for capital and can pay for it,' Dana declares, 'a dead country cannot.'

So in this odd way almost all that was once said against usury may now be said in its favor. The gifts of nature and the wealth of society are now

kept in motion and grow through usury; interest on capital feeds the widows and orphans, and allows the poor to start anew and share in the wealth. Prohibitions on usury deaden trade and force rich and poor alike to compromise themselves ethically. And finally, interest on capital bears the same hallmarks as a commerce of gifts – it brings people together and ensures the liveliness of the group.

So reads the post-Reformation argument in favor of removing all restraint on usury.

To reply in favor of gift exchange we shall have to widen the frame of the argument. When Calvin speaks of judging each situation by its inherent equity, he is articulating an ethic of 'balanced reciprocity,' one in which trade is marked by neither exploitation nor gift, neither affection nor animosity. The debate over usury has usually assumed a world clearly divided into brothers and others, friends and enemies. But most social life is not so rigorously symmetrical. Even in tribal groups, but more so in state and urban societies, there is a middle ground – cordial strangers, trustworthy tradesmen, distant cousins, friends of friends, dubious relations, who are neither wholly alien nor a part of the inner circle of unconditional sharing. And as there are degrees of relatedness (and therefore degrees of strangeness), so there are degrees of reciprocity.

If we were to place these degrees of reciprocity on a scale, pure gift would lie at one end, theft at the other; at one pole would be the disinterested sharing that creates or maintains kinship and friendship, and at the other, chicanery, exploitation, and profiteering. Balanced reciprocity, Calvin's 'equity,' lies midway between these extremes. In equable dealings, neither side gains nor loses and there is no enduring social feeling, neither good nor bad will. To this end the ethics of equity permit the reckoning of time and value which the ethics of gift exchange restrain. If we want our trade to leave neither kinship nor anger, then we seek to balance real costs in present time. In the case of loans, as a free loan amounts to the gift of the interest, we make the relationship equable simply by reckoning and charging the interest. What I have called ancient usury refers to this 'equity rate.' Where gift exchange is the accepted and moral form of commerce, even an equity rate is an immoral usury, as it removes the spirit of the gift. Tribal groups that have categorically prohibited this simple usury must be those that have little need for the balanced reciprocities of an amoral stranger trade, while those that have allowed it admit some need for an ongoing, stable trade with outsiders, foreigners, aliens.

Some tribal groups have obviously had reason to develop an ethic of equable stranger trade, but on the whole those situations that call for balanced reciprocity are not as common in pre-state societies as they are now. The shift from pre-state to state, from tribes or small towns to an urban, mass society brings with it a rise in stranger trade. The sphere of positive reciprocity has been shrinking for at least four centuries, until now the bulk of our dealings occur at that middle distance in which people are neither real friends nor real aliens but what I call cordial strangers.

Cordial strangers loan money to one another at the equity rate. It is a mutually agreed upon approximation of the real increase on wealth; it assures that the creditor-debtor relationship is a market relationship and no more; no one is connected, no one is hurt. In a society that recognizes the right to make a reasonable profit on capital, the equity rate is called the prime rate. Above the prime we have rates for speculators and suspicious strangers. Higher still, we have modern usury, loan sharking, theft by debenture. And below the prime we find various 'friendship rates,' which fall to different levels for different degrees of friendship, until we return to the interest-free loan, the pure gift case.

All societies, tribal or modern, have some such range of reciprocities to organize and express various degrees of relatedness or social distance. What is particular to a market society is the need to emphasize the balanced reciprocity that occupies the middle of the scale. With it the true citizens of a mass society – members of no community of common faith or purpose, and of no network of cooperating kin – are able to maintain an ongoing commerce with one another. Without it each citizen would be overwhelmed in two directions as all his dealings would lead him into either kinship or conflict. The ethic of equity which used to appear at the edge of the group now appears at the edge of the self, allowing essentially autonomous individuals to interact with one another. Moderate interest (on loans, but in the other sense as well) gives the modern self a semi-permeable skin so that we may express and deal with the relative strangeness of those with whom we eat our daily lunches. A market society cannot function without this interest, this ancient usury.

A reply to the pro-usury arguments that follow the Reformation has required that we back off in this way so that we might see the invisible assumptions upon which they lie. Their major points are true, *given* the rise of individualism and a decline of a common faith, an increased range of alienable property and the disappearance of the commons, the advent

of widespread market exchange, and the emergence of the state. Where commerce feeds no common spirit and social life takes its style from the market, commodity exchange does seem to imitate the functions of gift exchange. Calvin is right, our relationship is not the same as that of the ancient Jews. And he is right, capital will not increase unless it is used.

But market relationships and capital let out at interest do not bear the increase-of-the-whole that gift exchange will bear. Equable trade is not an agent of transformation, nor of spiritual and social cohesion. With the vector of increase reversed, interest is self-interest: it does not join man to man except in the paper connections of contract. And where the spirit of the gift has been suspended, legal contract replaces the felt bonds of gift exchange and a skeleton of law and police must appear to replace the natural structure and cohesion of faithfulness and gratitude (so that perfect law and order are perfect alienation). The liveliness that Dana speaks of is the bustle of trade, not the bustle of life. As we all know, it is possible to have a lively factory in which no one feels any personal energy. And as for Dana's 'poor, honest debtor' who has no access to capital, the fact that the poor are trapped in a net of property rights that would have them suffer more deeply if they didn't participate is hardly an argument for that system to continue.

Nonetheless, it is true that once the premises of the post-Reformation argument in favor of usury are in place, commodity exchange can begin its alluring imitation of gift exchange. A still odder thing happens: with the rise of the commodity as a form of property, the giving of gifts starts to look suspiciously like the old way of dealing with strangers! Gentlemen, after all, loan money to each other, not to the truly needy. How is it that the needy poor survive? Here is the way the word 'charity' comes to be used by William Paley in a book on morality dated 1825:

> I use the term Charity . . . to signify *the promoting the happiness of our inferiors.* Charity in this sense I take to be the principal province of virtue and religion: for, whilst worldly prudence will direct our behavior towards our superiors, and politeness towards our equals, there is little beside the consideration of duty, or an habitual humanity which comes into the place of consideration, to produce a proper conduct towards those who are beneath us, and dependent on us.

Such charity is not gift. The recipient of a gift should, sooner or later,

be able to give it away again. If the gift does not really raise him to the
level of the group, then it's just a decoy, providing him his daily bread while
across town someone is buying up the bakery. This 'charity' is a way of
negotiating the boundary of class. There may be gift circulation within
each class, but between the classes there is a barrier. Charity treats the
poor like the aliens of old; it is a form of foreign trade, a way of having
some commerce without including the stranger in the group. At its worst,
it is the 'tyranny of gift,' which uses the bonding power of generosity to
manipulate people. As Huddie Ledbetter sang in his song 'The Bourgeois
Blues':

> The white folks in Washington, they know how
> To give a colored man a nickel just to see him bow.

To argue over usury after about 1800 misses the point. By then the
usury question is a subtopic in the more central issues of individualism,
the ownership of capital, and the centralization of power. All of the pro-
usury arguments assume private property and exchange trade, and they
must be answered in those terms, not in terms of the usury debate.

Almost all nations and states repealed their usury laws during the last
half of the nineteenth century. England abolished hers in 1854, Germany
in 1867, and so on. At the same time other religious groups joined the
Protestants, who had long tolerated usury among friends. In 1806 Napoleon
called upon French Jews to clarify their position on the brotherhood, and
they replied that they were Frenchmen first and Jews second. Moreover,
they explained that the Talmud made it clear that brothers could legiti-
mately charge interest to one another. The Catholics also fell in line. Even
as far back as 1745 the Pope had defended 4 percent interest on a state
loan, and in the nineteenth century Rome continually authorized the
faithful to lend money at moderate rates. At present the Holy See puts out
its funds at interest and requires ecclesiastical administrators to do the
same.

Perfect gift is like the blood pumped through its vessels by the heart. Our
blood is a thing that distributes the breath throughout the body, a liquid
that flows when it carries the inner air and hardens when it meets the
outer air, a substance that moves freely to every part but is nonetheless

contained, a healer that goes without restraint to any needy place in the body. It moves under pressure – the 'obligation to return' that fascinated Marcel Mauss – and inside its vessels the blood, the gift, is neither bought nor sold and it comes back forever.

The history of usury is the history of this blood. As we have seen, there are two primary shades of property, gift and commodity. Neither is ever seen in its pure state, for each needs at least a touch of the other – commodity must somewhere be filled and gift somewhere must be encircled. Still, one usually dominates. The history of usury is a slow swing back and forth between the two sides. I have taken the double law of Moses as an image of the balance point, gift contained by a boundary like the blood moving everywhere within the limit of skin.

The image of the Christian era would be the bleeding heart. The Christian can feel the spirit move inside all property. Everything on earth is a gift and God is the vessel. Our small bodies may be expanded; we need not confine the blood. If we only open the heart with faith, we will be lifted to a greater circulation and the body that has been given up will be given back, reborn and freed from death. The boundaries of usury are to be broken wherever they are found so that the spirit may cover the world and vivify everything. The image of the Middle Ages is the expanding heart, and the deviant is the 'hardhearted' man. He is usually taken to be a Jew, the only man in town who feels no self-consciousness in limiting his generosity.

The Reformation brought the hard heart back into the Church. In a sense, the swing from gift to commodity recrossed its mid-point during these years, the high liveliness of the Renaissance. The Church still affirmed the spirit of gift, but at the same time it made peace with the temporal world that limited that spirit as it grew in influence.

But the heart continued to harden. After the Reformation the empires of commodity expanded without limit until soon all things – from land and labor to erotic life, religion and culture – were bought and sold like shoes. It is now the age of the practical and self-made man, who, like the private eye in the movies, survives in the world by adopting the detached style of the alien; he lives in the spirit of usury, which is the spirit of boundaries and divisions.

The 'bleeding heart' is now the man of dubious mettle with an embarrassing inability to limit his compassion. Among the British in the Empire it was a virtue not to feel touched by the natives, and a man who 'went

native' was quickly shipped home. (In *Mrs Dalloway*, Virginia Woolf lets us know with one sentence that Peter Walsh will never amount to much because he has fallen in love with an Indian woman.) Now the deviant is the heart that does not keep its own counsel and touches others with feeling, not reckoning. Gift exchange takes refuge in Sunday morning and the family. The man who would charge interest to his wife would still be called hardhearted, but outside the family circle there is little to restrain the fences of usury.

In this century the man with the bleeding heart is a sentimental fool because he has a feeling that can no longer find its form. Still, his sentimentality is appealing. Everyone likes Peter Walsh, though no one would give him a good job. In the empires of usury the sentimentality of the man with the soft heart calls to us because it speaks of what has been lost.

PART II

TWO EXPERIMENTS IN GIFT AESTHETICS

CHAPTER EIGHT

THE COMMERCE
OF THE CREATIVE
SPIRIT

See how Thy beggar works in Thee
By art.
GEORGE HERBERT

In the second half of this book we shall be turning to two quite different poets, Walt Whitman and Ezra Pound, to examine their work and their lives in the language of gift exchange. Before taking up these specific cases, however, I feel I should establish my terms in this new context. With only a few exceptions, it has been my hope from the outset that the ethnography, fairy tales, and anecdotes of the first half of this book could be read as parables or Just So stories of the creative spirit; before we set out to apply the language of those parables to particular poets, I want to offer some samples of how they may be read.

Let us begin at the beginning, with the question of the sources of an artist's work.

An essential portion of any artist's labor is not creation so much as

invocation. Part of the work cannot be made, it must be received; and we cannot have this gift except, perhaps, by supplication, by courting, by creating within ourselves that 'begging bowl' to which the gift is drawn. Remember Meister Eckhart: 'It were a very grave defect in God if, finding thee so empty and so bare, he wrought no excellent work in thee nor primed thee with glorious gifts.' It is the artist's hope that we may say the same of the creative spirit. In an autobiographical essay the Polish poet Czeslaw Milosz speaks of his 'inner certainty' as a young writer 'that a shining point exists where all lines intersect . . . This certainty also involved my relationship to that point,' he tells us. 'I felt very strongly that nothing depended on my will, that everything I might accomplish in life would not be won by my own efforts but given as a gift.'

Not all artists use these very words, but there are few artists who have not had this sense that some element of their work comes to them from a source they do not control.

Harold Pinter in a letter to the director of his play *The Birthday Party*:

> The thing germinated and bred itself. It proceeded according to its own logic. What did I do? I followed the indications, I kept a sharp eye on the clues I found myself dropping. The writing arranged itself with no trouble into dramatic terms. The characters sounded in my ears – it was apparent to me what one would say and what would be the other's response, at any given point. It was apparent to me what they would not, could not, ever, say, whatever one might wish . . .
>
> When the thing was well cooked I began to form certain conclusions. The point is, however, that by that time the play was now its own world. It was determined by its own engendering image.

Theodore Roethke in a lecture:

> I was in that particular hell of the poet: a longish dry period. It was 1952, I was 44, and I thought I was done. I was living alone in a biggish house in Edmonds, Washington. I had been reading – and re-reading – not Yeats, but Raleigh and Sir John Davies. I had been teaching the five-beat line for weeks – I knew quite a bit about it, but write it myself? – *no*; so I felt myself a fraud.
>
> Suddenly, in the early evening, the poem 'The Dance' started, and

finished itself in a very short time – say thirty minutes, maybe in the greater part of an hour, it was all done. I felt, I knew, I had hit it. I walked around, and I wept; and I knelt down – I always do after I've written what I know is a good piece. But at the same time I had, as God is my witness, the actual sense of a Presence – as if Yeats himself were in that room. The experience was in a way terrifying, for it lasted at least half an hour. That house, I repeat, was charged with a psychic presence: the very walls seemed to shimmer. I wept for joy . . . He, they – the poets dead – were with me.

Such moments of unwilled reception are not all there is to the creation of a work of art, of course. Notice Roethke: 'I had been teaching the five-beat line for weeks.' Or Pinter: 'I kept a sharp eye.' All artists work to acquire and perfect the tools of their craft, and all art involves evaluation, clarification, and revision. But these are secondary tasks. They cannot begin (sometimes they must not begin) until the *materia*, the body of the work, is on the page or on the canvas. The Kula prohibition on speaking of the value of the gift has its equivalent in the creative spirit. Premature evaluation cuts off the flow. The imagination does not barter its 'engendering images.' In the beginning we have no choice but to accept what has come to us, hoping that the cinders some forest spirit saw fit to bestow may turn to gold when we have carried them back to the hearth. Allen Ginsberg has been our consistent spokesman for that phase of the work in which the artist lays evaluation aside so that the gift may come forward:

The parts that embarrass you the most are usually the most interesting poetically, are usually the most naked of all, the rawest, the goofiest, the strangest and most eccentric and at the same time, most representative, most universal . . . That was something I learned from Kerouac, which was that spontaneous writing could be embarrassing . . . The cure for that is to write things down which you will not publish and which you won't show people. To write secretly . . . so you can actually be free to say anything you want . . .

It means abandoning being a poet, abandoning your careerism, abandoning even the idea of writing any poetry, really abandoning, giving up as hopeless – abandoning the possibility of really expressing

yourself to the nations of the world. Abandoning the idea of being
a prophet with honor and dignity, and abandoning the glory of poetry
and just settling down in the muck of your own mind . . . You really
have to make a resolution just to write for yourself . . . , in the sense
of not writing to impress yourself, but just writing what your self is
saying.

Having accepted what has been given to him – either in the sense of
inspiration or in the sense of talent – the artist often feels compelled, feels
the *desire*, to make the work and offer it to an audience. The gift must stay
in motion. 'Publish or perish' is an internal demand of the creative spirit,
one that we learn from the gift itself, not from any school or church. In
her *Journal of a Solitude* the poet and novelist May Sarton writes: 'There is
only one real deprivation, I decided this morning, and that is not to be able
to give one's gift to those one loves most . . . The gift turned inward, unable
to be given, becomes a heavy burden, even sometimes a kind of poison. It
is as though the flow of life were backed up.'
So long as the gift is not withheld, the creative spirit will remain a stranger
to the economics of scarcity. Salmon, forest birds, poetry, symphonies, or
Kula shells, the gift is not used up in use. To have painted a painting does
not empty the vessel out of which the paintings come. On the contrary, it is
the talent which is not in use that is lost or atrophies, and to bestow one of
our creations is the surest way to invoke the next. There is an instructive
series of gifts in the *Homeric Hymn to Hermes*. Hermes invents the first musical
instrument, the lyre, and gives it to his brother, Apollo, whereupon he is
immediately inspired to invent a second musical instrument, the pipes. The
implication is that giving the first creation away makes the second one
possible. Bestowal creates that empty place into which new energy may flow.
The alternative is petrifaction, writer's block, 'the flow of life backed up.'

To whom does the artist address the work? Long ago we said that a gift
eventually circles back toward its source. Marcel Mauss put the same idea
in slightly different terms: every gift, he wrote, 'strives to bring to its orig-
inal clan and homeland some equivalent to take its place.' And though it
might be hard to say with any certainty where we will find the homeland
of an inner gift, artists in every age have offered us myths to suggest where
we should look. Some take their gifts to be bestowals of the gods or, more

often perhaps, of a personal deity, a guardian angel, *genius*, or muse – a spirit who gives the artist the initial substance of his art and to whom, in return, he dedicates the fruit of his labor. Such, as we shall see, was Whitman's myth. The initial stirrings of his work he took to be bestowals of his soul (or of a young boy, sometimes – or both), and his responsive act was to 'make the work' (this being the motto that sat on Whitman's desk) and speak it back to the soul, the boy.

Ezra Pound's creative life was animated by a myth in which 'tradition' appears as both the source and ultimate repository of his gifts. Pound's first master, Yeats, articulated the sensibility: 'I . . . made a new religion, almost an infallible church of poetic tradition, of a fardel of stories, and of personages, and of emotions, inseparable from their first expression, passed on from generation to generation by poets and painters . . . I wished for a world where I could discover this tradition perpetually, and not in pictures and in poems only, but in tiles round the chimney-piece and in the hangings that kept out the draft.' For Pound, I think, what gifts we have come ultimately from the gods, but a 'live tradition' is the storehouse in which the wealth of that endowment is preserved. Pound speaks certain names over and over again – Homer, Confucius, Dante, Cavalcanti – the lineage of gifted souls whose works had informed his own. To the end of his days he dedicated a portion of his labor to the renewal of their spirits.

To offer but one more of these myths of closing the circle, of artists directing their work back toward its sources, the Chilean poet Pablo Neruda took the beginnings of his art to lie not with spirits or with the past, but with something human, current, and almost anonymous. His gifts sprang, he felt, from brotherhood, from 'the people,' and he quite consciously offered his art in recognition of the debt: 'I have attempted to give something resiny, earthlike, and fragrant in exchange for human brotherhood.' He counted as 'the laurel crown for my poetry' not his Nobel Prize but a time when 'from the depths of the Lota coal mine, a man came up out of the tunnel into the full sunlight on the fiery nitrate field, as if rising out of hell, his face disfigured by his terrible work, his eyes inflamed by the dust, and stretching his rough hand out to me . . . , he said: "I have known you for a long time, my brother."' To find an unknown worker who had heard his poems was sign enough that his gift had managed to bear some equivalent back to its original clan and homeland.

I opened the chapter on the increase of gifts with a description of a first-fruits ritual – the salmon bones returned to the sea that the salmon might remain plentiful. In the context of that chapter the account served to illustrate the increase of organic gifts; we may also read it as another Just So story of the creative spirit. Just as treating nature's bounty as a gift ensures the feritility of nature, so to treat the products of the imagination as gifts ensures the fertility of the imagination. What we receive from nature or from the imagination comes to us from beyond our sphere of influence, and the lesson of aboriginal first-fruits rituals seems to be that the continued fertility of these things depends on their remaining 'beyond us,' on their not being drawn into the smaller ego. 'All that opens the womb is mine,' says the Lord. First-fruits rituals protect the spirit of the gift by making evident the true structure of our relationship to the sources of our wealth. The salmon are not subject to the will of the Indians; the imagination is not subject to the will of the artist. To accept the fruits of these things as gifts is to acknowledge that we are not their owners or masters, that we are, if anything, their servants, their ministers.

To say the same thing in a slightly different fashion, the first-fruits ritual lays down a simple injunction in regard to fertility: Do not exploit the essence. The bones of the salmon, the fat of the lamb, the tokens of the forest *hau*, are directed back toward their homeland, and by that return the beneficiaries of these gifts avoid what we normally mean by exploitation. The return gift is, then, the fertilizer that assures the fertility of the source.

The fruit of the creative spirit is the work of art itself, and if there is a first-fruits ritual for artists, it must either be the willing 'waste' of art (in which one is happy to labor all day with no hope of production, nothing to sell, nothing to show off, just fish thrown back into the sea as soon as they are caught) or else, when there is a product, it must be this thing we have already seen, the dedication of the work back toward its origins. Black Elk, the Oglala Sioux holy man, dedicated his book, *Black Elk Speaks*, as follows: 'What is good in this book is given back to the six grandfathers and to the great men of my people.' Such is the dedication implicit in the work of anyone who feels his creativity to have been informed by a tradition. It is the artistic equivalent of the Maori ceremony we discussed in Chapter I, *whangai hau* ('nourishing hau'). For a creative artist, 'feeding the spirit' is as much a matter of attitude or intent as it is of any specific action; the attitude is, at base, the kind of

humility that prevents the artist from drawing the essence of his creation
into the personal ego (in what other line of work does the worker say, 'I
knelt down – I always do after I've written what I know is a good piece'?)
In his book of essays and interviews, *The Real Work*, the poet Gary Snyder
speaks of arriving at such an attitude, and of its consequences:

> I finished off the trail crew season and went on a long mountain
> meditation walk for ten days across some wilderness. During that
> process – thinking about things and my life – I just dropped poetry.
> I don't want to sound precious, but in some sense I did drop it. Then
> I started writing poems that were better. From that time forward I
> always looked on the poems I wrote as gifts that were not essential
> to my life; if I never wrote another one, it wouldn't be a great tragedy.
> Ever since, every poem I've written has been like a surprise . . .
> You get a good poem and you don't know where it came from. 'Did
> I say that?' And so all you feel is: you feel humility and you feel grat-
> itude. And you'd feel a little uncomfortable, I think, if you capitalized
> too much on that without admitting at some point that you got it
> from the Muse, or whoever, wherever, or however.

When we are in the frame of mind which nourishes *hau*, we identify
with the spirit of the gift, not with its particular embodiments, and whoever
has identified with the spirit will seek to keep the gift in motion. Therefore
the sign of this identity is generosity, gratefulness, or the act of gratitude:

> Thou that hast giv'n so much to me,
> Give one thing more, a gratefull heart:
> See how Thy beggar works in Thee
> By art:
>
> He makes thy gifts occasion more,
> And sayes, if he in this be crost,
> All Thou hast given him heretofore
> Is lost.

> GEORGE HERBERT,
> from 'Gratefulnesse' (1633)

We nourish the spirit by disbursing our gifts, not by capitalizing upon them (not capitalizing 'too much,' says Snyder – there seems to be a little leeway). The artist who is nourishing *hau* is not self-aggrandizing, self-assertive, or self-conscious, he is, rather, self-squandering, self-abnegating, self-forgetful – all the marks of the creative temperament the bourgeoisie find so amusing. 'Art is a virtue of the practical intellect,' writes Flannery O'Connor, 'and the practice of any virtue demands a certain asceticism and a very definite leaving-behind of the niggardly part of the ego. The writer has to judge himself with a stranger's eye and stranger's severity . . . No art is sunk in the self, but rather, in art the self becomes self-forgetful in order to meet the demands of the thing seen and the thing being made.' Rainer Maria Rilke uses similar terms in an early essay describing the attributes of art as a way of life:

> Not any self-control or self-limitation for the sake of specific ends, but rather a carefree letting go of oneself; not caution, but rather a wise blindness; not working to acquire silent, slowly increasing possessions, but rather a continuous squandering of all perishable values.

In Chapter 2 we spoke of the increase of gifts in three related ways: as a natural fact (when gifts are actually alive); as a spiritual fact (when gifts are the agents of a spirit that survives the consumption of its individual embodiments); and as a social fact (when a circulation of gifts creates community). I want to return to the first and last of these in connection with works of the imagination, using as our point of departure another remark of Flannery O'Connor's. Describing her sense of how the fiction writer works, O'Connor once wrote: 'The eye sees what it has been given to see by concrete circumstances, and the imagination reproduces what, by some related gift, it is able to make live.'

When we say that 'the whole is greater than the sum of its parts,' we are usually speaking of things that 'come alive' when their elements are integrated into one another. We describe such things by way of organic metaphors because living organisms are the prime example. There is a difference in kind between a viable organism and its constituent parts, and when the parts become the whole we experience the difference as an increase, as 'the whole is greater.' And because a circulation of gifts has a cohesive or synthetic power, it is almost as a

matter of definition that we say such increase is a gift (or is the fruit of a gift). Gifts are the agents of that organic cohesion we perceive as liveliness.

This is one of the things we mean to say, it seems to me, when we speak of a person of strong imagination as being 'gifted.' In *Biographia Literaria*, Coleridge describes the imagination as 'essentially vital' and takes as its hallmark its ability 'to shape into one,' an ability he named 'the esemplastic power.' The imagination has the power to assemble the elements of our experience into coherent, lively wholes: it has a gift.

An artist who wishes to exercise the esemplastic power of the imagination must submit himself to what I shall be calling a 'gifted state,' one in which he is able to discern the connections inherent in his materials and give the increase, bring the work to life. Like the shoemaker at the end of 'The Shoemaker and the Elves,' the artist who succeeds in this endeavor has realized his gift. He has made it real, made it a thing: its spirit is embodied in the work.

Once an inner gift has been realized, it may be passed along, communicated to the audience. And sometimes this embodied gift – the work – can reproduce the gifted state in the audience that receives it. Let us say that the 'suspension of disbelief' by which we become receptive to a work of the imagination is in fact belief, a momentary faith by virtue of which the spirit of the artist's gift may enter and act upon our being. Sometimes, then, if we are awake, if the artist really was gifted, the work will induce a moment of grace, a communion, a period during which we too know the hidden coherence of our being and feel the fullness of our lives. As in the Scottish tale, any such art is itself a gift, a cordial to the soul.

If we pause now to contrast the esemplastic cognition of imagination to the analytic cognition of *logos*-thought, we will be in a position to see one of the connections between the creative spirit and the bond that a gift establishes. Two brief folk tales will help set up the contrast. There is a group of tales which portray for us the particular kind of thought that destroys a gift. In a tale from Lithuania, for example, riches that the fairies have given to mortals turn to paper as soon as they are measured or counted. The motif is the reverse, really, of one we have already seen: worthless goods – coals, ashes, wood shavings – turning into gold when they are received as gifts. If the increase of gifts is in the erotic bond, then the increase is lost when exchange is treated as a commodity transaction

(when, in this case, it is drawn into the part of the mind that reckons value and quantity).

A second example will expand the point. A brief entry in a mid-nineteenth-century collection of English fairy tales tells of a Devonshire man to whom the fairies had given an inexhaustible barrel of ale. Year after year the liquor ran freely. Then one day the man's maid, curious to know the cause of this extraordinary power, removed the cork from the bung hole and looked into the cask; it was full of cobwebs. When the spigot next was turned, the ale ceased to flow.

The moral is this: the gift is lost in self-consciousness. To count, measure, reckon value, or seek the cause of a thing, is to step outside the circle, to cease being 'all of a piece' with the flow of gifts and become, instead, one part of the whole reflecting upon another part. We participate in the esem-plastic power of a gift by way of a particular kind of unconsciousness, then: unanalytic, undialectical consciousness.

To offer a last illustration that is closer to the concerns of artists, most of us have had the experience of becoming suddenly tongue-tied before an audience or before someone whom we perceive to be judging us. In order to sing in front of other people, for example, the singer cannot step back and listen to his own voice – he can't, that is, fall into that otherwise useful frame of mind that perceives the singer and the audience as separate things, the one listening to the other. Instead he must enter that illusion (an illusion that becomes a reality if the singer is gifted) that he and the audience are one and the same thing. A friend of mine had a strange experience when she took her first piano lessons. During an early session, to the surprise of both her teacher and herself, she suddenly began to play. 'I didn't know how to play the piano,' she says, 'but I could play it.' The teacher was so excited she left the room to find someone else to witness the miracle. As the two of them came back into the practice room, however, my friend's ability left her as suddenly as it had appeared. Again, the moral seems to be that the gift is lost in self-consciousness. (Thus O'Connor: 'In art the self becomes self-forgetful.') As soon as the musician senses that someone else is watching her, she begins to watch herself. Rather than using her gift, she is reflecting upon it. Cobwebs.

As is the case with any other circulation of gifts, the commerce of art

draws each of its participants into a wider self. The creative spirit moves in a body or ego larger than that of any single person. Works of art are drawn from, and their bestowal nourishes, those parts of our being that are not entirely personal, parts that derive from nature, from the group and the race, from history and tradition, and from the spiritual world. In the realized gifts of the gifted we may taste that zoë-life which shall not perish even though each of us, and each generation, shall perish.

Such is the context within which to cite more fully Joseph Conrad's description of the artist. The artist, Conrad tells us, must descend within himself to find the terms of his appeal:

> His appeal is made to our less obvious capacities: to that part of our nature which, because of the warlike conditions of existence, is necessarily kept out of sight within the more resisting and hard qualities – like the vulnerable body within a steel armor . . . The artist appeals . . . to that in us which is a gift and not an acquisition – and, therefore, more permanently enduring. He speaks to our capacity for delight and wonder, to the sense of mystery surrounding our lives; to our sense of pity, and beauty, and pain; to the latent feeling of fellowship with all creation – to the subtle but invincible conviction of solidarity that knits together the loneliness of innumerable hearts, to the solidarity . . . which binds together all humanity – the dead to the living and the living to the unborn.

In the chapter on the increase of gifts, I pointed out that at a Tsimshian mortuary potlatch a material thing – a broken copper – symbolizes a natural fact: the group survives despite the death of the individual. Should we call this fact biological, social, or spiritual? The distinctions break down. Once we realize that the thread of zoë-life runs beyond the physical body, beyond the individual self, it becomes harder to differentiate the various levels of our being. There is a larger self, a species-essence, which is a general possession of the race. And the symbolizations like those coppers, but, of course, I mean to include all works of art, paintings, songs, the tiles round the chimney-piece – these symbolizations which express and carry the 'facts' of zoë-life constitute the speech by which that larger self articulates and renews its spirit. By Whitman's

aesthetic, as we shall see, the artist's work is a word 'en masse,' an expression of Conrad's 'subtle but invincible conviction of solidarity.' The work of art is a copula: a bond, a band, a link by which the several are knit into one. Men and women who dedicate their lives to the realization of their gifts tend the office of that communion by which we are joined to one another, to our times, to our generation, and to the race. Just as the artist's imagination 'has a gift' that brings the work to life, so in the realized gifts of the gifted the spirit of the group 'has a gift.' These creations are not 'merely' symbolic, they do not 'stand for' the larger self; they are its necessary embodiment, a language without which it would have no life at all.

In first introducing these two Greek terms, I said that it is *bios*-life – individual and embodied – that dies, while *zoë*-life is the unbroken thread, the spirit that survives the destruction of its vessels. But here we must add that *zoë*-life may be lost as well when there is wholesale destruction of its vehicles. The spirit of a community or collective can be wiped out, tradition can be destroyed. We tend to think of genocide as the physical destruction of a race or group, but the term may be aptly expanded to include the obliteration of the *genius* of a group, the killing of its creative spirit through the destruction, debasement, or silencing of its art (I am thinking, for example, of Milan Kundera's analysis of the 'organized forgetting' which has been imposed upon the nations of Eastern Europe). Those parts of our being that extend beyond the individual ego cannot survive unless they can be constantly articulated. And there are individuals – all of us, I would say, but men and women of spiritual and artistic temperament in particular – who cannot survive, either, unless the symbols of *zoë*-life circulate among us as a commonwealth.

To offer a single example that strikes both the collective and individual levels of this issue, in her autobiography the writer and actress Maya Angelou recalls her graduation from an all-black junior high school. The assembled students and teachers had fallen silent, momentarily shamed by a casually racist speech given by a white administrator, when one of Angelou's classmates began to sing a song they all knew as 'the Negro national anthem,' its words written by a black man, its music by a black woman. 'Oh, Black known and unknown poets,' Angelou writes, 'how often have your auctioned pains sustained us . . . ? If we were a people much given to revealing secrets, we might raise monuments and sacrifice to the memories of our poets, but slavery cured

us of that weakness. It may be enough, however, to have it said that we survive in exact relationship to the dedication of our poets (including preachers, musicians and blues singers).' The elders who passed the Sacred Pipe of the Sioux to Black Elk warned him that 'if the people have no center they will perish.' Just as a circulation of ceremonial gifts among tribal peoples preserves the vitality of the tribe, so the art of any peoples, if it is a true emantion of their spirit, will stand surety for the lives of the citizenry.

In the last chapter I spoke of ancient usury as the conversion of unreck-oned gift-increase into reckoned market interest. We are now in a position to connect this idea to two others. First, if we define use value as the value we sense in things as we use them and make them a part of our selves, and if exchange value is the value we assign to things as we compare them or alienate them from ourselves, then there is something akin to ancient usury in the conversion of use values to exchange values. Second, there is a psychological parallel as well: something related to the spirit of usury lies in the removal of energy from the esemplastic powers and its reinvest-ment in the analytic or reflective powers.

I do not mean to pretend that these three things are one and the same; I am working with two groups of associated ideas and trying to describe a particular relationship between them. We have, on the one hand, imag-ination, synthetic thought, gift exchange, use value, and gift-increase, all of which are linked by a common element of *eros*, or relationship, bonding, 'shaping into one.' And we have, on the other hand, analytic or dialectical thought, self-reflection, logic, market exchange, exchange value, and interest on loans, all of which share a touch of *logos*, of differentiating into parts.

Neither of these poles, the joining or the splitting, is more important or more powerful than its opposite. Each has its sphere and time of ascen-dancy, and it is not impossible to strike a balance between the two. But that harmony is easily lost. There is such a thing as modern usury; there are times when the inordinate extension of exchange value destroys all use value. The hegemony of the market can undermine the possibility of gift exchange, the esemplastic powers can be destroyed by an overvalua-tion of analytic cognition, song can be silenced by self-consciousness, and the plenitude of the imagination can be lost to the scarcity of logic. And if we understand all of these to be modern avatars of the spirit of usury we shall be in a position to understand – when we come to it – Ezra Pound's

preoccupation with that spirit. Pound's initial complaint against usury is best connected to his coeval complaint against the interjection into art of overly analytic or abstract thought. If we say, as Marx suggested, that 'logic is the money of the mind,' then we might add as a corollary that the imagination is its gift. And there will be times when an otherwise useful application of *logos* wounds the imagination, times when the money of the mind destroys the gift of the mind (or, to transfer the argument to society, times when the spirit of the market destroys that gift which cultures have in their works of art).

A full description of the consequences of the commercialization of art lies beyond the scope of this chapter. And yet that commercialization is the constant background to the ideas being developed here, some of which will be thrown into greater relief if we pause to illuminate what lies behind them. Two news items addressing themselves to art and the marketplace will provide a kind of counterpoint. The first (reproduced verbatim from the *New York Times*) tells us a great deal about how drama is currently produced for commercial television:

'The irony,' Robert Thompson, producer of 'The Paper Chase' on CBS-TV, says, is that 'other producers write me letters saying that my program is the best show on the air.'

If praise could be translated into audience-popularity rating points, 'The Paper Chase' would not be stuck in the swampy lowlands of the Nielsen list with an average 19 percent of the audience.

In an attempt to give 'The Paper Chase' a transfusion of rating points, CBS will move the program away from the blockbuster opposition of 'Happy Days' and 'Laverne and Shirley' for five weeks. It will be shown Friday night at 10 P.M. against the weaker competition of a 'Dean Martin Roast' on NBC and a movie about teen-age suicide on ABC . . .

'If ever there existed a series too good to succeed on television . . .' was the melancholy lament of most of the country's television critics when the program went on the air last September. The critics were not only referring to the style and literacy of the show, which deals with a group of first-year law students and their tyrannical professor . . . , but they were also wincing at the fact that CBS had scheduled 'The Paper Chase' at 8 P.M. Tuesdays, opposite the two major ABC hits.

'They certainly put us in Death Alley,' says Sy Salkowitz, president of 20th Century-Fox Television, producers of 'The Paper Chase . . .'

The current economics of television make 'The Paper Chase's' survival – even this long – more than unusual. 'If 'M*A*S*H' were to start its career this year and get its original low ratings,' Mr. Salkowitz . . . adds, 'it would be canceled at mid-season. The people running television have hardened because the economics have changed. At one time everybody lived or died on the cost-per-thousand viewers. If a show's audience dwindled, the cost-per-thousand went up. Now cost-per-thousand doesn't matter.

'With a great deal of trepidation several years ago, the networks raised the cost-per-thousand by raising their per minute advertising prices; and they discovered that the advertisers didn't make too much fuss. At about the same time, television became a seller's market, the most desirable advertising medium for certain products – for cars, beer, mass-produced foods, and soap.'

Now, advertisers pay $45,000 for a 30-second commercial on an average show and $90,000 for the same spot on a very successful show. 'So a single Nielsen rating point on a single program over the course of a year has become worth $2.8 million,' according to Mr. Salkowitz. 'The stakes are so much bigger that it's like a World Series ballgame. In an ordinary game, you might replace your pitcher once. In a World Series game, you'll replace your pitcher three or four times.'

In fact, CBS has already tried several other pitchers against the ABC comedies – with harrowing results. 'The Fitzpatricks,' 'Shields and Yarnell,' 'Challenge of the Sexes,' 'Young Dan'l Boone' and 'Sam' have all ended as bleached bones. 'Sam,' a half-hour series about a police dog, had a considerably higher rating than 'The Paper Chase.'

A second news item strikes some of the same chords in terms of an individual artist:

With his business affairs in disarray, his health failing and his hands trembling so badly that he can no longer affix a reliable signature to a piece of paper, Salvador Dali is trying to put some order into the chaos that his life has become . . .

The artist's 11th-hour attempt to carve out an autonomous and vaguely organized financial situation threatens, however, to disrupt a global network of makeshift contracts and shadowy companies that have converted Salvador Dali into a highly lucrative, multimillion-dollar industry . . .

Dali has made his own contributions to this anarchic state of affairs. According to a large number of highly reliable informants in several nations, Dali for years signed blank sheets of paper and, in happier times, joked merrily about what easy, profitable work it was. On May 3, 1973, a Paris huissier de justice, a kind of notary, signed an official document affirming that Dali had signed 4,000 sheets, weighing 346 kilograms (about 760 pounds), in the Hotel Meurice.

In 1974, French customs police halted a small truck on its way into Andorra loaded with 40,000 blank pieces of paper signed by Dali . . .

The implications for the value of existing Dali lithographs of this uncounted stock of empty pieces of paper signed by the Surrealist draftsman are enormous, highlighted by the recent surfacing of purportedly false Dali lithographs in California, Canada and Italy. One former associate of the painter recounted that 'on a good day' Dali was capable of signing 1,800 sheets in an hour, aided by three attendants who briskly moved the papers as the master dashed off his signature . . .

A prominent figure in the French art world who has acquired [a reproduction of a painting] . . . described it as a color photograph, bearing a Dali signature and sprinkled with gold flake to give it the appearance of value. It sells in Paris for 750 francs, or about $153.

I do not want to overreach the bounds of my argument here. The destruction of the spirit of the gift is nothing new or particular to capitalism. All cultures and all artists have felt the tension between gift exchange and the market, between the self-forgetfulness of art and the self-aggrandizement of the merchant, and how that tension is to be resolved has been a subject of debate since before Aristotle.

And yet some aspects of the problem are modern. *Eros* and *logos* have a distinctly new relationship in a mass society. The remarkable analysis of commodities with which Marx opens *Das Kapital* appears in

the nineteenth century, not any earlier. And the exploitation of the arts which we find in the twentieth century is without precedent. The particular manner in which radio, television, the movies, and the recording industry have commercialized song and drama is wholly new, for example, and their 'high finance' produces an atmosphere that all the sister arts must breathe. 'The Paper Chase' may be the best show that ever came to television, but it belongs to a class of creations which will not live unless they are constantly fed large sums of money. The more we allow such commodity art to define and control our gifts, the less gifted we will become, as individuals and as a society. The true commerce of art is a gift exchange, and where that commerce can proceed on its own terms we shall be heirs to the fruits of gift exchange: in this case, to a creative spirit whose fertility is not exhausted in use, to the sense of plenitude which is the mark of all erotic exchange, to a storehouse of works that can serve as agents of transformation, and to a sense of an inhabitable world – an awareness, that is, of our solidarity with whatever we take to be the source of our gifts, be it the community or the race, nature, or the gods. But none of these fruits will come to us where we have converted our arts to pure commercial enterprises. The Nielsen ratings will not lead us toward a civilization in which the realized gifts of the gifted stand surety for the life of the citizenry. Sprinkles of gold flake will not free the *genius* of our race.

When I pass to and fro, different latitudes, different seasons, beholding the crowds of the great cities, New York, Boston, Philadelphia, Cincinnati, Chicago, St Louis, San Francisco, New Orleans, Baltimore – when I mix with these interminable swarms of alert, turbulent, good-natured, independent citizens, mechanics, clerks, young persons – at the idea of this mass of men, so fresh and free, so loving and so proud, a singular awe falls upon me. I feel, with dejection and amazement, that among our geniuses and talented writers or speakers, few or none have yet really spoken to this people, created a single image-making work for them, or absorb'd the central spirit and the idiosyncrasies which are theirs – and which, thus, in highest ranges, so far remain entirely uncelebrated, unexpress'd.

Dominion strong is the body's; dominion stronger is the mind's. What has fill'd, and fills to-day our intellect, our fancy, furnishing the standards therein, is yet foreign . . . I say I have not seen a single

writer, artist, lecturer, or what not, that has confronted the voiceless
but ever erect and active, pervading, underlying will and typic aspi-
ration of the land, in a spirit kindred to itself. Do you call those genteel
little creatures American poets? Do you term that perpetual, pista-
reen, paste-pot work, American art, American drama, taste, verse? I
think I hear, echoed as from some mountaintop afar in the west, the
scornful laugh of the Genius of these States.

—Walt Whitman, 1871

CHAPTER NINE

A DRAFT OF WHITMAN

I am not blind to the worth of the wonderful gift of 'Leaves of Grass.'
EMERSON TO WHITMAN, 1855

1 • The Grass Over Graves

. . . I guess [the grass] is a uniform hieroglyphic,
And it means, Sprouting alike in broad zones and narrow zones,
Growing among black folks as among white,
. . . I give them the same, I receive them the same.
'SONG OF MYSELF'

In an 1847 notebook Walt Whitman, then about twenty-eight years old, recorded a short fantasy concerning food. 'I am hungry and with my last dime get me some meat and bread, and have appetite enough to relish it all. – But then like a phantom at my side suddenly appears a starved face, either human or brute, uttering not a word. Now do I talk of mine and his? – Has my heart no more passion than a squid or clam shell has?'

But in truth he feels no desire to share his meal. He's hungry. No law forbids a man to feed his stomach. 'What is this then that balances itself upon my lips and wrestles as with the knuckles of God for every bite I put between them, and if my belly is victor . . . follows the innocent food down my throat and turns it to fire and lead within me? – And what is it but my soul that hisses like an angry snake, Fool! will you stuff your greed and starve me?'

I am reminded of the story of Saint Martin of Tours, one of the earliest saints of the Western Church. Martin had a vision as a young soldier serving in the Roman army. Having torn his cloak in half to cover a naked beggar, he saw, the following night, an image of Christ wrapped in the garment he had given away. There are spirits that appear as beggars in our peripheral vision; what we bestow upon them draws them into the foreground and joins them to us. 'Song of Myself,' Whitman's greatest poem, begins with an invitation to the 'starved face' of his hunger fantasy. 'Loafe with me on the grass,' he says to his soul, 'loose the stop from your throat, / . . . Only the lull I like, the hum of your valvéd voice.'

Somehow – it is not recorded – he gave the soul its bread. It came toward him as a lover then, not as a beggar or beast. It stretched him on the grass and entered his body. Its throat opened and it began to sing.

Whitman was born in 1819 into a large family. His father appears to have been a man of independent spirit, a devotee of Thomas Paine and the Quaker dissenters. At one time he had been a farmer on Long Island, but he soon turned his hand to carpentry after moving the family to Brooklyn, where he built plain houses for working-class families. He never made much money. The Whitmans moved from house to house as each was finished and sold to pay the mortgage. Whitman himself began to work when he was eleven, first as a lawyer's boy, then as an apprentice in a print shop. Like many printers, he developed an interest in journalism. In his late teens he taught school for several years; in the 1840s he wrote for and edited, with some success, newspapers in and around New York. He wrote sentimental fiction and conventional poetry.

The mystery of this life, or at least its surprise, was that in 1855 this previously run-of-the-mill writer came to publish *Leaves of Grass*, a book remarkable both in content and in style. The turn in Whitman's life has been explained in many ways – that he was inspired by a trip

to a phrenologist, that he cribbed it all from Emerson, that he fell in love on a trip to New Orleans, that he'd been reading Carlyle on heroes, that he became enthusiastic over a modern version of Hermes Trismegistus found in a George Sand novel, and more. Each of these explanations is true to some degree (except for the New Orleans love affair). After Whitman died, a friend of his, Maurice Bucke, put forward yet another – that in June of 1853, when Whitman was thirty-five, he had an awakening, a rebirth, a moment of 'cosmic consciousness.' Whitman himself never explicitly corroborated Bucke's thesis, but he does describe such an epiphany in Section 5 of 'Song of Myself.' Having invoked his soul, he addresses it:

I mind how once we lay such a transparent summer morning,
How you settled your head athwart my hips and gently turn'd over
 upon me,
And parted the shirt from my bosom-bone, and plunged your tongue
 to my bare-stript heart,
And reach'd till you felt my beard, and reach'd till you held my feet.

Swiftly arose and spread around me the peace and knowledge that
 pass all the argument of the earth,
And I know that the hand of God is the promise of my own,
And I know that the spirit of God is the brother of my own,
And that all the men ever born are also my brothers, and the women
 my sisters and lovers,
And that a kelson of the creation is love,
And limitless are leaves stiff or drooping in the fields,
And brown ants in the little wells beneath them,
And mossy scabs of the worm fence, heap'd stones, elder, mullein
 and poke-weed.

It is of little account for the story I wish to tell whether this infusion, this lovemaking between the self and the soul, happened in fact or in imagination; either way we may begin. We have two gifts already. The sequence of events implies that Whitman shared the bread with his soul, and now the soul has given him a return gift, its tongue. Their commerce is an exact parallel to the one I described earlier between the Roman and his *genius*, an interior give-and-take between a man and his tutelary spirit.

In this case, though, the man is a poet and the spirit is a poet's soul. Whitman's account of their commerce constitutes the creation myth of a gifted man. In the circulation of gifts Whitman becomes a poet, or, to put it another way, through the completed give-and-take he enters a way of being, a state, in which an ongoing commerce of gifts is constantly available to him.

Whitman's hunger fantasy differs from all later accounts of his intercourse with the soul in its underlying tension. And one of the first things we can say about the gifted state which his epiphany initiates is that this tension, the 'talk of mine and his,' falls away. As gift exchange is an erotic commerce, joining self and other, so the gifted state is an erotic state: in it we are sensible of, and participate in, the underlying unity of things. Readers are usually struck by Whitman's bolder, more abstract assertions of unity. – 'I am not the poet of goodness only, / I do not decline to be the poet of wickedness also' – but the real substance of the state Whitman has entered lies in the range of his attention and affections:

> I . . . do not call the tortoise unworthy because she is not something else,
> And the jay in the woods never studied the gamut, yet trills pretty well to me,
> And the look of the bay mare shames silliness out of me.

One of the effects of reading Whitman's famous catalogs is to induce his own equanimity in the reader. Each element of creation seems equally fascinating. The poet's eye focuses with unqualified attention on such a wide range of creation that our sense of discrimination soon withdraws for lack of use, and that part of us which can sense the underlying coherence comes forward:

> The carpenter dresses his plank, the tongue of his foreplane whistles its wild ascending lisp,
> The married and unmarried children ride home to their Thanksgiving dinner,
> The pilot seizes the king-pin, he heaves down with a strong arm,
> The mate stands braced in the whale-boat, lance and harpoon are ready . . .

The spinning-girl retreats and advances to the hum of the big wheel,
The farmer stops by the bars as he walks on a First-day loafe and
 looks at the oats and rye,
The lunatic is carried at last to the asylum a confirm'd case,
(He will never sleep any more as he did in the cot in his mother's bed-
 room) . . .

Whitman puts hierarchy to sleep. He attends to life wherever it moves.
He would be useless in that ethic's-class dilemma mentioned earlier in
this book: deciding which member of the family to throw from the
sinking lifeboat. All things carry equivalent worth simply by virtue of
their existence, be they presidents or beetles rolling balls of dung. The
contending and reckoning under which most of us suffer most of the
time – in which this thing or that thing is sufficient or insufficient, this
lover, that lover, this wine, that movie, this pair of pants – is laid aside.
You may relax,

The moth and the fish-eggs are in their place,
The bright suns I see and the dark suns I cannot see are in their place,
The palpable is in its place and the impalpable is in its place.

Having fallen into this state, Whitman resists being drawn back into that
part of the mind which reckons value or splits things apart. He refuses
commerce with what we might call 'the brain that divides' or with any spirit
which might divorce him from his newly wedded soul, or which might – to
fill out the list with Whitman's typical unities – divide men from women,
human beings from animals, the rich from the poor, the smart from the
dumb, or the present from the past and the future. In a striking passage
toward the beginning of 'Song of Myself,' Whitman declares his satisfaction
with his awakening and asks rhetorically:

As the hugging and loving bed-fellow sleeps at my side through the
 night, and withdraws at the peep of the day with stealthy tread,
Leaving me baskets cover'd with white towels swelling the house with
 their plenty,
Shall I postpone my acceptation and realization and scream at my
 eyes,
That they turn from gazing after and down the road,

And forthwith cipher and show me to a cent,
Exactly the value of one and exactly the value of two, and which is
 ahead?

In the first edition of the poem it is God who shares the poet's bed and
leaves the baskets of rising dough. In an early notebook, Whitman,
thinking of various heroes (Homer, Columbus, Washington), writes that
'after none of them . . . does my stomach say enough and satisfied. –
Except Christ; he alone brings the perfumed bread, ever vivifying to me,
ever fresh and plenty, ever welcome and to spare.' Each of these breads,
like that of the hunger fantasy, is a gift (from the god-lover, to the soul),
and Whitman senses he would lose that gift were he to 'turn from gazing
after' his lover and reckon its value or peek to see if the baskets hold
whole wheat or rye.

Showing the best and dividing it from the worst age vexes age,
Knowing the perfect fitness and equanimity of things, while they
 discuss I am silent, and go bathe and admire myself.

In abandoning the brain that divides, Whitman quits as well all ques-
tioning and argument (what he calls 'talk'). I do not mean he is silent –
he affirms and celebrates – but his mouth is sealed before the sleep-
less, pestering questions of the dividing mind. 'Master,' Whitman wrote
in a preface addressed to Emerson, 'I am a man who has perfect faith.'
Faith does not question. Or, to give the matter its proper shading, faith
is the aftermath of questioning – not the answers but the quitting of
doubt. It is an ancient wisdom that questioning itself postpones or
prohibits faith. In a Buddhist sutra a monk comes to the Buddha saying
he shall abandon the religious life unless the master can answer his
questions. Is the world eternal, or isn't it? Does the saint exist after
death or doesn't he? Are the soul and the body identical or are they
two things? The Buddha says he does not hold to either side of any of
these questions, for they are 'questions which tend not to edification.'
Two lines from Kabir, the fifteenth-century mystic poet, make the same
point:

The flavor of floating through the ocean of deathless life has quieted
 all my questions.

Just as the tree is inside of the seed, so all our diseases are in the
 asking of these questions.

Several times in *Leaves of Grass* Whitman tells us of periods in his own
life when he could not feel his perfect faith. 'I too felt the curious abrupt
questionings stir within me,' he confides to the reader in one poem, 'I too
knitted the old knot of contrariety.' One of the love poems suggests the
content of Whitman's questions – and tells how they were quieted. The
poems gathered under the heading *Calamus* address themselves, in
Whitman's terms, to 'the passion of friendship for men,' to 'adhesiveness,
manly love.' They are quite clearly the record, sometimes frank and some-
times veiled, of Whitman's frustrated love affair with a man in the late
1850s. A poem called 'Of the Terrible Doubt of Appearances' lists the doubts
he suffers when he cannot feel 'the equanimity of things':

. . . That we may be deluded,
That may-be reliance and hope are but speculations after all,
That may-be identity beyond the grave is a beautiful fable only,
May-be the things I perceive, the animals, plants, men, hills, shining
 and flowing waters,
. . . are . . . only apparitions . . .

But, like Kabir, Whitman found something to dissolve his doubt:

When he whom I love travels with me or sits a long while holding
 me by the hand, . . .
Then I am charged with untold and untellable wisdom, I am silent,
 I require nothing further,
I cannot answer the question of appearances or that of identity beyond
 the grave,
But I walk or sit indifferent, I am satisfied,
He ahold of my hand has completely satisfied me.

We have now seen three situations in which Whitman falls into a gifted
state. Reckoning and dividing, talking and doubt, all leave him when his
lover holds his hand, when the god-lover shares his bed and gives him the
baskets of rising dough, and when the soul plunges its tongue into his
breast. Note that in each of these cases Whitman's body is the instrument

of his conversion. The intercourse that leads him to the gifted state is a
carnal commerce, one of bread and tongues, hands and hearts. Whitman
is what has traditionally been known as an enthusiast. To be 'enthusiastic'
originally meant to be possessed by a god or inspired by a divine afflatus.
The bacchants and maenads were enthusiasts, as were the prophets of the
Old Testament, the apostles of the New, or, more recently, Shakers and
Pentecostal Christians. Enthusiasts, having received a spirit into the body,
have never been hesitant to describe their spiritual knowledge in terms of
the flesh, to speak of 'a sweet burning in the heart' or of a 'ravished soul.'
Whitman is no exception, as all our examples so far illustrate. He takes his
own body to be the font of his religion:

> If I worship one thing more than another it shall be the spread of
> my own body, or any part of it,
> Translucent mould of me it shall be you!
> Shaded ledges and rests it shall be you!
> Firm masculine colter it shall be you!
> You my rich blood! your milky stream pale strippings of my life! . . .
> My brain it shall be your occult convolutions!
> Root of wash'd sweet-flag! timorous pond-snipe! nest of guarded
> duplicate eggs! it shall be you!

This is the enthusiastic voice, both its subject and its breathlessness.*

Enthusiasm has recurrently fallen into disrepute because there have
always been those who claim they are filled with the spirit when they are
only full of hot air (or worse, full of malice, self-will, or the Devil). And
where the enthusiast, sensing a spirit is near, might invoke its powers, the
critics of enthusiasm proceed with caution and forbearance. 'Enthusiastic
wildness has slain its thousands,' they rightly warn. The passions of the
flesh, even if inspired by the gods, are prone to error. Those who are wary
of enthusiastic religion prefer their spiritual knowing to be purified by the
cooler light of reason.

In the summer of 1742 a Massachusetts clergyman, Charles Chauncy,

* In the trajectory of Whitman's life one can discern a tendency toward a more dis-
incarnate spirituality. As an old man he wrote that *Leaves of Grass* was a collection of
songs of the body and that he had thought of writing a second book to indicate that 'the
unseen Soul govern[s] absolutely at last.' And yet, he says, 'It is beyond my powers,' adding
that 'the physical and the sensuous . . . retain holds upon me which I think are never
entirely releas'd . . .'

preached 'A Caveat Against Enthusiasm.' The text is instructive in our approach to Whitman, for it bears an uncanny resemblance to the caveats that were later to be published, or at least spoken, against Whitman. In Chauncy's day, a wild-eyed Christian, James Davenport, had emerged from the woods of western Massachusetts and started to stir up the Boston faithful, accusing the local deists, like Chauncy, of not *really* knowing the Word of God. Chauncy's sermon warns his congregation against the dangers of enthusiasm in general and Davenport in particular. His critique returns again and again to the question of how we are to know the true meaning of Scripture. When two men differ in their sense of the Word, how are we to settle on the truth? Chauncy would submit divergent views to reasonable debate. 'Nay,' he declares, 'if no reasoning is made use of, are not all the senses that can be put on scripture equally proper?' (The enthusiast would reply that it is reason itself which leads us to differing conclusions – that in matters of the spirit we must be guided by an inner light. The enthusiast waits for a *sensation* of truth.)

Chauncy gives his flock instruction on how to recognize the enthusiasts in their midst. That you can't reason with them is the first sign, but, interestingly enough, all the others have to do with their bodies: 'it may be seen in their countenance,' 'a certain wildness . . . in their general look,' 'it strangely loosens their tongues,' 'throws them . . . into quakings and tremblings,' they are 'really beside themselves, acting . . . by the blind impetus of a wild fancy.' It is precisely the feeling that one's body has been entered by some 'other' that Chauncy wishes to warn against.

With this dichotomy between spirits that move the body and a prophylactic 'reasoning,' we come to an issue we touched on in the last chapter, the destruction of the esemplastic powers by an overvaluation of analytic cognition and the related destruction of gift exchange by the hegemony of the market. The deist's attachment to reasonable discourse and his caution before the trembling body place the spirit of his religion closer to the spirit of trade than to the spirit of the gift. In gift exchange no symbol of worth need be detached from the body of the gift as it is given away. Cash exchange, on the other hand, *depends* upon the abstraction of symbols of value from the substances of value. The farmer doesn't move his produce until he's paid, and if he's paid in dollar bills (or checks or credit at the store), then he has exchanged embodied worth – wheat and oats – for symbolically valuable but substantially worthless paper.

When the system is working, of course, the symbols are negotiable and he can convert them back into substances at any time. Both market exchange and abstract thought require this alienation of the symbol from the object. Mathematics, that highly abstract form of cognition, could not proceed if we did not replace the 'real' objects of analysis with ciphers, just as the cash market could not operate if we could not convert apples and oranges into symbolic wealth and the symbols back into apples and oranges.

This affinity between abstract thought and market exchange seems to me the reason why Chauncy's 'reasonable' deism (or its immediate heirs, Unitarianism and transcendentalism) has historically been associated with the upper-middle class and with intellectuals. Cash exchange is to gift exchange what reason is to enthusiasm. In the old joke, a Unitarian comes to a fork in the road; one sign points to Heaven and the other to a Discussion About Heaven. The Unitarian goes to the discussion. The enthusiast, of course, knows his spiritual knowledge cannot be discussed because it cannot be received intellectually. Like Whitman, he testifies, he does not argue. And the ceremonies of enthusiastic religions tend to include the body, rather than talk. The celebrants dance and sing, they quake and tremble. But no one dances ecstatic dances in the churches of the rich. Nor do they speak in tongues or raise their hands in the gesture of epiphany the way the Christian enthusiasts do. The rich would seem to sense that the more you feel the spirit move in the physical body on Sunday, the harder it will be to trade in cash on Monday. Better to sit in one's pew and listen to a talk. The unitarianism that men like Chauncy developed called for no enthusiastic flights of fancy; it was, as others have pointed out, a religion with which the merchants of Boston could be at ease.

I have offered these remarks about enthusiasm partly to introduce the element of 'bodily knowing' into my description of Whitman's gifted state, but also to help us place Whitman in the spirit of his times. We might say that Whitman was Emerson's enthusiast, Emerson with a body. The sage of Concord stands midway between the crew-cut deist and the hairy-necked Whitman. Emerson left the Unitarian Church, to be sure, but he remained a curious mix of Chauncy's caution and the passion he prefigured for Whitman. In his own well-known epiphany, Emerson felt himself to be a 'transparent eyeball . . . I see all; the currents of the Universal Being circulate through me; I am part and parcel of God.' And not Charles Chauncy, then. But still, the lens of the eye is our only bloodless organ of sense. 'I

was born cold,' Emerson confided in his journal. 'My bodily habit is cold. I shiver in and out; don't heat to the good purposes called enthusiasm a quarter so quick and kindly as my neighbors.'

It was for Whitman to read Emerson's 'Nature' and take it to heart, to feel the soul's tongue move in his breast, an epiphany of animal heat. Emerson was moved by his first reading of *Leaves of Grass*, but in 1860 he walked Whitman around Boston trying to persuade him not to speak so frankly about the body in his poems – reading him, that is, a caveat against enthusiasm.* Apparently, Whitman found Emerson's reasoning sound and compelling. 'Each point . . . was unanswerable,' he wrote in his memoir of their talk, 'no judge's charge ever more complete and convincing.' Emerson was the greater intellectual and the greater critic. But Whitman was the greater poet, and faithful to his genius. He did not debate the master's caution, but when Emerson asked in conclusion, 'What have you to say to such things?' Whitman replied, 'Only that while I can't answer them at all I feel more settled than ever to adhere to my own theory and exemplify it.' Or, as he used to tell the story in old age, 'I only answer'd Emerson's vehement arguments with silence, under the old elms of Boston Common.'

Whitman begins 'Song of Myself' with a description of the delight of the passage of 'stuff' through his body: 'my respiration and inspiration, the beating of my heart, the passing of blood and air through my lungs.' (Or later, sounding like a true enthusiast: 'Through me the afflatus surging and surging, through me the current and the index.') The 'self' that Whitman's song presents to us is a sort of lung, inhaling and exhaling the world. Almost everything in the poem happens as a breathing, an incarnate give-and-take, which filters the world through the body. Whitman says of a long list of people and occupations, 'these tend inward to me, and I tend outward to them . . . / And of these . . . I weave the song of myself.' Upon hearing a noise, he says, 'I think I will do nothing for a long time but listen, / And accrue what I hear into myself . . . ,' and he then presents us with a long catalog of sounds. When he describes this material respiration in the language of gifts, Whitman speaks of his inhalation as

* When Whitman later tried to raise money for his work in the Civil War hospitals, a friend wrote to him from Boston: 'There is a prejudice against you here among the 'fine' ladies and gentlemen of the transcendental School. It is believed that you are not ashamed of your reproductive organs and, somehow, it would seem to be the result of their logic – that eunuchs only are fit for nurses.'

'accepting' the bounty of the world, his exhalation as 'bequeathing' or 'bestowing' (himself, his work).

The initial event of the poem, and of Whitman's aesthetic, is the gratuitous, commanding, strange and satisfying entry into the self of something that was previously separate and distinct. The corresponding gesture on Whitman's part is to give himself away. 'Adorning myself to bestow myself on the first that will take me.' He 'bequeath[s] Poems and Essays as nutriment' to the nation just as, at the end of his song, he bequeaths himself 'to the dirt to grow from the grass [he] love[s].' These gestures – the inhalation and exhalation, the reception and the bestowal – are the structuring elements of the poem, the passive and active phases of the self in the gifted state.

In the preface to the first edition of *Leaves of Grass*, Whitman calls the two phases of the artist's labor 'sympathy' and 'pride':

> The soul has that measureless pride which consists in never acknowledging any lessons but its own. But it has sympathy as measureless as its pride and the one balances the other and neither can stretch too far while it stretches in company with the other. The inmost secrets of art sleep with the twain.

In sympathy the poet receives (inhales, absorbs) the embodied presences of creation into the self; in pride he asserts (exhales, emanates) his being out toward others. As with any respiration, this activity keeps him alive:

> Dazzling and tremendous how quick the sunrise would kill me,
> If I could not now and always send sunrise out of me.

If either pole of the breath was interrupted, he would cease to exist. 'Whoever walks a furlong without sympathy walks to his funeral, drest in his shroud.' The human being *is* the give-and-take of sympathy and pride:

> To be in any form, what is that? . . .
> If nothing lay more develop'd the quahaug in its callous shell were
> enough.*

* The quahaug is the same one that appeared in the fantasy of the hungry soul: 'Now do I talk of mine and his? – Has my heart no more passion than a squid or clam shell has?'

Mine is no callous shell,
I have instant conductors all over me whether I pass or stop,
They seize every object and lead it harmlessly through me.

Between the poles of sympathy and pride lie the 'secrets of art,' the poet tells us, and if we are to gaze upon those secrets, we must follow the passage of these 'objects' through the body, follow the poet's breath from the sympathetic inhalation through to the out-breath, the pride 'out of which,' says Whitman, 'I utter poems.'

A poem called 'There Was a Child Went Forth' offers a typical description of Whitman's receptive sympathy. A young boy walks out of doors:

And the first object he look'd upon, that object he became . . .

The early lilacs became part of this child,
And grass and white and red morning-glories, and white and red
 clover, and the song of the phoebe-bird, . . .
And the water-plants with their graceful flat heads, all became part
 of him.

In his sympathetic phase, Whitman preserves the participatory sensuality of childhood. The boy who became the lilac when he saw the lilac survives in the older man. In the poems at least, Whitman seems to feel no distance between his senses and their objects, as if perception in the gifted state were mediated not by air or skin but by some wholly conductive element that permits immediate contact with the palpable substance of things. We believe the poems because he has drawn the scenes with such sharp detail. He spots the runaway slave 'through the swung half-door of the kitchen'; he sees how 'the young sister holds out the skein while the elder sister winds it off in a ball, and stops now and then for the knots.' Imagining himself floating over the nation, he sees below 'the sharp-peak'd farm house, with its scallop'd scum and slender shoots from the gutters.' We have all had moments of such contact: lost in the grays of snow blown sideways across the clapboards, or daydreaming in the rain pockmarking the tops of cars, the ants gathered where wisteria leans against the stucco. And we accept that Whitman knew, and wrote out of, such contact because he

noticed that half-door, the knots in the yarn, the shoots of green in the gutter dirt.

In this initial phase of his art, Whitman is essentially passive and things beyond the skin are active, 'libidinous' and 'electric.' Natural objects find him attractive. They approach him of their own accord and push at the edges of the self, like lovers:

> Crowding my lips, thick in the pores of my skin,
> Jostling me through streets and public halls, coming naked to me at
> night, . . .
> Calling my name from flower-beds, vines, tangled under-brush, . . .
> Noiselessly passing handfuls out of their hearts and giving them to
> be mine.

When the poet is in the gifted state, the world seems generous, exhaling odors and auras toward him. 'I believe,' he says, 'the soggy clods shall become lovers and lamps . . .' Animals, stones, the people in their daily lives enter into his body. 'I find I incorporate gneiss, coal, long-threaded moss, fruits, grains, esculent roots . . .' The fishermen packing layers of halibut in the hold, two men arguing over a penny, 'the silent old-faced infants and the lifted sick . . . / All this I swallow, it tastes good . . .'

By taking his nourishment through his senses, Whitman comes to have a carnal knowledge of the world. His participatory sensuality 'informs' him in both senses – it fills him up and it instructs.

> Oxen . . . , what is that you express in your eyes?
> It seems to me more than all the print I have read in my life

The poet studies inside of objects the way the rest of us might study in the library.

> To me the converging objects of the universe perpetually flow,
> All are written to me, and I must get what the writing means.

But the objects cannot be read as a book is read. They are hieroglyphs, sacred signs that reveal their meanings only to that host who is gracious enough to receive them into the body. The leaf of grass is 'a uniform hieroglyphic,' as are the oxen or those soggy clods, and perception, in

the gifted state, is a constant hierophany. The ducks scared up in the woods reveal their 'wing'd purposes.' Objects are 'dumb, beautiful ministers' which articulate their ministration when they are accepted by the self.

Whitman calls on us to leave the 'distillation' or 'perfume' gathered in books and to come out of doors to breathe the thinner 'atmosphere,' the original hieroglyphs, not the commentary of the scribes. As we inhale this atmosphere of primary objects, they exhale gnosis, a prolific, carnal science, not an intellectual knowing. 'I hear and behold God in every object, yet understand God not in the least.' As his body and its senses are the font of Whitman's religion, so the perception of natural objects is his sacrament. 'The bull and the bug never worshipp'd half enough, / Dung and dirt more admirable than was dream'd.' Whitman lists the gods of old and then says he learns more from watching 'the framer framing a house'; 'a curl of smoke or a hair on the back of my hand [is] just as curious as any revelation.'

What is the knowledge that the hieroglyphs reveal? It is in part a thing we cannot 'talk' about (the poem, like the eyes of the oxen, is to be received into the self, read with the breath). One or two things are clear, however. As with the first epiphany, Whitman's constant communion with objects reveals the wholeness of creation. He comes to feel 'in place' through this commerce, and knows his own integration with the world. He says the animals

> . . . bring me tokens of myself . . .
> I do not know where they got those tokens,
> I must have passed that way untold times ago and negligently dropt
> them,
> Myself moving forward then and now and forever . . .

Natural objects – living things in particular – are like a language we only faintly remember. It is as if creation had been dismembered sometime in the past and all things are limbs we have lost that will make us whole if only we can recall them. Whitman's sympathetic perception of objects is a remembrance of the wholeness of things.

Secondly, and here we come around to the beginning again, the reception of objects reveals that the gifted self is a thing that breathes. Their entrance is *itself* the lesson. We are not sealed in calcium like the clam.

Identity is neither 'yours' nor 'mine,' but comes of a communion with the world. 'Every atom belonging to me as good belongs to you.'

Whitman makes a distinction between the self and the narrower identity. Toward the beginning of 'Song of Myself' he offers a compendium of personal history:

> . . . The effect upon me of my early life or the ward and city I live in,
> or the nation, . . .
> My dinner, dress, associates, looks, compliments, dues,
> The real or fancied indifference of some man or woman I love,
> The sickness of one of my folks or of myself, or ill-doings or loss or
> lack of money, or depressions or exaltations . . .

But these, he says, 'are not the Me myself.'

> Apart from the pulling and hauling stands what I am,
> Stands amused, complacent, compassionating, idle, unitary . . .

Identity forms and disperses inside the container of the self. Recurrently in the work we find a curious image, that of a sea alive with countless particles which occasionally cohere into more complex bodies, and then dissolve again. To be born, to take on life in a particular form, is to be drawn into 'a knit of identity' out of the 'pallid float' of this sea. Whitman says that he, like the rest of us, was 'struck from the float forever held in solution' and 'receiv'd identity by [his] body . . .' Identity is specific, sexed, time-bound, mortal. It is transitory, drawn together and then dispersed. The self is more enduring, standing apart from 'the pulling and hauling.' In terms of our argument so far, the self takes on identity through its reception of objects – be they perceived lilac leaves or the atoms of the physical body – and the self gives up identity as it abandons these objects. The self is not the reception, not the dispersal, not the objects. It is the process (the breathing) or the container (the lung) in which the process occurs.

Whitman is not logically rigorous in his use of 'self' and 'identity,' but these generalizations offer an approximate beginning. I introduce them because there is a middle phase in the process of the gifted self: between sympathy and pride, between the reception and the bestowal, lies a moment in which new identity comes to life as old identity perishes. A sequence of three of these moments marks the center of 'Song of Myself.' In each,

Whitman calls on some outer object or person to enter or merge with him, beginning with the sea:

> I behold from the beach your crooked inviting fingers, . . .
> We must have a turn together, I undress, hurry me out of sight of
> the land,
> Cushion me soft, rock me in billowy drowse,
> Dash me with amorous wet, I can repay you . . .
> Sea beating broad and convulsive breaths,
> Sea of the brine of life and of unshovell'd yet always-ready graves, . . .
> I am integral with you . . .

Here is the first hint of the death that lies in Whitman's sympathy. The water of contact is a soporific, the amorous wet is full of graves. A line in the first edition speaks of a pain accompanying the fusion: 'We hurt each other as the bride groom and the bride hurt each other.' Old identity breaks to receive the new. The new may simply replace the old or, as in this figure, old identity may fuse with the outer object, a marriage, new flesh.

The fear, pain, and confusion of this integration is more marked in the next of these three moments. This time Whitman invokes sound; the catalog of what he hears ends with a woman singing in the opera:

> I hear the trained soprano . . . she convulses me like the climax of
> my love-grip;
> The orchestra whirls me wider than Uranus flies,
> It wrenches unnamable ardors from my breast,
> It throbs me to gulps of the farthest down horror,
> It sails me . . . I dab with bare feet . . . they are licked by the indolent
> waves,
> I am exposed . . . cut by bitter and poisoned hail,
> Steeped amid honeyed morphine . . . my windpipe squeezed in the
> fakes of death,
> Let up again to feel the puzzle of puzzles,
> And what we call Being.

The outer object is definitely sexual now, and if only because sexual identity is so deeply felt (especially for one who claims to have 'receiv'd identity by [his] body'), both the attraction and the fear are heightened – the singing

voice is both honey and poison. He must choose: will he risk admitting what
is clearly foreign into the self or will he erect a protective armor and close
himself off? Is this woman's song a gift to be refused? It is at this point in
the poem that Whitman pauses to define 'being'; the entrance of the
soprano's voice is followed immediately by the lines, already quoted, which
equate being alive with allowing the objects of the world to pass through
the self. The living self accepts the frailty of sympathy. 'To be in any form,
what is that? / . . . Mine is no callous shell . . .' Whitman does not deny his
hesitancy and fear, but in the end he opens the skin, accepting what is a
poison to particular identity so as to receive a higher sweetness for the
durable self.

The scene with the opera singer is quickly followed by the strongest of
the three moments of tension between the old and the new identity.
Whitman has been drawn to the sea and to a woman heard from a distance.
Now he says, 'To touch my person to someone else's is about as much as
I can stand.' Again, something fearful but inviting overtakes him. He
describes the entry in terms of a betrayal by his senses: normally, it seems,
his senses act as guards protecting the borders of the self – they let some
things enter, they stop others. But when he touches this person, 'touch'
takes over and he is possessed, both by his own desire and by the lover.

Is this then a touch? quivering me to a new identity,
Flames and ether making a rush for my veins,
Treacherous tip of me reaching and crowding to help them,
My flesh and blood playing out lightning to strike what is hardly
 different from myself,
On all sides prurient provokers stiffening my limbs,
Straining the udder of my heart for its withheld drip,
Behaving licentious toward me, taking no denial,
Depriving me of my best as for a purpose,
Unbuttoning my clothes, holding me by the bare waist,
Deluding my confusion with the calm of the sunlight and pasture-
 fields,
Immodestly sliding the fellow-senses away,
They bribed to swap off with touch and go and graze at the edges of
 me,
No consideration, no regard for my draining strength or my anger, . . .

I am given up by traitors,
I talk wildly, I have lost my wits . . .

As before, there is something threatening to the particular identity in this
fusion with what is foreign to the self. But a new and necessary detail is
now added: this time the sensual reception of the other leads toward new
life. He is 'quiver[ed] . . . to a new identity'; the panicky union leads to
these calmer declarations:

Parting track'd by arriving, perpetual payment of perpetual loan,
Rich showering rain, and recompense richer afterward.

Sprouts take and accumulate, stand by the curb prolific and vital,
Landscapes projected masculine, full-sized and golden.

There is a cycle: new identity follows the old. With these 'sprouts' we have
arrived at Whitman's central image, the leaves of grass, a form of life that
perishes but rises again and again out of its own decay.

Whitman's grass almost always appears over a grave. His invocation is not
'O grass' but 'O grass of graves.' The two are constantly connected, from
the beginning of the poem where a child asks, 'What is grass?' and
Whitman's associations soon lead him to death ('And now it seems to me
the beautiful uncut hair of graves'), to the end of the poem where he
describes his own eventual grave with its 'leafy lips.'
 This distinctive vein of Whitman's poetry comes, I imagine, out of a
meditation on the following brief sentence recorded in his earliest journal:
'I know that my body will decay.' No fixed identity can relax in the face
of this knowledge. Once it has entered our consciousness, that part of us
which takes identity seriously will begin to search for a way of being which
could include the fact of death and decay. In the same notebook, Whitman
wrote a fragmentary phrase: 'Different objects which decay, and by the
chemistry of nature, their bodies are [changed?] into spears of grass.'
'Song of Myself' is an attempt to replicate this chemistry. In the poem the
grass usually appears after something has entered, and altered, the self.
The scenes we have just reviewed, the 'sprouts' that follow touch, are a
good example (or, earlier, Whitman sees the grass for the first time, its

'leaves stiff or drooping in the fields,' immediately following his epiphany).
Whitman wishes to demonstrate that the self replicates or participates in
that chemistry of nature which changes decayed bodies into spears of
grass.

At one point in *Leaves of Grass* Whitman speaks of the compost of decay:
'It gives such divine materials to men, and accepts such leavings from them
at last.' In 'Song of Myself' the grass itself speaks: 'Growing among black
folks as among white, / . . . I give them the same, I receive them the same.'
As the grass is food for animal life, so we animals, with the death of the
body, become food for the grass. It accepts what we bestow upon it, then
gives itself away. But this, of course, is also how Whitman pictures the
gifted self. When it identifies with 'the grass over graves,' therefore, the self
assumes an identity harmonious with its own process in the gifted state.
The self that identifies with a cycle of gifts takes its own activity as its iden-
tity – not the reception of objects, not the bestowal of particular contents,
but the entire process, the respiration, the give-and-take of sympathy and
pride. And 'the grass over graves' therefore comes to stand for more than
enduring life in Whitman's cosmology. It stands for the creative self, the
singing self. Not only does the grass sprout from the grave, but it speaks;
it is 'so many uttering tongues' emerging from 'the faint red roofs' of the
mouths of the dead.

In accepting the decay of the body, the impermanence of identity, and
the permeability of the self, Whitman finds his voice. His tongue comes to
life in the grave and begins its song. Or perhaps we should not say 'grave,'
but 'threshold,' for at the moment of change we cannot well distinguish
between birth and death:

> And as to you Death . . . it is idle to try to alarm me.
>
> To his work without flinching the accoucheur comes,
> I see the elder-hand pressing receiving supporting,
> I recline by the sills of the exquisite flexible doors,
> And mark the outlet, and mark the relief and escape.

The 'accoucheur' is a midwife or obstetrician, so these 'doors' are both an
entrance to the grave and an exit from the womb. 'The new-born emerging
from gates and the dying emerging from gates,' says another poem.
Whitman addresses us from this gate or doorway: 'From the cinder-strew'd

threshold I follow their movements . . .'; 'I wait on the door-slab.' The poems appear in the frame of the flexible doors, and they themselves are the leaves of grass, threshold gifts uttered from the still-point where life both rises and falls, where identity forms and perishes.

The grass over graves is a very old image, of course; Whitman did not invent it. Vegetation has always been taken as a sign of indestructible life, and the vegetable gods of antiquity were its personification. I discussed Dionysos in an earlier chapter; Osiris is the other good example, the one with which Whitman seems to have been acquainted. A friend of his once recounted that Whitman as a young man living in New York 'paraded on Broadway with a red shirt on, open in front . . . , and compared himself with Christ and Osiris.' Later, in the 1850s, visitors to Whitman's room in his mother's house would find a group of unframed pictures pasted on the wall – Hercules, Dionysos or Bacchus, and a satyr. Whitman apparently used to meditate on images of the gods, trying to imagine them present in himself, or trying to speak with their voices. In 'Song of Myself' we read:

> Taking myself the exact dimensions of Jehovah,
> Lithographing Kronos, Zeus his son, and Hercules his grandson,
> Buying drafts of Osiris, Isis, Belus, Brahma, Buddha . . .

And so on; the list includes thirteen gods. Whitman was not a scholar of these things – he took most of his information from newspapers and popular novels – but his intuitive grasp was strong. He was able to flesh out an image by sensing what was still alive in it for his own purposes and experience.

In the Astor Library in New York, sometime during 1855, Whitman came across a huge compendium of etchings of Egyptian hieroglyphs and tomb carvings that had been published fifteen years previously by an Italian archeologist. One of these etchings, reproduced here, shows a version of the resurrection of the dead Osiris. A libation is being poured over Osiris' coffin, out of which grow twenty-eight stalks of wheat. We do not know if Whitman studied this particular drawing, but it seems likely. In 1856 he published 'Poem of Wonder at The Resurrection of The Wheat' (later, 'This Compost'), one of whose lines could serve as a caption for the drawing: 'The resurrection of the wheat appears with pale visage out of its graves . . .'

There are many conflicting accounts of the story of Osiris, but all agree

on certain elements. Osiris was a god-king who ruled Egypt in ancient times. His brother, Set, jealous of his power, killed him by trapping him in a box and floating it down the Nile. Isis, who was both Osiris' sister and wife, retrieved the body and brought it back to Egypt. Set found it again, however, and, tearing it apart, scattered the limbs. In some versions of the story, Isis gathered the limbs, put the body back together and then lay with her husband to bring him back to life. In other versions, Isis took the form of a bird and flew over the earth seeking Osiris' body. When she found it, she beat her wings so that they glowed with light and stirred up a wind; Osiris revived sufficiently to copulate with her, begetting their son, Horus.

The etchings that Whitman saw refer to a more vegetable version of the resurrection. Osiris was also a god of the crops,

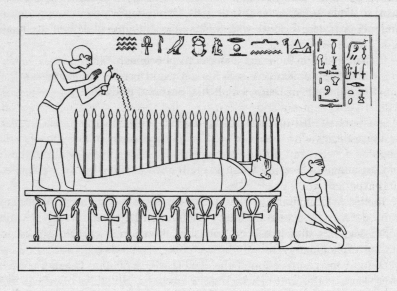

'The . . . wheat appears with pale visage out of its graves.'

The Osiris etching that Whitman probably saw in the Astor Library in 1855. The next year he wrote 'Poem of Wonder at The Resurrection of The Wheat.' The etching shows a libation being poured over the dead Osiris; twenty-eight stalks of grain sprout from the body.

identified with the annual Nile flood and subsequent reappearance of the wheat. A number of reliefs have been preserved in which plants or trees grow from his dead body. In paintings and statues, Osiris is typically painted green. It was also the custom to make a figure of Osiris in grain on a mat placed inside a tomb. In the museum at Cairo there is an Osiris mummy which in ancient times was covered with linen and then kept damp so that corn actually grew on it.

Osiris is the 'evergreen' principle in nature. Like the other wellknown vegetation gods, he stands for what is broken, dismembered and decayed yet returns to life with procreative power. His body is not just reassembled, it comes back green. With him we return to the mystery of things that increase as they perish – to the Tsimshian coppers cut apart at a chief's funeral, the Kwakiutl coppers dismembered and riveted back together with increased value, Dionysos and the spirits that grow *because* the body is broken. And the gift as we first described it: a property that both perishes and increases. Osiris is the mystery of compost: 'It grows such sweet things out of such corruptions.'

I have filled out the image of this god not because Whitman necessarily knew all of these details, but because I want to give some sense of the range of inherited meaning behind 'the grass over graves.' Whitman begins with 'I know that my body will decay,' and through a mysterious green chemistry he ends with the new shoots of grass. *And* he identifies that grass with his poetry:

Scented herbage of my breast,
Leaves from you I glean, I write . . . ,
Tomb-leaves, body-leaves growing up above me above death,
. . . O the winter shall not freeze you delicate leaves,
Every year shall you bloom again, out from where you retired you
 shall emerge again . . . *

The self becomes gifted when it identifies with a commerce of gifts and the gifted self is prolific. In nature the Osiris-force is the resurrection of the

* The poem from which these lines are taken is the one about which D. H. Lawrence made his perceptive comment, 'Whitman is a very great poet, of the end of life.' The remark is often quoted without its context so as to imply that Whitman is *only* a poet of death. But the context is the same as the one I am setting up here. '. . . Of the end of life,' says Lawrence, and he adds, 'But we have all got to die, and disintegrate. We have got to die in life, too, and disintegrate while we live . . . Something else will come. "Out of the cradle endlessly rocking."'

wheat; in a commerce of gifts it is the increase; in the gifted self it is creativity, and for a poet, in particular, it is original speech.

Whitman says that 'the inmost secrets of art' sleep between sympathy and pride. We have so far addressed him primarily by the first of these terms, sympathy, the receptive phase of his imagination. Objects approach and enter the permeable self, giving it identity – or, rather, a sequence of identities, for the old perishes as the new enters. Particular identity is dismembered, the particular body decays. But the self is not lost, new 'sprouts take and accumulate.' With them we come to the second pole of Whitman's art, the assertion of an active, autonomous, and idiosyncratic being. By 'pride' Whitman means not haughtiness but something closer to self-confidence. Animals are proud in this sense, 'so placid and self-contained . . . , / They do not lie awake in the dark and weep for their sins . . .' The proud are those who accept their being as sufficient and justified. The proud man, in Whitman's constantly repeated image, is he who will not remove his hat for any person, institution or custom. Whitman himself used to wear his hat in the house.

Pride is not antithetical to sympathy, but it is selective. 'Dismiss whatever insults your own soul,' counsels Whitman in the voice of pride. When pride is active, Whitman's sympathy has only what the mystics call a 'selective surrender.' Some things must be denied admission to the core of his being. Earlier we saw his senses surrender him to a lover; they reappear later as the agents of pride, and the result is different:

> You laggards there on guard! look to your arms!
> In at the conquer'd doors they crowd! I am possess'd!
> Embody all presences outlaw'd or suffering . . .

'To arms!' – this is an unusual note of quahaug-consciousness in 'Song of Myself.' Whitman wants to harden himself. Why? Because at this moment in the poem sympathy has drawn him toward the dying and the empty. They enter his body: he is a convict handcuffed in prison, he is a child arrested for stealing:

> Not a cholera patient lies at the last gasp but I also lie at the last gasp,
> My face is ash-color'd, my sinews gnarl, away from me people retreat.

> Askers embody themselves in me and I am embodied in them,
> I project my hat, sit shame-faced, and beg.

This is dangerous. It is one thing to sympathize with the sick, but quite another to be infected with cholera. It is one thing to accept the perishing that leads to rebirth, and quite another to suffer the dead-end death in which the soul is lost. As D. H. Lawrence pointed out in his essay on Whitman, the leper hates his leprosy: to sympathize with him means to join in his hatred, not to identify with the disease. Here pride demands the assertion of the self against the outer object. Or better, it calls for a bestowal, an out-breathing, of the contents of the self, not a new infusion. The beggar holding out his hat has nothing to offer the self. It is *he* who needs to be filled – with food, matter, flux, a shot of the spirit. In short, the terms of the poem must change. Sympathy is insufficient. The next lines are unique in Whitman:

> Enough! enough! enough!
> Somehow I have been stunn'd. Stand back! . . .
> I discover myself on the verge of a usual mistake.
>
> That I could forget the mockers and insults!
> That I could forget the trickling tears and the blows of the bludgeons
> and hammers!
> That I could look with a separate look on my own crucifixion and
> bloody crowning.
>
> I remember now,
> I resume the overstaid fraction,
> The grave of rock multiplies what has been confided to it, or to any
> graves,
> Corpses rise, gashes heal, fastenings roll from me.
>
> I troop forth replenish'd with supreme power, one of an average
> unending procession . . .

'Song of Myself' is not a highly organized poem, but to my mind it draws a certain coherence from a series of three 'passions.' In the first of these (Section 5) the invited soul makes love to the poet. He comes to life. A long

188 The Gift

'in the world' section follows in which an essentially passive self suffers an escalating series of identities which culminate in the second passion (Sections 28 and 29 – the touch that ends in the new sprouts). Another 'in the world' section follows, this one closing with the beggar holding out his hat, and then the final passion (Section 38, just quoted). Whitman drops the sympathetic voice and takes up the voice of a rising spirit (Christ come from the grave or – in the first edition – as ascending dervish: 'I rise extatic through all . . . / The whirling and whirling is elemental within me.')

He asserts an identity: 'I resume the overstaid fraction' ('staid' in the sense of 'fixed' – he speaks from the part of the self that says 'I am eternal' rather than the part that accepts decay). He dissociates himself from 'the mockers and insults.' He becomes a character, a personality, an individual capable of giving off energy and vitalizing others. The idleness and passivity that mark the first half of the poem falls away after this scene; he is active now, a teacher and a lover. He fathers children, he heals the sick and strengthens the weak ('Open your scarf'd chops till I blow grit within you'). He doesn't actually raise the dead, but he calls the moribund back from the lip of the grave:

To anyone dying, thither I speed and twist the knob of the door, . . .

I seize the descending man and raise him with resistless will,
O despairer, here is my neck,
By God, you shall not go down! hang your whole weight upon me.

I dilate you with tremendous breath . . .

Our enthusiast has exhaled at last. He who absorbed the proffered world for a thousand lines now gives it all away. 'Anything I have I bestow.'

Whitman describes the being that gives itself away in a variety of images. It exhales a divine nimbus, it gives off auras and aromas (including 'the scent of these armpits'), it is 'electric' or 'magnetic,' its eyes flash with a light more penetrating than the sun, it 'jets' the 'stuff' of love* – and finally, it speaks or sings or 'utters poems.' This last, the poetry, is, of course, the

* To speak of procreation as a bestowal, Whitman is forced to abandon his habitual even-handedness toward the sexes. The male self ejaculates sperm, the female gives birth to babies.

emanation of the gifted self to which we shall attend here. But before doing so, I want to offer a brief biographical note on Whitman bestowing himself in love. The story will lead us back to our topic, the poetry as a gift, because in order to bestow his work, Whitman will set out to establish a gift-relationship with his reader, a love-relationship, really: 'This [the poem] is the touch of my lips to yours . . . this is the murmur of yearning.' Some specifics from Whitman's life will help us clarify the terms under which he courts his reader, and will anchor our analysis against some of our singer's loftier claims.

The basic fact is that Whitman was a man disappointed in love. A close reading of the poems collected as *Children of Adam* and *Calamus* tells us quite a bit. The former group, intended to express 'the amative love of women,' are not convincing. As in those churches in which sex is tolerated only as an instrument of procreation, it is a persistent quirk of Whitman's imagination that heterosexual lovemaking always leads to babies. His women are always mothers. No matter how graphically Whitman describes 'the clinch,' 'the merge,' within a few lines out pops a child. This has the odd effect of making Whitman's sexually explicit poems seem abstract: they have no emotional nuance, just biology. The women are not people you would know, nor anyone you feel Whitman knew.

But the *Calamus* poems are true love poems. They include all the feelings of love, not just attraction, excitement, and satisfaction, but disappointment, and even anger. They were written between 1856 and 1860 by a man who had extended his heart to someone and was waiting, in doubt, to see what might happen. His love was not returned, it seems – Whitman states it directly twice and nothing contravenes the impression:

> Discouraged, distracted – for the one I cannot content myself without,
> soon I saw him content himself without me.

> I loved a certain person ardently and my love was not return'd Yet
> out of that I have written these songs.

We don't know what went wrong, but Whitman clearly didn't get what he wanted. One of the finest of the *Calamus* poems presents Whitman's 'leaves' in a new context, that of loneliness and love:

I saw in Louisiana a live-oak growing,
All alone stood it and the moss hung down from the branches,
Without any companion it grew there uttering joyous leaves of dark
 green,
And its look, rude, unbending, lusty, made me think of myself,
But I wonder'd how it could utter joyous leaves standing alone there
 without its friend near, for I knew I could not . . .

The pride out of which Whitman utters poems is not a solitary self-containment. It is active and self-assured, but it is also continuous with the other phases of the self. Just as he enters the gifted state when the lover takes his hand, so the poems come to him when his friend is near. And their utterance is directed outward, a gift meant to 'inform' another self. That, at least, is the ideal – described in the poetry and desired in the life.

But we must set the live-oak of this poem beside another tree found in a journal entry from the summer of 1870. At the time Whitman was in love with a young man named Peter Doyle. The relationship proved to be one of the most satisfying of his life, but that summer Whitman was troubled. Disguising the entry by referring to Doyle as 'her' and replacing his initials with an alpha-numeric code, Whitman records, first, a resolution to cool his ardor.

TO GIVE UP ABSOLUTELY & for good, from this present hour, this FEVERISH, FLUCTUATING, useless undignified pursuit of 164 – too long, (much too long) persevered in, – so humiliating . . . Avoid seeing her, or meeting her, or any talk or explanations – or ANY MEETING WHATEVER, *FROM THIS HOUR FORTH, FOR LIFE.*

He was suffering, ten years later, the same kind of frustrated passion that lies behind *Calamus*. Immediately below this entry we find an 'outline sketch of a superb character':

his emotions &c are complete in himself irrespective (indifferent) of
 whether his love, friendship, &c are returned, or not
He grows, blooms, like some perfect tree or flower, in Nature, whether
 viewed by admiring eyes, or in some wild or wood entirely
 unknown . . .

Depress the adhesive nature
It is in excess – making life a torment
All this diseased, feverish disproportionate *adhesiveness*.

Whitman could settle at neither pole. Years before this journal entry he
had seen that indifferent, perfect tree 'uttering joyous leaves,' and he knew
it as an image of the being he longed for, 'complete in himself.' But he also
knew it was impossible, that he came best to song through contact. There
is a spiritual path in which the soul ascends in isolation, abandoning all
creatures. But this was not the path for Whitman, so hungry for affection
and so present in his body. As he grew older Whitman did in fact find a
form for his 'adhesive nature'; he managed a series of long-lasting, basi-
cally paternal relationships with younger men, Doyle being one of them.
But to judge from his letters, he wanted more. He wanted to 'work and live
together' with a man; he wanted to 'get a good room or two in some quiet
place . . . and . . . live together.' He never got it. When he presents himself
to the world as 'like some perfect tree,' we will be right, therefore, to feel
a touch of perfection's loneliness. All of this vegetable sex – these trees and
leaves of grass – carries in it, sometimes, the disappointment of an animal
desire. Even Osiris had Isis to warm his bones to life.

The picture I have drawn of the process of the gifted self began with its
inhalation of objects; to turn now to the bestowing phase of this self, and in
particular to the poetry as a gift, we must add a new and essential detail: the
objects that inform the self are unable to speak. 'You have waited, you always
wait, you dumb, beautiful ministers.' And not just objects – Whitman's world
is also filled with people who cannot speak. He offers them his tongue:

Through me many long dumb voices,
Voices of the interminable generations of slaves,
Voices of prostitutes and of deformed persons,
Voices of the diseased and despairing, and of thieves and dwarfs, . . .
Of the trivial and flat and foolish and despised,
Of fog in the air and beetles rolling balls of dung.

Dumb people, dumb objects. Not everything comes into the world with a
tongue, it seems. The poet Miriam Levine, who grew up in a working-class

neighborhood in New Jersey, tells me that her family used to speak of arti-
culate men and women as having been 'born with a mouthpiece.' Those
who can express themselves in speech have been given that mysterious
something, like the mouthpiece of a trumpet or the reed of a wind instru-
ment, through which experience is transmuted into sound. Whitman
receives the mute into the self in order to articulate what he calls their
'buried speech.' He becomes the mouthpiece of the dumb, and not, I suspect,
of these objects and slaves alone but of his family and his lovers. This last
in particular: in art as in life Whitman was always attracted to the figure
of an inarticulate young man:

> . . . I pick out some low person for my dearest friend,
> He shall be lawless, rude, illiterate . . . ,
> O you shunn'd persons, I at least do not shun you,
> I come forthwith in your midst, I will be your poet . . .

Peter Doyle was such an illiterate; Whitman taught him to read and write.

Knowing that Whitman's art begins in speechlessness, we may find a
new meaning in his invocation to the soul: 'Loafe with me on the grass,
loose the stop from your throat, / . . . Only the lull I like, the hum of your
valvèd voice.' It is the soul that has the mouthpiece, the mysterious ability
to translate dumb hieroglyphs into speech.* The soul acknowledges and
accepts what has entered the self by uttering its name. This responsive
speech we call 'celebration' or 'thanksgiving.' In the fairy tales the spoken
'thank you' or the act of gratitude accomplishes the transformation and
frees the original gift; so in the poetry, for the soul to give speech to the
stuff of experience is to accept it and to pass it along. Moreover, by
Whitman's model, the self does not come to life until the objects flow
through it. (The increase does not appear until the gift moves to the third
party.) Celebratory speech is the return gift by which what has been
received by the self is freed and passed along. To open a poem saying 'I
celebrate myself' is therefore to announce the reciprocation-by-song which
will simultaneously assure the life of the self and the liveliness of what

* There are other 'speech centers' in the self besides what Whitman is calling the soul. The
intellect can speak – it can describe the known world, it can draw logical conclusions. But
it cannot *create* speech for the mute. It is a gesture of the wakened soul to offer articulation
to the speechless content of the self. 'The talkers . . . talking the talk of the beginning and
the end' cannot do it; only soul, imagination, muse, *genius* can do it.

has been bestowed upon it.* Or, to put it another way, by Whitman's assumptions, we shall lose that life which remains unarticulated. This is why the family prizes the child with the mouthpiece (sometimes – not all families want to live!), or why a nation prizes its poets (sometimes) – and this also is the urgency behind Whitman's attention to the mute: he would assure their lives by giving them speech. He would be the tongue for the 'living and buried speech . . . always vibrating here, [the] howls restrain'd by decorum . . .'; he would allow his thoughts to be 'the hymns of the praise of things,' so that the spirits which have been bestowed upon him – by the unlettered boy, the wood duck, the eddies of fog – will not perish.†

Before we describe Whitman's work more fully in these terms, I should pause to clarify where, exactly, the gift lies in the creation of a work of art. In common usage the term covers three different things, unfortunately. And while I have tried to be more precise in my own usage, some confusion still creeps in. The initial gift is what is bestowed upon the self – by perception, experience, intuition, imagination, a dream, a vision, or by another work of art. Occasionally the unrefined materials of experience or imagination are finished works, in which case the artist is merely a transmitter or medium (the surrealist poets tried to work in this manner; the art of the religious

* When I speak of celebration, I do not mean that all our art must be a cheery affirmation. To utter sorrow and loss is also a responsive speech, and a form of celebration. I use the term broadly, of course, as when we speak of 'celebrating' the anniversary of someone's death. 'Sadness, in order to sing, / Will have to drink black water,' says the Spanish poet José Luis Hidalgo. No one welcomes the black water of grief, but it too, when it comes, may be accepted and articulated. Spoken sorrow – or despair, or longing – descries the shape of the lost. We keep alive through speech the spirit of what we do not have; we survive, spiritually, by uttering the names of the dead and the names of what we need but cannot find. (There is little of this in Whitman, by the way. Only in *Calamus* and in some of the old-age poems do we feel him trying to name what he could not find. He is primarily a poet of praise, 'I keep no account with lamentation,' he wrote early on. By that same token, however, some of his sorrow remained mute and some of his intensity never came to life.)
† In an account of a center serving the Jewish elderly in California, the anthropologist Barbara Myerhoff offers the following observation about storytelling: 'Stories are a renewal of the word, made alive by being spoken, passed from one to another, released from considerations of correctness and law . . . Rabbi Nechman of Bratzlav ordered that all written records of his teachings be destroyed. His words must be passed from mouth to mouth, learned by and in heart. "My words have no clothes," he said. "When one speaks to one's fellows, there arises a simple light and a returning light."'
 The oral tradition – stories, songs, poems passed from mouth to mouth – keeps the gift of speech alive. The poet Gary Snyder, asked in an interview why the oral tradition is so weak in the United States, answered: 'Because of the stress on individual names and the emphasis on keeping a text pure.'
 Each of these preoccupations – the one a concern of the market, the other a concern of the academy – treats our art as proprietary works, not gifts.

society of Shakers also fits this model, their artists being known as 'instruments' and their art as 'gifts'). But it is rare for the initial material to be the finished work of art; we must usually labor with it.

The ability to do the labor is the second gift. The artist works, to echo Joseph Conrad once again, from that part of our being which is a gift and not an acquisition. To speak of our talents as gifts distinguishes them from those abilities that we acquire through the will. Two men may learn to speak a foreign language with equal accuracy, but the one who has a gift for languages does not have to struggle with his learning as does the man who has no gift. Men or women of talent must work to perfect their gifts, of course; no one is exempt from the long hours of practice. But to set out to acquire the gift itself through work is like trying to grow an extra hand, or wings. It can't be done.

The artist's gift refines the materials of perception or intuition that have been bestowed upon him; to put it another way, if the artist is gifted, the gift increases in its passage through the self. The artist makes something higher than what he has been given, and this, the finished work, is the third gift, the one offered to the world in general or directed back specifically to the 'clan and homeland' of an earlier gift.

Whitman himself imagines the commerce of these gifts as both an inner and an outer activity. He has a strong sense of a reader to whom the poem is directed. That recipient is not always the conventional reader of the book, however; it is just as often an interior figure, Whitman's own soul – or muse or *genius* or spirit-lover (the one he imagined would meet him in death, 'the great Camerado, the lover true for whom I pine'). In one of his prefaces Whitman speaks of his poems as having been spoken to him by his soul – but he is dissembling if he would have us believe that these poems are the same as those we find printed on the page. The soul that translates dumb objects into speech does not speak the finished poem, as Whitman's fat revision books attest. Out of what the soul has offered him, the poet makes the work. And in this interior commerce the finished work is a return gift, carried back into the soul. In a famous letter Keats wrote that the world is not so much a 'vale of tears' as a 'vale of soul-making.' The artist makes a soul, makes it real, in the commerce of gifts. As when the Roman sacrifices to his *genius* on his birthday so that it may grow and become free spirit, or as with any number of the exchanges we have described, the point of the commerce is a spiritual increase and the eventual actualization of the soul.

Every artist secretly hopes his art will make him attractive. Sometimes he or she imagines it is a lover, a child, a mentor, who will be drawn to the work. But alone in the workshop it is the soul itself the artist labors to delight. The labor of gratitude is the initial food we offer the soul in return for its gifts, and if it accepts our sacrifice we may be, as Whitman was, drawn into a gifted state – out of time, coherent, 'in place.' And in those moments when we are gifted, the work falls together graciously. (Not always, of course. For some the work may fall into place regularly, but most of us cut out a thousand pairs of shoes before the elves begin to sew.)

When Whitman speaks of his work in terms of an outer audience, he tells us, to take a key example, that he intended *Leaves of Grass* 'to arouse' in the hearts of his readers 'streams of living, pulsating love and friendship, directly from them to myself, now and ever.' It seems an odd direction at first: 'from them to myself.' As we saw in Whitman's life, we have before us an artist who is hungry for love. He knew it. He speaks of his desire as 'this terrible, irrepressible yearning,' and he speaks of his poetry as the expression of a 'never-satisfied appetite for sympathy, and [a] boundless offering of sympathy . . . this old eternal, yet ever new interchange of adhesiveness . . .' If we read the next sentence literally, we shall find the source of his need: 'The . . . surest tie between me and Him or Her, who, in the pages of *Calamus* and other pieces realizes me . . . must . . . be personal affection.' Whitman is saying, as he said in the poem about the 'terrible doubt of appearances,' that the state in which he comes to life requires that he find a reader to whom he may communicate the gifts of his soul. He exists, he is realized, literally, through this completed contact:

> The soul, reaching, throwing out for love,
> As the spider, from some little promontory, throwing out filament
> after filament, tirelessly out of itself, that one at least may catch
> and form a link, a bridge, a connection . . .

Whitman's confessions of artistic intent reveal the same frustrated yearning that lies behind the *Calamus* poems, and I should not proceed without noting that his neediness sometimes undercuts the work itself. There are some clammy poems in *Leaves of Grass*. We feel a hand on our shoulder, a pushy lover (I am thinking, for example, of a moment in 'Crossing Brooklyn Ferry' when Whitman claims to have imagined all of

his readers before they were born; it seems presumptuous). But in the best poems, Whitman manages that poise, requisite to both art and love, which offers the gift without insisting. He may not have found the love he wanted in life, but it would be wrong to consign his appetites entirely to personal circumstance. Who among us has been sufficiently loved, whose heart has been fully realized in the returning gaze of the beloved?

Let us turn now to the function of the work once it has been given to the outer audience. When Whitman offers his poem to the literal reader, he sometimes addresses him as 'O reader of the future.' In part this is a poet's way of imagining a better audience than the one that was offered him in time, but I think we may also take the phrase as an atemporal invocation to the reader that lies potentially in each of us. Whitman directs his gift toward *our* souls now. He speaks in the prophetic perfect to wake the gifted self in any who would receive his poem. The poet, he says, 'spreads out his dishes . . . he offers the sweet firm-fibered meat that grows men and women.' 'This is the tasteless water of souls . . . this is the true sustenance.' A work of art that enters us to feed the soul offers to initiate in us the process of the gifted self which some antecedent gift initiated in the poet. Reading the work, *we* feel gifted for a while, and to the degree that we are able, we respond by creating new work (not art, perhaps, but with the artist's work at hand we suddenly find we can make sense of our own experience). The greatest art offers us images by which to imagine our lives. And once the imagination has been awakened, it is procreative: through it we can give more than we were given, say more than we had to say.* 'If you become the aliment and the wet,' says Whitman of his poems, 'they will become flowers, fruits, tall branches and trees.' A work of art breeds in the ground of the imagination.

In this way the imagination creates the future. The poet 'places himself where the future becomes present,' says Whitman. He sets his writing desk in the 'womb of the shadows.' Gifts – given or received – stand witness to meaning beyond the known, and gift exchange is therefore a transcendent commerce, the economy of recreation, conversion, or renaissance. It brings us worlds we have not seen before. Allen Ginsberg tells a story about a time

* This is one reason we cannot read an artist's work by his life. We learn something when we read the life, of course, but the true artist leaves us with the uncanny sense that the experience fails to explain the creation.

when he was a young man, out of luck and out of lovers, lying on his bed in Spanish Harlem, reading Blake. He had put the book aside. He had masturbated. He had fallen into a depression. And then, as he lay gazing at the page he heard a voice say Blake's poem, 'Ah sunflower, weary of time / That countest the steps of the sun . . .' 'Almost everything I've done since has these moments as its motif,' Ginsberg has said. 'The voice I heard, the voice of Blake, the ancient saturnal voice, is the voice I have now. I was imagining my own body consciousness . . .' It is Ginsberg's use of 'imagining' that I wish to mark. With a poem as his seed image, the young man imagined the sonority and quiddity with which the older man has come to sing the songs of Blake.

The imagination can create the future only if its products are brought over into the real. The bestowal of the work completes the act of imagination. Ginsberg could have said, 'O dear, now I'm hearing voices,' and taken a sedative. But when we refuse what has been offered to the empty heart, when possible futures are given and not acted upon, then the imagination recedes. And without the imagination we can do no more than spin the future out of the logic of the present; we will never be led into new life because we can work only from the known. But Ginsberg responded as an artist responds. The artist completes the act of imagination by accepting the gift and laboring to give it to the real (at which point the distinction between 'imaginary' and 'real' dissolves).

The college of imagination which conducts the discourse of art is not confined by time. Just as material gifts establish and maintain the collective in social life, so the gifts of imagination, as long as they are treated as such, will contribute toward those collectives we call culture and tradition. This commerce is one of the few ways by which the dead may inform the living and the living preserve the spiritual treasures of the past. To have the works of the past come to life in the active imagination is what it means 'to have gathered from the air a live tradition,' to use Ezra Pound's wonderful phrase. Moreover, as a commerce of gifts allows us to give more than we have been given, so those who participate in a live tradition are drawn into a life higher than that to which they have been born. Bestowed from the dead to the living and from the living to the unborn, our gifts grow invisibly among us to sustain each man and woman above the imperfections of state and age.

A live tradition is neither the rhetoric nor the store of facts that we can learn in school. In a live tradition the images speak for themselves. They

'itch at your ears,' as Whitman says. We hear voices. We feel a spirit move
in the poems that is neither 'me' nor 'the poet' but a third thing between.
In a live tradition we fall in love with the spirits of the dead. We stay up
all night with them. We keep their gifts alive by taking them into the quick
of our being and feeding them to our hearts.

Ezra Pound once wrote in a pamphlet: 'Of religion, it will be enough for
me to say, in the style of a literary friend . . . , "every self-respecting
Ravennese is procreated, or at least receives spirit or breath of life, in the
Mausoleum of Galla Placidia."' For Pound, a culture husbands its liveli-
ness in its works of art; they are like storage barrels for that 'tasteless water'
which the citizen drinks to revive, or procreate, his soul.

A live tradition extends in both directions in time, but most artists seem
to face themselves in a primary direction, toward either the past or the
future. The *fils à papa* (the father's son), say the French, has the spiritual
attitude that serves the past, while the *fils à maman* is in love with emerging
life. The terms well differentiate Whitman and Pound, to whom we shall
be turning soon. Pound – one of the few American poets who remained
close to his father throughout his life – was in love with the past. It fed his
soul, and he dedicated his work to its preservation.

But Whitman, the mother's son, courted the future. 'I meant *Leaves of
Grass* . . . to be the Poem of Identity (of *yours*, whoever you are, now reading
these lines) . . . ,' he says. He means 'identity' in the sense we have developed
– the poetry is a gift that offers to pass through and transform the self. When
we speak of 'the Whitman tradition' in art, we mean that line of artists – Hart
Crane, Isadora Duncan, William Carlos Williams, Pablo Neruda, Henry Miller,
to name only a few – who have professed the spirit that came to life with
their reception of the poetry. Just as Whitman was the enthusiast of Emerson
and Carlyle and George Sand, allowing their spirits space in his body, so these
artists are the enthusiasts of Whitman. They are not merely students, of
course, but laborers who permitted his gift to live in the imagination and be
the seed for new work, work connected to the spirits of the dead but distinct,
current, alive. 'Sprouts take and accumulate . . .'

II • Adhesive Riches

Democratic Vistas, Whitman's long, rambling, postbellum meditation on art
and politics, sets democracy on two opposed foundations, the individual

and the masses (the 'average,' 'the all-leveling aggregate'). Whitman gives preference to neither of these poles in the practice of his democracy, but in describing its formation he begins, as the poetry began, with the individual coming to his powers, or hers, in isolation. 'The noiseless operation of one's isolated Self' precedes community. Our actions and character must spring from what is received in the ground of our being, else they will be merely derived behaviors, appliqué personalities. Any political thinker will notice right away, of course, that we are dealing here with a politics of inner light, one in which 'man, properly train'd in sanest, highest freedom, may and must become a law, and series of laws, unto himself.' The initial event in Whitman's democracy is not a political event at all. 'Alone . . . – and the interior consciousness, like a hitherto unseen inscription, in magic ink, beams out its wondrous lines to the senses.'

Even Whitman's emphasis on the masses arises from his desire to nurture the idiosyncratic. Individual identity cannot thrive where some people count and others do not. Just as all are invited to the poetry ('I will not have a single person slighted or left away'), so democracy enfranchises every self – politically and spiritually. Whitman pauses in his *Vistas* to address the Europeans: 'The great word Solidarity has arisen. Of all dangers to a nation as things exist in our day, there can be no greater one than having certain portions of the people set off from the rest by a line drawn – they not privileged as others, but degraded, humiliated, made of no account.' Hierarchy, any line drawn to separate 'the best from the worst' in social life, is the hallmark of what Whitman calls 'European chivalry, the feudal, ecclesiastical, dynastic world,' a world whose manners, he felt, still held sway in the New World. He would have them replaced by his universal suffrage of the self – a suffrage not so much of the vote but one in which no man is obliged to take his hat off to any other. He places each citizen on this equal footing not only to protect the idiosyncratic self but to produce it as well. Democracy has a future tense. Enfranchisement 'commence[s] the grand experiment of development, whose end (perhaps requiring several generations) may be the forming of a full-grown man or woman . . .' Whitman begins his democracy with individual identity, but in its action neither the One nor the Many is primary, each exists to produce the other so that the nation might be their union, 'a common aggregate of living identities.'

To arrive at this union, Whitman's democracy needs one last ingredient. A series of realized selves does not automatically become a community.

There must be some sort of glue, a cohesive to bind the aggregate together. 'The two are contradictory,' says Whitman of the poles of his democracy, '. . . our task is to reconcile them,' and he does so, first of all, with a political version of the manly love of comrades: 'Adhesiveness or love . . . fuses, ties and aggregates . . . , fraternizing all.' Whitman borrowed the term 'adhesiveness' from phrenology. This nineteenth-century form of pop psychology distinguished between 'amative' sexual love and 'adhesive' friendship (which, in the phrenologist's iconography, was symbolized by two women embracing each other). Adhesive love is the second element in Whitman's politics which is not strictly political, at least insofar as politics has to do with power. Perhaps we would do well to differentiate the term: adhesiveness is an *eros* power while most of what passes as politics is *logos* power. Law, authority, competition, hierarchy, and the exercise of royal or despotic will through the courts, the police and the military – these are *logos* powers, and they are the skeletal structure of most political systems. The image of two women embracing is not found on any nation's flag. Whitman envisioned drawing isolated individuals into a coherent and enduring body politic without resorting to the patriarchal articles of the social contract. In short, he would replace capitalist home economics with 'the dear love of comrades.' His politics reveal an unspoken faith: that the realized and idiosyncratic self is erotic and that erotic life is essentially cohesive. He assumes that the citizen, like the poet, will emerge from the centripetal isolation, in which character forms, with an appetite for sympathetic contact and an urge both to create and to bestow.

In this last we come to the fusion of Whitman's aesthetics and politics, the social life of the gifted self. Even more than the love of comrades, I think, the true cohesive force in Whitman's democracy is art. In his political aesthetic, as we saw at the end of the last chapter, the artist absorbs not 'objects' but 'the central spirit and idiosyncrasies' of the people. And his responsive act is to create 'a single image-making work for them.' It is this work, or better, the nation's artistic wealth as a whole, which draws a people together. We could even say that the artist creates (or at least preserves) the 'central spirit' of the people, for, as in the poetry, a spirit that has never been articulated cannot endure. As the poet Robert Bly says in a different context, 'Praise to the first man who wrote down this joy clearly, for we cannot remain in love with what we cannot name . . .' Nor can we nurture or take sustenance from a spirit that remains unspoken. In Whitman's democracy the native author creates an 'embryo or skeleton'

of the native spirit. The artist absorbs a thing that is alive, of course, but its life is not assured until its name has been given. Literature does not simply absorb a spirit, says Whitman, it 'breed[s] a spirit.'

Whitman insisted that a spirit dwelt in the American people which was different from the one articulated by romantic novels from the Continent or by native authors, such as Longfellow. And he believed the spirit would soon be lost if it could not be realized in art. *Democratic Vistas* calls for American authors to create a domestic literature by which to ensure the survival of democracy. Our art should accrue a national image, he says, 'an aggregate of heroes, characters, exploits, sufferings, prosperity or misfortune, glory or disgrace, common to all, typical to all.' Literature forms the 'osseous structure' that fuses the nation together so that its spirit may survive trauma. The urgency of Whitman's essay grew out of his own disappointment with democracy in action in 1870. How, without a native literature, was the Union to survive the corruptions that followed the Civil War? 'The lack of a common skeleton, knitting all close, continually haunts me.'

Art is a political force for Whitman, but for a third time we must say that we are not speaking of politics in the conventional sense. Art does not organize parties, nor is it the servant or colleague of power.* Rather, the work of art becomes a political force simply through the faithful representation of the spirit. It is a political act to create an image of the self or of the collective. It has no *logos* power, but the law and the legislatures will say they thought it up when it comes to term. In an early letter Whitman writes that 'under and behind the bosh of the regular politicians, there burns . . . the divine fire which . . . , during all ages, has only wanted a chance to leap forth and confound the calculations of tyrants, hunkers, and all their tribe.' The work of the political artist creates a body for this fire. So long as the artist speaks the truth, he will, whenever the government is lying or has betrayed the people, become a political force whether he intends to or not, as witness American artists during the 1930s or during the Vietnam war, Spanish artists during their civil war, South Korean poets in recent years, all Russian artists since the Revolution, Bertolt Brecht as Hitler rose to power, and so forth. In times like these the spirit of the polis must be removed from the hands of the politicians and survive in the

* As it is, for example, in Mao Tse-tung's political aesthetic where 'work in literature and art . . . is subordinated to the revolutionary tasks set by the Party . . .'

resistant imagination. Then the artist finds he is describing a world that does not appear in the newspapers and someone has tapped his phone who never thought to call in times of peace.

In the middle of the nineteenth century the American spirit was largely absorbed in an expanding and self-confident mercantilism. The Industrial Revolution had arrived in the New World. And what was our poet's relationship to this part of the native spirit? He was in love with it, or with a part of it at least. Whitman is a sort of Richard Henry Dana, Jr., for poets, whose *Vistas* 'cheerfully include . . . a practical, stirring, worldly, money-making, even materialistic character . . . ,' whose 'theory includes riches, and the getting of riches . . .' What Whitman loved was the shimmer, the bustle, the electric excitement of the marketplace, not the practical aspects of making a living. He participated sensually in trade. In a letter to Peter Doyle he offers an emblematic description of his delight, sitting atop an omnibus in New York City:

> If it is very pleasant . . . [I] ride a trip with some driver-friend on Broadway from 23rd street to Bowling Green, three miles each way. You know it is a never-ending amusement & study & recreation for me to ride a couple of hours, of a pleasant afternoon, on a Broadway stage in this way. You see everything as you pass, a sort of living, endless panorama – shops, & splendid buildings, & great windows, & on the broad sidewalks crowds of women, richly-dressed, continually passing, altogether different, superior in style & looks from any to be seen any where else – in fact a perfect stream of people, men too dressed in high style, & plenty of foreigners – & then in the streets the thick crowd of carriages, stages, carts, hotel & private coaches, & in fact all sorts of vehicles & many first-class teams, mile after mile, & the splendor of such a great street & so many tall, ornamental, noble buildings, many of them of white marble, & the gayety & motion on every side – You will not wonder how much attraction all this is, on a fine day, to a great loafer like me, who enjoys so much seeing the busy world move by him, & exhibiting itself for his amusement, while he takes it easy & just looks on & observes.

In *Democratic Vistas*, Whitman ends a similar catalog of city delights saying that they 'completely satisfy my senses of power, fulness, motion, &c., give

me, through such senses and appetites, and through my esthetic conscience, a continued exaltation and absolute fulfilment.' This sensual participation in the liveliness of the market, along with Whitman's credo – 'all are invited' – means we find in him no reflexive antagonism toward the buyers and sellers. In life as in the poetry, he identifies as readily with the 'nonchalant' farmer as with the Yankee 'ready for trade.'

But, of course, Whitman stays seated on top of the omnibus, he doesn't get down and take a job with the fruit vendor. The wealth accumulated by the men along Broadway is different from that of the man who writes, 'I will carefully earn riches to be carried with me after the death of my body . . . ,' or who says that 'Charity and personal force are the only investments worth anything.' Whitman admits the traders as a part of his identity, but he is not a trader. They 'are not the Me myself.'

So if by the mercantile spirit we mean the spirit of men who feel their lives are inside the merchandise itself, who must leap from high windows when the stock market falls, then Whitman lacks this spirit. He would still be riding the omnibus, observing their desperation. As for that mercantilism which becomes snared in its own commodities, Whitman has this to say:

Here and there with dimes on the eyes walking,
To feed the greed of the belly the brains liberally spooning,
Tickets buying, taking, selling, but in to the feast never once going,
Many sweating, ploughing, thrashing, and then the chaff for payment
 receiving,
A few idly owning, and they the wheat continually claiming.

These lines have occasionally been misread as an expression of solidarity with the exploited, sweating workers. They aren't that at all. It's the man who owns the grain bins by the freight depot who gets the chaff; it's the mice who get the wheat. The key phrase is 'idly owning.' Animals are idle owners, the forest god Wotan is an idle owner, and Whitman is the idle owner of all the lights on Broadway.

Whitman imagined for us an American type I would call the village indolent. The village indolent appears whenever the will to work devours necessary leisure, whenever farmers in the Midwest start plowing at night or cutting down the groves around their homes so as to plant soybeans right up to the windows. Whitman's idle man stands for the hidden spirit

without which no one gets anything from trade. He refuses to do anything *but* enjoy the fruits of commerce. He eats up all the profits. The harder they work, the lazier he gets. The more money they reinvest in the company, the more he squanders his inheritance. The village indolent, like the religious mendicant, has riches that cannot be distinguished from his poverty. The 'poverty' of the mystic is not an absence of material objects; it consists, rather, in breaking down the habit of resting in, or taking seriously, things that are less than God. '"Blessed are the poor" is a psychological law,' says the poet Theodore Roethke, 'it's the business of Lady Poverty to confer on her lovers the freedom of the universe.' She gives them the run of the woods. The secret text of the Protestant ethic is this: 'You can't take it with you, but you can't go unless you've got it.' In his detachment from the body of property the village indolent comes into a wealth he will carry after the death of his body. Thoreau still has the run of Emerson's woods.

Whether by virtue of such an ideological indolence or not, Whitman himself always distinguished between earning a living and the labor of art. 'The work of my life is making poems,' he would declare when *Leaves of Grass* first appeared and, in old age, would claim that he had 'from early manhood abandoned the business pursuits and applications usual in my time and country,' obediently giving himself over to the urge to write poems, 'never,' adds a later preface, 'composed with an eye on the book-market, nor for fame, nor for any pecuniary profit.' Such remarks may seem a touch ingenuous at first glance; Whitman applied himself to business sometimes, and not just in early manhood, and one can watch his eye alight on the book-market from time to time. But his declarations are not meant to be facts of that sort; they are meant to express the spirit in which he worked, and in that sense they are not ingenuous at all.

We need only hold in the background our description of the gifted self – and of the social presence of that self and its works – to see why Whitman would separate the spirit of his art from the marketplace. If the merchant hopes to earn a profit in the sale of his commodities, the transaction cannot be a convivial communion, joining 'self' and 'other.' Commodities must move between reciprocally independent spheres, and the mercantile spirit therefore necessarily supresses the sympathetic faculty and welcomes the brain that divides. Reckoning time and value, marking and maintaining the distinction between self and other – these are the virtues of

the mercantile spirit and of the honest merchant who earns his living by their practice. Understood for their power and for their limitations, they are not necessarily toxic to the virtues of the gifted state, but they are distinct from them. I realize that I overstate my case a little – there are times in the creation of the work when the artist reckons and discriminates, just as there are times in the life of the successful merchant when he engages with his customers and imagines their desires. But I am speaking of ruling virtues. The salesman may imagine his buyer's wants, but in the end, to earn his daily bread he needs some 'other' who is not made a part of the self by the transaction. This may be an obvious point, but you cannot make money without calculating value and without the distinction between buyer and seller. Commodities are not adhesive riches as Whitman would have art be. And while the artist must evaluate, reckon, and judge at different phases in the creation of his work, such skills are not the ruling motives of art, at least not by Whitman's model. For Whitman the self becomes the gifted self – prolific, green – when it recognizes the stuff of its experience, its talents, and the products of its labor to be gifts, endowments. And the work of the artist can only come to its powers in the world when it moves beyond the self as a gift – from the artist to his audience or, in its wider functions, as that 'image-making work' whose circulation preserves the spirit of the collective and slowly accrues a culture, a tradition.

In Whitman's prose writings we find his remarks on the functions of the poetry alongside his claims to having 'abandoned the business pursuits.' How deeply he felt a conflict between the two may not be clear, but it is clear that he is a man who never exhibited much material ambition. There's an amusing and typical story from the years he spent in Washington, D.C., during the Civil War. When Whitman first arrived in the capital, he intended to find work as a clerk in one of the departments. To this end he wrote to Emerson asking for letters of introduction to the secretaries of State and Treasury. Emerson kindly complied, but by the time the letters arrived, Whitman had discovered he could earn his keep by working a few hours a day as a copyist and freelance journalist; his material wants were few and his energies had been quickly absorbed in ministering to wounded soldiers in the hospitals.

Emerson's letters lay undisturbed in the poet's trunk until eleven months later, when a friend from Boston, John Townsend Trowbridge, offered to deliver the one addressed to the Secretary of the Treasury,

Salmon Chase. Trowbridge happened to be a guest in Chase's home, 'a fine, large mansion,' he tells us, 'sumptuously furnished, cared for by sleek and silent colored servants, and thronged by distinguished guests . . .' The Chase mansion sat diagonally across the street from the house in which Whitman rented his quarters. On visiting this 'bare and desolate back room' one winter evening, Trowbridge found it to hold a bed, a cupboard made from a pine box, a few chairs, and a sheet-iron stove; for housekeeping utensils Whitman had a jackknife, a teakettle, a covered tin cup, and a bowl and spoon. Whitman was in the habit of eating from a sheet of brown paper and throwing it in the fire at the end of the meal. The night of Trowbridge's visit the fire had gone out in the stove. The window was open to the December air, and the men sat in their overcoats, arguing about literature.

The next day, upon learning of Emerson's letter, Trowbridge persuaded Whitman to let him carry it across the street. He presented it to the Secretary that evening after dinner. Chase was impressed to see Emerson's name, but averred that he couldn't imagine hiring Whitman. 'I am placed in a very embarrassing position,' he said. 'It would give me great pleasure to grant his request, out of my regard for Mr Emerson, but . . .' But *Leaves of Grass*, it seems, had made Whitman notorious; he was said to be a rowdy. 'His writings have given him a bad repute,' Chase concluded, 'and I should not know what sort of place to give to such a man.'

Trowbridge offered to relieve the Secretary of his embarrassment by withdrawing the letter. Chase hesitated, glancing at the signature. 'No,' he said, 'I have nothing of Emerson's in his handwriting, and I shall be glad to keep this.'

Whitman's friend was forced to report that not only had he failed to find the poet a job but he'd lost the letter to boot. Whitman was bemused. 'He is right,' he said, 'in preserving his saints from contamination by a man like me!'

Whitman himself had scant desire to become any but an idle owner. He didn't own a home until he moved to Camden, N.J., when he was sixty-five. Until then he had always lived with family, with friends, or in rented rooms. It wasn't that he was naïve about money. He knew how to get a construction contract, build a house and sell it. He was always able to find work as a journalist or editor when he wanted it. In the 1840s and again in the late 1860s he held down steady jobs. He was direct and frank when selling a poem ('the price is 4 pounds – $20 – in gold and four copies of

the number in which it is printed' reads a typical cover letter). He was both
frugal and generous. His solicitation of letters from Emerson reveals some
craft in the job market. But as the fate of those letters shows, he wasn't
really interested. His aspirations were plain. His fantasy of a house was 'a
regular Irish shanty . . . , two rooms, and an end shed.' His letters show he
didn't think of his accommodations in Washington as bare and desolate: 'I
have a little room, & live a sort of German or Parisian student life – always
get my breakfast in my room, (have a little spirit lamp) . . . walk quite a
good deal . . . go down the river, or off into Virginia . . .' Whitman spent
his days in Washington browsing through the newly built capital build-
ings, listening to speeches in the Congress, walking the banks of the
Potomac, writing poems and – the main thing – nursing the wounded in
the hospitals. 'With my office-hunting, no special results yet,' he wrote to
a friend. 'I cannot give up my Hospitals . . . I never before had my feelings
so thoroughly and . . . permanently absorbed.' When the war was over and
the hospitals empty, Whitman finally settled into a steady job. It bored him.
'A clerk's life . . . is not very interesting.'

III • *Saplings*

Whitman had traveled to Washington in December of 1862 to look for
his brother George, who the family feared had been wounded during the
second battle of Bull Run. While he was in the city he went to Campbell
Hospital to visit 'a couple of Brooklyn boys' from his brother's regiment.
About a hundred wounded men lay in a long shed with whitewashed
walls. Whitman stopped to try to comfort a boy who was groaning with
pain. 'I talked to him some time,' Whitman wrote to his sister. 'He seemed
to have entirely give up, and lost heart – he had not a cent of money –
not a friend or acquaintance.' Discovering that no one had examined the
boy since he was brought in, Whitman went and found a doctor. He sat
on the bedside and wrote out a letter that the young man dictated to his
family. The boy said he would like to buy some milk from a woman who
came through the ward each afternoon, and Whitman gave him the
change in his pocket. 'Trifling as this was, he was overcome and began
to cry.'

This serendipitous encounter drew on so many elements of Whitman's
personality that he soon abandoned his plans to return to New York. It not

only touched his sympathy and generosity but gave him a chance to 'emanate' – to heal through attention and affection – and to fulfill one of his roles as a poet, committing to paper the speech of the illiterate boy. He began to visit the hospitals daily. He wrote to friends in Boston and New York soliciting contributions so he could buy things for the soldiers, and soon he had settled into the routine that was to last all through the war – living in a rented room, working three or four hours a day at odd jobs, and visiting the hospitals.

He would arrive in the late afternoon and stay late into the night. Sometimes he would appear just before supper carrying a pot of food and go through a ward with a spoon, 'distributing a little here and there.' He discovered a store where he could buy homemade biscuits and cookies. He acquired a haversack and walked his rounds dispensing crackers, oysters, butter, condensed milk, newspapers, dressing gowns, and more. At the Armory Square Hospital six or seven hundred men lay wounded:

> I try to give a word or a trifle to every one without exception, making regular rounds among them all. I give all kinds of suste- nance, blackberries, peaches, lemons & sugar, wines, all kinds of preserves, pickles, brandy, milk, shirts & all articles of underclothing, tobacco, tea, handkerchiefs, &c &c &c. I always give paper, envelopes, stamps, &c . . . To many I give (when I have it) small sums of money – half of the soldiers in hospital have not a cent.

Once in the summer of 1864 he bought ten gallons of ice cream and, like someone's grandfather, carried it through all fifteen wards of Carver Hospital, giving a little to everyone ('Quite a number western country boys had never tasted ice cream before'). Always he would sit and take dictation, writing letters home for the men who couldn't write, adding at the bottom of the page, 'The above letter is written by Walt Whitman, a visitor to the hospitals.' He also wrote to the parents of soldiers who died. Sometimes he would read aloud to the men, individually or with the whole ward gathered around – the news, reports from the front, popular novels, the *Odyssey*, passages from Shakespeare and Scott, and his own poems.

One of Whitman's letters from the second year of the war describes what by then must have been a typical visit. The day is a Sunday and he arrives at the hospital in the midafternoon. He spends the evening feeding

men too wounded to feed themselves. He sits by a man's bed, peeling a peach, cutting the pieces into a glass and sprinkling them with sugar. He gives small sums of money to a few – 'I provide myself with a lot of bright new 10ct & 5ct bills . . . to give bright fresh 10ct bills, instead of any other, helps break the dullness of hospital life.' The men retire early, between eight and nine o'clock, and Whitman stays on, sitting in a corner to write his letter. 'The scene is a curious one – the ward is perhaps 120 or 30 feet long – the cots each have their white mosquito curtains – all is quite still – an occasional sigh or groan – up in the middle of the ward the lady nurse sits at a little table with a shaded lamp, reading – the walls, roof, &c are all whitewashed – the light up & down the ward from a few gas-burners about half turned down.'

On his very first visit to Washington, strolling near one of the hospital buildings, Whitman had suddenly found himself standing before 'a heap of feet, legs, arms, and human fragments, cut, bloody, black and blue, swelling and sickening – in the garden near, a row of graves.' What went on in these hospitals was often literally horrible, and the horror was part of what drew Whitman to the work. The hospitals were so informal and understaffed that Whitman was able to participate in almost all the details of life in the wards. He sat through the night with dying men. He cleaned wounds (the men brought in from the field sometimes arrived with maggots in their wounds), and he attended operations. He stood by as the doctors amputated the leg of Lewis Brown, one of the soldiers he had become fond of.

There is a creepy fascination to such horror – the kind that draws a crowd to an automobile accident – and that must have been part of its impact on Whitman. But beneath fascination, and beneath Whitman's own obsession with death, lies yet another reason why people are drawn to hospital work: to be in a place where children are born or where men and women are dying or suffering *in extremis* is to be close to the quick of life. Those who do not become inured to the work often find it strangely vitalizing. Death in particular focuses life, and deepens it. In the face of death we can discriminate between the important and the trivial. We sometimes drop our habitual or guardian reticence and speak clearly.

This last, at least, was one of the ways Whitman himself chose to explain why he became so deeply involved with working in the wards. He had stumbled upon a public form for his affections, a way for him to become 'undisguised and naked' without retreating to the woods. Of his

manner in the hospitals he writes, 'I have long discarded all stiff conventions (death and anguish dissipate ceremony here between my lads & me) – I pet them, some of them it does so much good, they are so faint – lonesome – at parting at night sometimes I kiss them right & left – The doctors tell me I supply the patients with a medicine which all their drugs & bottles & powders are helpless to yield.' The presence of death allowed Whitman a wider emotional life than he had ever had (a conjunction to which we shall have to return in a moment).

Whitman was a maternal man – a person, that is, who cares for and protects life – and the hospitals afforded him a chance to live out his maternalism, his 'manly tenderness.' Most of the soldiers were under twenty-five, and many were only fifteen or sixteen years old, almost literally 'offspring taken soon out of their mothers' laps,' and now wounded or sick, weak and helpless. He mothered them. He entered into a life of active charity. If you look back at that wonderful catalog of the treats he dispensed in the wards you will see that its structure is simply 'I give . . . I give . . . I give.' His nursing offered him a chance to bestow himself in a concrete way, and he describes it in the language of physicalspiritual emanation with which he had earlier described the bestowing phase of the self: the boys need 'personal magnetism,' they hunger for 'the sustenance of love,' they 'respond . . . electric and without fail to affections,' and so on. 'It has saved more than one life.' It is no secret that people die of loneliness, that those who lose their wives or husbands tend to die sooner than those whose spouses live, or that a wounded soldier far from home may fail to find the will to live. Whitman intends his 'presence & magnetism' to supply that subtle medicine which no doctor can prescribe. He enters the work on these terms in the very first encounter, of course – no one is attending the true need of the prostrate boy until Whitman speaks to him, writes his letter for him, and gives him a nickel to buy milk. It's a vivifying gift, literally.

Whitman tells his correspondents that he treats the men 'as if they were . . . my own children or younger brothers.' He gives them the kind of care that a parent would give to a sick child, and they respond to his attentions in kind. Several letters of gratitude have been preserved. The soldiers address him as 'dear Father.' They name their children after him. When he himself fell ill in the summer of 1864, a soldier from Illinois wrote: 'Oh! I should like to have been with you so I could have nursed you back to health & strength . . . I shall never be able to recompense you for your kind

care . . . while I was sick in the hospital . . . No Father could have cared for their own child better than you did me.' Whitman himself understood that his contentment and sense of purpose were in good measure a result of being the object of gratitude. As he wrote to a friend in New York, 'I need not tell your womanly soul that such work blesses him that works as much as the object of it. I have never been happier than in some of these hospital ministering hours.'

Whitman's nursing also gave him a chance to give and to receive physical affection. He complains that the other nurses are too restrained with the men, 'so cold & ceremonious, afraid to touch them.' How can the healing be transmitted without the body? Whitman pets the boys, he hugs and caresses them. Over and over in the letters he tells of exchanging kisses with the soldiers: 'some so wind themselves around one's heart, & will be kissed at parting at night just like children – though veterans of two years of battles & camp life.' Sometimes his kiss is not a parent's kiss but a lover's. Writing to a mutual friend about a visit with Lewis Brown, Whitman says, '[He] is so good, so affectionate – when I came away, he reached up his face, I put my arm around him, and we gave each other a long kiss, half a minute long.'

Late in the war, when Whitman was forty-five, he fell ill for the first time in his life, troubled with headaches and fainting spells. It was never clear what ailed him; by his own account, one doctor told him he had been 'saturated with the virus of the hospitals,' another that he had 'too deeply imbibed poison into [his] system,' and another that he had 'been penetrated by the malaria.'* Whitman had been bold and incautious in his nursing, going among smallpox victims and deliberately tending the worst fevers and wounds ('I go – nobody else goes.') When he himself began to weaken, he considered leaving the work, but soon realized that it was too important to him. As he wrote to his mother, 'It is now beginning to tell a little upon me, so many bad wounds, many putrified . . . but as it is I shall certainly remain here . . . it is impossible for me to abstain from going to see & minister to certain cases, & that draws me into others, & so on . . .'

There is no reason to doubt that Whitman was physically sick, but I think we may take his illness as a fact of the psyche as well. It seems

* Justin Kaplan, Whitman's most recent biographer, says that Whitman's symptoms suggest severe hypertension and, perhaps, mercury poisoning from overdoses of calomel.

clear that the emotional weight of Whitman's years of nursing lay in
the contact with the soldiers. He chanced upon a form for the dedica-
tion of his manly tenderness and, having found it, allowed it to absorb
him completely, giving himself away and receiving affection in return.
But then: sickness. To generalize his dilemma and put it boldly we might
say: affection decays identity. The ego-of-one is willingly wounded in love,
broken so as to receive the beloved. In the soldier's wounds, and in their
putrefaction, the ego sees itself, and its fear, reflected. Once the self has
abandoned its protective armor, will the lover come to fill the empty place,
or will the wound just fester? Whitman's claims to healing the sick with
his personal magnetism belong alongside his talismanic sentence 'I know
my body shall decay'; for, confined inside the knowledge of that decay,
the poet of 'Song of Myself' had chosen the decay of giving himself away,
the Osiris-decay in which with mingled fear and attraction he allowed
himself to be drawn into a dismemberment that bears new life as its first
fruit.

A prewar poem, 'This Compost' (the poem I earlier associated with the
Osiris etching), rehearses the drama of Whitman's hospital work in every
detail except, perhaps, the last. The poem opens with a man who hesitates
to give himself to love:

> I will not go now on the pastures to walk,
> I will not strip the clothes from my body to meet my lover the sea,
> I will not touch my flesh to the earth as to other flesh to renew me.

He senses the threat of disease. How, he asks, can he press his flesh to the
earth, 'Are they not continually putting distemper'd corpses within [it]? /
Is not every continent work'd over and over with sour dead?' Whitman
resolves the fear in his usual manner, through an invocation of 'the resur-
rection of the wheat.' Nature transforms the putrid:

> Out of its hill rises the yellow maize-stalk, the lilacs bloom in the
> dooryards,
> The summer growth is innocent and disdainful above all those strata
> of sour dead.

> What chemistry!
> That the winds are really not infectious,

That this is no cheat, this transparent green-wash of the sea which
 is so amorous after me,
That it is safe to allow it to lick my naked body all over with its tongues,
That it will not endanger me with the fevers that have deposited them-
 selves in it, . . .

The list ends with a striking image for the poet of grass:

What chemistry! . . .
That when I recline on the grass I do not catch any disease,
Though probably every spear of grass rises out of what was once a
 catching disease.

New love is cautious because it is vulnerable. There is a dark side to nature;
the green Osiris has a brother, Set, who rules the desert. If we open ourselves
to love, will love come in return, or poison? Will new identity appear, or the
dead-end death that leaves a restless soul? In the poem, at least, Whitman
resolves his hesitancy by fixing his eye on the give-and-take of vegetable life
in which the earth 'grows such sweet things out of such corruptions.' In
apparent decay the man of faith recognizes the compost of new life.

This, at any rate, is how Whitman resolves the association between love
and decay in the poetry. His central metaphor begins with the sympathetic
self receiving the outer world (the world of objects or the lover) with both
fear and delight, and then suffering a kind of death, the 'chemistry of
nature' that leads to the spring wheat, the new shoots, the grass over
graves. But in life things are a little more complicated. For Whitman 'in
the game' the sequence begins with a sympathetic man admitting the
soldiers to his heart, and feeling again the simultaneous attraction and
risk: a 'virus' saturates his system as he kisses them good-night. But here
the plot may have to change, for is there a 'chemistry of man' like the
'chemistry of nature' which will assure the life of a lover who has allowed
a foreign thing to penetrate his blood?

A curious anecdote will answer the question in the terms Whitman
himself might have used. Whitman's comrade after the war, Peter Doyle,
suffered at one time from a skin eruption called 'barber's itch.' Whitman
took him to a doctor for treatment. Writing soon thereafter, Whitman tells
Doyle: 'The extreme cases of that malady . . . are persons that have very
deeply diseased blood, probably with syphilis in it, inherited from parentage,

& confirmed by themselves – so they have no foundation to build on.' Both Whitman and Doyle had apparently worried that his rash might be a sign of syphilis. (The association between love and disease needed even less imagination in the days before penicillin. Whitman's brother Jesse had contracted syphilis from a prostitute and was later to die in an asylum.) There was no obvious 'diseased blood' in Whitman's own parentage, but he felt it close by. And as vegetable life has the chemistry of compost, so, for Whitman, we humans may clean our animal blood through the chemistry of love: 'My darling,' he wrote to Doyle, 'if you are not well when I come back . . . we will live together, & devote ourselves altogether to the job of curing you . . .'

Here, however, as in *Calamus*, we come to a gap between desire and accomplishment. Whitman was not able to cleanse the blood – either his or Peter's – in the fullness of a human love. He could not live out his affections in the form his fancy offered, and his illness dragged on – not, perhaps, the actual ailment that first broke his health but the more figurative 'virus of the hospitals . . . which eludes ordinary treatment.' It became Whitman's habit for the rest of his life to attribute frailty and disease to the 'hospital poison absorbed in the system years ago.' His own imagination, that is, sensed he was not cured. During the war he had allowed himself to cease being the 'superb calm character' imagined in his journal, 'indifferent of whether his love and friendship are returned.' Instead, he took the risk and opened himself up. And the soldiers returned his love, but not on the terms he wanted. He was always 'Dear Father' to them, never 'My darling.' His illness, 'tenacious, peculiar and somewhat baffling,' lingered on. Had he been born in a different land or a different era he might have found the way. But in the capital of the New World in the middle of the nineteenth century,

> When I hear of the brotherhood of lovers, how it was with them,
> How together through life, through dangers, odium, unchanging,
> long and long,
> Through youth and through middle and old age, how unfaltering,
> how affectionate and faithful they were,
> Then I am pensive – I hastily walk away fill'd with the bitterest envy.

In January of 1873 Whitman suffered a paralytic stroke on the left side of his body which left him bedridden for months. As was by then his custom, he associated his failing strength with his wartime illness. 'Had been simmering inside for six or seven years . . . Now a serious attack beyond

all cure.' Four months later, just as he was beginning to be able to walk again, Whitman's mother died, 'the only staggering, staying blow & trouble I have had,' he wrote to a friend. '*Unspeakable* – my physical sickness, bad as it is, is nothing to it.' In February of 1875 he had another paralytic stroke, this one on his right side. After his mother's death Whitman had moved from Washington, D.C., to Camden, N.J., at first living with his brother George and then by himself in a house on Mickel Street. It was the first home he had ever owned, but these were bad years, with Whitman isolated, debilitated, and depressed.

Early in 1876 Whitman met Harry Stafford, an eighteen-year-old boy working in the Camden printing office where Whitman's book *Two Rivulets* was being set in type. Stafford's parents owned a farm not far away in the New Jersey countryside, and Whitman soon became their constant visitor. George and Susan Stafford had seven children, and before long Whitman took his place by the fire as grandfather to the whole brood. He took young Harry under his wing. They wrestled and roughhoused together. 'Walt, the semi-invalid, drew enough strength from the younger man to pin him to the floor . . . ,' says Justin Kaplan. 'They cut up like two boys and annoy me sometimes,' a friend, the naturalist John Burroughs, wrote in his diary after a visit. Whitman was both father and mother to the boy, teaching him to read, offering advice on employment and education, buying him clothes and (for Christmas) a gold watch, asking the print shop to be sure that he learned how to set type, and so forth.

Whitman would have liked to be something more than a parent. 'My nephew & I when traveling always share the same room together & the same bed . . . ,' he tells a prospective host. In September of 1876 he gave Harry what was ostensibly a 'friendship ring,' but as the difficulties it stirred up make clear, it was something more besides. Whitman's rather spare journal entries are all we have to tell the story. Interlined among street addresses and records of petty cash we find:

talk with H S & gave him r[ing] Sept 26 '76 – (took r back)

Nov. 1 – Talk with H S in front room S street – gave him r again

Nov 25, 26, 27, 28 – Down at White Horse [i.e., the Staffords' farm] – Memorable talk with H S – settles the matter.

Dec 19 – . . .
evening, sitting in room, had serious inward rev'n & conv'n
– saw clearly . . .
what is really meant –
– very profound meditation on all – happy & satisfied at last . . .

(that this may last now
without any more perturbation)

scene in the front room Ap. 29 with H

July 20th '77, in the room at White Horse 'good bye'

And so forth. The relationship did not break off, the two men continued to see each other regularly that year, but Stafford was moody and quick-tempered while Whitman, we may infer, was perturbed. The ring seems to have remained with the poet. Early that winter, after a visit from Whitman, Harry wrote him an erratically spelled letter: 'I wish you would put the ring on my finger again, it seems to me ther is something that is wanting to complete our friendship when I am with you. I have tride to studdy it out but cannot find out what it is. You know when you put it on there was but one thing to part it from me and that was death.' And next we read in Whitman's journal: 'Feb 11 [1878] – Monday – Harry here – put r on his hand again.'

Whitman wanted to marry before he died. His mother's death seems to have freed him, or spurred him on. Four months after her funeral Whitman sent a friendship ring to Anne Gilchrest, an ardent English admirer who had been pursuing him for years in letters. Three years later, despite Whitman's cautions, she arrived at the dock in Philadelphia. Whitman could have made a marriage of convenience. The woman was more than devoted to him – she set up housekeeping in Philadelphia, kept a special room for him to stay in, fed him Christmas dinner . . . But she had completely misread the erotic poems. It was, as it had always been, the unlettered boy whom Whitman sought to marry to his soul, 'some low person . . . , lawless, rude, illiterate . . .'

One has to admire his unflagging desire. It was an old, lonely, crippled man who got Harry Stafford to wrestle on the floor with him, sleep in the same bed, and accept his ring. And he got some of what he wanted. In later years he wrote to Harry, 'I realize plainly that if I had not known

you . . . , I should not be a living man today.' By that time their relation-
ship had cooled. Harry had grown up. A journal entry of June 1884 reads:

H S and Eva Westcott married.

Whitman accompanied Harry and his bride to the civil ceremony,
consenting in the end to be the father again, the father who gives the boy
away, not the lover who may keep him.

The Stafford farm offered Whitman something besides Harry and the oppor-
tunity to play grandfather to a family. Not far from the house there was a
woods, a pond, and a stream called Timber Creek. Spring, summer, and
fall, sometimes with the local farm boys but often alone, Whitman would
go down to the water. He would drag along a portable chair and sit beneath
a large black oak ('exhaling aroma'), or sunbathe naked (except for his
hat – he kept his hat on). He carried pencil and paper and took notes on
the trees, the swarms of bumblebees, the song of the locust ('like a brass
disk whirling'), the hermit thrush, the quail, cedar apples, a spring that
rose from beneath a willow – 'gurgling, gurgling ceaselessly . . . (if one
could only translate it)' – and the pond itself with its calamus leaves, water
snakes, and birds ('the circle-gambols of the swallows flying by dozens in
concentric rings in the last rays of sunset, like flashes of some airy wheel').

Whitman returned to the self of his first song at Timber Creek. Hobbling
down the farm lane early in the morning, he would pause by the tall,
yellow-flowered mulleins to examine their woolly stems and the light-
reflecting facets of the leaf: 'Annually for three summers now, they and I
have silently return'd together.' He resumed that participatory sensuality
in which 'subject' and 'object' dissolve to be replaced by a presence, an
'invisible physician' he calls it now, whose medicine 'neither chemistry nor
reasoning nor esthetics will give the least explanation.' He wanted to be
healed. 'Hast Thou, pellucid, in Thy azure depths, medicine for case like
mine?' he asks the sky. 'And dost Thou subtly mystically now drip it through
the air invisibly upon me?'

As had been the case for the young Whitman, it was the trees that held
this old man's medicine. A yellow poplar stood near the creek, four feet
thick at the butt and ninety feet high. 'How dumbly eloquent! What sugges-
tions of imperturbability and *being*, as against the human trait of mere

seeming . . . How it rebukes, by its tough and equable serenity all weathers, this gusty-temper'd little whiffet, man . . .' The trees, like the animals, do not complain of lost love or unsatisfied desire. They celebrate themselves. Whitman began to fantasize about dryads and dream of trees speaking to him. 'One does not wonder at the old story fables . . . of people falling into love-sickness with trees, seiz'd extatic with the mystic realism of the resistless silent strength of them – *strength* . . .'

Whitman hit upon the idea of exercising his limbs by bending young trees ('my natural gymnasia,' he called them). The first day he spent an hour pushing and pulling an oak sapling, thick as a man's wrist and twelve feet high. 'After I wrestle with the tree awhile, I can feel its young sap and virtue welling up out of the ground and tingling through me from crown to toe, like health's wine.' He began to sing: 'I launch forth in my vocalism; shout declamatory pieces, sentiments, sorrow, anger, &c., from the stock poets or plays – inflate my lungs and sing the wild tunes and refrains I heard of the blacks down south, or patriotic songs . . .' All during the summer of 1876 he wrestled with the trees.

Whitman's nursing during the war had opened him to love. It changed his life. We find no relationships before the war like those he later established with Doyle or with Stafford: intense, articulated, and long-lasting. And yet, so opened he was also wounded. Something needing cure appeared in his blood. 'To touch my person to some one else's is about as much as I can stand.' It is the sadness of this life that Whitman could not cure himself with a human love. A baffled animal, he turned back to his trees in the end. But as he confides to us before he tells his tale of Timber Creek, 'after you have exhausted what there is in business, politics, conviviality, love, and so on – have found that none of these finally satisfy, or permanently wear – what remains? Nature remains . . .' Beyond the sadness of this life lies its genius, that Whitman was able to find the give-and-take to heal him, to find a green-force to overcome the blood's decay. He never married his unlettered boy, but he accepted virtue from an even more unlettered nature and gave it speech.

CHAPTER TEN

EZRA POUND
AND THE FATE OF
VEGETABLE
MONEY

1 • Scattered Light

'The images of the gods,' wrote Ezra Pound, '. . . move the soul to contemplation and preserve the tradition of the undivided light.' But those who turn to face either the poetry or the political economy of Ezra Pound will find no such light to guide them there. Something has scattered it in all directions, and it is this scattering to which we shall have to address ourselves if we are to speak of Pound.

Born in 1885, seven years before Whitman died, Pound grew up in the vicinity of Philadelphia, where his father was an assayer at the U.S. Mint. He attended the University of Pennsylvania and, briefly, Hamilton College in upstate New York. After graduation, Pound taught at Wabash College in Indiana, but not for long: his landlady one morning discovered an 'actress' in his rooms and reported the discovery to the college authorities. They suggested that he marry the girl or leave. He left. He left the country,

in fact, and but for two brief visits did not return until the end of the
Second World War, when the U.S. government flew him home to charge
him with treason for having taken the side, vocally, of the Axis powers
during the war.

During the course of his long career (he did not die until 1972) Ezra
Pound came to promulgate an elaborate economic theory and to write,
among many other things, an 800-page sequence of poems, the *Cantos*.
In order to describe the work and fate of this poet we could tell either of
these stories, the one about art or the one about politics. It is the politics
that will receive most of our attention here, but by that emphasis we shall
not be slighting the poetry entirely, for in telling one story we will be
giving at least an outline of the other. They have the same plot, it seems
to me: the playing out of an opposition in Pound's own temperament
between forces of fertility and forces of order, or, to use slightly different
terms, between two powers of the soul, imagination and will. Several
people have made this point, but I think Clark Emery was the first, putting
it in the language that Pound himself might have used: 'One of the tensions
[in the *Cantos*] . . . is the effort to bring together the Eleusinian (or
Dionysian) concept of natural fecundity and the Confucian concept of
human order . . . Without Eleusinian energy civilizations would not rise,
without Kungian order they dissipate themselves. Civilization occurs and
maintains itself when the two forces – the striving and the ordering –
approach equipoise.'

'Before sewing one must cut,' the proverb says, and to begin our tale
we must cut the pattern of these two forces, beginning with Eleusinian
fecundity.

Pound referred broadly to all polytheistic religions as 'pagan,' and when
he speaks of them he tends to speak of mystery, fertility, and procreation.
His 1939 statement, 'Religio,' reads:

> Paganism included a certain attitude toward, a certain under-
> standing of, coitus, which is the mysterium.
> The other rites are the festivals of fecundity of the grain and the
> sun festivals, without revival of which religion can not return to the
> hearts of the people.

A decade earlier he had written that 'at the root of any mystery' lies what
we now call 'consciousness of the unity of nature.' The point is simple:

nature's fecundity depends upon its unity, and we shall not long enjoy the fruits of that fecundity if we cannot perceive the unity. The rituals of ancient mysteries were directed toward the apprehension (and therefore the preservation) of this unity.

Pound is after something even broader than the fertility of the crops when he speaks of mystery, however. In a prose text he once described how a man can become 'suddenly conscious of the reality of the *nous*, of mind, apart from any man's individual mind, of the sea crystalline and enduring, of the bright . . . molten glass that envelops us, full of light.' When Pound speaks of Eleusinian mysteries, he is speaking not only of the wheat whose recurrence bespeaks the fecundity of nature but also of this light that bespeaks the fecundity of the mind. Twitted once by Eliot to reveal his religious beliefs, Pound (after sending us to Confucius and Ovid) wrote: 'I believe that a light from Eleusis persisted throughout the middle ages and set beauty in the song of Provence and of Italy.' This 'undivided light' occasions beauty in art, and vice versa – that is, beauty in art sets, or awakens, the knowledge of this light in the mind of man.

Over and over in essays and in the *Cantos*, Pound tries to make it clear that fecundity can be destroyed by any dividing or splitting of the unity; in art and spiritual life the destructive force is a certain kind of abstraction.

> We find two forces in history: one that divides . . . and one that contemplates the unity of the mystery . . . There is the force that destroys every clearly delineated symbol, dragging man into a maze of abstract arguments, destroying not one but every religion.

Before we go any further, I want to point out that this line of thought is of a piece with the central tenets of Imagism, that literary movement to which Pound's name will be forever linked. 'Go in fear of abstractions' was the cardinal Imagist injunction according to Pound's own 1913 manifesto. 'Don't use such an expression as "dim lands of peace." It dulls the image. It mixes an abstraction with the concrete.' Pound was drawn to the study of Chinese written characters partly because they are image-writing, concrete speech. Pictograms '[have] to stay poetic,' he says, because their form itself prohibits the 'maze' of abstractions that destroy the unity. He explains in the *ABC of Reading*:

In Europe, if you ask a man to define anything, his definition always moves away from the simple things that he knows perfectly well, it recedes into an unknown region, that is a region of remoter and progressively remoter abstractions.

Thus if you ask him what red is, he says it is a 'colour.'

If you ask him what a colour is, he tells you it is a vibration or a refraction of light, or a division of the spectrum.

And if you ask him what vibration is, he tells you it is a mode of energy, or something of that sort, until you arrive at a modality of being, or non-being, or at any rate you get in beyond your depth, and beyond his depth . . .

But when the Chinaman wanted to make a picture of . . . a general idea, how did he go about it? He is to define red. How can he do it in a picture that isn't painted in red paint?

He puts . . . together the abbreviated pictures of

ROSE	CHERRY
IRON RUST	FLAMINGO

Ezra Pound was essentially a religious poet. His cautions against abstraction in art serve the spiritual ends of the work; they are not merely advice on style. An Italian country priest once turned a corner of the temple of St Francis in Rimini – the temple erected by that hero of the *Cantos*, Sigismondo Malatesta – to find the poet bowing to the stone elephants carved in the side of the building rather than to the 'altar furniture.' Pound was an idolater in the old sense: he put himself in the service of images. One of the most remarkable things about the *Cantos* is Pound's ability to convey a sense of the undivided light in concrete speech:

> rain beat as with colour of feldspar

> in the gloom, the gold gathers the light against it

> with a sky wet as ocean / flowing with liquid slate

> Such light is in sea-caves
> e la bella Ciprigna

> where copper throws back the flame
> from pinned eyes, the flames rise to fade
> in green air.

And in old age:

> When one's friends hate each other
> how can there be peace in the world?
> Their asperities diverted me in my green time.
> A blown husk that is finished
> but the light sings eternal
> a pale flare over marshes
> where the salt hay whispers to tide's change . . .

While teaching in Indiana, long before he had discovered Chinese written characters, Pound wrote to William Carlos Williams: 'I am interested in art and ecstasy, ecstasy which I would define as the sensation of the soul in ascent, art as the expression and sole means . . . of passing on that ecstasy to others.' In an essay on the art of fiction Flannery O'Connor once wrote that 'the world of the fiction writer is full of matter'; fiction is an 'incarnational art,' she says, full of 'those concrete details of life that make actual the mystery of our position on earth.' I imagine Pound would have broadened the stroke: all art is incarnational, full of matter, and for the same reason, to make actual the mystery. Pound is right: some knowledge cannot survive abstraction, and to preserve this knowledge we must have art. The liquid light, the *nous*, the fecundity of nature, the feeling of the soul in ascent – only the imagination can articulate our apprehension of these things, and the imagination speaks to us in images.

Confucius (or Kung Fu Tseu, as Pound usually has it) first appears in Canto 13. For the question of 'Kungian order' the important lines are these:

> And Kung said, and wrote on the bo leaves:
> If a man have not order within him
> He can not spread order about him;
> And if a man have not order within him

> His family will not act with due order;
> And if the prince have not order within him
> He can not put order in his dominions.

'The principle of good is enunciated by Confucius,' Pound had explained in his magazine, *The Exile*. 'It consists in establishing order within oneself. This order or harmony spreads by a sort of contagion without specific effort. The principle of evil consists in messing into other people's affairs.'

Clark Emery speaks of a 'tension' in the *Cantos* between Eleusinian fecundity and Confucian order, but I am not sure it is immediately apparent why any such tension should exist. Fecundity is not without order. Order inheres in all that is fertile in nature, and the liquid light of the *nous*, Pound tells us, induces order in those who perceive it.

> This liquid is certainlya
> property of the mind
> nec accidens est but an element
> in the mind's make-up . . .
> Hast 'ou seen the rose in the steel dust
> (or swansdown ever?) so light is the urging, so ordered the dark
> petals of iron we who have passed over Lethe.

In art and in human affairs there is a force corresponding to that which has given swansdown its beauty, and that force is *virtù* ('in the light of light is the *virtù*,' says the same Canto). Just as electromagnetism induces order in a pile of iron filings, so *virtù* induces order in the works of man. And like the magnet, or so the image leads us to believe, this *virtù* creates order by its presence alone, 'by a sort of contagion without specific effort.'

At this point, however, we come to a slight disparity in Pound's idea of order. There is a strange phrase in his prose writings – strange, at least, if we set it beside this other one about 'contagion' – and that phrase is 'the will toward order.' *Virtù* is not the same thing as will power, but for Pound it is the will that directs the force of *virtù* and in the last analysis, therefore, it is the will that is the agent of order. In the context from which I have taken the phrase, 'the will toward order' refers to social order and to the men through whose will societies have developed and maintained their structures. But will power plays a role in Pound's aesthetic as well: 'The greater the artist the more permanent his creation, and this is a matter of WILL,' he writes,

a sentence that belongs beside Clark Emery's explication: 'Without Eleusinian energy civilizations would not rise, without Kungian order they dissipate themselves.' I am not, at this point, trying to address the validity of these ideas. I am only trying to point out that, for Pound, Confucian order is associated with two things, willpower and durability. The will is the agent of the forces of order, and durability is the consequence of its agency.

We shall have more to say of political will in a later section of this chapter; at this point I want to offer a few remarks on the role of will power in art. There are at least two phases in the completion of a work of art, one in which the will is suspended and another in which it is active. The suspension is primary. It is when the will is slack that we feel moved or we are struck by an event, intuition, or image. The *materia* must begin to flow before it can be worked, and not only is the will powerless to initiate that flow, but it actually seems to interfere, for artists have traditionally used devices – drugs, fasting, trances, sleep deprivation, dancing – to suspend the will so that something 'other' will come forward. When the material finally appears, it is usually in a jumble, personally moving, perhaps, but not much use to someone else – not, at any rate, a work of art. There are exceptions, but the initial formulation of a work is rarely satisfactory – satisfactory, I mean, to the imagination itself, for, like a person who must struggle to say what he means, the imagination stutters toward the clear articulation of its feeling. The will has the power to carry the material back to the imagination and contain it there while it is re-formed. The will does not create the 'germinating image' of a work, nor does it give the work its form, but it does provide the energy and the directed attention called for by a dialogue with the imagination.

Artists might be classified by the different weight given to these two phases of the work. Whitman or a prose writer like Jack Kerouac fall on the suspend-the-will side of the spectrum. Whitman begins to work by lolling on the grass. Kerouac's 'Belief & Technique for Modern Prose' – a list of thirty aphorisms – includes the following:

- Submissive to everything, open listening
- Something that you feel will find its own form
- Be crazy dumbsaint of the mind
- No time for poetry but exactly what is

- In tranced fixation dreaming upon object before you
- Composing wild, undisciplined, pure, coming in from under, crazier the better.

All these and one more – 'Don't think of words when you stop but to see picture better' – amount to an aesthetic of the imagination without the will, the 'spontaneous bop prosody' of accepting the image as it comes. (Yeats's trance writing would be another example, the one, in fact, that Kerouac credits as his model.) 'Never revise' was Kerouac's rule; he used to claim that he wrote the first draft of *On the Road* on a roll of teletype paper in a single two-week sitting, sniffing Benzedrine inhalers as he typed. Such writing is both more original and more chaotic than writing with a larger admixture of will. It is more personal and more of the moment. At its best it strengthens the imagination through trusting its primary speech and conveys that trust to the reader, along with the 'crazy' energy that comes from unqualified transcription of image and experience, that is, from taking everything bestowed upon perception as holy.

A writer with greater trust in the will works the text, turning the plasm of the moment into more durable gems. Such work has the virtues that come of revision – precision, restraint, intellectual consistency, density of images, coherence, and so forth. For a certain kind of author, Pound is correct, I think, to connect the presence of the will to the durability of the creation. Yeats, for example, may have cultivated his 'spooks' and written in trances, but unlike Kerouac, he educated the will. He worked at his craft; he refined what the imagination gave him.

I have gone into the issue of willpower a little because it is through this particular element in Pound's Confucian side that we can come to understand the tension between fecundity and order. Pound's work displays a curious incongruity: it is framed by clear declarations of erotic and spiritual ends which it does not achieve. There are moments of remarkable light in the *Cantos*, yes, but taken as a whole the poem scatters the very unity it set out to preserve (and the last lines of the last Canto read: 'Let those I love try to forgive / what I have made'). Pound's work is acerbic, impatient, argumentative, obsessed, and disappointed. The young man had written that he was 'interested in art and ecstasy,' but the poem he came to write does not convey 'the feeling of a soul in ascent'; it conveys the feeling of a soul in torment.

Pound's tone of voice in his prose writings offers a way to approach this

incongruity. His shortness with something called 'stupidity' seems particularly telling. The tone of voice of the man who wrote the *ABC of Reading*, for example, is that of a schoolmaster irritated by the ignorance of his pupils. The reader who approaches the book with sympathy begins to feel either like the dunce receiving the lecture or like the peeved schoolmaster set above the class. Either way, the sympathy is betrayed, the self divided. Eliot once asked Pound to write an explanation of Silvio Gesell's economic ideas for *The Criterion*. Pound handed in his usual complaint about the thickheadedness of his audience. Said Eliot to Pound, 'I asked you to write an article which would explain this subject to people who had never heard it; yet you write as if your readers knew about it already, but had failed to understand it.'

If we return to Whitman for a moment, we may be able to triangulate the irritability these examples reveal. We have seen Pound's 'Religio'; Whitman's is found in the original preface to *Leaves of Grass*:

> This is what you shall do: Love the earth and sun and the animals, despise riches, give alms to every one that asks, stand up for the stupid and crazy . . . , argue not concerning God, have patience and indulgence toward the people . . . , go freely with powerful uneducated persons and with the young and with the mothers of families . . . , dismiss whatever insults your own soul, and your very flesh shall be a great poem and have the richest fluency not only in its words but in the silent lines of its lips and face and between the lashes of your eyes and in every motion and joint of your body . . .

Contrast this passage with lines from the opening paragraph of Pound's *Guide to Kulchur*: 'In attacking a doctrine, a doxy, a form of stupidity, it might be remembered that one isn't of necessity attacking the man . . . to whom the doctrine is attributed or on whom it is blamed. One may quite well be fighting the same idiocy that he fought and where into his followers have reslumped from laziness, from idiocy . . .' The point may be well taken, but mark the underlying assumption, to wit, that culture will only stand up if we fight stupidity, idiocy and laziness, as if culture were a slouching adolescent being sent to a military academy in Pennsylvania.

I do not pretend that I can unravel the mare's nest of Pound's psychology in this one chapter, but I can proffer at least one intuition: what Pound is

calling 'stupidity' and 'idiocy' and 'laziness' should be associated with the erotic and, therefore, with the Eleusinian side of his temperament. As Whitman understood (and Pound, too, at times), one of the wellsprings of the creative spirit lies with 'the stupid . . . crazy . . . uneducated' and idle. Fertility itself is dumb and lazy. Put it this way: unity – the unity of nature, or of 'coitus . . . the mysterium,' or of the *nous* – is unwilled and unreflective. If we assume, therefore, that the only smart thought is reflective thought and the only active person is the willful person, fecundity itself will soon seem tinged with idiocy and laziness.

It may seem odd, I realize, to speak of Pound's irritation – or better, his frustration – with the erotic. But there it is. He has a clear sense of the value and power of that side of creative life, but he is also exasperated by its nature.

In seeking to reconcile this disparity, I found myself led into imagining a fable about Pound as a young poet. Was there a time, I wondered, when Pound himself had this experience of 'the soul in ascent'? Was there a Poundian epiphany, like Whitman's or Ginsberg's or like the moment when the young Eliot, walking in Boston, saw the street and all its objects turn to light? Such moments are rare, given only once or twice in a lifetime, and yet they serve as a fountain for a life's work. Did Pound have one, and if he did, what happened afterwards?

In *Pavannes and Divagations* Pound paused to imagine how a myth might have come about, saying:

> The first myths arose when a man walked sheer into 'nonsense,' that is to say, when some very vivid and undeniable adventure befell him, and he told someone else who called him a liar. Thereupon, after bitter experience, perceiving that no one could understand what he meant when he said that he 'turned into a tree,' he made a myth – a work of art that is, – an impersonal or objective story woven out of his own emotion, as the nearest equation that he was capable of putting into words. The story, perhaps, then gave rise to a weaker copy of his emotion in others, until there arose a cult, a company of people who could understand each other's nonsense about the gods.

Let us set this rumination beside the first poem in Pound's *Personae*:

THE TREE

I stood still and was a tree amid the wood,
Knowing the truth of things unseen before;
Of Daphne and the laurel bow
And that god-feasting couple old
That grew elm-oak amid the wold.
'Twas not until the gods had been
Kindly entreated, and been brought within
Unto the hearth of their heart's home
That they might do this wonder thing;
Nathless I have been a tree amid the wood
And many a new thing understood
That was rank folly to my head before.

Certainly, it does no violence to the spirit of the work for us to imagine that there was a time Pound felt himself 'turned into a tree' (or more simply, when he felt moved to the core of his being by the mosaics in Santa Maria in Trastevere, or became suddenly conscious of the reality of the *nous*). Nor does it seem unlikely that, on feeling with his whole being the worth of his experience, he set out to labor in the service of that metamorphosis or that image or that light.

Then: some 'bitter experience.' They think he's a liar. He discovers, in some way not hard to imagine, that what moves him the most has no currency in his age and homeland. Worse, it is under attack from all sides, ignored, belittled, and devalued. Ginsberg tells of such a reaction to his Blake vision:

I tried to evoke the sensations of the experience myself, artificially, by dancing around my apartment chanting a sort of homemade mantra: 'Come, spirit. O spirit, spirit, come. Come spirit. O spirit, spirit, come.' Something like that. There I was, in the dark, in an apartment in the middle of Harlem, whirling like a dervish and invoking powers.

And everybody I tried to talk to about it thought I was crazy. Not just [my] psychiatrist. The two girls who lived next door. My father. My teachers. Even most of my friends.

Now in a society which was open and dedicated to spirit, like in India, my actions and my address would have been considered quite normal. Had I been transported to a streetcorner potato-curry shop in

Benares and begun acting that way, I would have been seen as in some special, holy sort of state and sent on my way to the burning grounds, to sit and meditate. And when I got home, I would have been like gently encouraged to express myself, to work it out, and then left alone.

That was 1948. Imagine Pound a half a century earlier! His moment of light would have come sometime before 1908. The turn of the century was hardly a time of great spiritual awakening in America. American mercantile expansion was at its height, running from China, where the Boxer Rebellion had just been put down, to a South America newly 'freed' from Spain. A Rough Rider sat in the White House, and hardly a single great poet was alive and read on the American continent with the exception, I suppose, of Teddy Roosevelt's preferred bard, Edwin Arlington Robinson. I do not mean to ascribe all of Pound's bitterness to exterior sources, but even if his struggles are more aptly described as interior, we cannot say his countrymen offered him much solace.

In any event, I was led to imagine a Poundian epiphany such as this in order to fill the gap, to make sense of the odd combination of erotic intent and divisive tone that we find in the work. The little story in *Pavannes and Divagations* caught my eye because it speaks of the bitterness of lost worth and of a spiritual knowledge that could *not* be passed along. And although the faith in fertility can be seen in flashes, it is bitterness and disappointment that live on the surface of Ezra Pound's poetry.

Like Whitman, Pound knew very well that he had not been born into a world receptive to the spirit of his art.

> In meiner Heimat
> where the dead walked
> and the living were made of cardboard.

He never accepted the barrenness of his age, and there is no reason that he should have. But he never accepted, either, the limits of his ability to do anything about that barrenness. There is only so much that can be done to create fertile ground where none exists. Harmony may emanate from the unity of nature or the *nous* or the prince, but harmony cannot be imposed on those who are not ready to receive it. Electromagnetism may trace a rose in iron filings, but it is powerless to induce order into sawdust. The forces of fertility have no power in certain situations, and it is in Pound's

response to that powerlessness, it seems to me, that we shall find the true roots of the tension between fecundity and order, imagination and will. Pound's notion that we slump into 'stupidity' from 'laziness' implies its opposite, that we shall overcome it through hard work. Where Whitman senses that the ends of art call for long periods of idleness, Pound imagines that they might be accomplished through discipline and exertion. He is like a man who, unable to grieve upon discovering that his wife no longer loves him, becomes more and more aggressive in the dumb belief that love could be forced back into existence. Pound's Confucian side is marked not only by willfulness, but by a willfulness exaggerated in direct proportion to his frustration with the powerlessness of the erotic.

We can see some of this in Pound's reading of history. In its barest formulation the idea of 'Kungian order' seems like an anarchist ideal, order spread not by coercion but 'by a sort of contagion.' In practice, however, those who are drawn to Confucius usually end up working for the state government (or running it). The proverbial advice in China is that during the years when a man is a civil servant he should study Confucius; later, when he retires, he should study Buddhism. Why? It seems that when Confucius turned inward he discovered the 'right order' of a state bureaucrat (or maybe it was the bureaucrats who discovered him; either way, there is a connection). When the anarchist speaks of an inner, natural, noncoercive order, he does not suddenly leap to: 'If the prince has order within him he can put his dominions in order.' He finds no prince at all, or at least not one with dominions to worry about. But Confucius did, and so did Ezra Pound.

The prince that Pound found within, we must note, was one who loved poetry. 'And Kung said . . . ,' a Canto tells us, '"When the prince has gathered about him / All the savants and artists, his riches will be fully employed."' There was nothing in either history or politics that attracted Pound more than a ruler who liked art. He loved a 'boss' who'd been to the mysteries, from Odysseus down to the Renaissance rulers (Malatesta, the Estes, the Medicis), from Jefferson – who first appears in Canto 21 with a letter asking a friend to find him a gardener who plays the French horn – to Napoleon, who gets a bow in Canto 43 for supposedly having said:

> 'Artists high rank, in fact sole social summits
> which the tempest of politics can not reach.'

And from Napoleon to Mussolini: 'The Duce and Kung Fu Tseu equally perceive that their people need poetry . . .'

But these are not just strong men. With the exception of Jefferson, they are also bullies. One cannot talk of these 'princes' without talking of their overweening will. In the *Odyssey* Odysseus is plagued not by Trojans, after all, but by sleep, forgetfulness, animals, reveries, and women. He deals with these through violence, power, cunning, lies, seduction, and bravado. He whips his men who want to stay with the lotus-eaters; he takes Circe to bed at the point of a sword. When he gets home, he begins to put his affairs in order by murdering all the servant girls who've been sleeping with the suitors. He's the Mussolini of the ancient world.

To give Pound his due, we must add that although his heroes are men of the developed will, he goes to some lengths to distinguish good will from bad. When he tells us that 'the greater the artist the more permanent his creations, and this is a matter of WILL,' he does add that 'it is also a matter of the DIRECTION OF THE WILL . . .' Good will lifts us up and bad will pulls us down. And Pound took his heroes to be men of good will. 'Perhaps,' remarks Emery, 'it does not oversimplify to say that [in the *Cantos*] good and evil are a matter of *directio voluntatis*, with money-power . . . representing the most powerful leverage for evil will.'

The problem with this dichotomy is that it omits another form of evil: the use of the will when the will is of no use. Such evil is usually invisible to a willful man. Good will can fight bad will, but only in those cases where will is called for in the first place. At times when the will should be suspended, whether it is good or bad is irrelevant. Or to put it more strongly: at such times all will, no matter its direction, is bad will. For when the will dominates, there is no gap through which grace may enter, no break in the ordered stride for error to escape, no way by which a barren prince may receive the *virtù* of his people, and for an artist, no moment of receptiveness when the engendering images may come forward.

Any artist who develops the will risks its hegemony. If he is at all wary of that sympathy by which we become receptive to things beyond the self, he may not encourage the will to abandon its position when its powers are exhausted. Willpower has a tendency to usurp the functions of imagination, particularly in a man in a patriarchy. Yeats's shopworn formula – that 'rhetoric is the will doing the work of the imagination' – refers to such a state, for when the will works in isolation, it turns of necessity to dictionary studies, syntactical tricks, intellectual formulae, memory, history, and

convention – any source of material, that is, which can imitate the fruits of imagination without actually allowing them to emerge. Just as there are limits to the power of the erotic, so there are limits to the power of the will. The will knows about survival and endurance; it can direct attention and energy; it can finish things. But we cannot remember a tune or a dream on willpower. We cannot stay awake on willpower. Will may direct *virtù* but it cannot bring it into the world. The will by itself cannot heal the soul. And it cannot create.

Pound seems to have felt deeply the limits of the erotic, but I'm not so sure he felt the limits of willpower. Long portions of the *Cantos* – particularly those written in the decade 1935–45 – are rhetorical in Yeats's sense. The voice is full of opinion without erotic heat, like an old pensioner chewing his disappointed politics in a barbershop. The history cantos, in particular – all the material about China and the long portrait of John Adams – are deadly dull, never informed with the fire, complexity, or surprise that are the mark of living images. They are 2 percent poetry and 98 percent complaint, obsession, and cant theory, what Whitman called 'talk.' Working out of 'good will' alone, the poem becomes mired in time, argument, and explanation, forgetting the atemporal mystery it set out to protect.

> I don't receive a shilling a month, wrote Mr Adams to Abigail
> > > > in seventeen 74
> June 7th. approve of committee from the several colonies
> Bowdoin, Cushing, Sam Adams, John A. and Paine (Robert)
> 'mope, I muse, I ruminate' *le*
> *personnel manque* we have not men for the times
> Cut the overhead my dear wife and keep yr / eye on the dairy
> non importation, non eating, non export, all bugwash
> but until they have proved it
> > > in experiment
> no use in telling 'em.
> Local legislation / that is basic /
> > we wd. consent in matters of empire trade, It is
> by no means essential to trade with foreign nations at all
> > as sez Chas Francis, China and Japan have proved it . . .

Etcetera, etcetera. The talk goes on for two hundred pages before we come to real poetry again in the 'Pisan Cantos.'

And where were the 'Pisan Cantos' written? Pound stayed in Italy during the Second World War, making radio broadcasts denouncing the Allies; when the war was over, the U.S. Army captured him and locked him up in an army jail near Pisa. They treated him horribly: they kept him outdoors in a wire-mesh cage with the lights on; they allowed no one to speak with him. He had a breakdown. In short, they broke his will. He was forced to walk backwards, out of pride into sympathy. 'The ant's a centaur in his dragon world. / Pull down thy vanity . . .' He was shoved toward an inner life again, out of his mechanical opinions, and the poems return to poetry for a while.

II • Durable Treasure

Pound once wrote to Louis Zukofsky: 'My poetry and my econ are NOT separate or opposed. Essential unity.' To illustrate the connection and by so doing to move into the economics, I want to retell some old anecdotes about Pound and his fellow modernists. No one seems to deny that Ezra Pound could be arrogant and autocratic at times, but we have several remarkable testimonies to a gentler side of his personality as well. All of them bespeak a connection between art and generosity.

T. S. Eliot took a boat to London shortly before the First World War. He was working on a doctoral thesis. He had written some poems, most of which had been lying in a drawer for several years. Pound read them. 'It is such a comfort,' he wrote to Harriet Monroe, 'to meet a man and not have to tell him to wash his face, wipe his feet, and remember the date (1914) on the calendar.' He sent 'Prufrock' to *Poetry* magazine and midwifed it into print, refusing to let Monroe change it, refusing even to give her Eliot's address so she might, as he put it, 'insult' him through the mails with suggested alterations.

In 1921 Eliot left the manuscript of *The Waste Land* with Pound, and Pound went through it with his red pencil. He thought it was a masterpiece. And why should its author not go on writing such masterpieces? Well, he was working as a clerk in Lloyd's Bank in London and didn't have the time. Pound decided to free him. He organized a subscription plan called 'Bel Esprit.' The idea was to find thirty people who could chip in fifty dollars each to help support Eliot. Pound chipped in, as did Hemingway, Richard Aldington, and others. Pound threw himself into it,

hammering the typewriter, printing up a circular, sending out a stream of letters. (In the end, not enough subscribers were found and Eliot was embarrassed by the show. The publicity may have helped to draw the $2,000 *Dial* prize to him in 1922, however.)

A quarter of a century later Eliot wrote a portrait of his sponsor:

No one could have been kinder to younger men, or to writers who . . . seemed to him worthy and unrecognized. No poet, furthermore, was, without self-depreciation, more unassuming about his own achievement in poetry. The arrogance which some people have found in him, is really something else; and whatever it is, it has not expressed itself in an undue emphasis on the value of his own poems.

He liked to be the impresario for younger men, as well as the animator of artistic activity in any milieu in which he found himself. In this role he would go to any lengths of generosity and kindness; from inviting constantly to dinner a struggling author whom he suspected of being under-fed, or giving away clothing (though his shoes and underwear were almost the only garments which resembled those of other men sufficiently to be worn by them), to trying to find jobs, collect subsidies, get work published and then get it criticised and praised.

When W. B. Yeats showed Pound one of James Joyce's poems, Pound wrote to Joyce, then living in Italy, and before long he'd reviewed *Dubliners* and arranged for *The Egoist* to print *A Portrait of the Artist*, both serially and in book form. Joyce had earned his keep in Italy by teaching English, and he tried to do the same when he later moved to Zurich with his wife and children. By then he was writing *Ulysses*. Pound's efforts to place the art at the center of Joyce's labors were unflagging. He prevailed upon Yeats to squeeze £75 out of the Royal Literary Fund for Joyce, and he mailed him £25 of his own money as well, saying it came from an anonymous donor. He got the Society of Authors to send Joyce £2 a week for three months.

When the two men finally met in Paris, Joyce arrived thin as a rail, wearing a long overcoat and tennis shoes. Pound, on his return to London, sent a package back across the Channel which, when Joyce finally untangled its string cocoon, revealed a collection of used clothes and a pair of old brown shoes.

Finally, as Wyndham Lewis tells it,

Ezra Pound 'sold' the idea of Joyce to Miss Harriet Weaver. Subsequently that lady set aside a capital sum, variously computed but enough to change him overnight from a penniless Berlitz teacher into a modest rentier; sufficiently for him to live comfortably in Paris, write *Ulysses*, have his eyes regularly treated and so forth. These *rentes* were his – I know nothing beyond that – until he had become a very famous person: and the magician in this Arabian Nights Tale was undoubtedly Ezra.

There are other stories with similar plots – Hemingway, Frost, Blunt, Cummings, Zukofsky, and others. In 1927 the $2,000 *Dial* award went to Pound himself. He invested the money (or put it in the bank) at 5 percent and gave away the interest. He sent some of the money to John Cournos, writing: 'Investment of Dial prize is due to yield about one hundred bucks per annum. The first 100 has already gone, discounted in three lots, one ten guinea s.o.s. earlier this week . . . I think you better regard the enclosed as advance payment for something to be written for Exile, when the skies are clearer.' Pound's magazine, *The Exile*, was itself a fruit of this award.

Wealth that came to Pound left him in the service of art. As Hemingway wrote in a little 'Homage to Ezra':

> We have Pound . . . devoting, say, one fifth of his time to poetry. With the rest of his time he tries to advance the fortunes, both material and artistic, of his friends. He defends them when they are attacked, he gets them into magazines and out of jail. He loans them money. He sells their pictures. He arranges concerts for them. He writes articles about them. He introduces them to wealthy women. He gets publishers to take their books. He sits up all night with them when they claim to be dying and he witnesses their wills. He advances them hospital expenses and dissuades them from suicide.

No one failed to mention this part of Pound's spirit. It is a cornerstone of his way of being. Each anecdote has a simple structure: from the 'Bel Esprit' to the old brown shoes we have a man who responds with generosity when he is moved by art. True worth, for such a person, inheres in the creative spirit, and the objects of the world should move accordingly, not to some other, illusory value. Pound's essay 'What is Money For?' begins with its own answer: money is 'for getting the country's food and goods

justly distributed.' The title could as well have been 'Why Have No Proper Shoes Been Distributed to James Joyce?' In approaching Pound's economic theories, it seems to me that our work will be most fruitful if we use these anecdotes as a backdrop, if we see his work as an attempt to find a political economy that would embody the spirit they reveal. Pound sought a 'money system' that might replicate, or at least support, the form of value that emanates from creative life. He cared for neither Marxism nor bourgeois materialism because, he felt, neither held a place for the artist. He was attracted to the theories of an Englishman – Major C. H. Douglas – because Douglas was one of the first, according to Pound, 'to postulate a place for the arts, literature, and the amenities in a system of economics.' During the 1930s Pound printed his economic ideas in a series of 'Money Pamphlets'; in one of them he describes two different kinds of bank – one in Siena and one in Genoa – the first built 'for beneficence' and the second 'to prey on the people.' The last line of his analysis reads: 'The arts did not flourish in Genoa, she took almost no part in the intellectual activity of the renaissance. Cities a tenth her size have left more durable treasure.'

The point for the moment is not that Pound was either right or wrong about the Bank of Siena or about Major Douglas, but simply that Pound's money theories, at least at the start, were addressed to the situation of the artist and the liveliness of culture. Something had happened after the Renaissance, he felt, that ate away at art and made it less likely that an artist would have a decent pair of shoes. In Canto 46 we find the date 1527 – the time, roughly, of the Peasants' War, Luther's sermons on Deuteronomy and Thomas Müntzer's martyrdom – and with that date the line: 'Thereafter art thickened, thereafter design went to hell.' The changes that the end of the Middle Ages brought to political economy (and to religion and philosophy) are for Pound the touchstone for an explanation of the shift in the sense of value. To explain the whole, Pound focused on the post-Reformation re-emergence of usury.

CANTO 45

> With usura hath no man a house of good stone
> each block cut smooth and well fitting
> that design might cover their face,
> with usura
> hath no man a painted paradise on his church wall

harpes et luz
or where virgin receiveth message
and halo projects from incision,
with usura
seeth no man Gonzaga his heirs and his concubines
no picture is made to endure nor to live with
but it is made to sell and sell quickly
with usura, sin against nature,
is thy bread ever more of stale rags
is thy bread dry as paper,
with no mountain wheat, no strong flour
with usura the line grows thick
with usura is no clear demarcation
and no man can find site for his dwelling.
Stonecutter is kept from his stone
weaver is kept from his loom
WITH USURA
wool comes not to market
sheep bringeth no gain with usura
Usura is a murrain, usura
blunteth the needle in the maid's hand
and stoppeth the spinner's cunning. Pietro Lombardo
came not by usura
Duccio came not by usura
nor Pier della Francesca; Zuan Bellin' not by usura
nor was 'La Calunnia' painted.
Came not by usura Angelico; came not Ambrogio
 Praedis,
Came no church of cut stone signed: *Adamo me fecit.*
Not by usura St. Trophime
Not by usura Saint Hilaire,
Usura rusteth the chisel
It rusteth the craft and the craftsman
It gnaweth the thread in the loom
None learneth to weave gold in her pattern;
Azure hath a canker by usura; cramoisi is unbroidered
Emerald findeth no Memling
Usura slayeth the child in the womb

> It stayeth the young man's courting
> It hath brought palsey to bed, lyeth
> between the young bride and her bridegroom
> CONTRA NATURAM
> They have brought whores for Eleusis
> Corpses are set to banquet
> at behest of usura.

The poem is written out of a late medieval sensibility. We have covered this ground before. As with any scholastic analysis, Pound begins with the Aristotelian 'usura, sin against nature' and, following the traditional natural metaphor, declares that if such 'unnatural value' rules the market, all other spheres of value will decay, from human courtship and procreation, through craft, art and, finally, religion. In an early canto, the young Pound on a visit to Italy sees the 'Gods float in the azure air'; when 'azure hath a canker by usura,' the spirits themselves have sickened.

The poem may have a medieval argument, but it's a modern poem. I want to offer one example of twentieth-century usury here, so as to recall the argument of our earlier chapter and set it in its present frame. By 'usury' Pound usually means an exorbitant rent on the loan of money; other times he simply means any 'charge for the use of purchasing power.' But Pound also connects usury to the life of the imagination, and it is in that link that we must look for its real import. It's the spirit of usury we want to ferret out, not the percentages that appear on loan applications.

I take as my examples of the spirit of modern usury two cases of the marketing of commodities to children. For many years Philip Dougherty has written a fascinating column on advertising for the *New York Times*. In one of these columns he tells us that in 1977 the Union Underwear Company (the makers of B.V.D.'s and Fruit of the Loom) set out to increase their profits in the children's market. The company's researchers found that the children of the United States wear out 250 million pairs of underwear a year. At the going price, $2.25 a pair, the annual market is almost $600 million. With this in mind, the company hired an advertising agency that in turn contracted with a series of comic-book companies for the use of their characters (Spider Man, Superwoman, Superman, Archie, Veronica, and so on). Images or insignia of these characters were printed on the underwear, now renamed 'Underoos'

and repriced at $4.79 a pair, more than double the regular price. The *Times* columnist reports:

> 'There has never been a product like this before,' exclaimed Mr [James W.] Johnston [Union's marketing vice president], who noted that not only would it deliver higher profit margins than conservative underwear, but it would also react better to advertising and 'for the first time add children's influence to the purchasing decision' for underwear. He's talking about making "gimmes" out of the young set . . .'
>
> Mr Johnston . . . was later to say, 'Advertising is not necessary to sell the product, because it's a powerful product, but advertising is necessary to establish it as a permanent part of the children's culture.'

In a slightly different market, researchers for the nation's second largest fast-food chain, Burger King, discovered that one out of every three times a family goes out for some fast food, it's the child who chooses the brand. Apparently, when the weary father comes home and the tired mother says 'Let's eat out,' the father says 'Someplace cheap,' and then they do what the children say. Retail sales in this market were $14.5 billion in 1977, so in that year the desires of children directed the spending of about $5 billion.

In 1977 Burger King developed a character – a magician named Burger King – in an attempt to lure hungry children away from McDonald's, represented by a clown named Ronald McDonald. Burger King also bankrolled a 'giveaway' program in which they 'gave' the children of the nation $4 million worth of little toys. 'It's a tangible reward to the kid for switching his affections from Ronald to the King,' said the Burger King vice-president for marketing. Burger King was prepared to spend $40 million a year on advertising if they found their magician could attract and hold the kids' affections.

Several things characterize both of these advertising campaigns. First, each company seeks to turn a profit by marketing an image. Not just any kind of image, either. Magicians, clowns, and men and women with superpowers appeal to children in part because children are powerless and seek to release themselves from that burden through the imagination, and in part because super people are the stuff of fairy tale and myth. Secondly, this form of marketing uses gift decoys. Burger King's 'giveaway' toys are

technically bribes, not gifts. Sales rely on keeping these categories confused, however, for the intent is to use the bonding power of gifts to attach children to a product. The bond is not used, that is, for the increase that comes of gift exchange but for market profits. Finally, these campaigns are directed toward children because children are not as cynical as adults; they are more easily stirred by archetypal imagery and less likely to abstract themselves from emotional ties. Moreover, the child is needed to make an emotional appeal to the adult, the source of the cash. The profit depends on this formula: an innocent and imaginative child plus a parent with money plus an affectionate tie between the two. The people who marketed Underoos sold them in supermarkets rather than clothing stores because children more often accompany their mothers to the market and the whole promotional strategy would fall apart if this third thing, the bond between the parent and the child, was missing at the moment of the sale.

Usury in its ancient sense refers to rationalizing the increase and reciprocity of gift exchange so that it becomes a precondition of commerce that both principal and increase return to the original 'owner' of the good. With this rationalization the emotional and spiritual increase of commerce is lost, though the material may remain. The sin of usury is to separate goodwill from its vehicle. The usurer rents what should be a gift (or sells what should be a gift). Usury in this sense appears, therefore, whenever someone manages to convert a gift situation into a profit situation. Moreover, the usurer finds it in his interest to blur the distinction between the commodity mode and the gift mode so that the former may profit by the energy of the latter. In short, he converts erotic energy into money, goodwill into profit, worth into value.

The usurer is not really a comrade *or* a stranger because he makes his living by changing back and forth. On TV he ingratiates himself with the children in the morning to increase his profit margin when the mothers go out for food in the afternoon. He is different in kind from the simple merchant who may have no real interest in the well-being of your family but who at least gives sugar for sugar, salt for salt. The usurer settles for no such equilibrium. He's in the 'juice trade,' say the crooks in Chicago. He turns the juice of life (fantasy and affection in this case) into money.

Burger King and Union Underwear are modern usurers. The affections of children are drawn toward the market with a combination of counterfeit gifts and images that have a taproot in emotional life and the imagination. Then the child's awakened desire is brought to bear on the affectionate

tie to an adult who, because it is an emotional bond, will be more apt to
suspend judgment, enter the gift mentality, and part with the cash. In fine,
the usurer seeks out the bonds of affection and the liveliness of the imag-
ination to move his own product for his own profit. When this system
works, when kids 'switch their affections' to a new product, when the
profits are high enough to pay the advertisers and the promo men and the
royalties of the comic-book companies, then the images are kept 'alive'
with advertising and they become 'a permanent part of the children's
culture.' (Advertising is the 'culture' of a commodity civilization and the
images are kept 'alive' as long as they turn a profit – usually about a year.)

But what is the fate of affection and imagination if, whenever we are
drawn in their direction, we must pass a stranger collecting tolls?

> Usura slayeth the child in the womb
> It stayeth the young man's courting
> It hath brought palsey to bed, lyeth
> between the young bride and her bridegroom.

Once goodwill has been separated from its vehicles, matter will increase
without spirit. Objects will begin to appear that carry no social or spiritual
feeling, though they are the product of human hands.

> It rusteth the craft and the craftsman.
> It gnaweth the thread in the loom.

We may address ourselves to Imagism in slightly different terms now. If,
in turning toward the imagination, you begin with Pound's demand for
concrete speech (and with the spiritual ends of that demand), or if you
begin with William Carlos Williams's 'no ideas but in things,' or with T. S.
Eliot's 'objective correlative,' and if the date on the calendar is 1914, you
are in a fix. For when all exterior objects can be sold at will, when usury
has found a home even in the family food and clothing, then the objects of
the outer world can no longer carry the full range of emotional and spiri-
tual life. Feeling and spirit mysteriously drain away when the imagination
tries to embody them in commodities. Certainly this is part of the melan-
choly in those poems of Eliot's in which men and women are surrounded
by coffee spoons and cigarettes but cannot speak to one another. *The Waste
Land* could be a gloss on Marx's declaration that 'the only comprehensible

language which we can speak to each other . . . is not that of ourselves, but only that of our commodities and their mutual relations.' The imagination senses that packs of cigarettes or cafeteria trays are not emanations of *eros*. Some spirit other than the creative spirit attended to their manufacture. There is a line of modern poets who have continued to work with such materials, accepting (or not feeling) the limited amount of emotional and spiritual life in the poem. But another group of modern poets – and Eliot and Pound belong here – admitted the tension of lost life to their writing, allowing the missing vitality to disturb the surface of the poem. And some of these artists turned outward, drawn toward those ideologies that promised to limit the domain of the commodity. They undertook, in short, the redemption of the imagination, and their task led them, willy-nilly, into politics. Poets as disparate in temperament as Pound, Neruda and Vallejo all began with a strong pull toward 'thinking in images'; all found themselves brought up short, and all turned toward politics.

Before we go much further, however, we must tell two more anecdotes in which Ezra Pound gives a gift – two stories that take us a step closer to the style in which this particular poet moved from poetry to political economy.

In the late 1920s, W. B. Yeats, 'forbidden Dublin winters' by his health, stayed a season in Rapallo, the Italian town where Pound and his wife had finally settled. The two men were not at ease with each other. Unsure of his own work for the moment, Yeats showed a new verse play to Pound, who returned it with a one-word comment written across the front: 'Putrid!' Pound would talk nothing but politics. In *A Vision*, Yeats recalls their evening walks:

> Sometimes about ten o'clock at night I accompany him to a street where there are hotels upon one side, upon the other palm-trees and the sea, and there, taking out of his pocket bones and pieces of meat, he begins to call the cats. He knows all their histories – the brindled cat looked like a skeleton until he began to feed it; that fat grey cat is an hotel proprietor's favourite, it never begs from the guests' tables and it turns cats that do not belong to the hotel out of the garden; this black cat and that grey cat over there fought on the roof of a four-storied house some weeks ago, fell off, a whirling ball of claws and fur, and now avoid each other.
>
> Yet now that I recall the scene I think that he has no affection for

cats – 'some of them so ungrateful', a friend says – he never nurses
the cafe cat, I cannot imagine him with a cat of his own.

Cats are oppressed, dogs terrify them, landladies starve them, boys
stone them, everybody speaks of them with contempt. If they were
human beings we could talk of their oppressors with a studied
violence, add our strength to theirs, even organise the oppressed and
like good politicians sell our charity for power. I examine his criticism
in this new light, his praise of writers pursued by ill-luck, left maimed
or bedridden by the War . . .

Yeats sensed a touch of coldness in Pound's generosity. The gift does not
move out of simple compassion here, but out of a desire of some oppressed
part of the soul to come to power. And Yeats would untangle these threads,
for charity will not survive when the good politician sells it for power. Power
and generosity can sometimes live side by side, but that harmony is a deli-
cate balance, a rare resolution. In politics – and Yeats wants to mark this
in Pound as well – affection and generosity usually lose their autonomy
and become the servants of power.

In Saul Bellow's novel *Humboldt's Gift*, Charlie Citrine reflects on power
and poets, thinking of the American attitude toward its self-destructive
artists. He lists our dead – Edgar Allen Poe, Hart Crane, Randall Jarrell,
John Berryman – and comments:

This country is proud of its dead poets. It takes terrific satisfaction
in the poet's testimony that the USA is too tough, too big, too much,
too rugged, that American reality is overpowering. And to be a poet
is a school thing, a skirt thing, a church thing. The weakness of the
spiritual powers is proved in the childishness, madness, drunkenness,
and despair of these martyrs. Orpheus moved stones and trees. But
a poet can't perform a hysterectomy or send a vehicle out of the solar
system. Miracle and power no longer belong to him. So poets are
loved, but loved because they just can't make it here. They exist to
light up the enormity of the awful tangle and justify the cynicism of
those who say, 'If I were not such a corrupt, unfeeling bastard, creep,
thief, and vulture, I couldn't get through this either. Look at those
good and tender and soft men, the *best* of us. They succumbed, poor
loonies.'

The paragraph confuses two sorts of power. The 'power' that draws the trees toward song is not the 'power' that sends men to the moon, any more than the 'energy' in Blake's 'Energy is eternal delight' is the same as the one in 'the energy crisis.' But, of course, this is the confusion of the age. We wake up to it every morning. It is a modern drama in which a man of frustrated compassion begins to trade his compassion for power. Yeats sensed in Pound's politics the same tension we addressed in the poetry: a will to power born of a frustrated compassion begins to acquire a life of its own and live apart from that compassion.

And so we come to Mussolini. There is an oft-quoted letter of Pound's to Harriet Monroe, oft-quoted because it is one of the first times that Pound mentions his Italian hero: 'I personally think extremely well of Mussolini. If one compares him to American presidents (the last three) or British premiers, etc., in fact one CAN NOT without insulting him. If the intelligentsia don't think well of him, it is because they know nothing about "the state", and government, and have no particularly large sense of values.' The context of Pound's remarks is not usually noted: most of the letter is addressed to the problem of artists being unable to earn a living. Monroe had asked Pound to consider a lecture tour in the States and he asked if it might pay enough to free him to work: 'If I blow all that energy, I have got to have a few years free from WORRY AFTER it. Poverty here is decent and honourable. In America it lays one open to continuous insult on all sides . . .' Later: 'You might devote a special number, poesy contest for best estimate of psychology of the man who paid 20,000 bucks for copy of Poe's Tammammwhatever it is. Interest on 20,000 bucks wd. keep a live writer for life. Wot these bastards lack is a little intelligence.'

As I have said, Pound was attracted to any economic system that seemed hospitable to the artist and, in his estimation, Mussolini was a leader who knew his people needed poetry. Moreover, he was a man of action. He built people houses. He turned swamps into croplands. 'From the time of Tiberius the Italian intelligentzia has been *talking* of draining the swamps,' says Pound, but only Mussolini got it *done*. He was 'the Debunker par excellence.' He took no guff from financiers:

> They were to have a consortium
> and one of the potbellies says:
> > will come in for 12 million'
> And another: three millyum for my cut;

> And another: we will take eight;
> And the Boss said: but what will you
> DO with that money?'
> 'But! but! signore, you do not ask a man
> what he will *do* with his money.
> That is a personal matter.
> And the Boss said: but what will you do?

Mussolini understood that a money system, particularly after the Industrial Revolution, should be directed toward the distribution of abundance, not the management of scarcity. Pound reports that Mussolini gave a speech in 1934 in which, 'speaking very clearly four or five words at a time . . . to let it sink in,' he declared that the problem of production was solved and that people could now turn their attention to distribution. Pound was delighted; he sent an obituary to the *Criterion* in London: 'at 4:14 in the Piazza del Duomo, Milano . . . , Scarcity Economics died.'

Finally, Mussolini was a man 'filled with . . . the will toward *order*.' In a 1932 letter, Pound advised a friend, 'Don't knock Mussolini . . . He will end with Sigismondo and the men of order, not with the pus-sacks and destroyers. I believe that anything human will and understanding of contemporary Italy cd. accomplish, he has done and will continue to do.'

Which brings us to our last anecdote in which Ezra Pound gives a gift.

In the early 1930s Pound requested and was granted an interview with Mussolini in Rome. He had petitioned Mussolini's secretary for the meeting some ten months before, explaining that he wanted to talk about the accomplishments of Fascism, the cork industry, and conditions in the sulfur mines. Late in the day on January 30, 1933, Pound was admitted to see the Boss. He gave Mussolini a typewritten summary of his economic ideas and a vellum edition of *A Draft of XXX Cantos*, published a few years earlier in Paris. A later canto reports Mussolini's reaction:

> 'Ma questo,'
> said the Boss, 'è divertente.'*
> catching the point before the aesthetes had got there . . .

Pound accepted the remark as his laurel; his admiration of Mussolini took

* 'But this / . . . is entertaining.'

an exponential leap. Within a month he wrote his tract *Jefferson and / or Mussolini* (sending a copy to the Boss 'with devoted homage').

Isn't this account a little strange? Did Pound really believe that Mussolini had read the *Cantos* before they met (or even afterwards)? Had he never heard of polite conversation? And what could *Il Duce* have thought of the poet? Pound was firmly set in the habit of delivering his opinions without benefit of elaboration. We know for a fact that more than one Italian Fascist close to Mussolini found the poet 'unbalanced' and his written Italian 'incomprehensible.' In any event, it seems doubtful that Mussolini was as ripe to see the State Poet in Pound as Pound was to see the Poet's State in Mussolini's Italy. The meeting's real significance, then, lies in Pound's own cosmology, for Mussolini is the incarnation of Pound's Confucian side. Stated in this fashion, Pound's gift of the *Cantos* to the Boss concretizes and marks the moment when the imagination is given over to the will. In 1933 Pound literally handed Song over to Authority, a gift that cannot but break its own spirit, for neither the gift nor the imagination can survive as servants of the will toward order.

III • *The Jew in the Hedge*

Don't shoot him, don't shoot him, don't shoot the President. Assassins deserve worse, but don't shoot him. Assassination only makes more murderers . . . Don't shoot him, diagnose him, diagnose him.

EZRA POUND
in a radio broadcast from Rome,
February 18, 1943

It is difficult to speak directly of Ezra Pound's economic ideas. He was a man who rarely uttered a simple '2 + 2 = 4.' He would say, instead, '2 + 2 = 4, as anyone can see who isn't a ninny completely ballywhooed by the gombeen-men and hyper-kikes who CHOKE UP the maze of Jew-governed radio transmissions.' The specifics of his argument emerge with a tag line, a challenge or a baiting remark, and we must speak of both – both the substance and the style – if we are to speak at all.

Here we inevitably approach the question of Pound's sanity. Pound stayed in Italy when the Second World War broke out. He worked for several years at the Ministry of Popular Culture in Rome, making radio broadcasts to

America and to the Allied troops in Europe and North Africa. His broadcasts were a mixture of economic theory, insults to the Allied leaders and exhortations on the wisdom of Fascism. When Italy fell, the Allies captured the fifty-nine-year-old poet and put him in a prison camp. They treated him poorly, as I have mentioned, confining him to an outdoor isolation cage until he collapsed. After his breakdown, Pound was given a room of his own indoors and allowed to write. After a long delay the army flew him to Washington to be tried for treason for the radio broadcasts. His publisher, New Directions, hired an attorney who suggested to Pound that he plead insanity. Pound agreed, and after government and private psychiatrists had examined him, the plea was accepted. He was sent to St Elizabeths Hospital in Washington, D.C. Declared too crazy to be tried and treated as too crazy to be set free, he spent the next twelve years in a sort of legal limbo. The government finally released him in 1958. He returned almost immediately to Italy.

It was not just the government or Pound's lawyer who thought he was a little crazy. People close to him had had the same reaction for some time. When Joyce saw him in Paris in 1935, he thought Pound was 'mad' and felt 'genuinely frightened of him.' Afraid to be alone with him, Joyce invited Hemingway to go with them to dinner; Hemingway found him 'erratic,' 'distracted.' Later, T. S. Eliot also concluded that his friend had become unbalanced ('megalomania'), as did Pound's daughter, Mary ('his own tongue was tricking him, running away with him, leading him into excess, away from his pivot, into blind spots'). For the flavor of a man 'away from his pivot,' one need only read a few of the radio broadcasts. Rambling, erratic, frustrated, full of an anger uncut by humor, humility, or compassion, they fatigue the reader and leave a bitter taste.

There are two pitfalls to avoid in speaking of a crazy side to Pound's economics. First, we must be wary of reducing the ideas to psychological categories. As Thomas Szasz points out in his essay on the Pound case, it is an easy power play to take a man's ideas and, instead of saying 'You're right' or 'You're wrong,' say 'You're crazy.' It impugns the status of the thinker and cuts off the dialogue. On the other hand, once we've restrained ourselves from taking the ideas as 'merely psychological,' we cannot turn and take them flatly as ideas, either. Listen to thirty seconds of Pound at the microphone:

> This war is proof of such vast incomprehension, such tangled ignorance, so many strains of unknowing – I am held up, enraged by the delay needed to change the typing ribbon, so much is there that ought

to be put down, be put into young America's head. I don't know what
to put down, can't write two scripts at once. The necessary facts, ideas
come in pell-mell, I try to get too much into ten minutes . . . Maybe
if I had more sense of form, legal training, God knows what, I could
get the matter across the Atlantic . . .

Pound's ideas emerged so helter-skelter, so full of obsession and so stained
with their maker's breath that to make of them a coherent ideology is to
do a work that Pound himself never did and, therefore, equally to falsify
the story.

To approach the crazy side of Pound's economics, we may begin by
looking for those places in his presentation where the tone suddenly slips,
where his voice becomes unaccountably shrill. Pound constantly addresses
himself to money, for example, but it is the Jew as moneylender who comes
in for the strange twists of phrase and affect. Pound could write an entire
Money Pamphlet with sufficient cogent ideas to make his argument discuss-
able, but then on the last page suddenly say that 'the Jewspapers and worse
than Jewspapers' have been hiding the facts from the public.

If we list the topics that come to us with this fishy smell we find the
following: stupid and ignorant people, lazy people, the Americans and the
English, the Allied leaders (Roosevelt and Churchill in particular, American
presidents in general), usurers, monetary criminals, the Jews, and, to a
lesser extent, the Protestants. The elements in this list are all connected to
one another in Pound's cosmology: the lazy are ignorant; the ignorant are
usually Americans; the Americans elect 'their sewage' (the best example
being Roosevelt, whom Pound thought of as a Jew, calling him 'Jewsfeldt,'
'stinkie Roosenstein,' etc.); England hasn't been the same since they let in
the Jew, who, of course, is the best example of the usurer and the mone-
tary criminal. We are not dealing with discrete elements here, we're dealing
with a lump. If we speak of any part of the lump, we will be well on our
way to describing the whole. The part I shall focus on is the Jew as he
appears in Pound's writing.

'Pound's Jew,' as I would call this image, seems to me to be a version of
the classical god Hermes. One of Pound's early poems invokes Mercury,
the Roman counterpart to Hermes:

> O God, O Venus, O Mercury, patron of thieves,
> Give me in due time, I beseech you, a little tobacco-shop,

With the little bright boxes
 piled up neatly upon the shelves
And the loose fragrant cavendish
 and the shag,
And the bright Virginia
 loose under the bright glass cases,
And a pair of scales not too greasy,
And the whores dropping in for a word or two in passing,
For a flip word, and to tidy their hair a bit.

O God, O Venus, O Mercury, patron of thieves,
Lend me a little tobacco-shop,
 or install me in any profession
Save this damn'd profession of writing,
 where one needs one's brains all the time.

Hermes is a god of trade – of money and merchandise and the open road.
I shall say more about him in a moment; for now we need only note that
the poem says this deity could free the poet from some confinement. If
Hermes were to answer the call – with a little shop, some dirty money, and
cheap sex – Pound might be released from the troublesome burden of his
profession. My position here is that Hermes did in fact respond to Pound's
invocation, but that Pound backed off, refused his approach, and consigned
the god to his own shadow.

In psychoanalytic terms, the 'shadow' is the personification of those
parts of the self that *could* be integrated into the ego but for one reason or
another are not. Many people leave their feelings about death in the shadow,
for example. They *could* be carried in the daylight self but are left unspoken.
Random sexual desire remains in the shadow for most people. It could be
acted upon openly or it could be acknowledged and dismissed (which still
removes it from the shadow), but it isn't. What the ego needs but cannot
accept the psyche will personify and either present in dreams or project
onto someone in the outer world. These shadow figures then become objects
of simultaneous fascination and disgust – a recurrent and troubling figure
in dreams or someone in the neighborhood we don't like but can't stop
talking about.

Pound began to become obsessed with the money question around
1915, so I take that to be the approximate date when Hermes answered

his invocation. But, as I say, Pound backed off. Then, like any spurned deity, Hermes began to increase in power, taking on a more and more threatening aspect, until, by 1935, he had enough power to pull the ego from its pivot. By then Pound had projected this 'destructive' figure from his own darker side onto the Jew. His image of the Jew has in fact little to do with Jews; it is, as we shall see, an almost verbatim description of the classical Hermes.

If we imagine an ancient road at dusk, a road passing through no-man's-land and connecting two towns but itself neither here nor there, we will begin to imagine the ancient Hermes, for he is the God of the Roads, identified not with any home or hearth or mountain but with the traveler on the highway. His name means 'he of the stone heap': a traveler seeking the protection of Hermes would pile rocks into a cairn by the road or erect a herma, a stone pillar with a head on top.

At these roadside altars Hermes assumed his other ancient forms, the God of Commerce and the Protector of Thieves. He wants everything to be on the road: travelers, money, and merchandise. And as his patronage of *both* merchants and thieves shows, the moral tone of an exchange does not concern him. Hermes is an amoral connecting deity. When he's the messenger of the gods he's like the post office: he'll carry love letters, hate letters, stupid letters or smart letters. His concern is the delivery, not what's in the envelope. He wants money to change hands, but he does not distinguish between the just price and a picked pocket. Hermes still appears at a country auction whenever the auctioneer awakens our daydreams of 'making a steal,' that Hermetic mixture of commerce and larceny that cannot fail to loosen the cash. When we come to our senses later, wondering why we bought a cardboard carton full of pan lids, we know that Hermes was the auctioneer.

Hermes is not greedy, however. He likes the clink of coin but he has no hidden pile. Pictures of Hermes usually show him with a little bag of change, just enough to get the trading started. He's no miser asleep on heaps of gold. He loves the fluidity of money, not the weight. When he's a thief he's usually a generous thief. In the *Homeric Hymn to Hermes*, the new born god steals some of Apollo's cattle but immediately sacrifices them to the other gods. Later he invents the lyre and makes it a gift to Apollo, who, though he's still angry about the cattle, gives Hermes a staff in return. Hermes is hardly a god of gift exchange, but as the gift is marked by motion, he is not its antagonist, either.

Unlike the other gods, Hermes is never identified with a place. He can

stay 'on the road' because he has no territory to defend. Other Greek gods have, as it were, an ego position to uphold; they can always be pinned down, therefore, caught in a streak of vanity. Hermes is un-trappable. It's not that he's humble, he's shameless. After he steals Apollo's cattle, Apollo (who's very serious about right and wrong) takes the thief before Zeus. But Hermes just invents a fantastic lie, until Zeus, who knows very well what has happened, begins to laugh at his brassy denials. In that laugh Hermes remains free; he can't be hooked on Apollo's moral tone.

Hermes is sexually shameless as well. In the *Odyssey* Hephaestus makes a magic net and catches his wife in bed with Ares. The gods gather around, laughing at the trapped adulterers, and when someone says, 'Can you imagine yourself in Ares' position?' only Hermes pipes up: 'Yes!' He can climb into bed when the chance arises, but never gets stuck there. He has none of the virtues of the hearth. He's a god of what we call 'cheap sex,' sex on the highway. People who go through a series of casual affairs after a divorce have put themselves in the care of Hermes. Their other gods, those who call for more durable affection, may speak up ('Will he be with you on Christmas?'), but the first sparks of erotic fantasy cannot be struck from such serious tones.

Hermes can't be trusted, of course. They say 'he either guides the way or leads astray.' If you are stuck, Hermes will get you into bed or sell you something or push you down the path, but after that there's no guarantee. In this way he is identified with intellect and invention. In a Hermetic mood we will make a hundred intellectual connections only to find, when we check them with a less restless god, that ninety-nine of them are useless.

Homer tells us that Zeus gave Hermes 'an office . . . to establish deeds of barter amongst men throughout the fruitful earth,' and he has done his job well. He may be the twentieth century's healthiest Greek god. He is present wherever things move quickly without regard to specific moral content, in all electronic communication, for example, or in the mails, in computers and in the stock exchange (especially in international money markets).

Hermes will exchange gifts, but he is quite different from any god of the gift because his connections are made without concern for lasting affec-tion. He isn't opposed to durable bonds, he just doesn't care. In a *strict* gift-consciousness, then, or in any consciousness with a high moral tone, Hermes will be forced into the background. If your god says, 'Thou shalt

not steal,' Hermes will not leave (he's too tricky), but he will have to disguise himself. He'll turn his collar around and sell Bibles over the radio.

There are obvious connections between the mythology of Hermes and the European myth of the Jew. When the double law of Moses fell into disrepute, Christians identified themselves with the first half of the law, the call to brotherhood, and remembered the Jews primarily for the second half, the permission to usure. When a 'limit to generosity' was dropped from the collective attitude, it reappeared in the collective shadow as a tricky Jew, skilled in trade and not part of the group. Furthermore, ever since the Diaspora the Jew has been seen as the uprooted one, the wanderer and the stranger. Jews in Europe were taken to be alocal, able to live in a place without becoming identified with it. Jews have always been attacked, therefore, in times of local nationalism.*

Ezra Pound's image of the Jew is basically an elaboration of this mythology. First of all, for Pound the Jew was an international force, bearing allegiance to no particular country and therefore destructive to all. Pound tells the English, for example, that they used to have a fine empire, 'but you let in the Jew and the Jew rotted your Empire, and you yourselves outjewed the Jew. Your allies in your victimized holdings are the *bunya*, that is, the money lender.'

Second, as this quote already makes clear, for Pound the Jew is the usurer, not simply skilled in finance but a sneak thief who bleeds the nation. The 'kike god' is monopoly, and 'the first great HOAX' of these evil people 'was substitution of kike god . . . for universal god.' The main

* All cultures seem to find a slightly alien local population to carry the Hermes projection. For the Vietnamese it is the Chinese, and for the Chinese it is the Japanese. For the Hindu it is the Moslem; for the North Pacific tribes it was the Chinook; in Latin America and in the American South it is the Yankee. In Uganda it is the East Indians and Pakistanis. In French Quebec it is the English. In Spain the Catalans are 'the Jews of Spain.' On Crete it is the Turks, and in Turkey it is the Armenians. Lawrence Durrell says that when he lived in Crete he was friends with the Greeks, but that when he wanted to buy some land they sent him to a Turk, saying that a Turk was what you needed for trade, though of course he couldn't be trusted.

This figure who is good with money but a little tricky is always treated as a foreigner even if his family has been around for centuries. Often he actually is a foreigner, of course. He is invited in when the nation needs trade and he is driven out – or murdered – when nationalism begins to flourish: the Chinese out of Vietnam in 1978, the Japanese out of China in 1949, the Yankees out of South America and Iran, the East Indians out of Uganda under Idi Amin, and the Armenians out of Turkey in 1915–16. The 'outsider' is always used as a catalyst to arouse nationalism, and when times are hard he will always be its victim as well.

trick of Jewish bankers is to secretly steal the banking powers away from local governments. 'After Lincoln's death the real power in the United States passed from the hands of the official government into those of the Rothschilds and others of their evil combine.'

Third, for Pound the Jew is in charge of communication. Not only are the newspapers actually 'Jewspapers,' but 'the Morgenthau-Lehman gang control 99% of all means of communication inside the United States and . . . they can drown out and buy out nearly all opposition . . .' Jews fill the press and the radio waves with lies for their own selfish gain: 'An artificial ignorance is diffused, artificially created by the usurocratic press . . . ,' and so on.

Finally, as you can see, Pound's Jew has remarkable powers. He secretly controls huge nations, he controls ideas and intellectual life, he controls the money and he controls '99% of all means of communication.' Surely we are in the presence of a god! And though Hermes himself is not marked by the greed that Pound finds in this character, all the rest is pure Hermes – the Protector of Thieves and God of Commerce, the Messenger of the Gods and the Lord of the Roads.

The character Pound seeks to describe has one final trait: he is diseased (or disease-transmitting). Pound once wrote a newspaper article with the simple title 'The Jew: Disease Incarnate.' The sickness is sexual: 'Jewish control is the syphilis of any gentile nation'; Jews are the 'gonorrhoeal elements' of international finance. 'Usury and sodomy the Church condemned as a pair, to one hell, the same for one reason, namely that they are both against natural increase.' The image here is an extension of the natural metaphor out of which Pound works (as natural increase is sexual, so its enemy is a sexual disease), but I don't think we will get very far trying to connect this part of Pound's Jew to Pound's ideas. Nor does it have much to do with Hermes. It has to do with psychological repression. An aspect of the self forced to remain in the shadow invariably takes on a negative cast not at all inherent in it. It becomes dirty or violent, trivial or huge, diseased or evil. To integrate the shadow with the ego involves holding a sort of dialogue with it in which these negative aspects fall away and the repressed element comes forward in a simplified form, accepted as 'no big thing' into the daylight self. So long as the ego refuses commerce with the shadow, however, the shadow will always seem repulsive.

There is a strange fairy tale in the brothers Grimm collection which pulls together all the threads of our story so far – Pound's generosity toward

his fellow artists, his turn toward money and political economy, his devotion to Mussolini, his willfulness, his Jew, and the consequences of repression. The tale is at once a drama of the Jew in the shadow of the European Christian and a parable of Ezra Pound's life.

The Jew in the Hawthorn Hedge

Once upon a time there was an honest and hardworking servant who worked for a rich miser. The servant was always the first one out of bed in the morning and the last one in bed at night. Whenever there was a hard task no one else wanted to tackle, the servant would take it in hand. He never complained; he was always jolly.

The miser kept the servant around by never paying him his wages. After three years, however, the servant announced that he wanted to see a bit of the world and he asked for his pay. The miser gave him three farthings, one for each year, saying, 'That's a bigger and handsomer wage than you would have received from many a master.' The good servant, who understood little about money, pocketed his capital and went on his way, up hill and down dale, singing and skipping to his heart's content.

Soon the servant met a little dwarf who asked him for help, saying that he was poor and needy and too old to work. The kindhearted servant took pity on the dwarf and he handed over his three farthings. Then the dwarf said, 'Because you've been so good to me, I shall grant you three wishes.' 'All right,' said the servant, 'I'll wish myself first a blowgun that will hit everything I aim at; secondly, a fiddle which, when I play it, will make everybody dance who hears the sound; and thirdly, if I make a request of anybody, that he may not refuse it.'

The wishes granted, the servant went merrily on his way. Soon he met a Jew who was standing by the road, listening to a bird singing in the top of a tall tree. 'Miracle of God!' the Jew cried, 'to think that such a small creature should have such an awfully powerful voice! If only it were mine!' Whereupon the servant shot the bird with his newly acquired blowgun. It fell dead into a hawthorn hedge.

'You dirty dog,' said the servant to the Jew, 'go and fetch your bird!' 'Oh my!' said the Jew. 'If the gentleman will drop the "dirty,"

the "dog" will come on the run! I'm willing to pick up the bird, for after all, you hit it.' He lay on the ground and began to work his way into the bushes. When he was in the middle of the hawthorns, a spirit of mischief got the better of the good servant: he took up his fiddle and started to play. The Jew began to dance wildly; the thorns tore his coat, combed his goatee and pricked him all over. The Jew begged the servant to stop but he wouldn't, thinking, 'You've skinned plenty of people; now the hawthorn hedge won't be any kinder to you.' Finally the Jew offered to give the servant a whole purse of gold if he'd stop his fiddling. The servant took the gold and went on his way.

When the servant was quite out of sight the Jew began to curse him. 'You wretched musician, you tavern fiddler! You rogue, put a penny in your mouth so that you may be worth four farthings!' When he had thus given vent to his feelings he went into town to find a judge. The judge sent his people after the servant who was brought back to town, tried and condemned to the gallows for highway robbery. As he mounted the ladder with the hangman, however, the servant asked the judge to grant him one last wish. 'I beg you let me play my fiddle one last time.' Of course as soon as he started to play, everyone began to dance, even the town dogs, until all were so tired the judge offered to free him and give him anything if he would only stop playing. The good servant put down his fiddle and climbed down from the gallows. He stepped up to the Jew who was lying on the ground and gasping for breath. 'You dirty dog, now confess where you got your money or I'll begin to play again.' 'I stole it, I stole it!' screamed the Jew, 'but you earned it honestly.' The judge had the Jew led to the gallows and hanged as a thief.

This repulsive little story belongs to a group of tales in the Grimms collection in which the imaginative growth of the plot is cut off by some unquestionable collective attitude. It comes from a culture (early 19th-century Germany) that had not learned to live with the Jew in the hedge any more than Pound ever did.

The servant in the story is 'softhearted,' a character at home with gift exchange but not with money. The first thing we should note is that his softheartedness, *by itself*, is not a weakness or failing: his gift exchange works. It has its own power. He gets his wishes. In a different tale – if, for

example, the problem of the story were to find the servant a bride – things would have proceeded with no further ado after the gift exchange with the dwarf. But the problems in this story are power, greed, and social relations mediated by money. This seems to be a land where people sell their labor in the marketplace. The servant's soft heart is not enough. He's a naïf, somebody who just got off the boat. He's Walt Whitman lifted from a Civil War hospital, 1862, and set down in London, 1914.

At the start of the tale the miser cheats the servant and the servant doesn't feel the insult. On a conscious level, he has no idea what three years' labor is worth. He goes singing and skipping down the road, and we are left waiting for the other shoe to drop. Then on his first wish our happy worker calls for a weapon! Clunk. Now we know the insult *was* felt. It is not yet conscious, but the servant *does* have a money side to him, one that felt both hurt and unarmed when he was cheated.

The Jew appears. I take the Jew to be the servant's shadow, a personification of that part of him that felt the blow. The Jew is exactly the man

Arthur Rackham's illustration for 'The Jew in the Hawthorn Hedge.'

the servant needs to meet, too. Here is someone who knows about money, who could tell him the market value of a year's work. The Jew makes this clear with his parting insult: 'Put a penny in your mouth so that you may be worth four farthings.' The image sums up the problem: our simpleton with his three farthings is a three-quarter wit, so to speak, and needs a Jew to provide him the fourth coin.

Although the Jew shows a touch of greed ('If only it were mine!'), he first appears as a man who responds spiritually to beauty: he is moved by the song of the bird and he praises the Lord. Also, he appears immediately after the gift exchange, as if he were drawn into the circle of consciousness not only by the servant's need for him but by his own longing for something – something to do with song and gift.

So we have two men drawn to each other by mutual need. The servant might teach the Jew about the gift, and the Jew could teach him about money. The singing bird is the promise of their possible harmony, something beautiful and higher. For a moment we see the three of them together.

But the servant kills the bird. The touch of anger in him and the touch of greed in the Jew dominate and prevent the union. Then a 'spirit of mischief' comes over the servant and he tortures the Jew. What might have been a simple anger at the start of the story has turned into a bitterness that possesses the servant and sours him for the rest of the tale.

When the robbed Jew goes to find the judge, the imaginative tension of the tale collapses. The judge carries a solidified collective attitude. He seems to know only one law – 'Thou shalt not steal' – and applies it first to the servant and then to the Jew, never looking into the particulars of the case. At the end the Jew is simply murdered, and the problems of the story are left unsolved. The miser is never dealt with (a miser who is *not* a Jew, by the way); the servant's meanness and greed (it is *he* who steals the gold) are not addressed; his naïveté is left intact. Nor does the Jew's wonder and spiritual longing lead him anywhere. The bird is killed. There is no dialogue, no change. The death at the end of the tale redeems nobody, it is simply brutal.

There are three or four ways of dealing with shadow figures. The Christian way has been to say that everything on the dark side is 'not-God' and must be avoided or attacked. Another way is to face the shadow, address it and see what it wants. Such a dialogue requires that the ego position be suspended for a moment so that the shadow may actually speak. There is

a similar mystic or Buddhist approach in which one disidentifies with both the ego and the shadow. Finally, one could switch allegiance and identify with the shadow itself. In a Black Mass, for example, the priest approaches the dark side not to fight it or debate it but to worship. Many cultures have annual festivals – like the Mardi Gras – during which everyone may put on a mask and act out what is hidden during the rest of the year.

The servant in our story never gets close to the shadow, of course. He doesn't take the Jew seriously enough to either talk with him or be wary of him. As a result, his own shadow side takes control without his conscious self becoming aware of it. At the end of the story the servant himself has become what one expects will be a sanctimonious miser, bad-mouthing the Jews as he invests his stolen gold. In short, he leaves the tale a possessed simpleton, skipping and singing and killing birds!

Ezra Pound, from the time he left college until sometime in the 1920s, was the hardworking servant – the first out of bed in the morning and the last to sleep at night. Like our hero, he had an authentic sense of the gift and its power; not only was he personally gifted, but his relationship to the outer world was successfully mediated by generosity. At the same time, however, he seems to have suffered some insult that became buried in the unconscious. William Carlos Williams says that he and Pound had an ongoing argument about which was the correct food for a poet, bread or caviar. Pound favored caviar. Some part of Pound felt he was a king – and yet he had no castle and no kingly powers. Out of some disappointment – an unreciprocated gift, a lost kingdom – the poet turned to the money question and began looking for a thief. As if in answer to his own invocation a figure came toward him, a Hermes/Jew who might have been carrying the missing farthing. If he were an Old Testament Jew, he might have been able to teach Pound how to protect his gift, how to deal in cash at the edges of the self so that life might go on within.

But Pound, like the servant, went haywire when he met the Jew.

For a man given to invoking deities, Pound was strangely scornful of psychological phenomena. He once wrote to Joyce that 'Preserving public morality is more important than exploring psychological hinterlands.' As for modern psychotherapy:

> The general results of Freud are Dostoievskian duds, worrying about their own unimportant innards with the deep attention of Jim drunk occupied with the crumb on his weskit.

I see no advantage in this system over the ancient Roman legion, NO individual worth saving is likely to be wrecked by a reasonable and limited obedience practised to given ends and for limited periods. So much for commandments to the militia as superior to psychic sessions for the debilitated.

In short, the best physic for a man with bad dreams is a hitch in the army.

With Pound's own righteousness coupled to such an attitude toward the psyche – no wonder Hermes never got out of the shadow. As with the servant, the insult Pound felt to his own worth turned into an unending bitterness; what had been singing fell dead. An obsession with money and political thinking began to cut off the poetry, as Yeats had feared. Then everything escalated. Pound took the growing deadness as *caused* by the Jews – Jews were cutting him off from the news, Jews were stealing the gold, Jews were destroying the crops, Jews were fouling the nest. Like the servant, Pound never turned to face the Jew as a part of himself. He called for the judge, for men with a will toward order who could enforce 'public morality.' By the 1930s he could write a whole treatise on sharing the wealth with not a drop of compassion in it. And by the 1940s his hobbled imagination could only produce the old solution to the old story – kill the Jew:

> Don't start a pogrom. That is, not an old-style killing of small Jews. That system is no good, whatever. Of course, if some man had a stroke of genius, and could start a pogrom at the top . . . , there might be something to say for it.

IV • *Imagist Money*

In Federico Fellini's movie *Amarcord*, one of the workmen building a house pauses to say a little poem:

> My grandfather was a bricklayer.
> My father was a bricklayer.
> I am a bricklayer.
> How come I don't have a house?

In London before the First World War, Pound became involved in an

economic reform movement called Social Credit. Organized around the ideas of a Scottish engineer, Major C. H. Douglas, the Social Creditors sought to answer the bricklayer's question. Credit refers to our trust in the ability and intention of a purchaser to make payment at some future time of a debt incurred in the present. With credit, earning power over time can be concentrated in the present so that a third-generation worker might own outright a house his grandfather once bought 'on credit.' 'Credit is the future tense of money,' says Pound.

To explain why the bricklayer doesn't in fact own a house, Social Creditors distinguished between 'real credit' and 'financial credit.' Real credit is the purchasing power of a group over time – all that comes of labor, technology, and the gifts of nature. Financial credit is the same thing expressed with money. Social Creditors did not oppose the monetary expression of credit – large industries and nations cannot operate without that abstraction – but, they said, financial credit should equal real credit. What happens instead is that self-interested bureaucrats take over the management of financial credit and it begins to become detached from the real. If money managers with houses begin to appear alongside bricklayers who can't get a mortgage, then something is the matter with credit.

Pound, in his elaboration of these ideas, rests financial credit not only on real wealth but quite specifically on natural increase. 'What constitutes a sound basis of credit . . . was and is, the abundance, or productive capacity, of nature taken together with the responsibility of the whole people.' In the comparison of two banks which I mentioned some time ago, for example, the bank of Siena was a good bank because it based credit on natural abundance. As Pound describes it:

> Siena was flat on her back, without money after the Florentine conquest. Cosimo, first duke of Tuscany . . . , guaranteed the [bank's] capital . . .
> Siena had grazing lands down toward Grosseto, and the grazing rights worth 10,000 ducats a year. On this basis taking it for his main security, Cosimo underwrote a capital of 200,000 ducats, to pay 5 per cent to the shareholders, and to be lent at 5½ per cent; overhead kept down to a minimum; salaries at a minimum and all excess profit over that to go to hospitals and works for the benefit of the people of Siena . . .
> And the lesson is the very basis of solid banking. The CREDIT rests

in ultimate on the ABUNDANCE OF NATURE, on the growing grass
that can nourish the living sheep . . .

Pound's stock example of an evil bank was the Bank of England. In a
book by Christopher Hollis called *The Two Nations* Pound came across
a quote attributed to that bank's founder, William Paterson. A prospectus
written in 1694 for potential investors included this sentence: 'The bank
hath benefit of the interest on all moneys which it creates out of nothing.'
Pound repeats the sentence over and over in the *Cantos* and in his prose.
Here value is detached from its root in the natural world; here lies the seed
of the dissociation between real and financial credit. Money 'created out
of nothing' cannot have real value or real increase, but the 'hell banks,'
through abstraction and mystification, make it appear to have both. Once
such false money is at large, it secretly gnaws away at the true value that
rests on the growing grass and the living sheep.

Pound divided all goods into three classes:

1 transient goods ('fresh vegetables, luxuries, jerry-built houses, fake
 art, pseudo books, battleships'),
2 durable goods ('well constructed buildings, roads, public works,
 canals, intelligent afforestation'), and
3 permanent goods ('scientific discoveries, works of art, classics').

In phrases reminiscent of our description of a gift, Pound adds that the
goods in his third group 'can be put in a class by themselves, as they are
always in use and never consumed, or they are . . . not destroyed by
consumption.' The only change I would suggest in these groups would be
to move vegetables – or any life that is cyclically reborn – into the last cate-
gory, in the spirit of Pound's own lines from a late canto: 'The clover
enduring, / basalt crumbled with time.' Clover endures the way art endures.
The verb is the same as in the *usura* canto, 'no picture made to endure nor
to live with / but to sell and sell quickly.'

Pound felt that as long as we are going to use money as a symbol of
value, there should be different kinds of money to stand for different kinds
of value: clover money for clover and basalt money for basalt. 'For every
bit of DURABLE goods there ought certainly to be a ticket [i.e., a piece of
money] . . . But what about perishable goods, stuff that rots and is
eaten . . . ?' he asks. 'It would be better . . . if money perished at the same

rate as goods perish, instead of being of lasting durability while goods get consumed and food gets eaten.' He sought, therefore, a currency 'no more durable than . . . potatoes, crops or fabrics.' Until the symbols of value accurately reflect the various kinds of wealth, we will always have the unfair situation of some folks having 'money wealth' that increases in their bank accounts while others have 'potato wealth' that decays in their larder. So Pound proposed a vegetable currency which, like the bread the fairies leave at night, would perish in the hands of those who did not use it.

He was particularly keen on stamp scrip, a form of currency proposed by the German economist Silvio Gesell. As Pound tells it, Gesell 'saw the danger of money being hoarded and proposed to deal with it by the issue of "stamp scrip." This should be a government note requiring the bearer to affix a stamp worth up to I percent of its face value on the first day of every month. Unless the note carries its proper complement of monthly stamps it is not valid.' With stamp scrip, you lose money by having money. Whoever has something in his pocket on the first of the month will see it shrink by I percent, rather than grow. If you keep it a hundred months it will perish completely. (Stamp scrip is *Schwund geld* in German, 'shrinking money.' Pound sometimes calls it 'counter-usury,' and in letters to Mussolini refers to it as 'transient currency' and as money that bears 'negative interest.' It's money that decays.)

Both Pound and Gesell thought that stamp scrip would prevent hoarding and increase the velocity of the money in circulation. Nobody would want to hold on to it. I'm not sure that it does this any better than conventional interest – when all money bears interest, uninvested money shrinks, too. But there is one obvious difference between stamp scrip and conventional interest: the *direction* of the increase is reversed. A conventional interest payment goes to the owner of the money; with stamp scrip (as with gifts) the increase goes *away* from the owner of the wealth (it goes to the state, about which more later). Moreover, again as with a commerce of gifts, the increase of stamp scrip goes to the group as a whole, not to individuals. 'Anyone who thinks to keep it put by in a stocking will find it slowly melting away. Anyone who needs it to live by, or who uses it to stimulate and increase the well-being of the nation, will profit by it.'

The imagery of Pound's argument ties stamp scrip to the fertility of nature, just as he tied credit to 'the growing grass.' Metallic money should not stand for perishable goods, he declares, because its durability 'gives it certain advantages not possessed by potatoes or tomatoes.' Nor should it

represent the value of goods that increase by nature ('Gold . . . does not reproduce itself . . .'). But with stamp scrip – as long as the state prints the money and also sells the stamps – a sort of natural cycle is established: money dies in the state and the state gives it life again. It perishes but, like 'the clover enduring,' is reborn (increased if the group's wealth has increased). With the state playing the part of the topsoil, as it were, stamp scrip imitates animal and vegetable goods that decay into a fertile compost.

The state plays such a central role in Pound's economic theory that we can touch on almost all its remaining elements by simply listing the functions he assigns to government:

- The state runs the bank.
- The state issues and controls the currency (which will then be 'state notes,' not 'bank notes'). Rather than pay interest on a public debt borrowed from private financiers, the state should circulate a non-interest-bearing national debt as its currency.
- The state distributes purchasing power. When someone needs a loan or a large project needs financing, the state is the creditor. Money itself – the unit of purchasing power – is issued on the basis of 'work done for the state.' And when the national wealth increases, the state spreads the wealth by paying each citizen a national dividend.
- The state sets prices – either by influencing the market with 'state-controlled pools of raw products' or by regulating the value of labor.
- The state obviously has a great deal of power, but Pound was not particularly worried about its abuse. He intended the state to be a servant, not a boss. The state is a republic, Pound was fond of saying, and 'the *res publica* means, or ought to mean "the public convenience."'

The point of Pound's economics – we mentioned it long ago – is to 'get the country's food and goods justly distributed.' That, at any rate, is the point if we put it positively. But it often seems more accurate to state it as a negative: Pound wants to *prevent* unjust distribution – he wants, that is, to keep the swindlers from bleeding the public, to catch the crooks and wipe out trickery. No picture of Pound's political economy would be complete without a description of the crimes it is intended to prevent. We

have already seen the first example, the Bank of England creating money out of nothing. Three more specific cases will cover the field:

- 'Aristotle . . . relates how Thales . . . , forseeing a bumper crop of olives, hired by paying a small deposit, all the olive presses on the islands . . . When the abundant harvest arrived, everybody went to see Thales . . . The Exchange frauds are . . . [all] variants on this theme – artificial scarcity of grain and of merchandise, artificial scarcity of money . . .'
- 'The imperfections of the American electoral system were . . . demonstrated by the scandal of the Congressmen who speculated in the "certificates of owed pay" that had been issued . . . to the soldiers of the Revolution. It was an old trick, and a simple one: a question of altering the value of the monetary unit. Twenty-nine Congressmen . . . bought up the certificates from veterans and others at twenty per cent of their face value. The nation . . . then "*assumed*" responsibility for redeeming the certificates at their full face value.' [This was the 'Scandal of the Assumption.']
- 'Only God knows how much gold the people have bought during the war, from 1939 to the present time. The trick is simple. Whenever the Rothschild and other gents in the gold business have gold to sell, they raise the price. The public is fooled by propagandising the devaluation of the dollar, or other monetary unit according to the country chosen to be victimized.'

For a general description of these crimes we need first to distinguish between embodied value and abstract value. When you exchange a commodity for cash, the object – the body of the thing – is abandoned, and you are left with the symbol of its market value, the dollar bills in your pocket. In one of the phases of market exchange, value is detached from the object and carried symbolically. The symbols of market value are supposed to bear some relation to the commodity, of course – you don't pay $12 for a hacksaw unless you think it's a $12 hacksaw – but there is always a little slack in the line. The symbol is alienable. There is a gap between it and the body. In a famous essay on 'Geometry and Experience,' Albert Einstein wrote: 'As far as the laws of mathematics refer to reality, they are not certain; and as far as they are certain, they do not refer to reality.' Symbolization in either exchange or cognition requires that the

symbol be detached from the particular thing.* We could not think mathematically if we always used real oranges and apples the way children do in the first grade; in a market economy, without money we would have to lug the table and chair to the store when we needed beefsteak and wine. In a symbolic commerce we hope, of course, that our currency or our mathematics will bear some relation to reality when we come back down to earth, but for the duration we sever the link.

In these terms, the arch criminal for Pound is the man who makes sure that value is detached from its concrete embodiment and then 'plays the gap' between symbol and object, between abstract money and embodied wealth. Either the swindler fools the public into using a phantom currency and then grows rich on its increase, or else he gets a monopoly (either on a particular commodity or, better, on the actual symbol of value) and stirs up the market, inducing fluctuations in the relationship between embodied and symbolic value and getting rich playing the one against the other. All the crimes that Pound warns us against come down to one: to profit on the alienation of the symbol from the real. 'The finance of financiers is largely the juggling of general tickets against specific tickets.' In a corrupt economy the real worth of the creations of man falls every time some crook makes money by a mere manipulation of the market, or worse, makes money out of nothing. 'An increasingly large proportion of goods never gets its certificate [of value] . . . ,' says Pound. 'We artists have known this for a long time, and laughed. We took it as our punishment for being artists, we expected nothing else, but now it occurs to the artisan . . .'

The difference between an image and a symbol is simple: an image has a body and a symbol does not. And when an image changes, it undergoes metamorphosis: body changes into body without any intervening abstraction – without, that is, the gap which is both the freedom and the alienation of symbol-thought and symbol-change. To connect Pound's economics to his aesthetics, we need simply say that the crime he would prevent is one in which the enemies of the imagination enrich themselves through the trick of symbolic thought. The economist who connects credit

* Here we have another reason why Hermes is both the god of trade and of thieves. A commerce in commodities involves the trick of symbolic exchange.

to sheep or who writes that 'the Navy depended on iron, timber and tar, and not on the manoeuvers of a false finance,' is the same as the Imagist who preferred to define 'red' with 'ROSE CHERRY IRON RUST FLAMINGO' rather than resort to successive layers of generality.

In his sober moments Pound does not oppose abstraction or symbolic thought, but behind his argument lies the longing – and it is a poet's longing – to pull the whole world into the imagination. Money itself is a crime against that desire.

> The nineteenth century, the infamous century of usury . . . creat[ed] a species of monetary Black Mass. Marx and Mill, in spite of their superficial differences, agreed in endowing money with properties of a quasi-religious nature. There was even the concept of energy being 'concentrated in money,' as if one were speaking of the divine quality of consecrated bread.

We are back with Müntzer condemning Luther. When a writer declares that 'money alone is capable of being transmuted immediately into any form of activity,' Pound exclaims: 'This is the idiom of the black myth! . . . Money does not contain energy. The half-lira piece cannot *create* the platform ticket . . . or piece of chocolate that issues from the slot-machine.' To speak as if it does is 'the falsification of the word' and portrays a 'satanic transubstantiation.'

Pound's remarks on the image are typically cited in explications of his aesthetic ideas, but their meaning cannot be accurately conveyed if they have been removed from their original context, an ongoing argument for a spiritual economy of the imagination:

> The power of putrefaction . . . seeks to destroy not one but every religion . . . by leading off into theoretical argument. Theological disputes take the place of contemplation. Disputation destroys faith . . . Suspect anyone who destroys an image . . .

And in the same line:

> The theologians who put reason (logic) in the place of faith began the slithering process which has ended up with theologians who take no interest in theology whatsoever.

> Tradition inheres . . . in the images of the gods, and gets lost in
> dogmatic definitions.

When Pound asks, 'Who destroyed the mystery of fecundity, bringing
in the cult of sterility?' he himself might have answered, 'The Protestants
and the Jews,' but let us say, rather: the rise of market-value as *the* form
of value. Karl Marx once wrote that 'Logic is the money of mind . . .;
logic is alienated thinking and therefore thinking which abstracts from
nature and from real man.' Both men discern this constellation: logical
thinking, detachment from the real, and cash exchange. It is one and
the same country where the form of commerce allows financiers to
enrich themselves by juggling the general against the specific, where
faith is replaced by logic, and where images have lost their life to layers
of abstraction.

What is to be done? Pound offers two solutions (in addition to those
we've seen – stamp scrip, state banks, and so forth). First, we must speak
clearly about money. Over and over Pound quotes the reply that Confucius
gave when asked what he'd do first if he were boss: 'Call people and things
by their true and proper names.' Money is nothing but a 'ticket,' it has no
real worth of its own, it does *not* create, and so on. Pound has nothing
against an abstract currency so long as we call a ticket a ticket. The trick-
sters won't be able to dupe a public that knows precisely what money can
and cannot do.

But more often Pound does not want to clarify the nature of symbolic
exchange; he wants to get rid of it. Notice how he uses the word 'just':
'The issue of credit (or money) must be just, i.e., neither too much or too
little. Against every hour's work . . . an hour's certificate.' Or conversely:
'It is unjust that money should enjoy privileges denied to goods.' Justice
demands an hour-dollar for an hour-work, perishable money for perish-
able goods. Pound would like to reattach the symbols to their objects.
Thoreau once wrote: 'He would be a poet who could impress the winds
and streams into his service, to speak for him; who nailed words to their
primitive senses, as farmers drive down stakes in the spring, which the
frost has heaved . . .' The poet longs for a language in which the word *is*
the object, in which speech is as powerful and numinous as a voice in a
dream. 'A perfect writer,' says Whitman, 'would make words sing, dance,
kiss, do the male and female act, bear children, weep, bleed, rage, stab,
steal, fire cannon, steer ships, sack cities, charge with cavalry or infantry,

or do anything that man or woman or the natural powers can do.' The poet of Imagism longs to have symbolic value equal imaginative value. *That* would be justice. Only then would there be no risk of crime. And how are we to establish this equivalence? Either change the nature of money itself (stamp scrip) or else enforce a 'just' currency. Enforce it – with state power.

'STATE AUTHORITY behind the printed note is the best means of establishing a JUST and HONEST currency.' We now have come to the political version of willpower. There's no need to belabor the point; this should be familiar territory. 'The economic conditions of society depend on the will of its rulers,' says Pound, and the 'just price' – which attaches value to commodities in a 'real' correspondence – is the expression of goodwill in commerce. If we can't change the nature of money, we will have to police it. Rather than risk letting the crooks (the Hermes-crooks) sneak in, Pound hopes to enforce a just equivalence between symbolic and embodied value through a vigilant goodwill.* And so he called his political economy a 'volitionist economics,' and so he was attracted to Fascism. Mussolini offered 'a will system'; as the name of the nineteenth century was Usura, so 'the name of the Fascist era is *Voluntas*.'

v • *Bathed in Alkali*

One way to tell Pound's story is as a history of the world, saying that his mind wakes at the time of Homer and moves forward, through Aristotle, through Saint Ambrose, through the Middle Ages and the song of Provence, on into the Renaissance – where it stops. Or rather, sensing something in the Reformation antithetical to the creative spirit, it stops its organic maturation and leaps four hundred years to graft a medieval economics onto the modern state.

Pound's assumptions are tribal and ancient, connecting art, erotic life, natural fertility, and abundance. 'The opposing systems of European morality go back to the opposed temperaments of those who thought copulation was

* If we ask what's to keep tricky financiers from getting themselves appointed as price commissioners, Pound replies: 'No part or function of government should be under closer surveillance, and in no part or cranny of government should higher moral criteria be ASSURED.' Men of *super* goodwill will watch the men of goodwill who set the just price.

Pound was very sharp when it came to spotting crooks in the banking business, but he was a little dull when it came to crimes of power, order, and efficiency.

good for the crops, and the opposed faction who thought it was bad for the crops (the scarcity economists of pre-history).' Accepting Aristotle's distinction between 'natural' wealth-getting (farming and so forth) and 'unnatural' foreign trade, Pound proceeds to imagine 'a natural economic order' (as Gesell called it) in which credit is founded on the pastures, and money imitates the clover. The imagination would be at ease with such an order, for it senses that it is somehow kin to the plants and the animals, and that its products will increase abundantly if only they may be given away, like grain, like clover, like love.

From such tribal (or classic, or agrarian) assumptions, Pound moves easily into the Middle Ages. He is completely at home with canon law, which sought to codify the structure of a Brotherhood of Man: 'My efforts during the last ten years . . . ,' he wrote in 1944, 'have been toward establishing a correlation between Fascist economics and the economics of canon law (i.e. Catholic & medieval economics) . . .'

But this modernist did not live in the Middle Ages and his economy cannot stop there. In the development of his thought he now must face the same problems that Luther and Calvin faced: how to reconcile the emerging forms of exchange (commodities, cash, the 'little usury' of interest) with a spiritual commonwealth. Pound refuses the solution offered by the Reformation, a separation of spiritual and secular life through a new 'double law.' It didn't work, he declares – 'Thereafter design went to hell . . . Azure hath a canker by usura'; spiritual and aesthetic life were destroyed by unbridled market exchange and logic let in to feed in the house of faith.

Rather than separate spirit and empire, Pound combines them to arrive at an ideology of the state which has in it elements of both tribalism and the medieval Church.* But here his troubles begin. Canon law could rest on the assumption of a common and lively faith in the Lord. But the modernist, in assuming the structures of medieval law, must allow the state to stand in for the deity. In the community of faith the Lord gave us our daily bread, but in 'the perfect Fascist State' the state distributes purchasing power. Where 'Apollus watered and God gave the increase,' the workers work and the state pays national dividends. And where does stamp

* His repeated call for state sovereignty and his prohibition on foreign money in the homeland both seem tribal to me. (If you begin with such tribal nationalism, however, you soon must have either complete isolation *or* a double standard for dealing with strangers. With what can only be called the wisdom of Moses, Pound arrives at the latter solution: 'A country CAN have one currency for internal use, and another for home and foreign use.')

scrip go when it dies? Not to heaven. In ancient times the first fruits were returned to the Lord in smoke, but now a hundredth part goes to the state in stamps on the first of the month. Under the natural economic order the gift circles into neither nature nor mystery; it circles into bureaucracy.

In Pound's favor we should remember that the character of state power was not as obvious in 1930 as it is now; nor was he the only writer in that decade who felt moved to combine commonwealth and state. But the course of this century has revealed a strange equation: state power + good will = state power. The reason is simple: at the level of the state the ties of affection through which the will becomes good can no longer be felt. We touched on this when speaking of gifts as anarchist property. There are definite limits to the size of the feeling community. Gift exchange, as an economy of feeling life, is also the economy of the small group. When the commonwealth is too large to be based on emotional ties, the gift-feeling must be abandoned as a structuring element. For gift-feeling is not impartial. It will always seek to suppress its opposite. Small groups can absorb such antagonism because they can also support affection, but the antagonism of large groups is organized and cold. All commonwealths are wary of the stranger, but the huge ones – especially when threatened – put him to death.

One of the issues in the Peasants' War of 1524–26 was the introduction into Germany of Roman law, Roman property rights, and Roman cash purchase. Taken as a whole, these represent the forms of alienated thought, property, and exchange which are necessary in the organization and operation of a state that is *not* a commonwealth or brotherhood. Hermes, now the Roman Mercury, springs to life in such empires, for it is Hermes who will make connections when the scale is too large for affective bonds. In separating Church and state, Luther and Calvin gave some space to this god.* *If* you accept the large rationalized institutions that emerged after the Reformation, *if* you accept in particular the idea of the state, you must also accept some amoral stranger economics.

In terms of intellectual history, the transition from the Middle Ages to the modern world marked a new emphasis on (or need for) symbol-thought and symbol-exchange. Modern logic and the rise of the scientific method quickly followed the Reformation. Less than a hundred years separates Descartes and

* In formulating a modified permission to practice usury, the reformers revived the Mosaic law, and in that sense they brought the Jew into the Church. That, at any rate, was how Pound saw it; he was of the opinion, for example, that Calvin was really a Jew: 'that heretical scoundrel Calvin (the alias of Cauein, or Cohen, philo-usurer).'

Newton from Luther and Calvin. But as I suggested two chapters ago, just as 'logic is the money of mind,' so is the imagination its gift, and Pound was correct, I think, to mark this as the moment in which the imagination was wounded by abstraction. And he was also correct in connecting that wound with the rise of market exchange and its servants – usury, foreign trade, monopoly, and 'detached' units of value. The peasants of the Peasants' War were fighting the same battle Ezra Pound fought, the same hopeless battle.

Ezra Pound schooled himself 'to write an epic poem which begins "In the Dark Forest," crosses the Purgatory of human error, and ends in the light . . .' In his vision of the form of the *Cantos*, there was to be a descent into hell followed by an ascent with error burned away, 'bathed in alkali, and in acid.' But Pound did not return from the underworld.

In Virgil's story of the founding of Rome, Aeneas, too, makes a descent into hell. After the war with the Greeks, Aeneas is buffeted about the Mediterranean until he beaches at Carthage, where Dido, the queen, falls in love with him. They spend one happy season together, but in the spring Aeneas grows restless and sets sail for Italy, abandoning his love. Dido is brokenhearted. She kills herself for grief. The Trojans can see the light of her funeral pyre as they slip over the horizon.

Once he has returned to Italy, a sibyl offers to guide Aeneas into Hades so that he may speak with his dead father. As they cross the river Styx, he sees Dido's ghost. But she won't look at him; she turns her head away, still resentful over his betrayal. Aeneas pushes on to find his father, whose prophecy tells him how he will establish the city of Rome.

The *Aeneid* is the myth of the founding of a patriarchal urban culture. In the background lies an erotic connection cut off by politics. The love affair is destroyed for the sake of empire, and the feminine figure is left as a suicidal, unredeemed, and restless ghost. Aeneas' descent into hell is meant not to heal that wound but to seek out the father and his advice about government.

Ezra Pound's father was an assayer at the U.S. Mint in Philadelphia. If a man wanted to know if his gold was *real* or just fool's gold, Homer Pound would weigh it and drill it and tell him the truth. The most luminous memory from Pound's childhood concerns a time his father took him to visit the mint. In the enormous basement vaults, four million silver dollars lay where their sacks had rotted. 'They were heaving it into

the counting machines with shovels bigger than coal shovels. This spec-
tacle of coin being shovelled around like it was litter – these fellows naked
to the waist shovelling it around in the gas flares – things like that strike
your imagination.'

Like Aeneas, Pound descended into hell on the side of the father. A
memory of *eros* lingers in the background. There had been a desire to live
with those 'who thought copulation was good for the crops.' There was
a man who had once turned into a tree. There was a gifted man, moved
by the undivided light of Eleusis, who brought his consciousness forward
to the Renaissance and who, wary of the centuries of usury that followed,
descended into the underworld to try to bring that gift out again in its
clarity. But this was a modern man, living at the height of the patriarchies,
wary of his own emotions, classic by temperament, and given to willful-
ness. He chose the *via voluntatis*. Rather than revalue the gift through
affirmation, he undertook the hopeless task of changing the nature of
money itself. And so he met no Tiresias in hell. He met no boy lover, nor
did he see the face of the beloved. He met, instead, his own devil, a
Hermes/Jew whom he chose to fight man to man: he fought bad money
with good money, bad will with good will, politics with politics, and avarice
with power, all in the name of generosity and the imagination.

In 1961 Pound fell into silence. For the last eleven years of his life he
rarely spoke. When visitors would come to his apartment, he would shake
hands and then, while the others chatted, sit in silence or disappear upstairs.
Toward the beginning of these years a newspaper reporter came to see
him. 'Where are you living now?' the man asked. 'In hell,' replied Pound.
He never came up. He lost his voice.

In October of 1967 Allen Ginsberg visited Pound in Italy. Pound was
eighty-two; he had been in his silence for six years. Ginsberg spent several
days with him during which Pound hardly spoke at all and Ginsberg told
him stories – told him about his Blake vision and drug experiences and
Buddhism and what was happening in America. He chanted sutras for
Pound and played him phonograph records of Bob Dylan, Donovan, the
Beatles, and Ali Akbar Khan. On the third of these days, in a small Venetian
restaurant with a few friends, Ginsberg having been told that Pound would
respond to specific textual questions about the *Cantos*, they finally began
to talk. Ginsberg later recalled part of the exchange:

[I explained] how his attention to specific perceptions . . . had been

great help to me in finding language and balancing my mind – and to many young poets – and asked 'am I making sense to you?'

'Yes,' he replied finally, and then mumbled 'but my own work does not make sense.' . . . 'A mess,' he said.

'What, you or the *Cantos* or me?'

'My writing – stupidity and ignorance all the way through,' he said. 'Stupidity and ignorance.'

[Ginsberg and the others objected, Ginsberg concluding:] 'Williams told me . . . in 1961 – we were talking about prosody . . . anyway Williams said, "Pound has a mystical ear' – did he ever tell you that?'

'No,' said Pound, 'he never said that to me' – smiling almost shyly and pleased – eyes averted, but smiling, almost curious and childlike.

'Well I'm reporting it to you now seven years later – the judgment of the tender-eyed Doctor that you had a "mystical ear" – not gaseous mystical he meant – but a natural ear for rhythm and tone.'

I continued explaining the concrete value of his perceptions. I added that as humor – HUMOR – the ancient humours – his irritations, . . . against Buddhists, Taoists and Jews – fitted into place, despite his intentions, as part of the drama . . . 'The Paradise is in the desire, not in the imperfection of accomplishment – it was the intention of Desire we all respond to – Bhakti – the Paradise is in the magnanimity of the *desire* to manifest coherent perceptions in language.'

'The intention was bad – that's the trouble – anything I've done has been an accident – any good has been spoiled by my intentions – the preoccupation with irrelevant and stupid things—' Pound said this quietly, rusty voiced like an old child, looked directly in my eye while pronouncing 'intention.'

'Ah well, what I'm trying to tell you – what I came here for all this time – was to give you my blessing then, because despite your disillusion . . . , [my] perceptions have been strengthened by the series of practical exact language models which are scattered thruout the *Cantos* like stepping stones – ground for *me* to occupy, walk on – so that despite your intentions, the practical effect has been to clarify my perceptions – and, anyway, now, do you accept my blessing?'

He hesitated, opening his mouth, like an old turtle.

'I do,' he said – 'but my worst mistake was the stupid suburban
prejudice of antisemitism, all along, that spoiled everything—' . . .
 'Ah, that's lovely to hear you say that . . .'*

Later, Ginsberg and the others walked Pound back to his apartment. At
the door, Ginsberg took him by the shoulders and said, 'I also came here
for your blessing. And now may I have it, sir?'
 'Yes,' nodded Pound, 'for whatever it's worth.'
 In the history of the creative spirit in America, this encounter seems as
significant as the day, thirty-five years before, when Pound handed the
Cantos to Mussolini. For here the Jew – or rather, the Buddhist Jew (for he
has left the judge behind) – came to exchange a blessing with the bitter
servant. There were Jews who thought that Pound should have been put
to death for his broadcasts during the war. But that would have been no
more of a solution than the killing of the Jew in the fairy tale. Rather than
fighting devils with devils, Ginsberg managed to change the form of the
drama itself, and a light suddenly fell from a window no one had noticed.
The story of our poetry need not be finished in one man's life. Ginsberg
calls the light out of Pound's labor; the forces of decay will strip away the
'stupidity and ignorance.' The servant of the gift may yet regain his voice
and feel, with each word that leaves his body, his own worth return to him
as undivided light.

* One of Pound's last pieces of writing was a clarification: 'Re USURY. I was out of focus,
taking a symptom for a cause. The cause is AVARICE.'

CONCLUSION

It has been the implication of much of this book that there is an irreconcilable conflict between gift exchange and the market, and that, as a consequence, the artist in the modern world must suffer a constant tension between the gift sphere to which his work pertains and the market society which is his context. Such, at any rate, were my assumptions when I began to write. I not only placed creative life wholly within the gift economy, but I assumed that the artist of enduring gifts would be one who managed to defend himself against all temptations to commercialize his calling.

My position has changed somewhat. I still believe that the primary commerce of art is a gift exchange, that unless the work is the realization of the artist's gift and unless we, the audience, can feel the gift it carries, there is no art; I still believe that a gift can be destroyed by the marketplace. But I no longer feel the poles of this dichotomy to be so strongly opposed. In working out the details of the chapter on usury, in particular, I came to understand that gift exchange and the market need not be wholly separate spheres. There are ways in which they may be reconciled, and if, like the Jews of the Old Testament, we are a community that deals with strangers, or if, like Ezra Pound, we are artists living in a market society, it is the reconciliation we must seek. One of the lessons of Pound's life, certainly, is that there is little to be gained by a wholesale attack on the market. We can sometimes limit the scope of its influence, but we cannot

change its nature. The market is an emanation of *logos*, and *logos* is as much a part of the human spirit as *eros* is; we can no more do away with it than Pound could keep Hermes out of his head – or out of Europe.

The reader may remember that in order to introduce the idea of usury I imagined a tribe with a boundary drawn around it. In the center of the tribe, goods circulate as gifts and reciprocity is positive. Outside the tribe, goods move through purchase and sale, value is reckoned comparatively, and reciprocity is negative. I initially described the permission to usure as a permission to establish the boundary between these two spheres, to declare an outer limit to the circle of gift exchange. And in earlier, more polemical versions of the chapter I set out to strengthen that boundary, insisting (as Pound insists) that the creative spirit will be wounded if it is not carefully protected from the spirit of stranger trade.

But as I brought this argument into the modern world, my own ideas underwent a bit of a re-formation. I began to understand that the permission to usure is also a permission to trade between the two spheres. The boundary can be permeable. Gift-increase (unreckoned, positive reciprocity) may be converted into market-increase (reckoned, negative reciprocity). And vice versa: the interest that a stranger pays on a loan may be brought into the center and converted into gifts. Put generally, within certain limits what has been given us as a gift may be sold in the marketplace and what has been earned in the marketplace may be given as gift. Within certain limits, gift wealth may be rationalized and market wealth may be eroticized.

During the sixteenth century, Protestant churchmen began the still-unfinished work of defining these 'certain limits.' The Reformation refined the terms of the reconciliation between the two spheres by articulating degrees of reciprocity. The Old Testament (along with the Koran, most tribes, and Ezra Pound) does not differentiate well between degrees of negative reciprocity. Everything is usury. But post-Reformation morality differentiates. There is usury, but there is also interest. The problem is not 'Can gift and commodity coexist?' but 'To what degree may one draw from the other without destroying it?' From the point of view of the market, the white man has a point when he complains about Indians who refuse to invest capital: there can be no market if all wealth is converted into gifts. And from the other side, the Indians have a point when they resist the conversion of all gifts to commodities: there is a degree of commercialization which destroys the community itself. But between these two

extremes lies a middle ground in which, sometimes, *eros* and *logos* may coexist.

I posed a dilemma at the beginning of this book: How, if art is essentially a gift, is the artist to survive in a society dominated by the market? Modern artists have resolved this dilemma in several different ways, each of which, it seems to me, has two essential features. First, the artist allows himself to step outside the gift economy that is the primary commerce of his art and make some peace with the market. Like the Jew of the Old Testament who has a law of the altar at home and a law of the gate for dealing with strangers, the artist who wishes neither to lose his gift nor to starve his belly reserves a protected gift-sphere in which the work is created, but once the work is made he allows himself some contact with the market. And then – the necessary second phase – if he is successful in the marketplace, he converts market wealth into gift wealth: he contributes his earnings to the support of his art.

To be more specific, there are three primary ways in which modern artists have resolved the problem of their livelihood: they have taken second jobs, they have found patrons to support them, or they have managed to place the work itself on the market and pay the rent with fees and royalties. The underlying structure that is common to all of these – a double economy and the conversion of market wealth to gift wealth – may be easiest to see in the case of the artist who has taken a secondary job, some work more or less unrelated to his art – night watchman, merchant seaman, Berlitz teacher, doctor or insurance executive . . . The second job frees his art from the burden of financial responsibility so that when he is creating the work he may turn from questions of market value and labor in the protected gift-sphere. He earns a wage in the marketplace and gives it to his art.

The case of patronage (or nowadays, grants) is a little more subtle. The artist who takes a second job becomes, in a sense, his own patron: he decides his work is worthy of support, just as the patron does, but then he himself must go out and raise the cash. The artist who manages to attract an actual patron may seem to be less involved with the market. The patron's support is not a wage or a fee for service but a gift given in recognition of the artist's own. With patronage, the artist's livelihood seems to lie wholly within the gift-sphere in which the work is made.

But if we fail to see the market here, it is because we are looking only at the artist. When an artist takes a second job, a single person moves in

both economies, but with patronage there is a division of labor – it is the patron who has entered the market and converted its wealth to gifts. Once made, the point hardly needs elaboration. Harriet Shaw Weaver, that kindly Quaker lady who supported James Joyce, did not get her money from God; nor did the Guggenheims, nor does the National Endowment for the Arts. Someone, somewhere sold his labor in the marketplace, or grew rich in finance, or exploited the abundance of nature, and the patron turns that wealth into a gift to feed the gifted.

Artists who take on secondary jobs and artists who find patrons have, in a sense, a structural way to mark the boundary between their art and the market. It is not hard to distinguish between writing poems and working the night shift in a hospital, and easier still for the poet to know he is no Guggenheim. But the artist who sells his own creations must develop a more subjective feel for the two economies and his own rituals for both keeping them apart and bringing them together. He must, on the one hand, be able to disengage from the work and think of it as a commodity. He must be able to reckon its value in terms of current fashions, know what the market will bear, demand fair value, and part with the work when someone pays the price. And he must, on the other hand, be able to forget all that and turn to serve his gifts on their own terms. If he cannot do the former, he cannot hope to sell his art, and if he cannot do the latter, he may have no art to sell, or only a commercial art, work that has been created in response to the demands of the market, not in response to the demands of the gift. The artist who hopes to market work that is the realization of his gifts cannot begin with the market. He must create for himself that gift-sphere in which the work is made, and only when he knows the work to be the faithful realization of his gift should he turn to see if it has currency in that other economy. Sometimes it does, sometimes it doesn't.*

A single example will illustrate several of these points. For years before he established himself as a painter, Edward Hopper used to hire himself out as a commercial artist to magazines with names like *Hotel Management*. Hopper was an expert draftsman, and the illustrations and covers he drew during those years are skillfully rendered. But they are not art. They certainly have none of Hopper's particular gift, none of his insight, for example, into the way that incandescent light shapes an American city at

* Artists who sell their work commonly take on an agent as a way of organizing this double economy: the artist labors with his gift and his agent works the market.

night. Or perhaps I should put it this way: any number of out-of-work art students could have drawn essentially the same drawings. Hopper's magazine covers – happy couples in yellow sailboats and businessmen strolling the golf links – all have the air of assignments, of work for hire. Like the novelist who writes genre fiction according to a proven formula, or the composer who scores the tunes for television commercials, or the playwright flown in to polish up a Hollywood script, Hopper's work for the magazines was a response to a market demand, and the results are commercial art.

During his years as a commercial artist, Hopper created for himself what I have called the 'protected gift-sphere' by spending only three or four days a week at the magazines and painting at home the rest of the time. He would, of course, have been happy to sell his gift-sphere work on the market, but there were no buyers. In 1913, when he was thirty-one years old, he sold a painting for $250; he sold none for the next ten years. Then, between 1925 and 1930, he began to earn a living by his art alone.

In a sense Hopper's work for the magazines should be considered not a part of his art at all but a second job taken to support his true labors. But the point is that even when a market demand for his true art developed, Hopper still preserved the integrity of his gifts. It may be hard to formulate a rule of thumb by which to know when an artist is preserving his gifts and when he is letting the market call the tune, but we know the distinction exists. Hopper could have made a comfortable living as a commercial artist, but he didn't. He could have painted his most popular works over and over again, or he could have had them photographed and, like Salvador Dali, sold signed gold-flecked reproductions. But he didn't.

It is not my intention here to address the problems and subtleties of the various paths by which artists have resolved the problem of making a living. There are second jobs that deaden the spirit, there are artists who become beholden to their patrons and those whose temperament prohibits them from selling the work at all. But these and all the other ins and outs of artistic livelihood are topics for a different sort of book, one addressed to questions of arts policy or offering advice to working artists. The only point I want to add here is a general one, and that is that each of the paths I have described is most often a way of getting by, not a way of getting rich. No matter how the artist chooses, or is forced, to resolve the problem of his livelihood, he is likely to be poor. Both Whitman and Pound make good examples. Neither man ever made a living by his art. Whitman's

description of the 'sort of German or Parisian student life' he lived in Washington during the Civil War could be translated almost verbatim to Pound during his years in London and Paris, living in little rented rooms, wearing flamboyant but secondhand clothes, straining his coffee through a cloth in the morning, building his own furniture. (By Pound's own estimation, one of the attractions of Europe was its acceptance of an artist's limited means. Remember his letter to Harriet Monroe: 'Poverty here is decent and honourable. In America it lays one open to continuous insult on all sides.')

At one time or another during their lives both Whitman and Pound took on some sort of secondary employment. Whitman, when he was writing the early drafts of *Leaves of Grass*, edited newspapers, wrote free-lance journalism, ran a printing office and a stationery store, and worked as a house carpenter. Pound, too, hired out as a journalist. All during the First World War he was paid four guineas a month to churn out articles (two a week, year after year) for *The New Age*, a Social Credit newspaper. But for both men these were essentially bread-and-butter jobs, taken out of need and quit when need was relieved.

Nor was there any significant, concerted patronage in those days, at least not in America. In 1885 a group of Whitman's admirers bought the then-crippled poet a horse and phaeton so that he would not be confined to his house; at about the same time the nearby Harleigh cemetery donated the ground upon which the poet had his tomb erected. And this just about completes the list of return gifts America offered its earliest poet. Pound fared only a little better. The $2,000 Dial Prize was the single significant reward that he received before he was old and confined to St Elizabeths Hospital. Much later there were other awards – a $5,000 grant from the Academy of American Poets in 1963, for example – but again, we cannot say we are speaking of a man made rich by his patrons.

Finally, although both Whitman and Pound realized a modest income from the sale of their works in the last years of their lives, there were no returns when these men were young and most in need. Whitman lost money on the first edition of *Leaves of Grass*; Pound's American royalties for a typical year – 1915 – came to $1.85.

In sum we have two poets, each of whom was clearly a major figure in his century, known and read during his lifetime, each of whom at one time or another took on secondary work in support of his art, each of whom was happy to accept what little patronage was offered to him, each

of whom was an eager entrepreneur of his own creations – and each of whom was essentially poor into old age.

If we are to speak fully of the poverty of artists, we must pause here to distinguish between actual penury and 'the poverty of the gift.' By this last I intend to refer to an interior poverty, a spiritual poverty, which pertains to the gifted state. In that state, those things that are not gifts are judged to have no worth, and those things that are gifts are understood to be but temporary possessions. As I indicated in my chapter on the labor of gratitude, there is a sense in which our gifts are not fully ours until they have been given away. The gifted man is not himself, therefore, until he has become the steward of wealth which appears from beyond his realm of influence and which, once it has come to him, he must constantly disburse. Leviticus records the Lord's instruction to Moses: 'The land shall not be sold in perpetuity, for the land is mine; for you are strangers and sojourners with me.' Likewise, we are sojourners with our gifts, not their owners; even our creations – especially our creations – do not belong to us. As Gary Snyder says, 'You get a good poem and you don't know where it came from. "Did I say that?" And so all you feel is: you feel humility and you feel gratitude.' Spiritually, you can't be much poorer than gifted.

The artist who has willingly accepted such an interior poverty can tolerate a certain plainness in his outer life. I do not mean cold or hunger, but certainly the size of the room and the quality of the wine seem less important to a man who can convey imaginary color to a canvas. When the song of one's self is coming all of a piece, page after page, an attic room and chamber pot do not insult the soul. And a young poet can stand the same supper of barley soup and bread, night after night, if he is on a walking tour of Italy and much in love with beauty. Artists whose gifts are strong, accessible, and coming over into their work may, as Marshall Sahlins says of hunters and gatherers, 'have affluent economies, their absolute poverty notwithstanding.'

I do not mean to romanticize the poverty of the artist, or pretend to too strong a link between this state of mind and 'the facts.' A man may be born rich and still be faithful to his gifts; he may happen upon a lucrative second job; his work may be in great demand or his agent a canny salesman. Actual poverty and interior poverty have no necessary connection. And yet, as we all know, and as the lives of Whitman and Pound testify, the connection is not unknown, either. For one thing, fidelity to one's gifts often draws energy away from the activities by which men become rich.

For another, if the artist lives in a culture which is not only dominated by exchange trade but which has no institutions for the conversion of market wealth to gift wealth, if he lives in a culture that cannot, therefore, settle the debt it owes to those who have dedicated their lives to the realization of a gift, then he is likely to be poor in fact as well as in spirit. Such, I think, is a fair description of the culture into which both Whitman and Pound were born. Theirs was hardly an age of patronage, as my brief list of return gifts indicates; nor was theirs a time that would have likely understood that Trobriand social code, 'to possess is to give.' Theirs – and ours – was the age of monopoly capitalism, an economic form whose code expected and rewarded the conversion of gift wealth to market wealth (the natural gifts of the New World, in particular – the forests, wildlife, and fossil fuels – were 'sold in perpetuity' and converted into private fortunes). In a land that feels no reciprocity toward nature, in an age when the rich imagine themselves to be self-made, we should not be surprised to find the interior poverty of the gifted state replicated in the actual poverty of the gifted. Nor should we be surprised to find artists who, like Whitman and Pound, seek to speak to us in that prophetic voice which would create a world more hospitable to the creative spirit.

The root of our English word 'mystery' is a Greek verb, *muein*, which means to close the mouth. Dictionaries tend to explain the connection by pointing out that the initiates to ancient mysteries were sworn to silence, but the root may also indicate, it seems to me, that what the initiate learns at a mystery *cannot* be talked about. It can be shown, it can be witnessed or revealed, it cannot be explained.

When I set out to write this book I was drawn to speak of gifts by way of anecdotes and fairy tales because, I think, a gift – and particularly an inner gift, a talent – is a mystery. We know what giftedness is for having been gifted, or for having known a gifted man or woman. We know that art is a gift for having had the experience of art. We cannot know these things by way of economic, psychological, or aesthetic theories. Where an inner gift comes from, what obligations of reciprocity it brings with it, how and toward whom our gratitude should be discharged, to what degree we must leave a gift alone and to what degree we must discipline it, how we are to feed its spirit and preserve its vitality – these and all the other questions raised by a gift can only be answered by telling Just So stories. As

Whitman says, 'the talkers talking their talk' cannot explain these things; we learn by 'faint clues and indirections.'

A final story, then, of gifts and art.

In an essay called 'Childhood and Poetry,' Pablo Neruda once speculated on the origins of his work. Neruda was raised in Temuco, a frontier town in southern Chile. To be born in Temuco in 1904 must have been a little like being born in Oregon a hundred years ago. Rainy and mountainous, 'Temuco was the farthest outpost in Chilean life in the southern territories,' Neruda tells us in his memoirs. He remembers the main street as lined with hardware stores, which, since the local population couldn't read, hung out eye-catching signs: 'an enormous saw, a giant cooking pot, a Cyclopean padlock, a mammoth spoon. Farther along the street, shoe stores – a colossal boot.' Neruda's father worked on the railway. Their home, like others, had about it something of the air of a settlers' temporary camp: kegs of nails, tools, and saddles lay about in unfinished rooms and under half-completed stairways.

Playing in the lot behind the house one day when he was still a little boy, Neruda discovered a hole in a fence board. 'I looked through the hole and saw a landscape like that behind our house, uncared for, and wild. I moved back a few steps, because I sensed vaguely that something was about to happen. All of a sudden a hand appeared – a tiny hand of a boy about my own age. By the time I came close again, the hand was gone, and in its place there was a marvellous white toy sheep.

'The sheep's wool was faded. Its wheels had escaped. All of this only made it more authentic. I had never seen such a wonderful sheep. I looked back through the hole but the boy had disappeared. I went into the house and brought out a treasure of my own: a pine cone, opened, full of odor and resin, which I adored. I set it down in the same spot and went off with the sheep.

'I never saw either the hand or the boy again. And I have never seen a sheep like that either. The toy I lost finally in a fire. But even now . . . whenever I pass a toyshop, I look furtively into the window. It's no use. They don't make sheep like that any more.'

Neruda has commented on this incident several times. 'This exchange of gifts – mysterious – settled deep inside me like a sedimentary deposit,' he once remarked in an interview. And he associates the exchange with his poetry. 'I have been a lucky man. To feel the intimacy of brothers is a marvellous thing in life. To feel the love of people whom we love is a fire

that feeds our life. But to feel the affection that comes from those whom
we do not know, from those unknown to us, who are watching over our
sleep and solitude, over our dangers and our weaknesses – that is some-
thing still greater and more beautiful because it widens out the boundaries
of our being, and unites all living things.

'That exchange brought home to me for the first time a precious idea:
that all humanity is somehow together . . . It won't surprise you then that
I have attempted to give something resiny, earthlike, and fragrant in
exchange for human brotherhood . . .

'This is the great lesson I learned in my childhood, in the backyard of
a lonely house. Maybe it was nothing but a game two boys played who
didn't know each other and wanted to pass to the other some good things
of life. Yet maybe this small and mysterious exchange of gifts remained
inside me also, deep and indestructible, giving my poetry light.'

AFTERWORD

to the Canongate edition of *The Gift*

The Gift was written between 1977 and 1982 and published in 1983. It contains very little topical detail from those years, my hope at the time being to write what might be called a 'prophetic essay,' a rather grand way of saying that I intended to describe something that was the case no matter the decade rather than something contingently true. Nor, therefore, is *The Gift* a very practical book. It describes a problem – the disconnect between the practice of art and common forms of earning a living – but it refrains from exploring a resolution. That restraint is of a piece with the ahistorical impulse, of course, for most solutions are of their time and will vary as the times vary.

All of this notwithstanding, since *The Gift* first appeared I have sometimes been asked to speak to the puzzle of supporting creative work in the present moment. What may be the least obvious part of my current response to that question is this: I've come to believe that, when it comes to how we imagine and organize support for creative work, the pivotal event in my lifetime was the 1989 fall of the Soviet Union. To expand on that assertion, it will help to begin by restating two of *The Gift*'s motivating assumptions.

The first is simply that there are categories of human enterprise that are not well organized or supported by market forces. Family life, religious

life, public service, pure science, and of course much artistic practice: none of these operates very well when framed simply in terms of exchange value. The second assumption follows: that any community that values these things will find non-market ways to organize them. It will develop gift-exchange institutions dedicated to their support.

Take the example of pure science, that is to say, science that puzzles over questions whose answers can have no obvious utility. What is the shape of the planetary orbits? What is the sequence of the inert parts of the human genome? The funding for pure science cannot come simply from those who hope for future income. Sir Isaac Newton answered the question about planetary orbits while supported by Trinity College, Cambridge. He was elected a Fellow there in 1667, a position that entitled him to wages, a room, and the use of the library. He later became the Lucasian Professor, a sinecure that remained intact even when he moved to London and ceased to teach and lecture. In London, the king eventually extended his patronage, making Newton Warden and then Master of the Mint, a lucrative appointment.

As for the sequencing of the human genome, commercial science played a role but its aims were quite particular. The genome is vast, and the profit-seeking wing of the sequencing enterprise balkanized the territory, looking only for the profitable sites. The fullness of the genome was only described by the public Human Genome Project, and that was supported by philanthropic gifts (mostly from the Wellcome Trust in England) and by government funding (mostly the National Institutes of Health in the U.S.).

Not surprisingly, the institutions that support such noncommercial enterprises will change over time. If we tire of the focused patronage of an established church, we may separate church and state and give a tax exemption to all denominations. If we don't like royal patronage we may turn to private philanthropy. If the privately endowed colleges serve only the elite, we may turn to state and community colleges supported by the public purse. More broadly, where church or crown or private endowments do not meet our needs, we may turn to what might be called 'democratic patronage.' Public education, public hospitals, public libraries, pure science, the arts, and the humanities: in the last century, all of these have been underwritten by democratic communities that tax themselves to support things of value that would not otherwise thrive.

Which brings me back to the fall of the Soviet Union, for it was the Cold War that energized much of the public funding devoted to art and science in the decades after World War II. In my own country at least (and I must

confine my remarks to the American case, that being the only one I know well), these were the years when our leaders felt called upon to show off the liberal, capitalist state, and contrast its vitality with the banality of the Eastern bloc. Neutral nations and Eastern-bloc dissidents were meant to see the remarkable energy and innovation that the West's freedoms produced. In the case of support for the arts, the organizing opposition was well expressed in a 1952 *New York Times Magazine* essay by the founding director of the Museum of Modern Art, Alfred Barr: 'The modern artists' nonconformity and love of freedom cannot be tolerated within a monolithic tyranny and modern art is useless for the dictator's propaganda.'

The history of this period of what I now think of as 'democratic-propaganda patronage' falls into at least three phases, a series of responses to the question that Barr used as the title of his essay, 'Is Modern Art Communistic?' Barr argued the negative, setting American freedom and nonconformity against the Soviet's totalizing impulse, but his position held no sway in the U.S. Congress. Elected officials in the United States regularly attacked the arts ('All modern art is Communistic,' declared one Missouri congressman) and when the U.S. State Department tried to include artwork in its cultural diplomacy the Congress directly undercut the effort. The exemplary moment came in 1947 when an exhibition of modern painting called 'Advancing American Art' (including work by Georgia O'Keeffe and Arshile Gorky) traveled to Europe, first to Paris and then to Prague, where the Russians felt called-upon to mount a rival exhibition. They needn't have bothered, for the exhibition was sufficiently opposed at home, described in Congress as having been assembled by 'the Communists and their New Deal fellow travelers.' The tour was canceled and the art work sold as surplus government property at five percent of its value.*

Thus did Phase One of postwar cultural support really begin, the covert phase, for when Congress failed to support American cultural propaganda, the CIA stepped in. As the director of the CIA's International Organizations Division later remarked of one congressional opponent: 'He made it very difficult to get Congress to go along with some of the things that we wanted to do – send art abroad, send symphonies abroad, publish magazines abroad,

* An amusing echo of this debacle was heard many years later: in 1948 one of the tour's 'surplus' paintings, Stuart Davis's 'Still Life With Flowers,' was bought for a high school in Chicago by one of its art teachers. The price was $62.50. In 2006 the school sold the painting at auction for $3.1 million.

whatever. That's one of the reasons why it had to be done covertly . . . In
order to encourage openness we had to be secret.'

What the CIA actually managed to do has been told in Frances Stonor
Saunders' book, *The Cultural Cold War*, which describes at length the inter-
locking structures of cultural and political power found in the U.S. in the
1950s. Nelson Rockefeller was well connected to both worlds and so played
a key role. He had been, for example, wartime head of the intelligence
agency for Latin America, and that agency, in turn, had sponsored touring
exhibitions of contemporary American painting, tours that were mostly
organized by the Museum of Modern Art where Rockefeller also served
variously as trustee, treasurer, president, and chairman of the board. The
1950s CIA was particularly keen on Abstract Expressionism, which
Rockefeller himself famously described as 'free enterprise painting.' As one
Agency staffer later reported, 'we recognized that this was the kind of art
that did not have anything to do with socialist realism, and made socialist
realism look even more stylized and more rigid and confined . . . ' Not that
there was ever any direct support to artists like Jackson Pollock, or any
formal agreements between the CIA and the museums. 'For matters of this
sort,' the staffer goes on to say, it 'could only have been done through the
organizations or the operations of the CIA at two or three removes . . . '

As for 'the organizations,' the most famous was the Congress of Cultural
Freedom, which covertly sponsored a highbrow intellectual journal,
Encounter, paid the expenses of American and European intellectuals to
attend international conferences, and supported the foreign distribution
of American literary and cultural journals such as *Partisan Review, Kenyon
Review, Hudson Review,* and *Sewanee Review*. In the early 1960s, when the
Kenyon Review was edited by Robie Macauley, its circulation jumped from
2,000 to 6,000. Macauley had actually worked for the CIA before he took
over the *Review* from its founding editor, John Crowe Ransom, and was
later to boast that he had 'found ways of making money that Mr. Ransom
had never thought of.'

This period of covert funding came to an end with the Soviet's successful
launch of the first earth-orbiting satellite, and with the election of John
F. Kennedy as U.S. President. After Sputnik, the U.S. government poured
public dollars into scientific research, and that eased the way for similar
support to the arts and humanities. President Kennedy, in turn, was a
politician disposed to support the kind of open cultural diplomacy that
had disappeared a decade earlier. He invited Robert Frost to read at his

inauguration and later, at the Frost Library in Amherst, defended American cultural freedoms in terms of the standard opposition to communist oppressions, extolling the artist as 'last champion of the individual mind and sensibility against an intrusive society and an officious state.' After Pablo Casals played his cello at the White House, Arthur Schlesinger, Jr. declared the event 'of obvious importance . . . in transforming the world's impression of the United States as a nation of money-grubbing materialists.'

Such was the philosophy that guided the next quarter-century of public patronage, a period when Democrats and Republicans read from the same playbook. Lyndon Johnson, impressed with the goodwill Kennedy received for supporting the arts, signed the law that brought the National Endowment for the Arts into being. Richard Nixon doubled its budget. All deployed the rhetoric of the Cold War. Typical would be a remark by Gifford Phillips, trustee of the Phillips Collection in Washington: 'The artist has a special need to live outside of society . . . Whenever there is an official attempt to destroy this detachment, as there has been in the Soviet Union, for example, art is likely to suffer . . . '

Oddly, as the critic Michael Brenson has pointed out, it was always assumed that such detached and materially disinterested outsiders would never find themselves in conflict with America itself. It was as if the more 'outside' the artist went, the more fully would he or she embody the transcendent values of capitalist democracy. The seemingly asocial eccentric in his cabin at the edge of town is not actually 'outside' his country; quite the opposite: he inhabits the True America, the one the Soviets can never see if they focus only on the money-grubbing side of capitalism. 'We are the last civilized nation on the earth to recognize that the arts and the humanities have a place in our national life,' declared a New Jersey congressman in 1965. Twenty years earlier, Georgia O'Keeffe's work might have been sold as government surplus; now it could easily be the emblem of civilization itself, and her studio at Ghost Ranch in New Mexico its last outpost.

The ideological anomalies of this period aside, the institutions of overt democratic patronage arose from a wisdom worth preserving. In the U.S., the 1965 enabling legislation for the arts and humanities endowments articulated worthy goals: 'While no government can call a great artist or scholar into existence, it is necessary and appropriate for the federal government to help create and sustain not only a climate encouraging freedom of thought, imagination, and inquiry, but also the material conditions facilitating the

release of this creative talent.' This seems exactly right; the problem lies in the context of its expression, the long season of democratic-propaganda patronage during which, despite the well-put ideal, the arts and sciences were not supported as ends in themselves, but as players in a larger political drama.

Of that context one could say, to put it positively, that the Soviet Union turned out to provide a useful counterforce to the harsher realities of capitalism. It goaded the West into provisioning those parts of social life not well served by market forces. To put it negatively, however, if Cold War rhetoric lay at the foundation, then the entire edifice was historically vulnerable. Thus when the Soviet Union fell in 1989 so did the bulk of public patronage in the West. In the U.S., for example, we almost immediately got the attacks on the National Endowment for the Arts and the loss of nearly all funding to individual artists. A similar if less publicized story played out in basic science. In a 1998 interview Leon Lederman, Nobel laureate in physics, said: 'We always thought, naïvely, that here we are working in abstract, absolutely useless research and once the Cold War ended, we wouldn't have to fight for resources. Instead, we found, we *were* the Cold War. We'd been getting all this money for quark research because our leaders decided that science, even useless science, was a component of the Cold War. As soon as it was over, they didn't need science.'

In short, around 1990 the third phase of this history began, an era of market triumphalism in which not only has public support of the arts and sciences begun to dry up but those who stilled their voices during the Cold War, those who have long believed in an unlimited market, have felt free to advance unselfconsciously.

In instance after instance, public institutions have been encouraged to think of themselves as private businesses. The universities have set up 'technology transfer offices' and tried to fund themselves by selling knowledge rather than simply disseminating it, as their old mission statements once asked them to do. Grammar schools have learned that they can sell exclusive rights to soft-drink vendors intent on creating brand loyalty in the very young. Public radio and television are now cluttered with advertising. Even commercial television has become more so: in the U.S., the networks once limited their ads to nine minutes an hour; they gave that up in the last decade and ads now run eighteen minutes in prime time.

Natural abundance has been similarly commercialized, everywhere

subject to the grid of artificial scarcity. Ancient aquifers, by rights belonging
to all who live above them, are now pumped and packaged. Drinking water,
once an essence of life, has become a resource to be sold in little plastic
bottles. Broadcast spectrum, one of nature's richest gifts, has been parceled
out to industry and then sold back to the public.

Our cultural abundance suffers the same fate. The ever-expanding reach
of copyright has removed more and more art and ideas from the public
domain. The Walt Disney Company happily built its film empire out of folk
culture ('Snow White,' 'Pinocchio') but any folk who try to build on Disney
can expect a 'cease and desist' letter in the next mail. Patents are now used
to create property rights in things once thought inalienable – seedlings,
human genes, medicines long known to indigenous cultures. A company
that makes jam recently got itself a patent on the crustless peanut butter-
and-jelly sandwich.

This period of market triumphalism has, in sum, seen a successful move
to commercialize a long list of things once thought to have no price, and
to enclose common holdings, both natural and cultural, that we used to
assume no one was allowed to take private. All of which seems quite grim,
but only, I think, if we forget that history brought these changes and that
history continues to unfold. As I said before, gift-institutions supporting
the noncommercial portion of our lives will change as the times change.
None of us wants to return to the days when a great scientist had to hope
the king might make him Master of the Mint, nor – if we care for the arts
and sciences as ends in themselves – should we pine for the days of
patronage as propaganda. If we want our institutions to have the longevity
they deserve, then the commercial side of our culture needs to be met with
an indigenous counterforce, not a foreign one.

To close this excursion into matters topical and practical, then, let me
point to a necessarily limited sample of places where the commercial and
the noncommercial are found in better balance. A good number may be
seen on the internet, itself a post-Soviet surprise of history if there ever
was one. Numerous projects on the web have the structures and fertility
of gift communities. There are many examples, from the open-source soft-
ware movement to the donated labor supporting political blogs to the 'NASA
Clickworkers,' a set of over 85,000 anonymous, untrained volunteers who
helped classify all the craters on NASA's maps of Mars.

Or take the Public Library of Science. This web-based publishing venture
has protocols reminiscent of the scientific community as described in Chapter

V. There I write that papers published in scientific journals are called 'contributions' for good reason; 'they are in fact, gifts,' as one theorist says, gifts to a community whose currency is the merit that a scientist acquires when her ideas are accepted and passed along.

This gift ethic never extended, however, to the actual printing and distribution of scientific journals. On the contrary, the cost of subscribing to these journals has been a growing problem for many libraries (the price of publications in science rose by about 260% during the 1990s). A one-year subscription to *The American Journal of Human Genetics* now costs over $ 1,000, and a good science library needs scores of such subscriptions. At current rates, poorly endowed colleges and, more importantly, the poorer nations, literally cannot afford to enter the scientific community, no matter its internal ethic of generosity.

Internet publication has provided a solution. In 2000 a group of biomedical scientists, including Nobel laureate Harold E. Varmus, began urging scientific publishers to make all research available for free distribution online. When the publishers resisted, the group simply worked around them and in 2003 launched a nonprofit web publishing venture, the Public Library of Science. By now there are six on-line journals (*PLoS Biology*, *PLoS Medicine*, *PLoS Genetics*, and others). These are not web logs or chat rooms or sites where people may post whatever they wish; they are well-edited, peer-reviewed journals publishing original research, as with traditional journals. The difference is that PLoS journals are 'open access,' meaning that the authors grant to all users 'a free, irrevocable, worldwide, perpetual right of access' to their work. 'Everything we publish is freely available online throughout the world,' say the editors, 'for you to read, download, copy, distribute, and use (with attribution) any way you wish. No permission required.'

The Public Library of Science has added 'publishing as gift-exchange' to the older idea of 'research as gift-exchange.' Nor, I might add, is gift-exchange at odds with commerce in this case; the editors allow commercial reuse of their journals' content. In the introduction to *The Gift* I say that art works exist in two economies, though one is primary; the same might be said of scientific knowledge in the Public Library model: commerce is not excluded, but it follows after contributions are made, it does not come first.

To present my second example of a new noncommercial institution I need to back up and describe a little-known piece of the history of support

for the arts. In modern times, young artists in need of help have tradition-
ally received support either from public coffers or from private fortunes.
The question is, might there be a third path? Might not the art world itself
hold wealth sufficient to support emerging talents?

An interesting experiment in that line was initiated shortly after the
Second World War when musicians in the United States began to worry
that the popularity of long-playing records would cut into their perform-
ance income. What if every time the band goes to the recording studio all
they are doing is playing themselves out of half of next year's jobs?
Responsive to such concerns, the musicians union worked out an innova-
tive agreement with the recording companies such that a small percentage
of the sale of each recording would go into a trust fund, the fund then
being used to augment the income of musicians playing live performances.

After half a century this institution, the Music Performance Fund, still
exists. It distributes millions of dollars annually, and supports thousands
of concerts in the United States and Canada. It's the largest sponsor of live,
admission-free music in the world. In recent years it has also developed a
Scholarship Fund to help pay for the training of young musicians.

What I like especially about the Music Performance Fund is its recycling
feature, the wealth moving in a circle. That small percentage of the
commerce that goes into the Performance Fund is a kind of self-tithing
that the community has accepted so as to support its members, and to
support musical culture in general (most of the performances are given
for young people in schools). As a result, the recording industry is not
purely extractive; the business side itself agrees to support the cultural
ecology that nurtures musicians in the first place.

More to the point, I like the revealed fact that artists need not always
go begging to taxpayers or private patrons; *the arts themselves produce wealth*
and therefore, if we have the wit to organize the needed institutions, the
arts ought to be able to support the arts.* In the United States, 'The Arts
Endowing the Arts Act' was, in fact, the name given to a legislative proposal
that – had it been realized – would have nicely reproduced the structure
of the Music Performance Fund.

In 1994, U.S. Senator Christopher Dodd of Connecticut proposed a

* Actually, wit may not be the key ingredient; power helps. It was the American Federation
of Musicians that got the Music Performance Fund started as part of their collective
bargaining with the recording industry. The loss of union power is another chapter of the
recent saga of market triumphalism.

cunning way to use the value of past intellectual property to support artists and scholars working in the present. Dodd's suggested legislation would have added twenty years to the term of copyright protection, and used the income from those extra years to underwrite current creative work. At the time, American copyright protected an individual's work for his or her lifetime, plus fifty years; corporations with works 'made for hire' (most films, for example) held rights for seventy-five years. Under the Dodd proposal, at the end of each of these terms, the rights to an additional twenty years would have been publicly auctioned, the proceeds going to build endowments for the arts and humanities.

Copyright has always had a double function. It encourages creativity and, because its term is limited, it brings creative work into the public domain. It treats such work as a private good for a term, and then as a public or common good in perpetuity. What the Dodd proposal would have done, in effect, is to add a middle term between the private and public, a transition period during which wealth generated by copyright would underwrite currently active creative talent. Or, to put it another way, for a limited period we would consider 'the public' to be those men and women who are currently dedicating their lives to the arts and humanities, those who are most directly the aesthetic and intellectual heirs of the past, and who will most directly be the benefactors of any future cultural commons.

The logic of Senator Dodd's proposal, then, replicates the logic of creative life itself, in which the past feeds the present and the present will before long contribute to artists not yet born. It is all the more distressing then that in 1998, in another striking example of post-Cold War market triumphalism, the entertainment industry in the U.S. managed to outflank Dodd and his allies and persuade the U.S. Congress to substitute for 'Arts Endowing the Arts' their own 'Copyright Term Extension Act,' one that has added twenty years (retroactively!) to all copyright terms without any provision for the public domain side of the old balance between private wealth and common wealth. The Walt Disney Corporation lobbied heavily for this law; their early Mickey Mouse cartoons would have entered the public domain in 2003. Thanks to 'The Mickey Mouse Protection Act,' as it is now known, they are safe until 2023.

This sorry bit of statutory theft notwithstanding, the art–wealth recycling feature of both the Music Trust Fund and the Dodd proposal has been on my mind for a long time, and I tend to mention it whenever I am asked to speak to the question of how we are to empower the gifted in a world

dominated by market exchange. On one such occasion, a 1996 talk I gave in Providence, Rhode Island, Archibald Gillies and Brendan Gill happened to be in the audience. They were at the time the president and chairman, respectively, of the Andy Warhol Foundation for the Visual Arts, and it turned out that the Warhol Foundation was just then looking around for new funding models. I soon joined them in a more sustained conversation about what initiatives might be undertaken, especially given the post-Cold War loss of so much public funding for individuals in the visual arts. The result, after two years of brainstorming and fund raising, was a new nonprofit granting agency, the Creative Capital Foundation that since 1999 has been giving direct support to individual artists in film, video, literature, and the performing and visual arts.

Creative Capital differs from other arts organizations in several respects. For one thing, we make a multiyear commitment to the artists we support, extending and renewing grants where we can, and providing advisory services and professional assistance along with financial support. We ask that artists make a budget for their projects, one that includes fair value for their time; we help them find and negotiate with galleries; we suggest they insure their studios, and so forth. One Creative Capital grantee, whose studio was destroyed during the 9/11 attack on New York, had insured her space only months before.

Secondly, in line with the hope that the arts might support the arts, Creative Capital grantees agree to share a small percentage of any net profits generated by their projects with Creative Capital, which then applies those funds toward new grants. In designing this give-back portion of the program we had in mind not only the models I have just described but also the ethic by which the producer and director Joseph Papp used to manage the Public Theater in New York.

Papp's habit was to underwrite a great many theater productions and take a small ownership stake in each. Those that succeeded helped pay for those that came later. In the most famous example, *A Chorus Line* began at the Public Theater and then went to Broadway, opening in the summer of 1975. It ran without interruption for fifteen years, a commercial success that allowed Papp to support the work of less-established playwrights and companies. David Mamet, Sam Shepard, Elizabeth Swados, the Mabou Mines theater group and dozens more received support during the years that Papp managed the Public.

Potential profitability is not a criterion for funding awards at Creative

Capital; as with other arts funders, we ask our panels to look for originality, risk-taking, mastery, and so forth; we respond especially to projects
that transcend traditional disciplinary boundaries. That said, the principle
of sharing the wealth is essential to the Creative Capital model. It makes
explicit the assumption that all who have succeeded as artists are indebted
to those who came before, and it offers a concrete way for accomplished
practitioners to give back to their communities, to assist others in attaining
the success they themselves have achieved.

Creative Capital is a small experiment with much that we would like to
improve. In our first eight years we awarded more than $5 million to 242
artist projects, but we still lack an endowment that would make us self-
sustaining (our seed money necessarily came from private philanthropy).
We would dearly love to give larger grants, and more of them; we may well
find that the give-back provision works well with some disciplines and not
with others; and even if it works in a few cases, we may never find our
Chorus Line.

For now, however, the point is less about the particulars of this case
than about the search for practical responses to the general problem posed
by *The Gift*. Some responses will necessarily be fitted to their historical
period; the Music Performance Trust belongs to a time of powerful trade
unions, and the heyday of public support for art and science seems to
belong to the Cold War.

But surely there could also be responses that transcend their time. The
royal patronage that Sir Isaac Newton received may have fallen out of favor,
but other innovations from his day have survived. The idea that colleges
might have endowed professorships has not been lost. Newton was the
Lucasian Professor of Mathematics; that position was created in 1663 by
one Henry Lucas, and it endures to this day (the theoretical physicist
Stephen Hawking is its current occupant). The forums for scientific
discourse that Newton knew have likewise endured. In 1672, Newton sent
a long letter to Henry Oldenburg of the Royal Society in London, an outline
of his theory of light and color. Oldenburg immediately printed the letter
in the *Philosophical Transactions* of the Royal Society. It was Newton's first
scientific publication. *Philosophical Transactions* is the oldest scientific journal
in the English-speaking world, having now published for over 340 years.
Oldenburg was its founding editor. When he started it, it wasn't part of a
scientific community, it *created* a scientific community, and that community has endured.

Lucas and Oldenburg: these are good ancestors for the community of science; their institutions survive and their names are remembered. As for the community of artists, those who can be clear about supporting the arts, not as means to some other end but as ends in themselves; those who can shape that support in response to the gift economy that lies at the heart of the practice; those who have the wit and power and vision to build beyond their own day: for artists, those will be the good ancestors of the generations of practitioners that will follow when we are gone.

Lewis Hyde
Cambridge, Massachusetts
June 2006

BIBLIOGRAPHY

Part I

Bailey, F. G., ed. *Gifts and Poison: The Politics of Reputation*. New York: Schocken, 1971.

Barnett, H. G. 'The Nature of the Potlatch.' *American Anthropologist* 40, no. 3 (July–September 1938): 349–58.

Benveniste, Emile. *Indo-European Language and Society*. Translated by Elizabeth Palmer. Coral Gables: University of Miami Press, 1973.

Blau, Peter. *Exchange and Power in Social Life*. New York: Wiley, 1964.

Boas, Franz. 'The Social Organization and the Secret Societies of the Kwakiutl Indians.' *U.S. National Museum, Annual Report, 1894–1895*. Washington, 1897, pp. 311–738.

Drucker, Philip. *Cultures of the North Pacific*. Scranton, Pa.: Chandler Publishing Co., 1965.

Fox, Renée C., and Swazey, Judith P. *The Courage to Fail: A Social View of Organ Transplants and Dialysis*. Chicago: University of Chicago Press, 1974.

Goody, Jack, and Tambiah, S. J. *Bridewealth and Dowry*. London: Cambridge University Press, 1973.

Goody, Jack, ed. *The Character of Kinship*. London: Cambridge University Press, 1973.

Grimms' German Folk Tales, The. Translated by Francis P. Magoun, Jr., and Alexander H. Krappe. Carbondale: Southern Illinois University Press, 1960.

Hagstrom, Warren O. *The Scientific Community*. New York: Basic Books, 1965.

Hardin, Garrett. *The Limits of Altruism: An Ecologist's View of Survival*. Bloomington: Indiana University Press, 1977.

——. 'The Tragedy of the Commons.' *Science* 162 (1968): 1243–48.

James, Wendy R. 'Sister-Exchange Marriage.' *Scientific American*, December 1975, pp. 84–94.

——. 'Why the Uduk Won't Pay Bridewealth.' *Sudan Notes and Records* 51 (1970): 75–84.

Joll, James. *The Anarchists*. Boston: Little, Brown & Co., 1964.

Lévi-Strauss, Claude. *The Elementary Structures of Kinship*. Translated by James Bell et al. Boston: Beacon Press, 1969.

Malinowski, Bronislaw. *Argonauts of the Western Pacific*. London: George Routledge & Sons, 1922.

Marshall, Lorna. 'Sharing, Talking, and Giving: Relief of Social Tensions Among !Kung Bushmen.' *Africa* (journal of the International African Institute) 31, no. 3 (July 1961): 231–49.

Marx, Karl. *Capital*. Translated by Eden and Cedar Paul. New York: E. P. Dutton, 1930.

Mauss, Marcel. 'Essai sur le don: Forme et raison de l'échange dans les sociétés archaïques,' *L'Année Sociologique* 1 (1923–24), pp. 30–186. Available in English as *The Gift: Forms and Functions of Exchange in Archaic Societies*. Translated by Ian Cunnison. New York: Norton, 1967.

Meister Eckhart by Franz Pfeiffer. Translated by C. de B. Evans. London: John M. Watkins, 1924.

Nelson, Benjamin. *The Idea of Usury: From Tribal Brotherhood to Universal Otherhood*. 2nd rev. ed. Chicago: University of Chicago Press, 1969.

Nestrick, William. 'George Herbert – the Giver and the Gift.' *Ploughshares* 2, no. 4 (Fall 1975), pp. 187–205.

Onians, Richard Broxton. *The Origins of European Thought*. Cambridge: Cambridge University Press, 1951.

Rubin, Gayle. 'The Traffic in Women: Notes on the "Political Economy" of Sex.' In *Toward an Anthropology of Women*. Edited by Rayna R. Reiter. New York: Monthly Review Press, 1975, pp. 157–210.

Sahlins, Marshall. *Stone Age Economics*. Chicago: Aldine Publishing Company, 1972.

Schumaker, Millard. *Accepting the Gift of God*. Kingston, Ontario: Queen's Theological College, 1980.

———. 'Duty.' *Journal of Medical Ethics* 5 (1979): 83–85.

———. 'Loving as Freely Giving.' In *Philosophy and the Human Condition*, edited by Thomas Beauchamp, William Blackston, and Joel Feinberg. Englewood Cliffs, N.J.: Prentice-Hall, 1980.

———. *Moral Poise: Toward a Christian Ethic Without Resentment*. Edmonton, Alberta: St Stephen's College, 1977.

Schürmann, Reiner. *Meister Eckhart, Mystic and Philosopher*. Bloomington: Indiana University Press, 1978.

Scott, Russel. *The Body as Property*. New York: Viking, 1981.

Shell, Marc. *The Economy of Literature*. Baltimore: Johns Hopkins University Press, 1978.

Simmel, Georg. 'Faithfulness and Gratitude.' In *The Sociology of Georg Simmel*, edited by Kurt H. Wolff. Glencoe, Ill.: Free Press, 1950, pp. 379–95.

Simmons, Roberta G.; Klein, Susan D.; and Simmons, Richard L. *The Gift of Life: The Social and Psychological Impact of Organ Transplantation*. New York: John Wiley & Sons, 1977.

Smelser, Neil. 'A Comparative View of Exchange Systems.' *Economic Development and Cultural Change* 7 (1959), pp. 173–82.

Stack, Carol B. *All Our Kin: Strategies for Survival in a Black Community*. New York: Harper & Row, 1974.

Titmuss, Richard. *The Gift Relationship: From Human Blood to Social Policy*. New York: Pantheon, 1971.

Tournier, Paul. *The Meaning of Gifts*. Translated by John S. Gilmour. Richmond, Va.: John Knox Press, 1963.

Usury Laws: Their Nature, Expediency and Influence. Economic Tract Number IV. New York: The Society for Political Education, 1881.

Van Baal, J. *Reciprocity and the Position of Women*. Amsterdam: Van Gorcum, Assen, 1975.

Van Gennep, Arnold. *The Rites of Passage*. Translated by M. B. Vizedom and G. L. Caffee. Chicago: University of Chicago Press, 1960.

Weiner, Annette B. *Women of Value, Men of Renown: New Perspectives in Trobiand Exchange*. Austin: University of Texas Press, 1976.

Yaron, Reuven. *Gifts in Contemplation of Death in Jewish and Roman Law*. London: Oxford University Press, 1960.

Part II

Asselineau, Roger. *The Evolution of Walt Whitman.* 2 vols. Cambridge, Mass.: Harvard University Press, 1962.

Budge, E. A. Wallis. *The Gods of the Egyptians, or Studies in Egyptian Mythology.* Vol. 2. London: Methuen & Co., 1904.

——. *Osiris and the Egyptian Resurrection.* Vol. 1. New York: G. P. Putnam's Sons, 1911.

Chauncy, Charles. *A Caveat Against Enthusiasm.* Boston: J. Draper, 1742.

Doob, Leonard W., ed. *'Ezra Pound Speaking': Radio Speeches of World War II.* Westport, Conn.: Greenwood Press, 1979.

Emery, Clark. *Ideas Into Action: A Study of Pound's Cantos.* Coral Gables: University of Miami Press, 1958.

Ginsberg, Allen. 'Encounters with Ezra Pound,' *City Lights Anthology.* San Francisco: City Lights Books, 1974.

Hall, Donald. *Remembering Poets.* New York: Harper & Row, 1978.

Heymann, C. David. *Ezra Pound: The Last Rower.* New York: Viking, 1976.

Kaplan, Justin. *Walt Whitman: A Life.* New York: Simon & Schuster, 1980.

Kenner, Hugh. *The Pound Era.* Berkeley and Los Angeles: University of California Press, 1971.

Lawrence, D. H. *Studies in Classic American Literature.* New York: Viking, 1964.

Lopez-Pedraza, Rafael. *Hermes and His Children.* Zurich: Spring Publications, 1977.

Neruda, Pablo. *Memoirs.* Translated by Hardie St. Martin. New York: Farrar, Straus & Giroux, 1977.

Neruda, Pablo. *Twenty Poems.* Translated by James Wright and Robert Bly. Madison, Minn.: Sixties Press, 1967.

Norman, Charles. *Ezra Pound.* New York: The Macmillan Company, 1960.

O'Connor, Flannery. *Mystery and Manners.* New York: Farrar, Straus & Giroux, 1969.

Pound, Ezra. *ABC of Reading.* New York: New Directions, 1960.

——. *America, Roosevelt and the Causes of the Present War.* Translated by John Drummond. London: Peter Russell, 1951. (First published in Venice in 1944.)

——. *The Cantos.* New York: New Directions, 1972.

——. *Guide to Kulchur.* New York: New Directions, 1970.

——. *Jefferson and/or Mussolini.* London: Stanley Nott, 1935.



———. *The Letters of Ezra Pound, 1907–1941*. Edited by D. D. Paige. New York: Harcourt, Brace & Company, 1950.

———. *Literary Essays of Ezra Pound*. Edited by T. S. Eliot. New York: New Directions, 1964.

———. *Make it New*. New Haven: Yale University Press, 1935.

———. *Pavannes and Divagations*. New York: New Directions, 1958.

———. *Personae*. New York: New Directions, 1971.

———. *Selected Prose 1909–1965*. Edited by William Cookson. New York: New Directions, 1973.

———. *Social Credit: An Impact*. London: Peter Russell, 1951. (First published in 1935.)

Rosellini, Ippolito. *I Monumenti Dell' Egitto e Della Nubia*. Vol. 3, *Monumenti del Culto*. Pisa: 1844.

Shell, Marc. *The Economy of Literature*. Baltimore: Johns Hopkins University Press, 1978.

Shephard, Esther. 'Possible Sources of Some of Whitman's Ideas and Symbols in 'Hermes Mercurius Trismegistus' and Other Works.' *Modern Language Quarterly* 14, no. I (March 1953): 60–81.

Snyder, Gary. *The Real Work: Interviews and Talks 1964–1979*. New York: New Directions, 1980.

Whitman, Walt. *The Correspondence*. 6 vols. Edited by Edwin Haviland Miller. New York: New York University Press, 1961–1977.

———. *Daybooks and Notebooks*. 3 vols. (paginated consecutively). Edited by William White. New York: New York University Press, 1978.

———. *Leaves of Grass*. Brooklyn, N.Y.: 1855.

———. *Leaves of Grass*. 'Comprehensive Reader's Edition.' Edited by Harold W. Blodgett and Sculley Bradley. New York: New York University Press, 1965.

———. *Prose Works 1892*. 2 vols. (paginated consecutively). Edited by Floyd Stovall. New York: New York University Press, 1963.

———. *The Uncollected Poetry and Prose*. 2 vols. Edited by Emory Holloway. Garden City, N.Y.: Doubleday, Page & Co., 1921.

NOTES

Introduction

p. ix: 'The artist appeals': Joseph Conrad, in the preface to *The Nigger of the Narcissus* (New York: Doubleday, Page & Co., 1926), p. xii.

p. ix: Silhouette Romances: *New York Times*, 11 August 1980, p. C 13.

p. x: 'Not I, not I': D. H. Lawrence, *The Complete Poems*, 2 vols. (London: Heinemann, 1972), 1: 250.

Epigraphs

. p. xvii: 'O wonderful!': This 'mystical chant' is found at the end of the Taittirīya Upanishad. See, for example, *The Thirteen Principal Upanishads*, translated by Robert Hume (London: Oxford University Press, 1932), p. 293. The translation is my own.

p. xvii: 'You received gifts': Czeslaw Milosz, from 'A Separate Notebook: The Mirrored Gallery,' translated by Robert Hass and Renata Gorczynski, *Ironwood* 18 (1981), p. 186.

Chapter 1

p. 3: 'An Indian gift': Thomas Hutchinson, *The History of the Colony of Massachusets-Bay* (Boston: Thomas & John Fleet, 1764), vol. 1, p. 469n.

p. 4: 'One man's gift': See, e.g., Sahlins, p. 160.

p. 4: The Uduk: James, *Sudan Notes*, pp. 81–82.

pp. 5–7: 'The Girl and the Dead Man': John Francis Campbell, ed. and trans., *Popular Tales of the West Highlands* (Paisley: Alexander Gardner, 1890), vol. 1, pp. 220–25.

p. 8–n: A stab at its meaning: My interpretation of the tale is influenced by the method of Marie-Louise von Franz, a Jungian who typically begins her analysis by looking for the 'marriage quaternity,' a husband and wife and their spiritual counterparts. Von Franz's works include *Problems of the Feminine in Fairytales* (Zurich: Spring Publications, 1972) and *Shadow and Evil in Fairytales* (Zurich: Spring Publications, 1974).

p. 8: Bread into toadstools: Wirt Sikes, *British Goblins* (London: Sampson Low, 1880), p. 119.

p. 9: 'Some food we could not eat': See Malinowski, p. 473.

p. 9: 'If I receive money': James, *Scientific American*, p. 90.

p. 9: 'potlatch' and 'killing wealth': See Mauss, pp. 4, 84.

pp. 10–11: 'The Ungrateful Son': *Grimms*, p. 507.

p. 11: 'The gift is to the giver': Walt Whitman, 'A Song of the Rolling Earth,' line 87.

pp. 12–15: The Kula: All citations are from Malinowski, pp. 81–97.

p. 15: '*To possess is to give*': Malinowski, p. 97. Emphasis mine.

p. 17: 'I effuse my flesh in eddies': Whitman, 'Song of Myself,' lines 1338–40.

p. 18: Folk tale from Kashmir: W. Norman Brown, 'Tawi Tales' (Manuscript in Indiana University Library, Bloomington, Ind.)

pp. 18–19: The Maori: In general, see Mauss, pp. 8–10, and Sahlins, pp. 149–71. Both men draw on the field work of Elsdon Best, whose publications are listed in Sahlins, p. 316.

p. 18: 'Causes the birds to be abundant': Sahlins, p. 158.

p. 18: *Whangai hau*: Sahlins, p. 158.

p. 19: 'Consecrate to me': Exod. 13:2.

p. 20: Sacrificing the firstborn son: See, e.g., 2 Kings 3:27 and 16:3. See also the note on the first of these in *The New Oxford Annotated Bible* (New York: Oxford University Press, 1973), p. 458.

p. 20: 'All that opens the womb': Exod. 34:19–20.

p. 20: 'You shall sprinkle their blood': Num. 18:15–18.

p. 21: 'Your emotions never seem in proportion': E. M. Forster, *A Passage to India* (New York: Harcourt Brace & World, 1924), p. 254.

p. 22: 'If money goes': Ibid., p. 160.

p. 22: 'Modern capitalist societies': Sahlins, pp. 3–4.

pp. 23–24: 'Let us borrow': Eckhart, p. 86.

p. 24: 'Represents the ultimate theological root': Thomas Merton, *The Asian Journal*, eds. Naomi Burton et al. (New York: New Directions, 1973), pp. 341–42.

p. 24: Tale from Bengal: L. B. Day [Lalavihari De], *Folk-Tales of Bengal* (London: Macmillan & Co., 1883), pp. 1–2.

Chapter 2

p. 27: 'Tasteless water': Walt Whitman, *Leaves of Grass*, 1st ed. (Brooklyn, N.Y., 1855), p. 24.

p. 27: The salmon: Drucker, pp. 85, 96–8.

p. 28n: Lizard god: *New York Times*, 3 September 1980, p. A4.

p. 29: Copper plaques: Material on coppers is drawn primarily from Boas, pp. 341–58, and Drucker, pp. 65–66, 127. The illustration is from Boas, p. 342.

p. 31: Civilized debtors: Drucker, pp. 213–15.

p. 31: 'Rivalry potlatch': Drucker, pp. 64, 197.

p. 31: 'Monster child': Mauss, p. 44.

p. 31: Boas's accounts: Boas, pp. 341–58.

p. 32: 'Feast for the dead': Drucker, pp. 124–27.

p. 33: 'Riveted together': Boas, p. 354.

p. 33: *Bios/zoë*: Carl Kerényi, *Dionysos: Archetypal Image of Indestructible Life*, Bollingen Series LXV 2, trans. Ralph Manheim (Princeton, N.J.: Princeton University Press, 1976), pp. xxxi–xxxvii.

p. 33: 'A natural phenomenon': Ibid., p. 38.

p. 34: Greek celebrants: Ibid., p. 66.

p. 34: 'Bones of the dead': Drucker, p. 65.

p. 34n: 'Things are to some extent parts of persons': Mauss, p. 11.

p. 35n: Russian folk tale: William R. S. Ralston, *The Songs of the Russian People* (London: Ellis & Green, 1872), p. 159.

p. 35: 'Complete harmony': Barnett, p. 353.

p. 36: 'Good will of our forefathers': Boas, p. 347.

p. 36: Mistakenly insulted: Drucker, p. 74.

p. 37: 'For as long as it is known': Joseph Epes Brown, *The Sacred Pipe* (Norman: University of Oklahoma Press, 1953), p. xii.

p. 37: Maori elder: Sahlins, pp. 157–59.

p. 37: 'The term "profit"': Sahlins, pp. 160–61.

p. 38: 'God has excluded': St. Ambrose [S. Ambrossi], *De Tobia*, ed. and trans. Lois M. Zucker (Washington, D.C.: Catholic University of America, 1933), p. 67.

Chapter 3

p. 41: 'My vocation': Jean-Paul Sartre, *The Words*, trans. Bernard Frechtman (Greenwich, Conn.: Fawcett, 1966), p. 121.

pp. 41–43: Gifts over the coffin: Wirt Sikes, *British Goblins* (London: Sampson Low, 1880), pp. 323–25. The illustration is from Sikes, p. 324.

p. 42: Haida believed: Van Gennep, p. 155.

p. 42: 'At each important phase': Weiner, p. 20.

p. 42n: Remarks on divorce: Van Gennep, pp. 142–43.

p. 44: 'Women untie the dead': Weiner, p. 22.

p. 44: The Sabians: Van Gennep, p. 107. See also pp. 81, 91.

p. 44n: 'There is a medical usage': Benveniste, p. 55.

p. 45: *Talmud: The Babylonian Talmud, Seder Mo'ed Shabbath*, vol. 2 (London: Soncio Press, 1938), p. 156b.

p. 49: 'The Shoemaker and the Elves': For the original, see *Grimms*, pp. 148–49.

p. 50n: Tales with the same motif: See, for example, William Henderson, *Notes on the Folklore of the Northern Counties of England and the Borders* (London: Longmans, Green & Co., 1866), pp. 210–12; Joseph Jacobs, *English Fairy Tales* (London: David Nutt, 1890), pp. 204–5; Thomas Keightley, *The Fairy Mythology* (London: H. G. Bohn, 1870), pp. 299–300; and M. C. Balfour, *Folk-Lore*, vol. 2 (1891), pp. 264–71.

p. 52: 'A few good poems': Paul Goodman, *Five Years: Thoughts During a Useless Time* (New York: Vintage, 1969), p. 194.

pp. 53–54: George Bernard Shaw: See Erik Erikson, *Young Man Luther:*

A Study in Psychoanalysis and History (New York: W. W. Norton & Co., Inc., 1962), p. 44.

p. 54: *genius*: Apuleius' essay is *De deo Socratis*. For a translation see *The Works of Apuleius* (London: Bell & Daldy, 1866), pp. 350–73 (esp. pp. 363–64). For other material on *genius*, see: Onians, pp. 123–67, 224–28, 240; J. C. Nitzche, *The Genius Figure in Antiquity and in the Middle Ages* (New York: Columbia University Press, 1975); Marie-Louise Von Franz, *A Psychological Interpretation of 'The Golden Ass' of Apuleius* (Zurich: Spring Publications, 1970), esp. chap. 1, p. 10.

p. 55: 'That man should receive God': Schürmann, p. 4; Eckhart, p. 35.

p. 55: 'God's endeavor': Schürmann, p. 93.

p. 55: 'I will praise him': Schürmann, p. 58.

pp. 55–56: 'Our Lord Jesus Christ went up': The verse in question is Luke 10:38, more usually translated as 'He entered a village, and a woman named Martha received him into her house.' For an explanation of Eckhart's translation, see Schürmann, pp. 9–10.

p. 56: 'A human being': Schürmann, p. 53.

p. 56: A virgin is detached: See Schürmann, pp. 16ff.

p. 56: 'Know then, that God is bound to act': Eckhart, p. 23.

p. 56: 'If a human were to remain a virgin': Schürmann, p. 4.

p. 56: 'Gazes back': Eckhart, p. 272.

p. 56: 'Man ought to be flowing out': Eckhart, p. 160.

p. 56: 'In the abstract Godhead': Eckhart, p. 188.

Chapter 4

p. 58: 'Conflict exists': Lévi-Strauss, pp. 58–60.

p. 59: New Caledonia: M. Leenhardt, 'Notes d'ethnologie néocalédonniene,' *Travaux et mémoires de l'Institut d'Ethnologie* 8 (1930): 65.

pp. 61–62: Ten perfections: Henry Clarke Warren, *Buddhism in Translations* (Cambridge, Mass.: Harvard University, 1909), p. 33.

p. 61: Perfect in almsgiving: Ibid., p. 35.

pp. 61–62: Wise Hare: Ibid., pp. 274–79.

p. 62: 'The acme': Ibid., p. 35.

p. 62: 'Linen': Marx, p. 18.

p. 63n: 'In the seventeenth century': Marx, p. 4n.

p. 63: 'Communities of India': Marx, p. 11.

p. 63: 'The only products which confront': Marx, p. 11.

p. 63: Famous law: Deut. 23:19–20.

p. 64: 'Any wealth': James, *Sudan Notes*, p. 81.

pp. 64–66: Pinto: My data come from Mark Dowie, 'Pinto Madness,' *Mother Jones*, September–October 1977, pp. 18–32.

In a 1980 trial in Winamac, Ind., a jury found Ford not guilty of reckless homicide in a case involving three girls who burned to death when their Pinto was struck from the rear by a van and burst into flame. Another jury in a 1978 product-liability trial in California, however, found Ford guilty and ordered the company to pay over $100 million to a badly burned Pinto owner. (The case is on appeal.)

Immediately following the publication of Dowie's *Mother Jones* article, the National Highway Traffic Safety Administration began its own investigation into the safety of the Pinto; nine months later, it concluded that the car was in fact defective. Ford thereupon recalled the cars in question, offering to install in them a device to improve their resistance to fire.

p. 67: Success rate: Simmons, pp. 425, 427.

p. 67: Some risk: Simmons, pp. 166, 435; Fox, p. 340.

p. 67: Do not regard their choice: Simmons, p. 241.

p. 67: 'I never thought about it': Simmons, p. 243.

p. 67: 'I don't think': Simmons, p. 246.

p. 67: 'The term decision': Simmons, p. 283.

p. 68: 'One hardly needs a study': E.g., Simmons, pp. 183, 230.

p. 68: 'Yakut refused': Lévi-Strauss, p. 57.

p. 69: 'Labor should not be sold': Ernesto Cardenal, *In Cuba*, trans. Donald D. Walsh (New York: New Directions, 1974), p. 117.

p. 69: 'Literary property': Ibid., p. 143.

p. 71: 'Debases the man': Mauss, p. 41.

p. 71: Incest taboo: Fox, p. 344.

p. 71: Problems are rare: Simmons, pp. 451–52.

p. 71: To minimize the recipient's sense of debt: Simmons, p. 457.

p. 71: A young man: Simmons, p. 453.

p. 71: 'He doesn't owe': Simmons, p. 326.

p. 72: 'Very selfish girl': Simmons, p. 174.

p. 72: 'Not uncomfortable': Simmons, p. 174.

p. 72: 'Labor pains': Simmons, p. 325.

p. 74: Food offered by the dead: The advice is given to Psyche, for example.

See Apuleius, *The Golden Ass*, trans. Jack Lindsay (Bloomington: Indiana University Press, 1962), pp. 138–39.

p. 74: An Irish tale: *Folk Tales and Fairy Lore in Gaelic and English*, collected by James Macdougall, ed. George Calder (Edinburgh: John Grant, 1910), pp. 271–79.

p. 75n: Schizophrenia: *New York Times*, 13 November 1979, pp. C1–C2.

p. 75: Refuse the food: See, for example, Grimms, p. 92; Marie-Louise von Franz, *Shadow and Evil in Fairy Tales* (Zurich: Spring Publication, 1974) pp. 74, 241.

p. 75: 'Twelve black men': Grimms, pp. 337–42.

Chapter 5

p. 76: Cowrie shells: Marshall, p. 241.

p. 77: 'Kin': Stack, pp. 9, 90; chapter 6 in general.

p. 77: What happened to the money: Stack, pp. 105–7.

p. 78: Lydia: Stack, p. 109.

p. 78: 'Far-hearted': Marshall, p. 233.

p. 78n: Peasant communities: George M. Foster, 'Peasant Society and the Image of Limited Good,' *American Anthropologist* 67, no. 2 (April 1965): 303.

p. 79: 'Manuscripts for which the scientific authors': Hagstrom, pp. 12–13.

p. 79: 'Negative value': Hagstrom, p. 22.

p. 79: 'Unlike recognition': Hagstrom, p. 23.

p. 79: 'One reason why': Hagstrom, p. 104.

pp. 80–81: Kwakiutl names: Boas, pp. 343–48.

p. 81: 'Virtue rests': See first note for p. 35.

p. 81: 'The acceptance by scientific journals': Hagstrom, p. 13.

p. 81n: 'A parent would not touch': Erik Erikson, *Childhood and Society* (New York: Norton, 1950), pp. 139–40.

p. 82: 'Like the Jewish Torah': Hagstrom, p. 48.

p. 83n: 'Industrial research': Hagstrom, p. 39.

p. 84: 'In the past one of the strengths': *Boston Globe*, 3 November 1980, p. 19.

pp. 84–85: 'There used to be a good exchange': Nicholas Wade, 'La Jolla Biologists Troubled by the Midas Factor,' *Science* 213 (7 August 1981): 628.

p. 85: 'Contractual' theory: See Hagstrom, pp. 54–55.

p. 86: Polynesian island: Raymond Firth, *Primitive Polynesian Economy*

(London: George Routledge & Sons, Ltd., 1939), p. 324. The chart of marriage gifts is from Firth, p. 323.

p. 88: 'Total social phenomenon': Mauss, pp. 76–77.

p. 88: 'Real' and 'personal': Mauss, pp. 46–52.

p. 89: Town of Münster: James Joll, *The Anarchists* (Boston: Little, Brown & Co., 1964), pp. 24–26.

p. 89: 'A time will come': Ibid., p. 56.

p. 90: 'Village of Lentino': Ibid., p. 122.

p. 90: Case of ingratitude: I am indebted to Millard Schumaker's as yet unpublished essay, 'Sharing Without Reckoning,' for this point.

p. 91: 'Moral memory': Simmel, p. 388.

p. 92: 'In awe': All material from Hobbes is taken from the 13th chapter of *Leviathan*. See, for example, Thomas Hobbes, *The English Works*, ed. William Molesworth (London: John Bohn, 1839), pp. 110–16.

p. 92: 'The laws of nature': Sahlins, p. 179. Sahlins does not connect gift exchange to anarchism, but his remarks (pp. 168–83) on 'the political aspects' of Mauss's essay initiated my thinking in this line.

p. 93: 'Primitive tribes he observed': Joll, *The Anarchists*, pp. 154–55. Kropotkin's full remarks may be found in *The Essential Kropotkin*, ed. Emile Capouya and Keitha Tompkins (New York: Liveright, 1975), p. 34.

p. 93n: 'By opposing reason': Mauss, p. 80.

p. 93n: 'Voluntary guise': Mauss, p. 3.

p. 94: Blind pelican: Joll, *The Anarchists*, p. 155.

Chapter 6

p. 95: 'Your own mother': Margaret Mead, *Sex and Temperament in Three Primitive Societies* (New York: William Morrow, 1935), p. 83.

p. 95: 'Their daughters': Gen. 34:21.

p. 96: Not a chattel: See, for example, Phyllis Bird, 'Images of Women in the Old Testament,' in *Religion and Sexism*, ed. Rosemary Radford Ruether (New York: Simon & Schuster, 1974), pp. 54ff.

p. 96: 'Right of action': *Century Dictionary and Cyclopedia*, under 'property.'

p. 96: Property rights in the body: Scott, pp. 186–89; Renée C. Fox, 'Ethical and Existential Developments in Contemporaneous American Medicine: Their Implications for Culture and Society,' *Milbank Memorial Fund Quarterly, Health and Society* (Fall 1974): 466.

p. 97: Anatomical Gift Act: Scott, pp. 70–73; Blair L. Sadler and Alfred M. Sadler, Jr., 'Providing cadaver organs: three legal alternatives,' *The Hastings Center Studies* 1 (1973): 14–26.

p. 98: All children are given: For an example, see Mauss, pp. 6–7.

p. 98n: Exchange their baby: *New York Times*, 5 September 1980, p. Bl.

p. 98: 'Bridewealth is childwealth': Goody, p. 11.

p. 99: '"Borrowed man"': Goody, p. 6; see also Eleanor Leacock, 'The Changing Family and Lévi-Strauss, or Whatever Happened to Fathers,' *Social Research* 44 (Summer 1977): 248.

p. 99n: Our lives are gifts: See Talcott Parsons, Renée C. Fox, and Victor M. Lidz, 'The "gift of life" and its reciprocation,' *Social Research* 39 (Autumn 1972): 367–415.

p. 99: 'All that opens the womb': Exod. 34:19.

p. 99: 'Sons you shall redeem': Exod. 34:20.

p. 100: Polynesian mythology: Marshall Sahlins, 'Polynesian Riches – With Special Reference to Cooked Men and Raw Women in the Fiji Islands.' Essay in manuscript.

p. 100: 'The old lie': Wilfred Owen, *Poems* (London: Chatto & Windus, 1920), p. 15.

pp. 101–103: Uduk: James, *Sudan Notes*, pp. 78–84.

p. 103: Tend to be tokens: See Goody, p. 17, for a defense of this generalization.

p. 103: Code of Manu: Goody, p. 68.

p. 104: Men alone may give: For expanded discussions of this issue, see both Van Baal and Rubin.

p. 104: Father still gives: Emily Post, *Etiquette*, 12th rev. ed. (New York: Funk & Wagnalls, 1969), p. 379.

p. 104: Daughter's 'hand': Ibid., p. 326.

p. 104: 'Present is sent to her': Ibid., p. 423 (emphasis mine).

p. 104: Thank-you notes: Ibid., p. 368.

p. 104: 'Try to understand': Ibid., p. 329.

p. 106: '"Unsuccessful turkeys"': *New York Times*, 26 January 1981, p. C26.

p. 108: Clergyman: Post, *Etiquette*, p. 268.

p. 110: Charles Follen: Ann Douglas, *The Feminization of American Culture* (New York: Alfred A. Knopf, 1977), pp. 18–19.

p. 110: 'A skirt thing': Saul Bellow, *Humboldt's Gift* (New York: Avon Books, 1976), p. 113.

Chapter 7

p. 112: Loan of a fungible: *New Catholic Encyclopedia*, under 'usury.'

p. 113n: 'Loans at interest': Drucker, p. 61.

pp. 113–14: Islamic laws: See Robert Roberts, *The Social Laws of the Qôran* (London: Williams & Norgate, 1925), pp. 70–72, 103–8.

p. 114: 'Blot out usury': Koran, Sûra 2: 276.

p. 114: 'No increase from God': Koran, Sûra 30:38.

p. 114: 'Two sorts of wealth-getting': Aristotle, *Politics* 1. 10.

p. 115n: Capital: See Onians, pp. 123–25, 144. Onians also tells us (p. 159n) that the term *capitalis* was applied to the gifted because originality was associated with the prompting *genius* and therefore with the head. I realize that priority in time carries no necessary authority, but still, the current use of 'capital' is not the aboriginal or the spiritual use. Works of genius are our true capital.

p. 116n: 'Native moralists': Douglas Oliver, *A Solomon Island Society* (Cambridge: Harvard University Press, 1955), p. 82. For this and other examples, see Sahlins, p. 191.

p. 119: 'Brother': St Ambrose [S. Ambrossii], *De Tobia*, ed. and trans. Lois M. Zucker (Washington, D.C.: Catholic University of America, 1933), pp. 65, 67.

p. 119: 'Desire to harm': Ibid., p. 67.

p. 120: 'Who then was the stranger': Ibid.

p. 120: A few examples: See Nelson, pp. 10–14.

pp. 120–21: 'Temporal goods': Nelson, p. 21n.

p. 121: Word 'brother': Nelson, p. 3.

p. 121: 'From him demand usury': Nelson, p. 18.

p. 121: 'Jews were forbidden': Nelson, p. 14.

pp. 122–23: Roman law: Roland Bainton, *Here I Stand: A Life of Martin Luther* (New York: New American Library, 1950), p. 208.

p. 123: 'What will you say to Christ': Martin Luther, *Lectures on Deuteronomy*, ed. J. Pelikan (St Louis: Concordia Publishing House, 1960), pp. 144–45.

p. 124: 'Deal with risk': Martin Luther, *Letters*, ed. G. Krodel (Philadelphia: Fortress Press, 1972), 2: 50–55.

p. 124: Dispute in Denmark: Nelson, p. 62.

p. 124: 'Luther says': Bainton, *Here I Stand*, p. 215.

p. 125: Ministers in Regensberg: Nelson, p. 47.

p. 125: *interesse*: *Oxford English Dictionary*, under 'interest.'

p. 126: 'Brotherhood of man': Nelson, p. 19.

p. 126: Leo X: Nelson, pp. 24–25.

p. 127: 'Sums freely invested': Nelson, p. 64.

p. 127: Similar discriminations: Nelson, p. 47.

p. 128: 'Why is it': Luther, *Lectures*, p. 145.

p. 128: 'Common herd': Luther, *Letters*, p. 54.

p. 128: 'Christians are rare': Nelson, pp. 50–51.

p. 129: 'The Jews do well': Luther, *Lectures*, p. 145.

p. 129: 'Know then': Eckhart, p. 23.

p. 130: '"Prophetic perfect"': Edmund Wilson, *Red, Black, Blond and Olive* (New York: Oxford University Press, 1956), p. 426.

p. 131: 'He has bidden us': Nelson, p. 153.

p. 131: Lawyer: Erik H. Erikson, *Young Man Luther* (New York: Norton Library, 1962), pp. 56, 97.

p. 132: 'A tragedy of moral history': Nelson, p. 136.

p. 132: 'Common good': Georgina Harkness, *John Calvin: The Man and his Ethics* (New York: Henry Holt & Company, 1931), p. 205.

p. 132: 'Tighter fetters': *Usury Laws*, p. 33.

p. 133: 'He does not mean': *Usury Laws*, pp. 33–34.

p. 133: 'It is said': Harkness, *Calvin*, p. 206; see also Nelson, p. 78.

p. 133: 'usury is not now unlawful': Nelson, p. 79.

p. 134n: Islamic parallel: See 'Islamic Views on Interest,' *New York Times*, 22 January 1981, p. A11; 'Abolhassan Bani-Sadr: Man in the News,' *New York Times*, 28 January 1980, p. A8; 'Iran's Oil Director Disputes Khomeini on Primacy of Islam,' *New York Times*, 29 May, 1980, p. A1.

p. 135: 'If money is shut up': Harkness, *Calvin*, p. 206.

p. 135: 'Better may it be': Nelson, p. 84.

p. 135: 'Widows and orphans': Nelson, p. 98.

pp. 135–36: Dana: All citations from Dana's speech are from *Usury Laws*, pp. 43–56.

p. 137: Degrees of reciprocity: See Sahlins, chapter 5, esp. pp. 188–204.

p. 139: 'I use the term Charity': Nelson, pp. 163–64 (emphasis in original).

p. 140: Usury laws: *Usury Laws*, p. 62.

p. 140: French Jews: Nelson, p. 111.

p. 140: Catholics: *New Catholic Encyclopedia*, under usury.

Chapter 8

p. 146: 'Grave defect': *Meister Eckhart by Franz Pfeiffer* (London: Watkins, 1924), p. 23.

p. 146: 'Inner certainty': Czeslaw Milosz, *Native Realm* (Berkeley: University of California Press, 1981), p. 87.

p. 146: 'The thing germinated': Harold Pinter, 'Letter to Peter Wood,' *The Kenyon Review* 3, no. 3 (Summer 1981), p. 2.

pp. 146–47: 'I was in that particular hell': Theodore Roethke, *On the Poet and His Craft*, ed. Ralph J. Mills, Jr. (Seattle: University of Washington Press, 1966), pp. 23–24.

pp. 147–48: 'Parts that embarrass': Allen Ginsberg, *Composed on the Tongue* (Bolinas, Calif.: Grey Fox Press, 1980), pp. 111–12.

p. 148: 'Real deprivation': May Sarton, *Journal of a Solitude* (New York: Norton, 1973), p. 191.

p. 148: Hermes: Lopez-Pedraza, pp. 44–47.

p. 148: 'Original clan': Marcel Mauss, *The Gift* (New York: Norton, 1967), p. 10.

p. 149: 'I made a new religion': William Butler Yeats, *The Autobiography* (New York: Collier Books, 1965), p. 77.

p. 149: 'I have attempted': Neruda, *Twenty Poems*, p. 15.

p. 149: 'Lota coal mine': Neruda, *Memoirs*, p. 171.

p. 150: 'What is good': *Black Elk Speaks*, as told through John G. Neihardt (Lincoln: University of Nebraska Press, 1961), p. v.

p. 151: 'I finished off': Snyder, p. 126.

p. 151: '"Did I say that?"': Snyder, p. 79.

p. 151: 'Thou that hast giv'n': *The Poems of George Herbert* (London: Oxford University Press, 1958), p. 111. For a discussion of Herbert's work and gift exchange, see William Nestrick's essay, listed in the bibliography for Part I.

p. 152: 'Art is a virtue': O'Connor, pp. 81–82.

p. 152: 'Not any self-control': Rainer Maria Rilke, *Verse und Prosa aus dem Nachlass* (Leipzig: Gesellscaft der Freunde der Deutschen Bücherei, 1929), pp. 41–49. The translation is by Norman O. Brown; see *Life Against Death* (Middletown, Conn.: Wesleyan University Press, 1970), pp. 67, 237.

p. 152: 'The eye sees': O'Connor, p. 195.

p. 153: 'Esemplastic': *The Portable Coleridge*, ed. I. A. Richards (New York: Viking, 1950), pp. 494, 515–16.

p. 153: Riches turn to paper: See Stith Thompson, *Motif-Index of Folk Literature* (Bloomington: Indiana University Press, 1955), the listings under F 348.6; see also Wirt Sikes, *British Goblins* (London: Sampson Low, 1880), pp. 119–20.

p. 154: Inexhaustible barrel of ale: Michael Aislabie Denham, *The Denham Tracts*, ed. James Hardy, 2 vols. (London: David Nutt, 1892–95), 2: 85.

p. 155: 'His appeal is made': Joseph Conrad, *The Nigger of the Narcissus* (New York: Doubleday, Page & Co., 1926), pp. xi–xii.

p. 156: 'Black known and unknown poets': Maya Angelou, *I Know Why the Caged Bird Sings* (New York: Bantam Books, 1971), p. 156.

p. 158: 'Logic is the money': Quoted by Shell, p. 36.

pp. 158–159: 'The Paper Chase': *New York Times*, 15 January 1979, p. C20.

pp. 159–160: Dali: *New York Times*, 26 March 1981, p. 8A.

pp. 161–62: 'When I pass': Whitman, *Prose*, pp. 388–89.

Chapter 9

NOTE: Whitman's works, listed in the Bibliography for Part II, are cited here by abbreviated titles only. The first edition of *Leaves of Grass* bears the date of publication to differentiate it from the New York University Press edition.

p. 163: 'Not blind': *Leaves*, p. 729.

p. 163: 'I guess [the grass] is a uniform hieroglyphic': *Leaves*, p. 34.

p. 163: 'I am hungry': *Uncollected*, p. 67.

p. 164: 'Loafe with me': *Leaves*, p. 33.

p. 164: The turn in Whitman's life has been explained: See Asselineau, I: 47–62.

p. 165: 'I mind how once we lay': *Leaves*, p. 33.

p. 166: 'Not the poet of goodness': *Leaves*, p. 50.

p. 166: 'Call the tortoise unworthy': *Leaves*, p. 40.

p. 166: 'The carpenter dresses': *Leaves*, p. 41.

p. 167: 'The moth': *Leaves*, p. 45.

p. 167: 'As the hugging and loving bed-fellow': *Leaves*, pp. 31–32.

p. 168: 'After none of them': *Uncollected*, 2: 83.

p. 168: 'Showing the best': *Leaves*, p. 31.

p. 168: 'Perfect faith': *Leaves*, p. 731.

p. 168: 'Edification': Henry Clarke Warren, *Buddhism in Translations* (Cambridge, Mass.: Harvard University, 1909), pp. 117–28.

p. 168: 'The flavor': *One Hundred Poems of Kabir*, trans. Rabindranath Tagore and Evelyn Underhill (London: Chiswick Press, 1914), p. 41. The translation is my own, based on Tagore's.

p. 169: 'Knot of contrariety': *Leaves*, pp. 162–63.

p. 169: 'Adhesiveness': *Leaves*, p. 90n.

p. 169: 'Terrible Doubt': *Leaves*, p. 120.

p. 170: 'If I worship one thing': *Leaves*, p. 53.

p. 170n: 'Unseen Soul': *Leaves*, p. 746n.

p. 170: 'Enthusiastic wildness': Chauncy, p. iii.

p. 171: 'No reasoning': Chauncy, p. 19.

p. 171: 'It may be seen': Chauncy, pp. 3–4.

p. 172: 'Transparent eyeball': Ralph Waldo Emerson, *Nature, Addresses, and Lectures* (Boston: Houghton Mifflin, 1898), p. 16.

p. 173: 'Born cold': Ralph Waldo Emerson, *Selected Prose and Poetry*, ed. Reginald L. Cook (New York: Holt, Rinehart & Winston, 1950), p. 461.

p. 173: 'I only answer'd: *Prose*, pp. 281–82, 493–94.

p. 173: 'Respiration and inspiration': *Leaves*, p. 29.

p. 173: 'The afflatus': *Leaves*, p. 52.

p. 173: 'Tend inward': *Leaves*, p. 44.

p. 173: 'Accrue what I hear': *Leaves* (1855), p. 31.

p. 173n: 'There is a prejudice': *Correspondence*, 1: 123n.

p. 174: 'Accepting': See, e.g., *Leaves*, p. 75 (line 1,036).

p. 174: 'Adorning myself': *Leaves*, p. 41.

p. 174: 'He bequeaths': *Leaves*, p. 752.

p. 174: 'To the dirt': *Leaves*, p. 89.

p. 174: 'Soul has that measureless pride': *Leaves*, p. 716.

p. 174: 'Dazzling and tremendous': *Leaves*, p. 54.

p. 174: 'Whoever walks a furlong': *Leaves*, p. 86.

p. 174: 'To be in any form': *Leaves*, p. 57.

p. 175: 'Utter poems': *Leaves*, p. 253.

p. 175: 'First object': *Leaves*, p. 364.

p. 175: Such sharp detail: Examples are from *Leaves*, pp. 38, 42, 61.

p. 176: 'Libidinous': *Leaves*, p. 54.

p. 176: 'Crowding my lips': *Leaves*, pp. 81–82.

p. 176: 'Soggy clods': *Leaves*, p. 59.

p. 176: Enter his body: Examples are from *Leaves*, pp. 43, 59, 66.

p. 176: 'Oxen': *Leaves*, p. 40.

p. 176: 'Converging objects': *Leaves*, p. 47.

p. 176: 'Hieroglyphic': *Leaves*, p. 34.

p. 177: Ducks: *Leaves*, p. 40.

p. 177: 'Ministers': *Leaves*, p. 165.

p. 177: 'Perfume': *Leaves*, p. 29.

p. 177: 'Behold God': *Leaves*, p. 86.

p. 177: 'Bull and bug': *Leaves*, p. 76.

p. 177: 'The framer': *Leaves*, p. 75.

p. 177: 'Bring me tokens': *Leaves* (1855), p. 34.

p. 178: 'Every atom': *Leaves*, p. 28.

p. 178: 'Effect upon me': *Leaves*, p. 32.

p. 178: A sea alive: Examples are from *Leaves*, pp. 31, 82, 162.

p. 179: 'I behold': *Leaves*, pp. 49–50.

p. 179: 'Hurt each other': *Leaves* (1855), p. 27. The line is actually addressed to the earth, which Whitman invokes along with the sea.

p. 179: 'Trained soprano': *Leaves* (1855), p. 32.

p. 180: 'Touch my person': *Leaves*, p. 57.

p. 180: 'Is this then a touch': *Leaves*, pp. 57–58.

p. 181: 'Parting track'd': *Leaves*, p. 58.

p. 181: 'Grass of graves': *Leaves*, p. 87.

p. 181: Constantly connected: *Leaves*, pp. 34, 87.

p. 181: 'Body will decay': *Uncollected*, 2: 66.

p. 181: 'Different objects': *Uncollected*, 2: 64.

p. 182: 'Leaves stiff': *Leaves*, p. 33.

p. 182: 'Divine materials': *Leaves*, p. 370.

p. 182: 'Black folks': *Leaves*, p. 34.

p. 182: 'Uttering tongues': *Leaves*, p. 34.

p. 182: 'As to you Death': *Leaves*, p. 87.

p. 182: 'New-born': *Leaves*, p. 424.

p. 182: This gate: *Leaves*, pp. 39, 89.

p. 183: 'Paraded on Broadway': Shephard, p. 74.

p. 183: Unframed pictures: Asselineau, 1: 92.

p. 183: 'Taking myself': *Leaves*, p. 75.

p. 183: Egyptian hieroglyphs: Shephard, p. 74; the etching reproduced on p. 181 is from Rosellini, plate 24.

p. 183: 'Wheat appears': *Leaves*, p. 369.

pp. 183–86: Osiris: See Budge, *The Gods of the Egyptians*, 2: 122, 126, 138–39, 147, 150; Budge, *Osiris*, 1: 58, 86.

p. 185: 'Such sweet things': *Leaves*, p. 369.

p. 185: 'Scented herbage of my breast': *Leaves*, pp. 113–14.

p. 185n: 'Of the end of life': Lawrence, p. 170.

p. 186: 'So placid': *Leaves*, p. 60.

p. 186: 'Dismiss': *Leaves*, p. 715.

p. 186: 'You laggards': *Leaves*, p. 71.

p. 186: 'Cholera patient': *Leaves*, pp. 71–72.

p. 187: Leprosy: Lawrence, p. 176.

p. 187: 'Enough!': *Leaves*, p. 72.

p. 188: 'Rise extatic': *Leaves*, (1855), p. 43.

p. 188: 'Scarf'd chops': *Leaves*, p. 74.

p. 188: 'Anyone dying': *Leaves*, p. 74.

p. 188: 'Anything I have': *Leaves*, p. 74.

p. 188: Variety of images: *Leaves*, pp. 96 (nimbus), 165 (aroma), 53 (armpit), 253 (electric), 73 (light), 253 (utter), 74 and 96 (stuff and jets).

p. 189: 'Touch of my lips': *Leaves* (1855), p. 25.

p. 189: 'Discouraged': *Leaves*, p. 596.

p. 189: 'I loved': *Leaves*, p. 134.

p. 190: 'Saw in Louisiana': *Leaves*, pp. 126–27.

p. 190: 'GIVE UP ABSOLUTELY': *Uncollected*, 2: 96.

p. 191: To judge from his letters: See *Correspondence* 1: 121; 2: 84.

p. 191: 'You have waited': *Leaves*, p. 165.

p. 191: 'Through me': *Leaves* (1855), p. 29.

p. 192: 'Buried speech': *Leaves*, p. 36.

p. 192: 'I pick out': *Leaves*, p. 109.

p. 192: Taught him to read: Asselineau, 2: 124.

p. 192n: 'Talking the talk': *Leaves*, p. 30.

p. 193n: 'Sadness': José Luis Hidalgo, 'Shore of Night,' *Roots and Wings*, ed. Hardie St. Martin (New York: Harper & Row, 1976), p. 369.

p. 193n: 'No account with lamentation': *Leaves* (1855), p. 50.

p. 193: 'Living and buried speech': *Leaves*, p. 36.

p. 193: 'Hymns': *Leaves*, p. 713.

p. 193n: 'Renewal of the word': Barbara Myerhoff, *Number Our Days* (New York: E. P. Dutton, 1979), pp. 271–72.

p. 193n: 'Stress on individual names': Snyder, p. 75.

p. 194: Shakers: See Edward Deming Andrews and Faith Andrews, *Visions*

of the Heavenly Sphere: A Study in Shaker Religious Art (Charlottesville: University Press of Virginia, 1969), pp. 9–13.

p. 194: 'Camerado': *Leaves*, p. 83.

p. 194: Spoken to him: *Leaves*, p. 750.

p. 194: 'Soul-making': John Keats, *The Letters*, ed. Hyder Edward Rollins (Cambridge, Mass.: Harvard University Press, 1958), 2: 100–4.

p. 195: 'To arouse': *Leaves*, p. 751n.

p. 195: 'The soul': *Uncollected*, 2: 93.

p. 196: 'Spreads out his dishes': *Leaves*, p. 713.

p. 196: 'Water of souls': *Leaves* (1855), p. 24.

p. 196: 'Become the aliment': *Leaves*, p. 124.

p. 196: 'Places himself': *Leaves*, p. 716.

p. 196: 'Womb': *Leaves*, p. 76.

pp. 196–97: Ginsberg: Edward Lucie-Smith, *Mystery in the Universe: Notes on an Interview with Allen Ginsberg* (London: Turret Books, 1965), p. 6; Allen Ginsberg, *Allen Verbatim: Lectures on Poetry, Politics, Consciousness*, ed. Gordon Ball (New York: McGrawHill, 1974), p. 21.

p. 197: 'Live tradition': Pound, *The Cantos*, p. 522.

p. 198: 'Itch': *Leaves*, p. 85.

p. 198: 'Self-respecting Ravennese': Pound, *Selected Prose*, p. 322.

p. 198: 'Poem of Identity': *Leaves*, p. 752.

p. 199: 'Average': *Prose*, p. 403.

p. 199: 'Isolated Self': *Prose*, p. 399.

p. 199: 'Properly train'd': *Prose*, pp. 374–75.

p. 199: 'Alone': *Prose*, p. 399.

p. 199: 'Single person': *Leaves*, p. 46.

p. 199: 'Solidarity': *Prose*, p. 382.

p. 199: 'European chivalry': *Prose*, p. 366.

p. 199: 'Grand experiment': *Prose*, p. 380.

p. 199: 'Common aggregate': *Prose*, p. 380.

p. 200: 'Our task': *Prose*, p. 373.

p. 200: 'Adhesiveness': *Prose*, p. 381.

p. 200: Women embracing: Kaplan, p. 152.

p. 200: 'Image-making': *Prose*, p. 388.

p. 200: 'Praise to the first man': Robert Bly, *This Body Is Made of Camphor and Gopherwood* (New York: Harper & Row, 1977), p. 59.

p. 200: 'Embryo': *Correspondence*, 1: 247.

p. 201: 'Breed': *Prose*, p. 407.

p. 201: 'Aggregate of heroes': *Prose*, p. 368.

p. 201: 'Osseous': *Prose*, p. 366.

p. 201: 'The lack': *Prose*, p. 368.

p. 201n: 'Work in literature': Mao Tse-tung, 'Talks at the Yenan Forum on Literature and Art,' *On New Democracy* (Peking: Foreign Languages Press, 1967), p. 97.

p. 201: 'Under and behind the bosh': *Correspondence*, 1: 40.

p. 202: 'Cheerfully include': *Prose*, pp. 384n–385n.

p. 202: 'It is very pleasant': *Correspondence*, 2: 57.

p. 202: 'Completely satisfy': *Prose*, p. 371.

p. 203: He identifies: *Leaves*, p. 44.

p. 203: 'I will carefully earn': *Leaves*, p. 703.

p. 203: 'Charity': *Leaves*, p. 374.

p. 203: 'Here and there': *Leaves*, p. 77.

p. 204: 'Lady Poverty': The remark is to be found in Theodore Roethke's notes for a lecture on mysticism. Manuscript Collection, Suzallo Library, University of Washington, Seattle. Box 72, File 13.

p. 204: Labor of art: Examples are from *Leaves*, pp. 731, 739–40, 750n.

p. 205: Trowbridge: All the details of the visit with Salmon Chaseare to be found in John Townsend Trowbridge, *My Own Story* (Boston: Houghton Mifflin & Co., 1903), pp. 377–89.

p. 206: 'The price': *Correspondence*, 2: 75.

p. 207: 'Irish shanty': *Correspondence*, 2: 72.

p. 207: 'Have a little room': *Correspondence*, 1: 142.

p. 207: 'Cannot give up': *Correspondence*, 1: 77.

p. 207: 'Clerk's life': *Correspondence*, 1: 275.

p. 207: To comfort a boy: *Correspondence*, 1: 63–64.

p. 208: Go through a ward: *Correspondence*, 1: 153.

p. 208: 'Try to give a word': *Correspondence*, 1: 122.

p. 208: 'Quite a number': *Correspondence*, 1: 230.

p. 208: 'Above letter': *Correspondence*, 1: facing 244.

p. 208: Read aloud: *Correspondence*, 1: 163, 262n; Kaplan, p. 280.

p. 209: 'The scene': *Correspondence*, 1: 153–55.

p. 209: 'Heap of feet': *Correspondence*, 1: 81n.

p. 209: Maggots: *Correspondence*, 1: 231.

p. 210: 'Stiff conventions': *Correspondence*, 1: 122.

p. 210: Bestowing phase: Examples are from *Correspondence*, 1: 70, 102, 152.

p. 210: Subtle medicine: *Correspondence*, 1: 159.

p. 210: 'My own children': *Correspondence*, 1: 125.

p. 210: Letters of gratitude: *Correspondence*, 2: 95n.

p. 210: 'I should like': *Correspondence*, 1: 188n.

p. 211: 'I need not tell': *Correspondence*, 1: 155.

p. 211: 'So cold': *Correspondence*, 1, 203.

p. 211: 'Some so wind themselves': *Correspondence*, 1: 153.

p. 211: 'So good': *Correspondence*, 1: 91.

p. 211: It was never clear: Examples are from *Correspondence*, 1:236, 237, 254.

p. 211*n*: Hypertension: Kaplan, p. 295.

p. 211: 'I go': *Correspondence*, 1: 151–52.

p. 211: 'It is now beginning': *Correspondence*, 1: 229.

p. 212: Poem: 'This Compost,' *Leaves*, pp. 368–69.

p. 213: Peter Doyle: See *Correspondence*, 2:84.

p. 214: 'Virus of the hospitals': *Correspondence*, 1: 236.

p. 214: 'Hospital poison': *Correspondence*, 2: 86.

p. 214: Tenacious: *Correspondence*, 1: 254.

p. 214: 'When I hear': *Leaves*, pp. 129–30.

p. 214: 'Simmering inside': Kaplan, p. 346.

p. 215: 'Staggering, staying blow': *Correspondence*, 2: 242.

p. 215: 'Walt, the semi-invalid': Kaplan, p. 359.

p. 215: Burroughs: *Correspondence*, 3: 4.

p. 215: Both father and mother: *Correspondence*, 3: 4; Kaplan, pp. 360–61.

p. 215: 'My nephew & I': *Correspondence*, 3: 68.

p. 215: Spare journal entries: *Daybooks*, pp. 44–58.

p. 216: 'I wish': *Correspondence*, 3: 6–7.

p. 216: 'Monday': *Daybooks*, p. 85.

p. 216: 'I realize plainly': *Correspondence*, 3: 81.

p. 217: 'Married': *Daybooks*, p. 337.

p. 217: Timber Creek: All material is drawn from *Prose*, pp. 119–34, 143–53.

Chapter 10

NOTE: Pound's works, listed in the Bibliography to Part II, are cited here by abbreviated titles only.

p. 219: 'Move the soul': *Slected Prose*, p. 307.

p. 220: 'One of the tensions': Emery, pp. 5, 29.

p. 220: 'Religio': *Selected Prose*, p. 70.

p. 220: 'Unity of nature': *Selected Prose*, p. 59.

p. 221: 'Suddenly conscious': *Guide*, p. 44.

p. 221: 'Light from Eleusis': *Selected Prose*, p. 53.

p. 221: 'We find two forces': *Selected Prose*, p. 306.

p. 221: 'Go in fear of abstractions': *Literary Essays*, p. 5.

p. 221: 'Stay poetic': *ABC*, p. 22.

p. 222: 'In Europe': *ABC*, pp. 19–20.

p. 222: Stone elephants: *Jefferson*, p. 31.

p. 222: 'Light' in concrete speech: Examples are from *Cantos*, pp. 51, 494, 529, 631, 794.

p. 223: 'Interested in art and ecstasy': *Paedeuma* 1, 1 (Spring and Summer 1972), p. 109.

p. 223: 'Incarnational art': O'Connor, pp. 67–68.

p. 223: 'And Kung said': *Cantos*, p. 59.

p. 224: 'Principle of good': *The Exile* 2 (Autumn 1927), p. 35.

p. 224: 'This liquid': *Cantos*, p. 449.

p. 224: '*Virtù*': *Cantos*, p. 429.

p. 224: 'Will toward order': *Jefferson*, p. 99.

pp. 224–25: 'The greater the artist': *Jefferson*, pp. 15–16.

p. 225: 'Belief & Technique': Jack Kerouac, 'Belief & Technique for Modern Prose,' *Evergreen Review* 2, 8 (September 1959), p. 57.

p. 226: Kerouac credits: Ann Charters, *Kerouac* (San Francisco: Straight Arrow Books, 1973), p. 147.

p. 226: Teletype paper: Ibid., pp. 131–35.

p. 226: Durable gems: The image is borrowed from D. H. Lawrence's essay, 'Poetry of the Present.' See *The Complete Poems* (London: Heinemann, 1972), 1: 182.

p. 227: 'I asked you to write': T. S. Eliot, 'Ezra Pound,' *Poetry* 68, no. 6 (September 1946), p. 336.

p. 227: 'What you shall do': Whitman, *Leaves*, pp. 714–15.

p. 227: 'In attacking a doctrine': *Guide*, p. 7.

p. 228: Young Eliot: See Lyndall Gordon, *Eliot's Early Years* (New York: Oxford University Press, 1977).

p. 228: 'First myths arose': *Pavannes*, pp. 143–44.

p. 229: 'The Tree': *Personae*, p. 3. For a discussion of the apparent

biographical situation of this poem, see Janice S. Robinson, *H.D.: The Life and Work of an American Poet* (Boston: Houghton Mifflin, 1982), pp. 10–20.

p. 229: 'I tried to evoke': Jane Kramer, *Allen Ginsberg in America* (New York: Random House, 1969), p. 72.

p. 230: 'In meiner Heimat': *Cantos*, p. 794.

p. 231: 'And Kung said': *Cantos*, p. 59.

p. 231: Jefferson: *Cantos*, p. 97.

p. 231: Napoleon: *Cantos*, p. 227.

p. 232: 'The Duce': *Guide*, p. 144.

p. 232: 'DIRECTION OF THE WILL': *Jefferson*, pp. 15–16.

p. 232: 'Money-power': Emery, p. 20.

p. 233: 'Mr Adams to Abigail': *Cantos*, p. 344.

p. 234: 'The ant's a centaur': *Cantos*, p. 521.

p. 234: 'My poetry and my econ': Norman, p. 333.

p. 234: 'Such a comfort': *Letters*, p. 40.

p. 235: 'No one . . . kinder': T. S. Eliot, 'Ezra Pound,' *Poetry* 68,no. 6 (September 1946), p. 328.

p. 235: Joyce: See Norman, pp. 171–73.

p. 236: 'Investment of Dial prize': Norman, p. 291.

p. 236: Hemingway on Pound: Ernest Hemingway, 'Homage to to Ezra,' *This Quarter* 1, no. 1 (1925), p. 223.

p. 237: 'To postulate': Heymann, p. 33.

p. 237: 'Arts did not flourish': *Social Credit*, p. 9.

p. 237: 'Art thickened': *Cantos*, p. 234.

pp. 237–39: Canto 45: *Cantos*, pp. 229–30.

p. 239: 'Gods float': *Cantos*, p. 11.

p. 239: 'Use of purchasing power': *Cantos*, p. 230.

p. 239: Underoos: *New York Times*, 29 June 1978, p. D17.

pp. 240–41: Burger King: *New York Times*, 23 January 1978, p. D4.

p. 242: 'Only comprehensible language': See Shell, p. 5.

p. 243: 'Sometimes about ten o'clock': W. B. Yeats, *A Vision* (New York: Collier Books, 1966), pp. 5–6.

p. 244: 'Proud of its dead poets': Saul Bellow, *Humboldt's Gift* (New York: Avon Books, 1976), pp. 113–14.

p. 245: Pound on Mussolini: *Letters*, pp. 204–5.

p. 245: 'From the time of Tiberius': *Jefferson*, p. 23.

p. 245: 'The Debunker': *Jefferson*, p. 74.

p. 245: 'Have a consortium': *Cantos*, p. 202.

p. 246: 'At 4:14': *Jefferson*, pp. vii–viii.

p. 246: 'Will toward *order*': *Jefferson*, p. 99 (Pound's emphasis).

p. 246: 'Don't knock Mussolini': *Letters*, p. 239.

p. 246: 'Ma questo': *Cantos*, p. 202.

p. 247: 'Devoted homage': Heymann, p. 317.

p. 247: One Italian fascist: Heymann, p. 320.

p. 247: 'Don't shoot him': Heymann, p. 120.

p. 248: In Paris in 1935: Heymann, p. 62.

p. 248: 'Megalomania': Hall, p. 107.

p. 248: 'His own tongue': Mary de Racheweiltz *Discretions* (Boston: Little, Brown, 1971), p. 173.

p. 248: Szasz: Thomas S. Szasz, *Law, Liberty and Psychiatry* (New York: Macmillan, 1963), p. 206.

p. 248: 'War is proof': Heymann, p. 119.

p. 249: 'Jewspapers': *Selected Prose*, p. 299.

p. 249: 'Jewsfeldt': Heymann, p. 97.

pp. 249–50: 'O God': *Personae*, p. 117.

p. 251: Imagine the ancient Hermes: Most of my material on Hermes comes from Rafael Lopez-Pedraza's book. See especially pp. 3, 8, 36ff., 48, 59ff., 91. Lopez works from the ancient images of Hermes to imagine him as a guide for psychoanalysis. For another analysis of Pound and Hermes, see Janice S. Robinson, *H.D.* (Boston: Houghton Mifflin, 1982), chapter 4.

p. 253: 'You let in the Jew': Heymann, p. 116.

p. 253: 'Kike god': Heymann, p. 236.

p. 254: 'After Lincoln's death': *America*, p. 17.

p. 254: 'Morgenthau-Lehman gang': Heymann, p. 117.

p. 254: 'Artificial ignorance': *America*, p. 7.

p. 254: The sickness is sexual: See Heymann, pp. 68, 236.

p. 254: 'Usury and sodomy': *Social Credit*, p. 6.

pp. 255–56: Jew in the Hawthorn Hedge: For a full translation of the original tales, see *The Grimms' German Folk Tales* (Carbondale: Southern Illinois University Press, 1960), pp. 400–4.

p. 259: Bread or caviar: Norman, p. 413.

p. 259: 'Preserving public morality': Heymann, p. 60.

p. 259: 'General results of Freud': *Jefferson*, pp. 100–1.

p. 260: 'Pogrom': Heymann, p. 118.

p. 261: 'Future tense of money': *Selected Prose*, p. 308.

p. 261: 'What constitutes': *America*, p. 6.

p. 261: 'Siena was flat': *Selected Prose*, p. 270.

p. 262: Divided all goods in three: *Selected Prose*, pp. 214–15.

p. 262: 'Clover enduring': *Cantos*, p. 634.

p. 262: 'Every bit of DURABLE goods': *Jefferson*, p. 81.

p. 262: 'It would be better': *Selected Prose*, p. 330.

p. 263: 'Potatoes, crops': *Selected Prose*, p. 336.

p. 263: '"Stamp scrip"': *Selected Prose*, p. 295.

p. 263: 'Counter-usury': *Selected Prose*, p. 274.

p. 263: Letters to Mussolini: Heymann, pp. 318, 323.

p. 263: 'Anyone who thinks': *Selected Prose*, p. 330.

p. 263: 'Certain advantages': *Selected Prose*, p. 347.

p. 264: 'Gold': *Selected Prose*, p. 348.

p. 264: 'State sets prices': *Selected Prose*, p. 293.

p. 264: 'State has power': *Selected Prose*, p. 214.

p. 265: Three more specific cases: *Selected Prose*, pp. 172, 181, 338.

p. 265: 'Laws of mathematics': Albert Einstein, 'Geometry and Experience,' in *Readings in the Philosophy of Science*, ed. Herbert Feigl and Mary Brodbeck (New York: Appleton-Century-Crofts, 1953), p. 189.

p. 266: 'Finance of financiers': *Selected Prose*, p. 240.

p. 266: 'Artists have known': *Selected Prose*, p. 236.

p. 267: 'Navy depended': *Selected Prose*, p. 168.

p. 267: 'Nineteenth century': *Selected Prose*, pp. 346–47.

p. 267: 'Money alone': *Selected Prose*, p. 307–9.

p. 267: 'Power of putrefaction': *Selected Prose*, p. 317.

p. 267: 'Theologians': *Selected Prose*, p. 322.

p. 268: 'Who destroyed the mystery': *Selected Prose*, p. 317.

p. 268: 'Logic is money of mind': See Shell, p. 36.

p. 268: 'Call people': *Selected Prose*, p. 333.

p. 268: The word 'just': *Selected Prose*, pp. 252, 330.

p. 268: 'He would be a poet': Henry David Thoreau, 'Walking,' in *Walden and Other Writings* (New York: Modern Library, 1937), p. 619.

p. 268: 'A perfect writer': Whitman, *Daybooks*, p. 742.

p. 269: 'STATE AUTHORITY': *Selected Prose*, p. 292.

p. 269: 'Economic conditions': *Selected Prose*, p. 293.

p. 269n: 'No part or function': *Selected Prose*, p. 297.

p. 269: 'Volitionist': *Selected Prose*, p. 294.

p. 269: 'Voluntas': *Selected Prose*, p. 312.

p. 269: 'Opposing systems': *Make It New*, p. 17.

p. 270: 'My efforts': *America*, p. 16.

p. 270n: 'A country CAN': Heymann, p. 70.

p. 271n: 'That heretical scoundrel': Heymann, p. 265.

p. 272: 'Write an epic poem': *Selected Prose*, p. 167.

p. 272: 'Bathed in alkali': *Cantos*, p. 67.

pp. 272–73: 'They were heaving it': 'Ezra Pound: An Interview,' *Paris Review* 28 (Summer-Fall 1962), p. 40.

p. 273: 'In hell': Heymann, p. 271.

pp. 275–75: Ginsberg: The story is told in Ginsberg, pp. 9–21.

p. 275n: 'Re USURY': Hall, p. 188.

Conclusion

p. 276: Edward Hopper: Lloyd Goodrich, *Edward Hopper* (New York: Harry N. Abrams, Inc., 1976), pp. 22–27, 35.

p. 281: 'Poverty here': Pound, *Letters*, p. 204.

pp. 281–82: Whitman and Pound: For material on Pound's income, see *Letters*, p. 259; Heymann, pp. 34, 60, 110, 190, 248–49, 276. For material on Whitman's income, see especially *Correspondence*, 6: xi–xxxvi.

p. 282: 'Sold in perpetuity': Lev. 25: 23.

p. 282: 'You get a good poem': Snyder, p. 79.

p. 282: 'Affluent economies': Marshall Sahlins, *Stone Age Economics* (Chicago: Aldine, 1972), p. 3.

p. 284: 'Childhood and Poetry': For the original of this essay, see Pablo Neruda, *Obras Completas*, 2nd ed. (Buenos Aires: Losada, 1962), pp. 17–30. The translation I use is by Robert Bly, from Neruda, *Twenty Poems*, pp. 14–15.

p. 284: 'Enormous saw': Neruda, *Memoirs*, p. 13.

p. 284: 'This exchange of gifts': Neruda, *Twenty Poems*, p. 110.

ACKNOWLEDGMENTS

It is now time to try to free some of the spirits who labored with me in the creation of *The Gift*.

The idea for this book took shape during a month spent at the Center for Intercultural Documentation in Cuernavaca, Mexico. I am grateful to Ivan Illich both for the example of his work and for the fertile atmosphere I found at CIDOC.

A creative writing fellowship from the National Endowment for the Arts gave me the freedom to begin my project, and a fellowship for independent study and research from the National Endowment for the Humanities supported a year's work in the library. The Millay Colony for the Arts provided a month of meals, shelter, and butterfly hunting without which my chapter on Whitman might never have taken shape.

The endowments and colonies such as Millay are truly gift institutions. I am grateful.

Both friends and strangers have given their support throughout the years, sending me newspaper clippings, talking all morning over coffee, convincing me of my errors, and offering typing, solace, diversion, and hope. I particularly wish to thank Robert Bly, Abby Freedman, Donald Hall, Patricia Hampl, Robert Hass, Dan Hobbing, Richard Hobby, Miriam Levine, Julia Markus, Jim Moore, Sherman Paul, Kris Rosenthal, Wendy Salinger,

Marshall Sahlins, Millard Schumaker, Ron Sharp, Marc Shell, Daveda Tenenbaum, and Larry Wolken.

Bill Clark helped me gain access to valuable research materials. Charlotte Sheedy gave advice when it came time to enter the marketplace. Jonathan Galassi edited the book with intelligence and care; his confidence in the unpredictable rhythms of creative labor often exceeded my own.

Linda Bamber responded to the book in manuscript, chapter by chapter. An ideal reader, she managed to combine a stranger's cold eye with a sister's unconditional support. If there are moments of clarity in *The Gift*, many of them are hers, not mine.

To Patsy Vigderman I owe a debt that I hope to repay, slowly, for years to come.

INDEX

ABOUT THE
AUTHOR

Lewis Hyde was born in Boston in 1945 and educated at the universities of Minnesota and Iowa. His much reprinted essay 'Alcohol and Poetry: John Berryman and the Booze Talking' (1975) grew out of his experiences as an alcoholism counselor. He has also worked as an electrician, teacher, and carpenter to support himself while writing. His edition of the selected poems of the Nobel Prize-winning Spanish writer Vicente Aleixandre, *A Longing for the Light*, was published in 1979. Hyde has received grants from the National Endowment for the Arts, the National Endowment for the Humanities, and the Massachusetts Council on the Arts. His poetry and essays have appeared in numerous journals, including the *Kenyon Review*, the *American Poetry Review*, the *Paris Review*, and the *Nation*. He lives in Watertown, Massachusetts, with his family.

344 The Gift

Grateful acknowledgment is made to the following for permission to reprint previously published material:

Actac Ltd.: Excerpt from a letter by Harold Pinter originally published in *The Kenyon Review* (Summer 1981). Reprinted by kind permission of Actac Ltd.

City Lights Books: Excerpt from an essay by Allen Ginsberg in *City Lights Anthology.* Copyright © 1974 by Allen Ginsberg and City Lights Books. Reprinted by permission of the publisher.

Concordia Publishing House: Excerpt from *Luther's Works,* Volume 9,© 1960 Concordia Publishing House. Used by permission.

E. P. Dutton, Inc.: Excerpts from *Argonauts of the Western Pacific* by Bronislaw Malinowski, 1922 edition. Reprinted by permission of the publisher.

Grey Fox Press: Excerpt from *Composed on the Tongue* by Allen Ginsberg. Copyright © 1980 by Allen Ginsberg. Reprinted by permission of Grey Fox Press.

Ernest Hemingway: Excerpt from 'Homage to Ezra' by Ernest Hemingway. First published in *This Quarter*, 1925. Reprinted by permission of the Estate of Ernest Hemingway.

Houghton Library, Harvard University: An etching by Rossollini. Reprinted by permission of Houghton Library.

Indiana University Press: Excerpt from *Meister Eckhart: Mystic and Philosopher*, translated by Reiner Schurmann. Published by Indiana University Press, 1978.

Ironwood: Excerpt from 'A Separate Notebook: The Mirrored Gallery' by Czeslaw Milosz, translated by Robert Hass and Renata Gorczynski. Reprinted from *Ironwood* (Special Milosz Issue).

Liveright Publishing Corporation: Excerpt from *Jefferson and/or Mussolini* by Ezra Pound. Copyright 1935, 1936 by Ezra Pound.

Macmillan Publishing Co., Inc. and A. P. Watt Ltd., London: Excerpt from *A Vision* by William Butler Yeats. Copyright 1937 by William Butler Yeats; renewed 1965 by Bertha Georgie Yeats and Anne Butler Yeats.

MCA, Inc.: Excerpt from 'I Wonder' by Bill Broonzy © copyright 1947 by MCA MUSIC, a division of MCA Inc., New York, N.Y. Copyright renewed. Used by permission. All rights reserved.

New Directions Publishing Corp.: Excerpts from works by Ezra Pound. *Personae*. Copyright 1926 by Ezra Pound. *The Cantos of Ezra Pound*. Copyright 1934, 1937, 1940, 1948, © 1956, 1959, 1962, 1963, 1966, 1968 by Ezra Pound. Copyright © 1972 by the Estate of Ezra Pound. *The ABC of Reading*. Copyright 1934 by Ezra Pound. *Guide to Kulchur*. Copyright © 1970 by Ezra Pound. *Pavannes & Divagations*. Copyright © 1958 by Ezra Pound. *Selected Prose 1909–1965*. Copyright © 1973 by the Estate of Ezra Pound. *Selected Letters of Ezra Pound 1907–1941*. Copyright 1950 by Ezra Pound. Reprinted by permission of the publisher.

Poetry: Excerpt from 'Ezra Pound' by T. S. Eliot. First published in *Poetry*. Copyright 1946 by The Modern Poetry Association. Reprinted by permission of the Editor of *Poetry*.

The Shoe String Press Inc.: 'Marriage gifts among the Tikopia' from *Primitive Polynesian Economy* by Raymond Firth, 1965, p. 323. Reprinted from Archon Books, Hamden, Conn.

Sixties Press: Excerpt from *Twenty Poems of Pablo Neruda*, translated by Robert Bly. Copyright © 1967 by Robert Bly. Reprinted by permission of Robert Bly.

Southern Illinois University Press: 'The Ungrateful Son' is reprinted from *The Grimms' German Folk Tales*, translated by Francis P. Magoun, Jr., and Alexander H. Krappe. Copyright © 1960 by Southern Illinois University Press. Reprinted by permission of the publisher.

TRO: Excerpt from 'The Bourgeois Blues'; words and music by Huddie Ledbetter. Edited with new material by Alan Lomax. TRO–© Copyright 1959 Folkways Music Publishers, Inc. Used by permission.

The University of Chicago Press: Excerpt reprinted from *The Idea of Usury* by Benjamin N. Nelson by permission of the publisher. Copyright © 1949, 1969 by Benjamin N. Nelson. All rights reserved.

The University of Washington Press: Excerpt from a lecture by Theodore Roethke as published in *On the Poet and His Craft*, edited by Ralph J. Mills. Reprinted by permission of the publisher.